Chinese Ornament

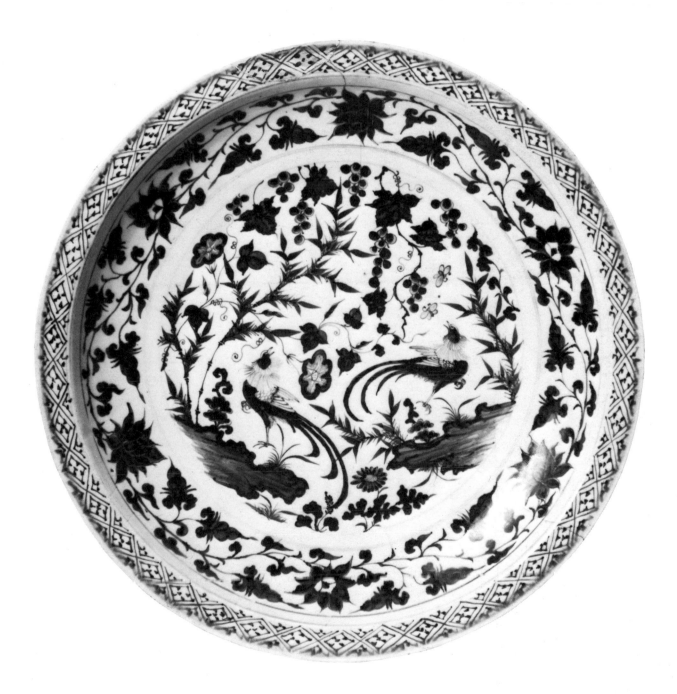

CHINESE
ORNAMENT

The Lotus and the Dragon

JESSICA RAWSON

Published for the Trustees of the British Museum by
BRITISH MUSEUM PUBLICATIONS LIMITED

© 1984 The Trustees of the British Museum

Second impression 1990

Published by British Museum Publications Ltd.
46 Bloomsbury Street, London WC1B 3QQ

British Library Cataloguing in Publication Data

Rawson, Jessica
 Chinese ornament: the lotus and the dragon.
 1. Decoration and ornament – Animal forms –
 China 2. Decoration and ornament – Plant
 forms – China
 I. Title
 745.4'4951 BK1483

ISBN 0-7141-1431-6

Page 1 Figure 2 (see p. 13).
Pages 2–3 Figure 168 (see p. 192).
Pages 4–5 Figure 169 (see p. 192).

Designed by Roger Davies

Set in Monophoto Photina and printed in
Great Britain by Balding + Mansell Limited,
London and Wisbech

Contents

Preface

This book accompanies an exhibition of the same name, although both are designed to stand on their own and are not interdependent. Using slightly different material, they both address the same question, namely what are the sources of flower and animal designs that are widely displayed in Chinese art and especially on Chinese porcelains?

The strange twists in the history of Chinese flower design first became apparent to me in my studies of Chinese silver, which followed upon the mounting of the exhibition 'Wealth of the Roman World' at the British Museum (1 April–1 October 1977). A connection between Chinese silver and silver in the lands to the west of China has been acknowledged for some time. During this exhibition, I came to see that the link was not straightforward and began to look for new answers. The publication of Sir Ernst Gombrich's *The Sense of Order* in 1979 offered a range of possibilities of which I had hardly dreamed. It drew my attention to continuities in the Western tradition of flower and foliage ornament and opened up the discussion of links between this Western series of designs and foliage patterns in the Far East. My first debt is therefore to Sir Ernst Gombrich and to the stimulus his many works have given me. I am also grateful for his kind encouragement in this project and for his permission to quote from *The Sense of Order* in the Introduction.

My second debt is to the British Museum itself and above all to its rich collections, for the issues addressed here could be tackled only in the light of material from ancient Egypt, the Classical world, Iran, the Indian sub-continent and the Far East. I am grateful to the Keepers of the Departments of Egyptian Antiquities, Greek and Roman Antiquities, Medieval and Later Antiquities and Western Asiatic Antiquities for their help in lending items to the exhibition, for their patience in answering my many questions, and for their generosity in placing the resources of their departments at my disposal in my researches. My special thanks go to Harry James for allowing me to call on the services of Christine Barratt in the preparation of the drawings and maps, and I am grateful to her for her careful interpretation in clear and elegant drawings of the many sources I presented to her. In the preparation of both the text of the book and the exhibition I should like to acknowledge the help of Carol Andrews, Lucilla Burn, John Curtis, Aileen Dawson, Lesley Fitton, Julian Reade, Susan Walker and Dyfri Williams. My own department has given me infinite help and support, and I must thank in particular Derek Gillman, Michael Rogers and Wladimir Zwalf, to whom I owe both many essential ideas and references. Rachel Astor, Elizabeth Foxell, Victor Harris, Sue Beeby, Sian Jay and Sue Grundy, and the department's team of Museum Assistants have also provided invaluable assistance. The wide range of the subject has led me to seek help from Nigel Hepper of the Royal Botanic Gardens, Kew, from Filiz Çağman and Zeren Tanidi of the Topkapi Saray Library, and Mimi Neill of the Yale University Art Gallery. John Carswell, Peyton Skipwith, Norah Titley, Stuart Carey Welch and Jeffrey West have contributed invaluable photographs and information. I should also like to thank my husband for his tolerance and support throughout my work on this book, and especially for his help on the index. The preparation of the manuscript for press has been undertaken with dedication by Deborah Wakeling, and I thank her for her untiring efforts.

I should like to thank all those who have made possible the loans to the exhibition from other institutions, including Mr B.C. Bloomfield, Patricia Herbert and Peter Lawson of the British Library, Roger Moorey, Mary Tregear and Helen Whitehouse of the Ashmolean Museum, Robin Crighton of the

Fitzwilliam Museum and Joe Earle, Rose Kerr, Oliver Watson and Verity Wilson of the Victoria and Albert Museum. For work on the display I must thank Ivor Heal, the designer of the exhibition, together with the staff of the Museum's Design Office, especially Gordon Barber and Elizabeth Robertson.

The Photographic Department of the British Museum has contributed many photographs to both the book and the exhibition. In addition, I am grateful to the following for permission to reproduce photographs: Archaeological Survey of India, 26; Ashmolean Museum, Oxford, 56; British Library, 144, 147, 149, 154, 155, 156, 161, 172, pl. 7; Conway Library, Courtauld Institute, 12; Edinburgh University Library, 133; Sir John Figgess, 84; Fogg Art Museum, Harvard University, 168, 171; A.F. Kersting, 19; Musée du Louvre, Paris, 175; National Library, West Berlin, 134, 157, 158; Ann Paludan, 97; Royal Botanic Gardens, Kew, 9, 10, 176; Syndics of the Fitzwilliam Museum, 114; Topkapi Saray, Istanbul, 78, 136, 150, 151, 159, 167; Victoria and Albert Museum, 2, 4, 5, 63, 91, 101, 124, 169, 174, pl. 6; Warburg Institute 18.

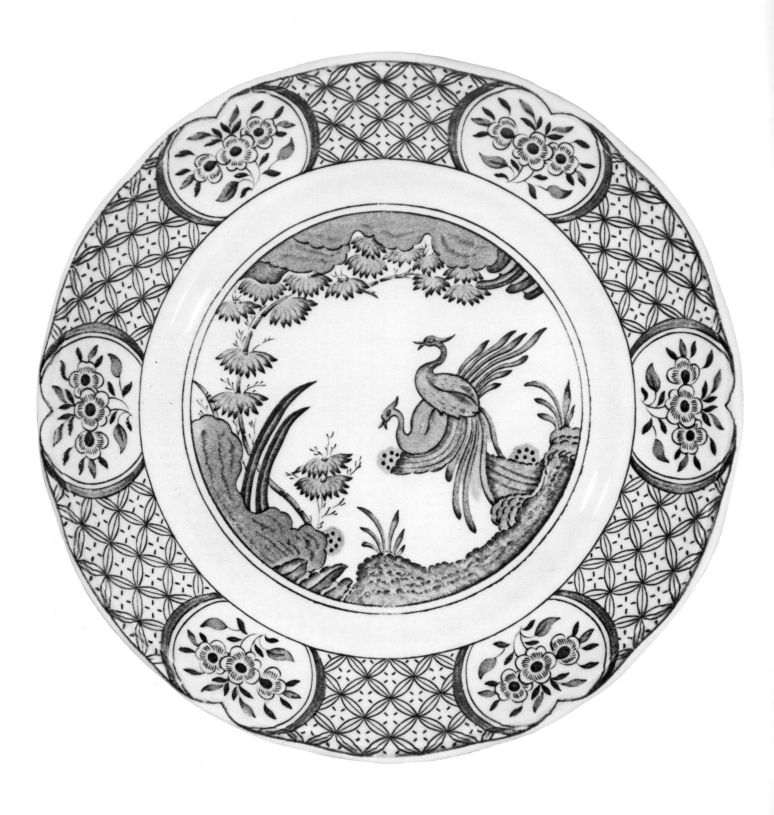

Fig. 1 Earthenware dish decorated with birds and other motifs in Chinese style, Staffordshire, *c.*1950. Diam. 19.5 cm. Private collection.

Chinese flower and animal patterns, including the lotus and the dragon of the title of this book, are amongst the most influential designs in the world. Although the first stages of the development of these motifs are to be found in remote areas of China, in Buddhist cave temples carved in the late fifth century AD, such flower and animal patterns are not at all removed from our day-to-day lives in the twentieth century. A glance at almost any decoration of a white ceramic, be it porcelain, stoneware, or pottery, reveals flowers, animals and even figures that are distantly related to Chinese examples.

Some ceramic decoration follows Chinese models more closely than others. The designs in blue on a small dish in figure 1, which might be used on any breakfast table in the land, are based upon decoration on Chinese porcelains of the fourteenth, fifteenth and sixteenth centuries. The dish displays a pair of birds in a sketchy landscape, surrounded by a broad border of panels and lozenges, a design that may be compared with ornaments on Chinese porcelains in figures 2 and 3. White tableware, at first incised or moulded with flowers and animals, and later decorated with similar designs in underglaze blue or coloured enamels, was developed in China from the eleventh century. European white dishes decorated with flower sprays or with a central figure or animal therefore take up a formula invented in China. Even when the designs on our dinner plates do not reproduce a Chinese motif, the use of white plates with some sort of pictorial central design, with or without a dense border, grew out of the European taste for Chinese porcelain dishes. Thus flower and animal patterns, whose sources are the subject of this book, had a range of influence on European pots that was equal to the influence of Western ornament, based upon the mouldings and foliage designs of Classical architecture, upon the furnishings of European houses.

The reasons for the widespread borrowing of Chinese motifs and decorative compositions lay not so much in the attractiveness of the designs as in the technical excellence of Chinese porcelain. Porcelain requires the use of a white rock, a decomposed form of granite, which is called porcelain stone. Varieties of this rock found in China are both extremely abundant (particularly in the south) and also especially suitable for working into porcelains. European forms produce less malleable pastes and are less readily exploited.[1] Furthermore, the Chinese were able to achieve the very high temperatures needed for the production of porcelains long before high-firing kilns were developed in Europe. For many centuries, therefore, China led the field in the production of fine, translucent, white ceramics. With a large labour force at their disposal, the great kilns manufactured vast quantities of porcelains, which were exported all over the world. Boat loads of ceramics were transported to the coast from the main kilns at Jingdezhen, in central southern China, and were then shipped to South-East Asia, the Near East, Europe and the New World.

Despite the staggering quantities that reached Europe and the Near East, Chinese porcelain remained a luxury, out of reach of many. So, in both Europe and the Near East, attempts were made to copy the fine ceramic; however, the technical qualities of Chinese porcelain were and are difficult to reproduce. This was equally true for Japanese porcelain, technically related to Chinese porcelain, which was also highly regarded in seventeenth- and early eighteenth-century Europe (a large proportion of the designs on Japanese export wares were greatly influenced by Chinese ornament). By the eighteenth century, the factories at Meissen and Sèvres produced good hard-paste bodies in imitation of imported Chinese and Japanese ceramics, but the chemistry was

jealously guarded and many other factories had to be content to copy Far Eastern porcelains in less sophisticated clays. Thus delftware from both Holland and England was made in low-fired earthenwares, covered with an opaque white glaze to mimic the white body of porcelain, and was painted in blue with designs that incorporated some Chinese motifs. Often these were replaced by subjects familiar to the Europeans, but the format generally remained Chinese, with an outer border of panels or flowers and an inner design which hinted at some sort of picture.[2] In this way, Chinese porcelains provided models that European potters copied in materials of low cost, which required limited technical expertise.

The imprint of Chinese porcelains on European ceramic production can be illustrated in just a few examples. A large Yuan dynasty (fourteenth-century) porcelain dish, decorated in underglaze blue, has a central design of birds in a rocky landscape surrounded by foliage (fig. 2). The cavetto of the dish is filled with an undulating scroll supporting large flower heads, with pointed petals and small pointed leaves. The rim contains a border of lozenges. This combination, of a central motif of creatures in a landscape with a border of flowers, was a standard formula used on porcelain dishes at this date.

Other patterns might take the place of the scroll, including various arrangements of lobed panels, seen here on a sixteenth-century dish (fig. 3). The central motif on this second dish is simply a later form of the birds on a rock motif seen on the previous example. The landscape is slightly more realistic – with towering cliffs and clouds, glimpsed over an expanse of water, set beyond trees and the rock on which the bird sits. As described in Chapter 3, this example elaborates the earlier design by taking account of advances in landscape painting. An exactly comparable design, including both the panels and the bird motif, is found on a seventeenth-century English delftware basin in the Victoria and Albert Museum (fig. 4).[3] The details of the panels, being less familiar to the European potter than to the Chinese, are executed with rather less precision than on the Chinese prototype. The landscape settings of the bird and rock are also more summary. A rather later dish, also of English delftware, shows another version of the same design, with a large rock and diminutive birds (fig. 5). The border around the rim is based upon a further lobed shape of Chinese origin. The flexibility exercised by the Chinese potters, mixing a series of central motifs with a range of borders, was also exploited by the Europeans. In East Asia, the Near East and Europe, this shared repertory produced an interesting variety within a standard series of designs. The small dish illustrated in figure 1 belongs to this long tradition.

At first sight, it may seem a little unlikely that flower and animal patterns have much of a history. It might well be asked whether they were not drawn from nature. Indeed, it is often suggested that flower designs, consistently used on some of the elegant porcelains made under the Song dynasty (960–1279), were inspired by a concern with nature, evident in poetry and painting of the period. An almost unvarying series of animal designs and the peculiar character of the flowers used on ceramics, however, suggest that some source other than a direct transcription of nature must be discovered.

Animal subjects are in fact very limited and include dragons and phoenixes, birds on rocks, deer, lions and fish.[4] The first two creatures had ancient symbolic associations and were employed to decorate buildings to ensure their protection. Deer, lions and fish likewise started out as creatures with auspicious powers, but over 1,000 years the more awesome associations of all

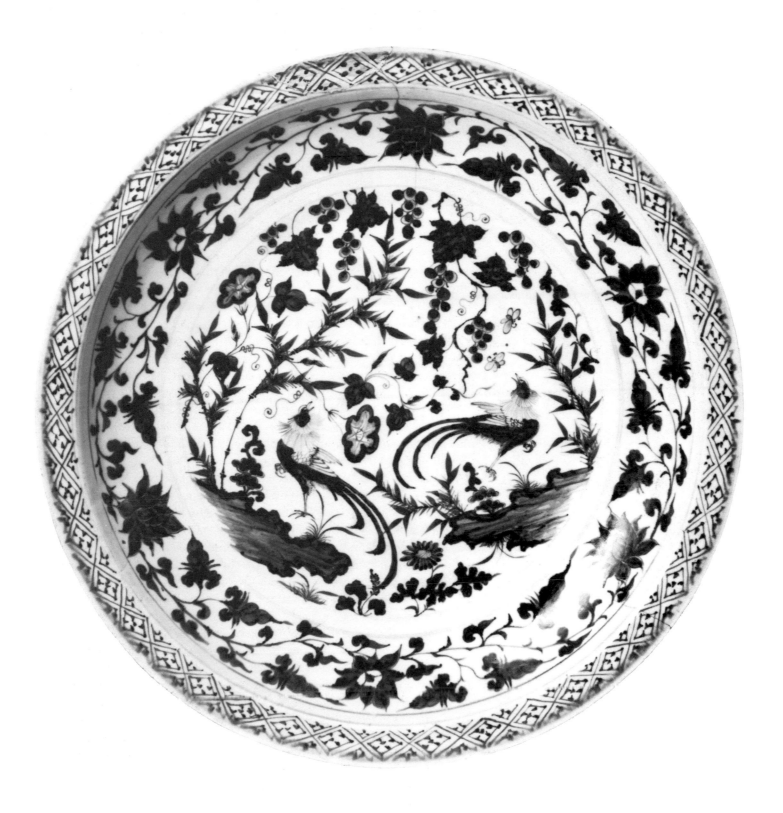

Fig. 2 Porcelain dish decorated with birds amid a landscape, China, Yuan dynasty, 14th century.
Diam. 45.8 cm. Victoria and Albert Museum.

these animals receded in importance, and by the fourteenth century they were, by and large, no more than pleasing decorative motifs.

Flowers are more puzzling. Neat flower heads on the scroll around the fourteenth-century dish in figure 2 are presumably intended to represent the pink lotus, *Nelumbo nucifera*. The pointed petals on the flowers in the scroll approximate to the real flower illustrated in figure 9; however, the dense arrangement of the petals of some of the painted blooms is not particularly lifelike. In later lotus scrolls, small artificial hooks were added, as on a scroll from a bowl made about 1400 (fig. 7). Both the lotus scrolls just mentioned have most peculiar leaves; the real lotus, shown in the botanical illustration, has large round flat leaves that float like water-lily leaves on the surface of ponds and lakes. The flower scrolls, however, and all others like them, make no reference to the real leaf of the lotus and are embellished instead with pointed leaves supported on two rounded commas. Some central, as against border, motifs show lotus flowers with their correct leaves growing in a pond (see figs 109, 152 below).

Peony scrolls, also popular on porcelains of the fourteenth century, are not much more like real flowers. The scroll in figure 8 matches the lotus patterns described. Its stem undulates broadly, and in each wave single large flower heads are held on their own stalks. The petals of these peonies are all bordered with small rounded arcs. Both these regular arcs and the short leaves with simple jagged edges are rather different from the flowers and leaves of most genuine varieties of peony, represented here by *Paeonia lactiflora* (fig. 10). The petals of the real flowers are much less florid than those of the blooms on the painted scroll; furthermore, in nature peony leaves are long and divided rather than short and jagged. Both peonies and lotuses are repeatedly shown on undulating stems, uncharacteristic of the plants in nature, so neither plant is accurately depicted. Such forms demand an explanation.

The history of these plants as decoration is particularly intriguing because almost no plant ornament was used in ancient China – that is to say, before the advent of the unified empires of the Qin (221–206 BC) and Han (206 BC–AD 220).[5] The development of flower patterns starts with the use of quite elementary undulating scrolls in the decoration of Buddhist architecture during the period of divided rule, known as the Six Dynasties period (220–589, fig. 11). Flowers finally came into their own in architectural ornament in the Sui (581–618) and Tang (618–906) periods, when China once again came under a powerful dynasty, which extended her influence widely across Central Asia. Until this date, flower scrolls used in architecture had not been generally employed on secular utensils. Now, however, simple foliate scrolls appeared on silverware. Thereafter, during the Song period (960–1279), and the rule in the north of the non-Chinese dynasties of the Liao (907–1125) and the Jin (1115–1234), flower designs were gradually exploited on porcelains. Throughout these centuries, the undulating outline of the stems of the early foliage patterns remained embedded in designs of increasing complexity and naturalism, surviving to determine the wavy outline of the scrolls described above (figs 7, 8).

Examples of early foliage scrolls are shown in figure 11. The simple lobed leaf can be compared with Western foliage designs descended from Classical acanthus and palmette ornament. Indeed, a connection between Western acanthus patterns and early Chinese foliage designs has long been recognised.[6] However, the means by which these patterns were transmitted across Asia

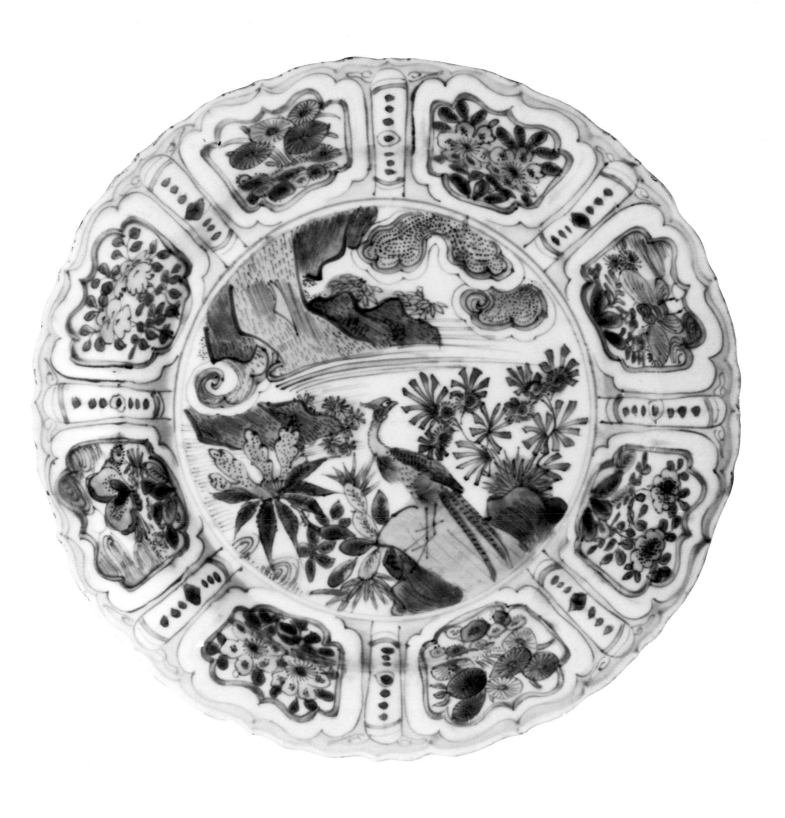

Fig. 3 Porcelain dish decorated with a bird on a rock, China, Ming dynasty, 16th–17th centuries. Diam. 20.6 cm. British Museum.

have not been studied. The first chapter will therefore trace the sources of Chinese foliage patterns to the Western acanthus and half-palmette borders, and will discuss the history of decorated architectural façades in Iran and Central Asia, which made possible the borrowing of this ornament. Chapter 2 will consider the way in which architectural motifs came to be transferred to secular utensils and the variations introduced into lotus and peony borders.

Chapter 3 is concerned with animal subjects. Once again an account has to be given of the way in which motifs invented for the embellishment of architecture were transferred to ceramics. Lobed panels and outlines, used to divide motifs from one another, will be considered in Chapter 4. Like the foliage borders, some of the animal designs and all the lobed motifs were dependent on the introduction of foreign designs, which accompanied the patronage of Buddhism during the fifth and sixth centuries. The last chapter will turn to a history of Chinese motifs exploited in Iran and Turkey following the Mongol conquests. In Iran Chinese lotus and animal motifs both became very popular from the thirteenth century. An Iranian drawing in Chinese style illustrates an exact transcription of the motif of birds on the rock (fig. 6). Here, however, a Chinese design, which in its original form had a lyrical aspect, has been turned into an aggressive dialogue. Such motifs were probably transmitted to Iran in media other than ceramics. Much of the discussion will, however, concentrate on the decoration of ceramics and silver and on the sources of these motifs in architectural ornament. Here there is abundant material to be considered and sequences of designs can be set out reasonably fully. Another influential medium, textiles, is less easily discussed because very few examples have survived from the relevant early periods. For this reason it is difficult to assess whether textile patterns were or were not important to the development of designs used on other materials.[7]

We are surprisingly short of terminology and methods with which to approach this study, for ornament of any kind receives scant attention in present-day art history. To explain this neglect we must therefore examine Western attitudes to ornament and also mention Alois Riegl and E.H. Gombrich, whose works illumine this otherwise little-explored field.

The *Oxford English Dictionary* defines ornament as anything used to adorn; a decoration or embellishment. In this general description, the term ornament can refer to any addition to a building, object or person to increase its attractiveness to the eye. This definition brings too much within its purview; it makes no distinctions between different types of ornament, or ornament of different dates and different places. However, before turning to the special use of the word 'ornament' in the context of European art and thus its use in English, it is necessary to mention a further problem that the word carries with it. Since the end of the nineteenth century, ornament has received a very bad press. It has been cast out as impure, superficial, childish, perhaps even immoral, and it is consequently difficult nowadays to discuss ornament objectively. The sources of this prejudice lie in the heated debates at the end of the nineteenth century about the values of different styles of ornament in architecture, and the revulsion that such concerns finally generated.[8] Adolf Loos is regarded as the torchbearer of the campaign against ornament. His most striking attack on ornament consisted of an equation of the use of ornament with uncivilised primitive attitudes:[9]

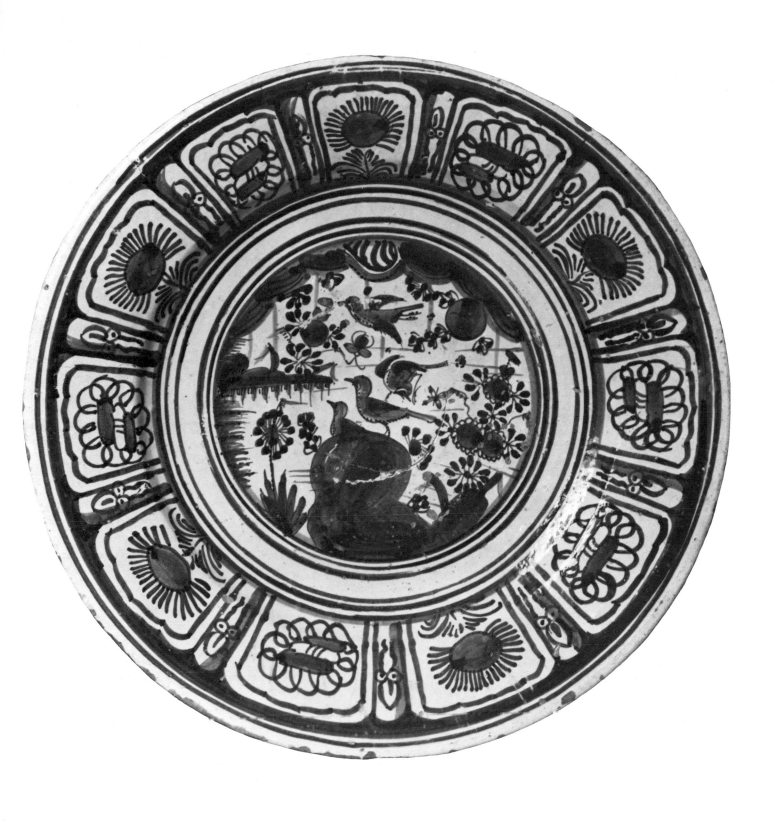

Fig. 4 Earthenware dish decorated with birds on a rock, London, Lambeth delftware, 17th century. Diam. 49 cm. Victoria and Albert Museum.

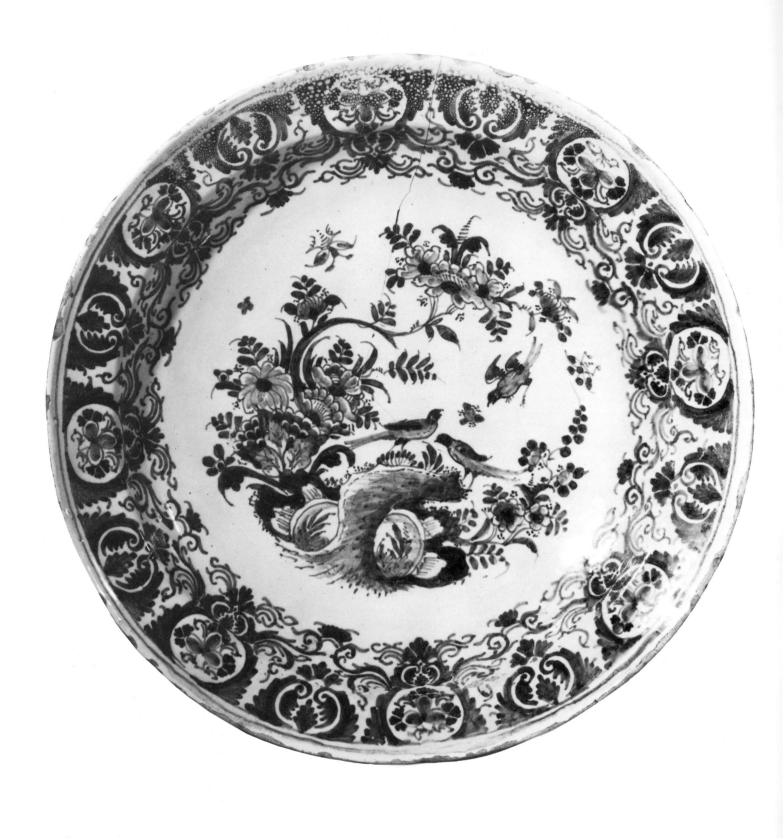

Fig. 5 Earthenware dish decorated with birds on a rock, England, Bristol delftware, 1716. Diam. 34.5 cm. Victoria and Albert Museum.

The child is amoral. To our eyes, the Papuan is too. The Papuan kills his enemies and eats them. He is not a criminal. But when modern man kills someone and eats him he is either a criminal or a degenerate. The Papuan tattoos his skin, his boat, his paddles, in short everything he can lay his hands on. He is not a criminal. The modern man who tatoos himself is either a criminal or a degenerate . . .

What is natural to the Papuan and the child is a symptom of degeneracy in the modern adult. I have made the following discovery and I pass it on to the world: the evolution of culture is synonymous with the removal of ornament from utilitarian objects . . .

The modern man who holds ornament sacred as a sign of the artistic superabundance of past ages will immediately recognise the tortured, strained and morbid quality of modern ornaments. No ornament can any longer be made today by anyone who lives on our cultural level . . .

We have grown finer, more subtle. The nomadic herdsmen had to distinguish themselves by various colours; modern man uses his clothes as a mask. So immensely strong is his individuality that it can no longer be expressed in articles of clothing. Freedom from ornament is a sign of spiritual strength . . .

Loos argued that ornament was not only unnecessary and inappropriate, it was a crime because it wasted human resources in the form of human labour.

Few if any of these arguments would be put forward today. Loos' comments on Papuans would be completely unacceptable. However, such polemics were in harmony with their time and coincided with the aspirations of some architects who, perhaps understandably, had become oppressed by the debates on style. Louis Sullivan put the architects' point of view:

I take it as self-evident that a building, quite devoid of ornament, may convey a noble and dignified sentiment by virtue of mass and proportion. It is not evident to me that ornament can intrinsically heighten these elemental qualities. Why, then, should we use ornament? Is not a noble and simple dignity sufficient? Why should we ask more?

If I answer the question in entire candour, I should say that it would be greatly for our aesthetic good if we should refrain entirely from the use of ornament for a period of years, in order that our thought might concentrate acutely upon the production of buildings well formed and comely in the nude. We should thus perforce eschew many undesirable things, and learn by contrast how effective it is to think in a natural, vigorous and wholesome way. This step taken, we might safely inquire to what extent a decorative application of ornament would enhance the beauty of our structures – what new charm it would give them.[10]

Sullivan's sentiments, and those of his contemporaries and followers, accompanied the birth of a new style of architecture, the Modern Movement. At Sullivan's behest, architects have refrained from ornament for more than three-quarters of a century. The effects have not always been what Sullivan and his fellow architects might have hoped to achieve. Simple buildings, unadorned inside and out, unrelieved except by beams and window mullions, have not always conveyed the integrity of design their creators hoped to proclaim. Often executed on a vast scale, large slabs of concrete and glass with no ornament, frequently without even simple vertical divisions, have proved difficult for the beholder to comprehend;[11] worse, they have appeared impersonal and even threatening. The inhabitants of the new architecture, unable to identify with vast blank areas, have only too often resorted to graffiti and vandalism; such attacks at least break up the surfaces and make them memorable.[12] We should not be surprised by these reactions, however: in other contexts, we all know and have always known that blank surfaces are repellant and test our endurance. Prisoners are confined to bare cells and interrogated in bare rooms where there is no relief to the eye in the forms of lines, let alone ornament, to break the monotony of the white walls. Why was

Fig. 6 Ink drawing of two birds on a rock, Iran,
15th century. British Museum.

it possible to make this mistake and regard ornament as unimportant?

This misunderstanding seems to have been brought about by a failure to appreciate the role and historical development of ornament in Western European art. Western ornament is intimately related to architecture, and has descended from the decoration of Classical and medieval buildings.[13] Indeed, it is difficult to draw meaningful distinctions between the architecture and the ornament of a European building before the period of the Modern Movement. Plinths, columns, pilasters and pediments were used both on the exteriors and on the interiors of Classical buildings as both architecture and ornament. In the medieval period likewise Romanesque and Gothic columns, arches, piers, and vaults were reused in galleries, arcades and windows. It is impossible, therefore, to say where the architecture ends and the ornament begins.

At all periods of European history, such devices were transferred from the interiors of buildings to their furnishings, and employed on fixed items such as doors, panelling and fireplaces and on movable items such as beds and buffets.[14] From furniture these features were extended to utensils including silverware and ceramics. Commonplace features of Western furniture, and even silver and ceramic utensils, are those modulations of profile we call mouldings, borrowed from Classical architecture. Stylised plant ornament, the ubiquitous acanthus and its cousin the palmette, provides other widely used elements of the major decorative repertoires in all periods of European history from the fifth century BC to the end of the nineteenth. Alongside these decorative devices, floral patterns, derived from several sources, but above all

from China and Islam, were widely used, especially for wall hangings; but even these designs were modified by references to Classical plant ornament. This Western ornamental tradition, dominated by architectural details such as mouldings and acanthus scrolls, must be assessed in relation to those forms of embellishment we call art, for it is from this comparison that in the West ornament has derived its inferior position.

Traditionally, we use the word 'art' for sculptures and paintings with a religious, narrative or descriptive purpose.[15] In the West, we expect such art to bear some reference to a world exterior to the art form. Before the nineteenth century, much art was representational in intent, a major inheritance from the Classical world. Even today many forms of art draw upon these representational canons and so are not independent of them. Above all, art is expected to have a message. In the past such messages were religious, political or didactic in a general sense, making points about man's relationship to the world; nowadays we expect art to be expressive of the personal views of the artist.[16] All Western art was and is in some sense intended to be read, both for a reference to some aspect of the real world and for its expression of ideas or emotions. We are expected to look at painting or sculpture and understand what we see: this understanding is additional to any pleasure we may derive from formal elements – from, for example, a balance of line or colour.

Classical and related medieval architecture were at all periods before the twentieth century an essential part of this art, a fact that has often been overlooked.[17] From the time of the ancient Greeks, Classical sculpture had an architectural setting, standing on plinths with mouldings, surrounded on three sides by a building or by niches reproducing the features of a building. All medieval sculpture was provided with similar settings in Romanesque or Gothic styles, in which Classical architectural details were reused in modified forms. From Pompeii to the English country houses of the eighteenth century, paintings were similarly framed. These frames were embellished with architectural ornaments, such as mouldings or acanthus leaves, and were set on walls between columns or pilasters. Free-standing paintings, such as altarpieces, were framed to match the buildings in which they were placed. Such architectural settings were indeed integral with the art. Whether the sculptures and the paintings were to illustrate the tenets of a faith, the might of a ruler, or simply the wealth and good taste of a patron, they had to be seen, and to be seen they had to be displayed. In European cultures, to which monumental building made an essential contribution, it was inevitable that these works of art should be intimately associated with buildings.

However, if an audience was to appreciate the art, and above all its content, it was desirable that the viewer should not be distracted by the settings; they had in large measure to take the surroundings for granted. Architectural mouldings, columns, pediments, and scrolls, traditionally used in Western buildings as settings for sculpture and painting, were ideal for this role. They referred not to people or animals, subjects that demand our active attention, but to buildings. Unlike living creatures, buildings are static; they do not move and thus, alongside such subjects, they demand less of our immediate interest. After all, buildings do not generally pose a threat, but our fellow human beings or wild animals might well do so.[18]

Furthermore, because buildings are widely familiar, ornament derived from Classical architecture is also well known. We can take for granted objects or ornaments with which we are familiar, as E.H. Gombrich explains: 'In the

study of perception the force of habit makes itself felt in the greater ease with which we take in the familiar. We have seen that this ease can even result in our failure to notice the expected because habit has a way of sinking below the threshold of awareness.'[19] Alongside Western 'high art', which it frames, Western ornament has sunk below the threshold of our awareness.

The relationship between Western art and ornament can be further illustrated in terms of an analogy. The aim of Western art to reproduce aspects of 'reality' in sculpture and painting is widely acknowledged, and within that art, representation of figures plays a large part. These figured sculptures and paintings exploit the reactions that we have developed in our relations with people. As Gombrich has discussed, we scan portraits to observe how carefully the painter has captured the personality and idiosyncrasies of the sitter.[20] We are thus matching the subject of the painting to observations we make about the person in life. We watch all people and animals for sudden movements, for moments of anger and traces of affection; but if for our own safety, we are to pay attention to people and animals (and machines), our minds cannot be overburdened by having to scan unfamiliar environments. Most of us feel safest in familiar streets or landscapes, where we can take much for granted and pay attention only to things that are of immediate concern – a friend coming up the street, a car lurching towards us. We build up this recognition slowly, until we can recognise large sections; we remember whole streets, not single bricks laid on each other one by one.

We treat Western architectural ornament like a familiar street. We take decorative schemes for granted, concentrating on the figured sculpture around which they are arranged. We remember not just detailed mouldings or single leaves, we remember complete sections. Our memories are assisted by regular repetition. However, such regularities must not be too mechanical, otherwise we cannot establish where we are in the sequence. Like the landscapes in which we live, we do not question the ornament if it is executed within certain limits. If radical changes are made, however, the result jars immediately. To remove the mouldings, arches and pinnacles from a cathedral façade would be as disturbing as the destruction of the figures. Without the figures the façade is blind; without the ornament the figures are naked and vulnerable.

Indeed, if we reflect upon the relationship between figures and ornament in the decorated façade of a building, we can observe that although we concentrate on the figures and pay less attention to the ornament, the ornament is by no means unimportant. Mouldings and plinths establish the figures in relation to one another, and our eyes use such settings as a means to make the bridge from figure to figure. As these features do not convey meanings, we do not need to pay too much conscious attention to them. Moreover, as they are often repeated in any one composition, we find the elements easy to recognise. These characteristics of Western ornament, its stability, its lack of didactic content and its familiarity, led to the unfortunate supposition that ornament as such was unimportant. The banishment of ornament from Western architecture hastened its disappearance from the interiors of buildings, from our furniture and utensils, all of which had, over centuries, partaken of a related repertory of design.

Suggestions that ornament was unimportant – so unimportant it could properly be omitted – were made as a consequence of the peculiar history of art and architecture in western Europe. Such assumptions were misleading and were to have undesired and undesirable effects; yet these views still have a

strong hold, and continue to support a separation of art and ornament which is applied quite generally, not only to the arts of the West but also to the arts of the East.

For example, Chinese figured sculpture, carved in Buddhist cave temples in China, is treated as art, while borders of foliage and flowers from the same caves are considered as ornament. Figured sculptures have been widely discussed, but flower borders have been much less fully described. Yet both figures and flowers belong to the same compositions and may often have been carved by the same craftsmen. A division between art and ornament in such circumstances is not helpful. With ornament relegated to an inferior position, the contribution of these flower borders to many aspects of Chinese art has been virtually ignored.

Chinese flower patterns, used alongside the didactic art of Buddhist figured sculpture, parallel Western architectural and foliage ornaments that accompany Western figured sculptures and paintings. This similarity between the relative positions of Chinese and Western foliage and flower patterns is neither a coincidence nor evidence of the universal development of art forms in all parts of the world. The practice of decorating façades in Chinese Buddhist caves with figures combined with leaf scrolls was derived in its entirety from provincial forms of Hellenistic architecture employed in Central Asia. Thus the role of Chinese foliage and flower patterns was directly related to the function of acanthus and vine scrolls in the West. Chinese flower patterns inherited also some of the passive aspects of Western ornament. It will become evident later that other motifs used with flower scrolls evoke different responses from the viewer.

For the purposes of this book, however, Chinese flower and animal motifs developed between 400 and 1400 will all be termed ornament because, like Western ornament, such motifs were borrowed from architecture to embellish furnishings and secular utensils. Moreover, in their fully developed form, such motifs, like Western decoration, seem to have been without a 'message'; they were employed to make the object they covered attractive and intriguing.

Earlier forms of Chinese art, such as the ritual bronzes of the Shang and Zhou periods, and arts of other parts of the world untouched by the Classical tradition can be less easily termed ornament; they often have associations that cannot be properly described by the Western usage of the word. The tattoos of the Papuans are a case in point: Loos probably regarded these as ornament because in Western vocabulary art is assumed to be concerned with representations conveying a meaning or purpose. Since such tattoos were not art, they must be ornament. The techniques, themes and purposes of these

Fig. 7 Lotus scroll from a deep porcelain bowl, China, Ming dynasty, *c.*1400. British Museum. The bowl is shown in figure 66 and plate 3.

Fig. 8 Peony scroll from a large porcelain jar,
China, Yuan dynasty, 14th century.
British Museum.

tattoos, however, were determined by practices of the Papuans and had a
special significance within Papuan society that bore no relationship at all to
the forms of art that are called ornament in the West. Such separate art forms
are best treated in terms of the culture that produced them, and their
consideration should not be circumscribed by terminology generated in
discussions of Western art.

Because Chinese flower designs are remotely descended from Western
architectural ornament, one of the principal accounts of Western ornament,
Stilfragen by Alois Riegl, has a special relevance to its study.[21] Riegl, a Keeper
in the Textile department of the Oesterreichische Museum für Kunst und
Industrie during the 1880s, set out in *Stilfragen*, published in 1893, to describe
the origins of the acanthus in the lotus and the palmette ornament of the
eastern Mediterranean.[22] His concern was with formal continuity, to trace the
steps by which borders of one plant form were turned into borders of another.
In part, he was reacting to an earlier study by W.H. Goodyear, who had noticed
certain constancies between lotus and palmette designs and had proposed that
a common symbolism was responsible for this likeness.[23] Riegl's rejection of
this approach and his painstaking study of the formal connections must be
applauded; it is still impossible to look at the plant ornament of the ancient
world without using his analysis. Much of the account given in the Appendix,
as a background to the development of acanthus designs transmitted
eastwards to Central Asia and China, takes up points that Riegl made explicit
in *Stilfragen*.

In place of symbolism, Riegl stressed another concept, which he called
Kunstwollen, to explain the continuities within the development of forms that
he discussed.[24] This word is difficult to translate, but at its simplest it refers to
the artist's will or aim. In putting forward this concept, Riegl was combating
notions of the day expressed by Gottfried Semper, who argued that the nature
of the material employed determined forms in ornament and in art.[25] Riegl
emphasised the thought and will of the artist over the demands of the material
in creating a work of art, and allied this notion to a general movement from a
concern with three-dimensional shape to an interest in line.

Although the notion of *Kunstwollen* is no longer recognised as a fundamental explanation of artistic development, Riegl's emphasis on a study of forms is an essential starting-point for the discussion of any art. The forms employed by an artist working in any material are his building blocks. If the building blocks cannot be defined and described, it is difficult, if not impossible, to discuss how a work of art is constructed or developed. The nature of the building blocks may differ from place to place and from time to time, but the need to distinguish the blocks and to describe the history of the combinations is pressing in all art forms, be they paintings of the Nativity, Roman architectural façades or Chinese flower scrolls.

It would be very difficult to discuss the history of an art if one generation did not make some use of the building blocks employed by the previous generations. Riegl was able to describe the long history of the Egyptian lotus borders only because for centuries, even millennia, craftsmen exploited shapes and combinations of shapes they had inherited from their predecessors. The reasons why man uses the artistic forms of his fathers and grandfathers have been the subject of much of E.H. Gombrich's writing. He has described the process very eloquently in the following passage:

What these observations confirm is the psychological fact that designers will rather modify an existing motif than invent one from scratch. The difficulties in the way of a radical innovation are both psychological and social. The number of truly original minds is small and those which exist are apt to be told by the public to stick to established traditions. Hence, as George Kubler, Focillon's disciple, says in his thoughtful book on *The Shape of Time*: 'The human situation admits invention only as a very difficult tour de force'.

Nothing comes out of nothing. The great ornamental styles could no more have been the invention of one man, however inspired, than could the organ fugue. Anglo-Irish ornament, the arabesque or the Rocaille come to mind as such typical 'end products' of a long sequence of what Kubler calls 'linked solutions'. We have seen why it is much easier to modify, enrich or reduce a given complex configuration than to construct one in a void.[26]

However, Gombrich is concerned with much more than a description of the linked solutions to be discovered in the history of either representational or ornamental art. He has suggested that there are psychological reasons why artists of one period make use of the experiences and skills of their predecessors. These reasons are discussed most fully in *Art and Illusion*, but the same principles inform all his other writings:

In *Art and Illusion* I have tried to show 'why art has a history'. I gave psychological reasons for the fact that the rendering of nature cannot be achieved by an untutored individual, however gifted, without the support of a tradition. I found the reason in the psychology of perception, which explains why we cannot simply 'transcribe' what we see and have to resort to methods of trial and error in the slow process of 'making and matching', 'schema and correction'.[27]

Although it is impossible here to do justice to Gombrich's wide-ranging discussions, his insights have suggested the following brief account of the arguments that can be marshalled to explain the survival of certain features of Chinese designs and the radical changes made to others.

If we consider first the factors that support an existing tradition, we find that the most significant contributions to stability are made by the learning of skills to execute a design and by the development of perceptions required to appreciate it. All skills have to be learned, and the more complicated the task

and the skills it demands, the more one generation is dependent on instruction from the previous one. Children learn from their parents to speak and count, while musicians, athletes and craftsmen learn their trades from their teachers, coaches and masters. Once a repertory of skills has been learned, the investment of effort in that range inhibits change.[28] Moreover, when a skill involves a high risk, that is to say, mistakes can be easily made and cannot be easily retrieved during the performance of the task, much learning has to prepare the artist for his first excursions into the public arena.[29] Before a potter could draw the lotus patterns of figure 7, he had to develop complete control of the design – the degree of pressure on the brush required, the spacing of the undulations and the variations available for leaves and flowers. For as the pigment sinks into the raw clay, no changes of mind are permissible; hesitations and errors will show as flaws in the fired piece. Thus the potter must have spent many years learning the repertory of porcelain decoration before he started to draw the lotus patterns seen here. Once learned, such designs were likely to be consistently used with little change, as examples of similar lotus scrolls on the dishes in figures 2 and 98 demonstrate.

As the training required by a potter or a silversmith is considerable, such craftsmen seem likely to adhere to the repertory of decoration they learned during their apprenticeship and are not generally drawn to search out other designs. One consequence is that designs used on one material are not necessarily available for craftsmen working at the same date in another medium. In the earlier periods under discussion, many of the motifs to be described were restricted in their use.[30] Thus in China, flower patterns were developed in architecture over several hundred years. They were therefore widely used in many forms of stone carving but not, for example, on ceramics. Training as a stonemason required the learning of a series of floral patterns; training as a potter evidently did not. When the designs finally were transferred from stone to metalwork and then to ceramics, there were straightforward reasons why such borrowings took place. The repertory of stone was, for example, shared with metalwork when both materials were required for a single object or two related objects, as in the manufacture of reliquaries. Designs were transferred from metal to ceramics, on the other hand, when cheaper materials, that is, ceramics, were substituted for more expensive ones, such as silver or gold.

There is at least one important exception to this early restriction of designs by material or craft; the ornaments associated with a religious belief were quite widely used, regardless of the traditions of design in different materials. Patrons of Buddhism sponsored monuments in stone and implements in both bronze and ceramics. For religious reasons, lotus designs were used on all these materials. Thus we find that large lobed petals, used in architecture to represent a lotus (figs 14, 106), were moulded, slightly incongruously, on to fine ceramics (fig. 56). New fashions or new commercial demands might stimulate a search for new designs. Ebullient peony designs were a consequence of an interest in the peony in the seventh and eighth centuries; in the fourteenth century, with new demands for exceptionally large dishes in porcelain, potters seem to have felt the need to extend their repertory of ornament.

Given the strength of craft traditions and a preference for the familiar over the new, the transfer of ornament from place to place requires explanation. The use of Western foliage patterns in China and the borrowing of Chinese

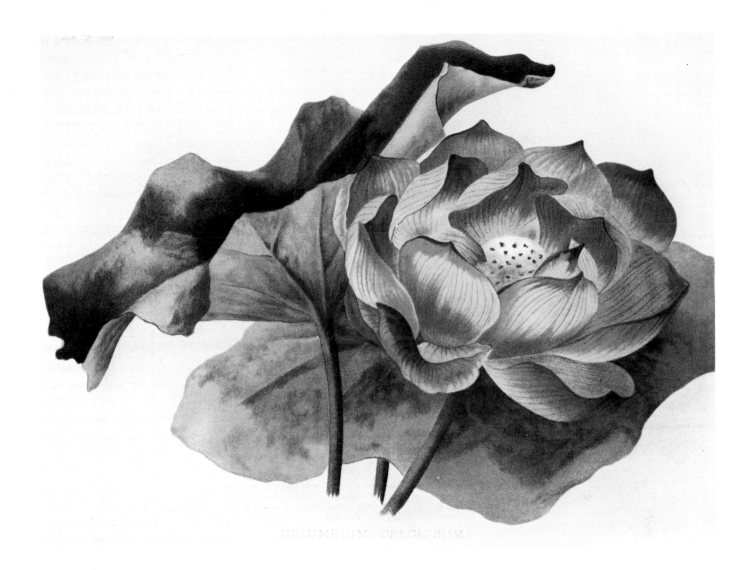

NELUMBIUM SPECIOSUM

Fig. 9 Nelumbo nucifera Gaertn. After *The Garden*, 3 June 1893, vol. 43, pl. 912.

lotus patterns in Iran are two of the major themes of this book. These borrowings were only made possible by large-scale political upheavals, which disturbed the existing order and at the same time brought foreign designs first into China and much later into Iran. The movement of peoples in Central Asia assisted the spread of Hellenistic modes of architecture, and led to their use for Buddhist monuments in Central Asia; thereafter, the introduction of Buddhism into China, which accompanied a decline of centralised authority, brought architectural styles from west of the Pamirs into the heart of China. Foliage patterns related to the acanthus were an integral part of these architectural styles. A political vacuum had made possible the introduction of a foreign religion and foreign architecture, and quite incidentally these developments introduced Western leaf scrolls to China. Chinese flower patterns reached Iran following the Mongol conquests, which allowed the movement of people and goods across Asia in the reverse direction. A concern with Chinese flower patterns was advanced both by the destruction and havoc caused by the Mongols, which impaired existing traditions, and by a respect for things Chinese among the new ruling élite.

A transfer of Chinese patterns to Iran was probably also assisted by a common background to foliage and flower motifs shared by the decorative

traditions of China, Central Asia and Iran. In all these areas, Classical acanthus patterns had provided a starting-point for the development of flower scrolls, a fact that probably made the assimilation of Chinese patterns in Iran particularly easy. In the history of ornamental art, two designs that share certain features are often drawn together, making possible the development of a third design, which assumes characteristics of both originals.

Such developments are dependent not simply on skills developed by craftsmen but also on perceptions that are intimately bound up with those skills. At the most basic level, of course, without developed perceptions no skills can exist. We have to know and have in our imaginations the outlines we are going to draw before we draw them. In addition, appreciation of a design, in the sense of deriving pleasure from it, depends as much upon an established tradition as its execution depends upon learned skills. When talking about perception we are less concerned with the properties of our eyes and brain, essential though these are, than with our developed abilities to recognise ornaments and design. Unless we recognise what we see, we cannot understand or appreciate it. The same process is true of other sensations, such as sounds and smells. As Gombrich has demonstrated, in all visual arts such recognition is a very complicated process.[31] It depends much more upon familiarity with the 'schema', the devices employed by the artist in his art, than upon any resemblance of these devices to forms that we know outside that art. Thus we recognise as a house a rectangle containing small symmetrically placed rectangles and surmounted by a triangle, not because the 'schema' looks like the house we live in, but because as children we were taught this simple device as the formula for a house. In understanding this geometric configuration, we gain little help from the world outside. Here recognition depends upon familiarity with art and its devices.[32]

Attachment to a familiar formula provides the principal explanation for continued use of lotus scrolls with undulating tendrils and pointed leaves, which bear no resemblance to any known plant, let alone a lotus plant (fig. 9). Undulating stems and pointed leaves were used with lotus flower heads without any suggestion of incongruity because these devices had been so used for centuries. They were familiar and they were thus accepted without question. (How they came to be used in the first place is a separate issue and will be described in Chapter 2.) It should perhaps be stressed that this recognition does not necessarily entail a meaning – in the sense that the geometric construction of squares and triangles is taken to be a house and a border of undulating lines supporting flower heads is thought to be a lotus. Regardless of whether it has a particular meaning, all art and design must be recognised before it can be fully accepted. Thus meander patterns or acanthus scrolls have no particular meaning, but they are generally better appreciated by those who have seen them before than by those who have not.[33] Unconsciously we match these designs to examples we have seen on previous occasions, and make assumptions, judgements or simple acceptances on the basis of past experience.

Indeed, recognition of a simple design is complicated by the intrusion of shapes suggestive of real flower heads among leaves and stems that are clearly fantastic. We recognise the lotus heads not just because they recur in all the examples, but also because they look a little like real flowers. We match the flower heads to flowers we have seen and, more importantly, to other representations of flowers we know; we are then convinced by this matching

Fig. 10 Paeonia lactiflora Pall. After *Andrews Botanist's Repository* I, 1799, pl. 64.

Pæonia albiflora

2

3

1

29

that the flowers in the lotus scroll refer to real flowers. Indeed, because of this similarity we tend to concentrate on the flower heads and ignore the stems and leaves. Animals in a landscape, the subject of many central motifs in Chinese design, evoke a similar response. We compare designs, such as birds on a rock (figs 2, 3), to scenes we know and also to a variety of paintings and drawings of birds that we may have seen, and we are convinced by these comparisons that the ornament refers in some way to a real scene, even if that scene is known to us second-hand from a representation, rather than from a moment we have ourselves observed in nature.

Other ornaments employed by craftsmen in other quite separate cultures make use of similar responses. Thus entwined monster heads and strange birds on Anglo-Saxon metalwork arouse our interest because we look at them as distantly related to creatures in the real world. These monsters are often attached to long interlaced bodies, and we are therefore drawn to unravel the ornament, to discover whether there are any more creatures entwined in this maze, and indeed to find out whether we are looking at real or fantastic beasts. Representations of creatures and more especially eyes are particularly intriguing, as we seem to react to them as though they were real.[34] Flowers are only slightly less alive. The undulating stems produce some of the effect of the

Fig. 11 Palmette scrolls and petal mouldings from cave 9 at Yungang, Datong, Shanxi province, Northern Wei dynasty, late 5th century AD. After Mizuno and Nagahiro 1952, vol. VI text, fig. 28.

interlaced creatures. We follow the waving lines to see where they lead, and to find out if there are more flowers attached at different points.

Recognition of ornament may be further complicated by symbolism. For example, a single lotus flower is to be understood as a symbol of Buddhism. In looking at a lotus ornament, the viewer must first be concerned to match the shape to previously seen examples and then to consider the relationship of the shape to real flowers; though perhaps uppermost in his mind, the symbolism of the lotus is in fact recognised last of all. For as Kubler remarks: 'Every meaning requires a support, or a vehicle or a holder. These are the bearers of meaning and without them no meaning would cross from me to you, or from you to me or from any part of nature to any other part.'[35] We have to recognise the supports before we can comprehend their meanings.

Indeed, we should beware of attaching too much importance to meaning, which fluctuates while form remains much more constant. In the West, we are quite familiar with dramatic changes of meaning. For example, some of the figures of Classical mythology were reused in the iconography adopted by the early Christian Church. The familiarity of the form, readily available to the craftsman and easily recognised by his audience, was essential to these transformations. Furthermore, forms quite often gain and lose meaning. Thus simple foliage scrolls borrowed from the West first acquired a symbolic association with Buddhism, and then seem to have lost such specific meaning. The undulating lotus scrolls on large porcelain dishes, which were exported to many non-Buddhist parts of the world, are unlikely to have been employed so regularly if their associations with Buddhism had been uppermost in the minds of the craftsmen. Some link with the Buddhist religion may have lingered, but this link was probably tenuous. Flower ornament was appreciated not for its meaning but because it was attractive and intriguing.

We have already mentioned the way in which certain configurations are interesting, none more so than interlace with its tantalising suggestions of lines that disappear out of sight and then return again to view. Much of the intrigue of ornament, and indeed of any art, lies in the clever manipulation of our interest in arrangements of lines and spaces. Some repetition is helpful but not too much. If a blank wall is frustrating because it gives us nothing to concentrate on, a wall covered in a chequer-board of regular black and white squares is dazzling. Among the regularities that are helpful, bilateral symmetry is the most obvious. In such symmetrical designs, we match one half to the other, and this matching provides immediate recognition within the one pattern or composition presented to us. Undulating scrolls and radiating patterns also seem particularly satisfying.[36]

In considering those aspects of a design that make it interesting to its audience, we come to the need for change, for change is as significant as the preservation of existing traditions. In later chapters, some direct transcriptions of designs will be described, but such simple copying is generally less interesting than innovations that exploit and extend existing patterns. In extreme cases, repetition is confusing; it is also frequently boring. To a greater or lesser degree we all derive pleasure from change.[37] However, change is only interesting as change, if it can be so recognised. Some resemblance to past models is necessary if changes are to be readily assessed; too much change is experienced as chaos.

The most consistent reason for changes in designs, or in other works of art, seems to reside in the wish of the artist or the patron to attract attention by his

clever variations on an existing theme. Competition is a great spur. This incentive has been described by Gombrich in his essay 'The Logic of Vanity Fair', in which he cites the competition which between the 1160s and 1240s led from the construction of the vault of Notre-Dame de Paris at a height of 114 ft 8 in (35 m approx.) to the vault of Beauvais Cathedral at a height of 157 ft 3 in (48 m approx.). In 1284 the vault of Beauvais collapsed.[38]

Many of the changes made to designs follow the path taken by the builders of the vaults towards extremes. Thus the simple foliage patterns of figure 11 were in the course of centuries made into elegant but complicated flower scrolls (figs 7, 8). However, excessive detail sometimes brings a desire for clarification, and changes may then proceed in another direction. The fine curly lines of leaves on early flower scrolls, which linger in lotus patterns, were in the case of the peony exchanged for rather more simple, if not particularly realistic, outlines (fig. 8).

These changes are, however, quite small. More drastic revolutions take place when an existing tradition is interrupted by the introduction of motifs from a different culture. In these circumstances, traditional restraints do not apply and, for a time at least, more fundamental changes are possible. A motif brought from another country is unrecognised in its new abode and is thus less circumscribed by existing practice. The craftsman is unaware of the constraints provided by the culture from which the motif was borrowed. Thus Western foliage patterns, based upon Classical acanthus and vine scrolls, could be turned into lotus and peony scrolls in China. Much later Chinese designs of lotus plants growing in lotus ponds were borrowed by Iranian and Ottoman craftsmen. In these Islamic countries, the lotus was irrelevant as a symbol and seemingly unrecognised as a plant. Large lotus leaves were therefore turned into fantastic flowers.[39] However, despite these changes, elements of the original motifs remained, especially in the composition or underlying framework of the new design. Thus peony and lotus scrolls retain the framework of the undulating stems of the acanthus scroll. Similarly, vertical compositions of fantastic flowers invented in the Islamic world retain the outline of the Chinese motif of a lotus plant growing in a pond.

The discussion that follows will seek to suggest how these motifs were transmitted across Asia and will illustrate the imprint that the borrowed motifs left on the designs as they were developed in their new homes. The reuse, not of full compositions but of small fragments of existing design, will also be considered. At the same time, if we are to understand the development of these formal elements, the distraction offered to us by designs that suggest real plants and animals has to be identified. For only by this means can we overcome our assumptions and understand the ways in which the flower and animal patterns of China were constructed. As accurate depictions, they fall some way short of success; as designs, however, they are among the most effective and enduring arts in the world.

I
Architectural decoration in Asia

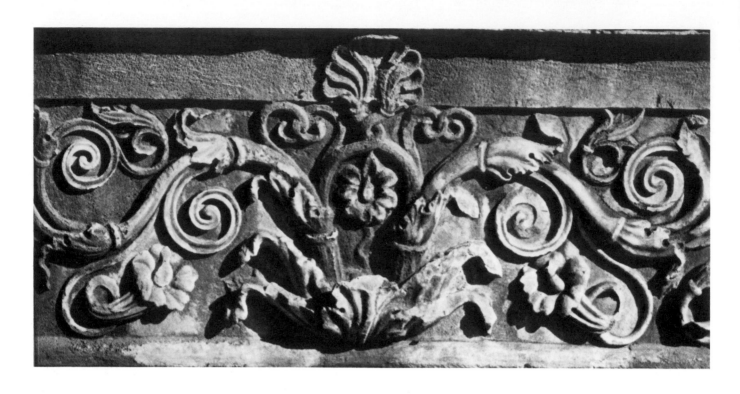

Acanthus and half-palmette

Simple leaf patterns, illustrated in the Introduction (fig. 11), were introduced to China in the fifth century AD. As these leaf scrolls seem to be related to Western acanthus and vine ornament, it is necessary to illustrate some Western forms of these foliage patterns before describing their early use in China.

Acanthus scrolls were constructed by adding small realistic leaves, rather like those of an acanthus plant, to a pattern of s-shaped scrolls supporting a device known as a palmette.[1] In a scroll from a large capital (fig. 12) which was found at the site of the Hellenistic Temple of Apollo at Didyma in Turkey, a palmette, a pseudo-flower consisting of a fan of graded spines, rises to the top of the design.[2] It is supported on paired scrolls, which emerge from a calyx of acanthus leaves at the base of the composition. The main stems divide below the palmette and bend towards the outer corners, with further stems branching off, sprouting small flowers and palmettes. In addition to a central calyx of leaves, small acanthus leaves cover the points where the stems branch. The arrangement of stems, palmettes and small flowers was descended from much earlier Mediterranean plant ornament illustrated in the Appendix.

Undulating and branching stems inherited from these earlier designs remained a feature of later acanthus patterns. Because such motifs were not based on a single plant but combined elements from different sources, they could be varied, though only within certain limits. Thus acanthus leaves, lying along undulating stems, accompany a strange flower in a decorative border from the Temple of Bel, built during the Roman period at Palmyra, a trading city in the Syrian desert (fig. 13a).[3] Flowers with five pointed petals seem to have been invented using sections of leaf. Below this imaginary plant runs a vine scroll, which also makes use of a regular undulating stem devised for the acanthus patterns. In the place of the acanthus leaves and leaf flower, bunches of grapes and vine leaves occupy the spaces within the wavy system.

A scroll from Aphrodisias in Asia Minor, dating from the second to third centuries AD, provides another very common form of acanthus scroll (fig. 13b). A pair of stems rises out of a central calyx, as on the capital from Didyma, and each undulation of the stem is filled with a tightly coiled tendril, supporting a small figure.[4] The leaves are much enlarged and appear to droop either side of the stems, as though divided in half, with one flat edge and one spiky outline. When acanthus designs of this type were simplified, a pattern such as the example in figure 13c resulted. This third border is taken from a temple at Kanawat in the Hauran area of Syria (fig. 13c).[5] The main stem of the previous designs survives, but subsidiary stems, seen both on the example from Aphrodisias and on the border from the Temple of Bel, have been omitted. Leaves, which were originally wrapped over the minor stems, are left projecting into the spaces without support, but the leaf shape remains the same. Like the leaves on the scroll from Aphrodisias, acanthus leaves appear to have been bent in half, providing one flat edge and one lobed side. In this example the rest of the space is filled with fruit or animals.

This type of simplified acanthus scroll seems to have been the model for one of the most influential ornaments in Europe and in China, the half-palmette scroll (see fig. 11, Introduction). It consists of an undulating stem which, like the example from Kanawat, encloses a single leaf within each wave. The typical relationship of stems and leaves in the half-palmette scroll seems, therefore, to be based on simplified acanthus patterns. Half-palmette scrolls are found with a variety of slightly different leaves, some of which refer to half of

Fig. 12 Acanthus scroll from a pier capital from the Temple of Apollo, Didyma, Turkey, 3rd–2nd centuries BC.

Fig. 13 Acanthus scrolls

a from the west façade of the Temple of Bel, Palmyra, Syria, 1st century AD. After Seyrig, Amy and Will, 1975, album, pl. 33.

b on a frieze from Aphrodisias, Turkey, now in the British Museum, 2nd–3rd centuries AD. British Museum.

c simplified acanthus scroll on a frieze from Kanawat, Syria, possibly 2nd century AD. After Toynbee and Ward Perkins 1950, pl. 20:3.

the pseudo-flower, the palmette, rather than to half an acanthus leaf. Scrolls with these different leaf forms can be understood as varied interpretations of a debased acanthus scroll. Although the half-palmette seems to have been generated from an acanthus scroll, the traditional name will be retained to allow for the continued references to palmette shapes.[6]

In parallel with the use of acanthus patterns on buildings in the Near East and in Greece, half-palmette designs in China first appeared prominently in architecture. The sources of this architecture are thus crucial to a discussion of Chinese flower patterns.[7]

Leaf scrolls and China

In China Buddhist temples display the first influential foliage patterns. Such buildings were constructed under foreign influence, for the Chinese had had to turn to Central Asia for information on the correct texts, images and temple plans to be employed in the worship of the Buddha. Only a few monuments and other artefacts survive from the early periods of Chinese patronage of Buddhism. However, from the second half of the fifth century, substantial cave temples at Dunhuang, Maijishan and above all Yungang, near Datong in Shanxi province, provide outstanding examples of figured sculptures and decorative motifs in architectural settings dedicated to the worship of the Buddha. The east wall of the rear chamber in cave 7, probably carved between AD 460 and 475, can be taken as representing such early work at Yungang (fig. 14).

The wall is divided horizontally into rows of niches containing figures. These niches are defined by small pilasters, crowned by pairs of leaves, or by small gathered bundles. Pointed arches or angular brackets bridge the pilasters. Foliage scrolls, with which we are particularly concerned, appear on the cave wall dividing two tiers of niches, but they should not be considered in isolation. They were used at Yungang among a large number of other architectural elements, most of which were foreign to China, including petal-shaped borders, pilasters, arches and coffered ceilings. Furthermore, the use of organised decoration, reproducing a façade of a building, to display figured sculpture was an innovation. In the West architectural façades, divided by niches containing religious images, are widely familiar. They appear on Classical and medieval European buildings and in all architecture that descended from, or revived, these earlier styles.[8] It is therefore easy to take for granted a regular display of figures in niches in the early caves at Yungang. However, such East Asian architectural settings for religious images are quite remarkable and require explanation, for before the introduction of Buddhism monumental stone buildings of several storeys, with or without a display of figured sculpture, were unknown in China.

Neatly arranged tiers of niches of approximately the same size, laid out in both horizontal and vertical rows, are indeed a peculiarity of early Buddhist caves in China. In later caves, hollowed out at Yungang in the early sixth century, niches were randomly carved across the cave surfaces. A similar lack of concern for regular division of the cave wall is seen in the sixth-century caves at another important cave temple, Longmen, on the Yellow River.[9] As the use of formal patterns of niches declined, so the horizontal borders and the semi-architectural outlines of the niches were modified. Half-palmette leaf scrolls remained in use but, released from their position as dividing borders, they could now be used in other contexts. Similarly, a second border illustrated

Fig. 14 East wall of the rear room of cave 7 at Yungang, Datong, Shanxi province, Northern Wei dynasty, late 5th century AD. After Beijing 1977, pl. 31.

in figure 14, a band of petals, which mimics the enrichment of a Western moulding known as a *cyma reversa*, was less frequently employed as a border, surviving as ornament for pedestals and plinths.

Other architectural and decorative features of the early caves at Yungang were either modified or abandoned. Early caves supply many examples of pilasters supporting pairs of acanthus leaves or large volutes, which can be explained as debased versions of Corinthian and Ionic capitals (see p. 59). In other caves these pilasters were replaced by small pagoda-like structures.[10] Similarly, Chinese roofs were added to arches placed over figures, and coffered ceilings enclosing rosettes were replaced in many instances by single lotus flowers.[11] Especially unusual details borrowed from the Near East, stepped merlons and double animal capitals, are found only in early caves.[12] Thus the architectural façades of the early Buddhist caves, framing figures of the Buddha and Bodhisattvas, seem to have incorporated many foreign elements which were adapted quite quickly as Buddhist practices became established. It is in this context that the history of the foliage scroll will be considered.

This chapter suggests that the ultimate sources of the architectural façades of early Buddhist cave temples in China, of the display of figures for religious or

propaganda purposes, and of the leaf scrolls and other ornaments associated with them, must be sought in Hellenistic buildings in the Near East. Between the Mediterranean coast and China lies an immense area which is now part of the modern states of Syria, Iraq, Iran, the Soviet Union and of China herself. These modern political boundaries suggest divisions that did not exist in the third and second centuries BC. Through trade and conquest, Egypt, Greece and the Near East had been in contact over many centuries and shared many preoccupations. Their most interesting common trait was the construction of monumental stone buildings. Hellenistic building was developed from Classical Greek architecture but also took advantage of some Near Eastern practices.

Following Alexander's conquest, Hellenistic architecture was borrowed in territories further east and was combined with local building styles. In the period from the second century BC to the second century AD, several parallel architectural traditions were developed in the Near East, Iran and Central Asia, which shared common features, such as decorated façades, divided into storeys and enriched by pilasters surmounted by Doric, Ionic or Corinthian capitals. Niches containing figures, placed between these pilasters, and some decorative motifs, including acanthus scrolls, were also shared.

Alexander's conquest of Iran and the Punjab in 324 BC was the first and most important of several political upheavals that encouraged the spread of Greek and Near Eastern methods of building to Iran, Afghanistan, Central Asia, India and China. The establishment of the Hellenistic kingdoms in the Near East and Central Asia was cemented by the construction of cities modelled on Greek plans. The easternmost Greek city discovered so far is Ai Khanum in Afghanistan on the Oxus.[13]

Within 150 years, the hold of the Hellenistic kingdoms was first weakened and then destroyed by a series of nomad invasions affecting the whole of Asia. The first threat was posed by the Parthians; their incursions into Iran and Mesopotamia were followed by the movements of the Scythian Sakas and the Yuezhi, the latter embracing the tribe or tribes we know as the Kushans. These peoples arrived in Iran and Central Asia to find well-established cities with magnificent architecture. As they had previously lived as nomads, neither the Parthians nor the Kushans had their own competing style of building with which to replace these substantial structures. They were not unnaturally content to perpetuate and, with further military conquests, to spread the Western Classical building styles they came upon. However, because the religious and cultural background of the Parthians and Kushans differed from that of the peoples of the Hellenistic cities, they were willing to adapt and modify the buildings they found to suit their own purposes. Thus Ionic and Corinthian orders appeared not in Classical temples but in new structures, the *iwans*, or ceremonial halls, of the Parthians and the Buddhist stupas, or reliquary mounds, of the Kushans.

Political events in China are also of crucial importance to the story. Nomads, known to the Chinese as the Xiongnu and to us as the Huns, were responsible both for driving the Yuezhi westwards and for provoking the Chinese into an offensive foreign policy which led to their control of the Tarim Basin. This conquest was part of a general expansion of Chinese authority over much of East Asia, an expansion which eventually brought about the collapse of the Han dynasty (206 BC–AD 220). In the wake of the downfall of a centralised Chinese empire, a number of different rulers divided her territory, including the

Liang dynasty on the western edge of Gansu province and the Toba tribes who ruled part of China as the Northern Wei dynasty. Members of both these ruling houses espoused Buddhism, and it is through their patronage that monks, translators, texts, images and temple plans were brought to China from the Buddhist monasteries in the Tarim Basin and the even more distant centres established by the Kushans in what is today Soviet Central Asia, Afghanistan and Pakistan.

Much of the area between the Mediterranean and China has been unevenly investigated: only a few of the principal cities of the Parthians and the Kushans have been excavated. It has also proved difficult to match the historical record, derived from coins and from the Greek, Roman and Chinese histories, to the material remains. It is not, therefore, always possible to document the contact between the different areas of Asia that stimulated the use of common architectural details, such as Ionic and Corinthian capitals and acanthus borders. Despite the limitations of the record, it is difficult to regard the architecture of the Chinese Buddhist caves and its accompanying ornament as other than the eastern end of a continuum of architectural design that stretched from the Near East to China and embraced Iran, north India and Central Asia. The following sections will therefore consider the development of decorated façades in the Hellenistic and Roman periods, and will describe briefly the buildings of the Parthians, Kushans and the oases in the Tarim Basin in Xinjiang province. The last section will review the contribution of architectural practices of these areas to the decorated façades of the cave temples of Yungang.

While the programme of works associated with Buddhism was the most important channel bringing Western styles and designs, albeit in very provincial forms, to the northern periphery of China, trade also played a part. In exchange for silk, the Chinese acquired horses, glass and Western metalwork. For example, a gilt-bronze stem-cup from a hoard found at the Northern Wei capital at Datong is decorated with a vine scroll, a motif popular at Palmyra (fig. 15) and other sites in the Near East but unknown in East Asia before this date.[14]

Classical architecture in the Near East

From the fourth century BC, buildings in Asia Minor and Syria were constructed with façades decorated with attached columns, pilasters and with niches framing figures. Such architectural design was derived from elements of buildings that at an earlier date had had a structural as well as a decorative function. The development of decorated architectural façades in the Hellenistic world can be illustrated by a comparison of two buildings, widely separated in date – the Nereid Monument from Lycia in Asia Minor, now in the British Museum (fig. 16), and the *scaenae frons* (stage building) of the Roman theatre at Ephesus (fig. 17).

The Nereid Monument, which reproduces the form of a small temple, was built at Xanthos as a tomb for a Lycian chief about 400 BC. It seems that the custom of using a temple form as a tomb had originated in Asia Minor. The building has four columns with Ionic capitals supporting the entablature and the pediment above. Three windswept figures, carved in the round, thought to be the Nereids that give the building its modern name, stand between the columns. A high podium is decorated with sculptured narrative friezes. Predecessors of such narrative sculpture are found in the stone friezes from the

palaces of the Assyrian kings, which display scenes from the life of the monarch, as he hunted, feasted and received tribute.[15] Sculpture on Classical Greek buildings was much more allusive, making political points, if any, by the use of myth.

The drawing of the *scaenae frons* of the theatre at Ephesus (fig. 17), thought to have been constructed in the first century AD, shows the way in which the columns, entablature and pediment, framing figures on the Nereid Monument, have been multiplied to produce a richly decorated façade. The building is divided horizontally, with two orders of columns, Ionic below and Corinthian above; the third upper order is a later addition. In the lower storey, eight pairs of columns are brought forward from the main façade on extensions of the plinth. Continuing into the upper storey, these small structures are crowned by small pediments, triangular or segmented (arc-shaped), with two examples of volute pediments, made up of s-shaped scrolls; against the main wall small niches with pediments or arched recesses contained figures. While the windswept figures on the Nereid Monument are framed by the main structural elements of the tomb, on the *scaenae frons* at Ephesus the figures are placed within miniature buildings applied as decoration to a flat surface.

When explaining the path that led architects from the Nereid Monument to

Fig. 15 Gilt-bronze stem-cup decorated with a vine scroll, found at Datong, Shanxi province, but possibly imported from Central Asia, 5th century AD. After Beijing 1972a, p. 151.

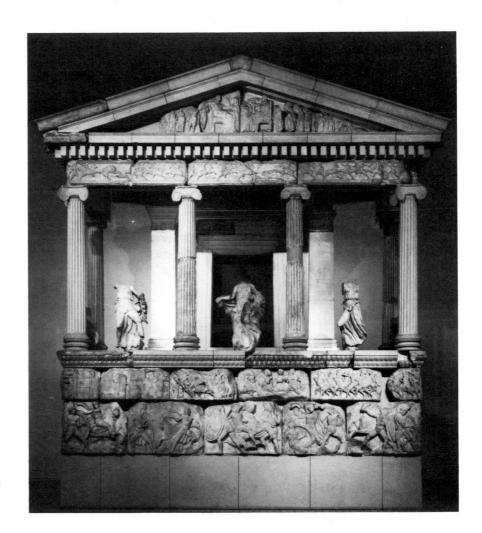

Fig. 16 The Nereid Monument, from Xanthos in Lycia, Turkey, *c.*400 BC. H. 8.3 m. British Museum.

Fig. 17 Provisional reconstruction of the *scaenae frons* of the theatre at Ephesus, Turkey. *c.* 1st century AD. After Hörmann 1923.

the theatre at Ephesus, contributions from several sources must be taken into account. First, the continuous popularity of the combination of figures and architecture was furthered by the happy conjunction of Greek skills in representing the human figure with Eastern demands for records of dynastic ambition. The narrative or even propagandist purposes of the Nereid Monument were carried to extravagant lengths on the tomb built for Mausollos at Halicarnassus, from which the word mausoleum is derived. As on the Nereid Monument, large figures were placed between free-standing columns supporting the entablature, above which rose a truncated pyramid as a roof. Narrative friezes of sculpture appeared on the building, complementing a free-standing composition of riders. In addition to the narrative scenes, the monumental figures were important in representing Mausollos and perhaps a long line of ancestors or contemporary members of his court. As Geoffrey Waywell has suggested, these portraits transformed the tomb into a monument to glorify the dynasty.[16] Thus buildings such as the Nereid Monument and the Mausoleum established a convention of using sculpture within an architectural context for political as well as religious purposes. In the West the practice of combining figures and architectural façades to tell a story or to convey a political message was carried to further heights in the Forum of Augustus at Rome, as Susan Walker has pointed out.[17] We are even more familiar with this tradition as it appears in medieval Europe, in the construction of cathedral and palace façades, and in their use for a display of figures of monarchs as well as of Christ and the saints.

Architecture with such didactic purpose was particularly accessible to Mesopotamia and Iran from whence it had been borrowed in the first place. Moreover, this shared tradition explains the easy transition from buildings that proclaimed the virtues of the Greek gods and ruling dynasties to shrines and temples that were employed to glorify Eastern rulers and religion, above all the might of the Kushan kings and the religion they espoused, Buddhism.

On both the Nereid Monument and the Mausoleum, the principal figures are shown in the round and are framed by structural columns. When applied either to sarcophagi or to underground and rock-cut tombs, both figures and structural elements were rendered in low relief, becoming pictorial or decorative. Contemporary with the Mausoleum, the Sarcophagus of the Mourning Women in Istanbul is carved as a miniature building (fig. 18). On the sarcophagus both the columns and the figures appear in low relief, to be read as a representation of a real building. Simplified versions, presenting a single figure below a pediment, also appear in some rudimentary depictions of real buildings.[18]

As Margaret Lyttelton has shown, an additional stimulus for the development of highly ornamented façades is found in the construction of tombs, both underground and in rock faces, notably at Alexandria and Petra.[19] In both circumstances it was easier to construct façades with attached columns or piers than to hollow out tons of earth or rock to create an impression of a free-standing building. Thus while some of the most ambitious tombs at Petra have some free-standing columns, the majority were hollowed behind rock faces decorated to look like buildings. The Khazna at Petra is one of the more elaborate tombs (fig. 19). At its entrance four Corinthian columns are surmounted by a triangular pediment. This pediment is of course carved out of the rock face and is not solely dependent on the columns for support. A central rotunda is cut almost free of the rock face. Despite these details, the tomb façade

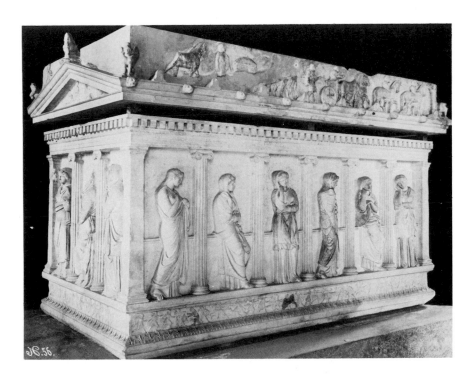

Fig. 18 Sarcophagus of the Mourning Women, 4th century BC. Archaeological Museum, Istanbul.

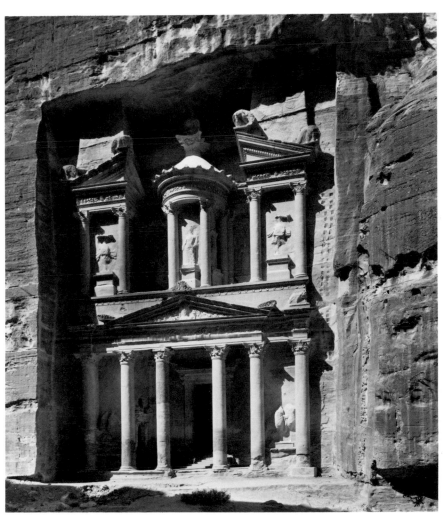

Fig. 19 The Khazna, Petra, Jordan, *c.* 1st century AD.

Fig. 20 Detail of the elevation of the cella of the Temple of Bacchus, Baalbek, Lebanon, 2nd century AD. After Schulz and Winnefeld 1921, plates, vol. 2, pl. 10.

is simply a decorated rock surface; vestiges of figures framed by attached columns in both storeys illustrate the way in which the elaborately carved rock faces encouraged the flattening of three-dimensional compositions. While the ornamental detail of the Khazna has Greek sources, the custom of decorating rock-cut tombs as though they were buildings was already known in the Near East at an earlier date; the tombs of the Achaemenids were carved in cliffs at Naqsh-i Rustam near Persepolis in the fifth century BC.[20]

Ancient traditions of monumental stone building, with massive colonnades and doorways, common to much of the Near East, were combined with a more recently developed interest in decorated façades in such buildings as the Roman Temple of Bacchus at Baalbek in Lebanon, constructed in the second century AD (fig. 20). Gigantic columns rise the height of two storeys in front of a façade embellished with niches capped by miniature pediments. Both the Temple of Bacchus, and other buildings in the Lebanon and Syria, were at the same time intricately decorated with acanthus and vine scrolls. A drawing of scrolls on the Temple of Bel at Palmyra is shown in figure 13a.[21] An engraving from an eighteenth-century account of Palmyra by Robert Wood illustrates the rich surface that such ornament contributed to these complicated buildings (fig. 21).

In Iran, Afghanistan and the Punjab, almost no structures of similar size or complexity survive. Often only fragments remain at these Eastern sites, paralleling the architecture already described. However, at Yungang in China are found comparable monumental façades, gigantic orders and intricate scrolling ornament loosely based on Near Eastern models.[22] It seems that most of the important intermediaries between the Near East and China have been lost and that only a rather limited range of architectural fragments from the first to the fourth centuries AD survives. In the next section attention is concentrated on the Parthians rather than their successors from the third century, the Sasanians. Although buildings of the Sasanians may have contributed to the architecture on which the Yungang caves were modelled, most of the surviving Sasanian remains date to the sixth century and are thus too late to have provided an example for the Chinese craftsmen working at Yungang in the second half of the fifth century.

The Parthians

The rise of the nomad tribes we know as the Parthians is bound up with the fortunes of the successors of Alexander.[23] In 245 BC the satrap of Parthia revolted against the Hellenistic rulers, the Seleucids, and then in 239 BC the governor of Bactria defected. The Parni, a nomad tribe living to the east of the Caspian Sea, took advantage of these upheavals to seize control of the Parthian satrapy. Henceforth the Parni are known as the Parthians. Despite repeated attempts by the Seleucids to regain control, the Parthians resisted annihilation. Under their king Mithradates I (171–38 BC) they did more than hold their ground, gaining control of most of Iran. Following the death of Mithradates, the Parthians were faced by further attacks from the Seleucids and were also subjected to incursions from nomads to the East. Parthian fortunes recovered under Mithradates II (124–87 BC).

The Romans and Parthians were embroiled in competition for control of the Near East on a number of occasions. In 55 BC Crassus, inspired to emulate the achievements of Pompey and Caesar, embarked on a campaign against the Parthians which proved disastrous. Of the 40,000 men led against the

Fig. 21 Monumental arch, Palmyra, Syria, 2nd century AD. After Wood 1753, pl. XXVI.

Parthians, only 10,000 returned to Syria from Iran. The Parthians continued to challenge the Romans, often inviting attack by meddling in the politics of Roman clients. The last burst of Parthian power came in the second century AD under Vologases IV, when they resoundingly defeated the Roman army in Syria. Continued Roman incursions, however, exhausted Parthian fighting strength and their empire was conquered by the Sasanian Prince Ardashir in AD 224.

In many areas the Parthians took over Hellenistic cities intact, and in excavations Parthian layers have proved difficult to distinguish from the earlier settlements at, for example, Seleucia on the Tigris, Babylon and Dura Europos. A clearer picture of early Parthian occupation has been gleaned from an early Parthian settlement discovered at Nysa in Russian Central Asia. Other early Parthian sites include the site of the ancient city of Hecatompylos found at Shahr-i Qumis, and remains of a palace or sanctuary at Khurha near Isfahan; provincial versions of Ionic capitals appear on the columns of this building (fig. 22). The importance of figured sculpture of deities within these architectural settings is demonstrated by finds of remarkable bronze statues at Shami, a remote site in the Zagros Mountains.[24] These fine castings combine both Iranian and Greek features in magnificent sculpture.

The use of figures in architecture to celebrate religious or dynastic aspirations is also illustrated by the Round and the Square Houses at Nysa. Although the excavated remains of the Square House are often discussed as a rebuilding of the first century AD, they may, like the Round House, reflect a structure of the second century BC. Four large piers supported the roof of the

Fig. 22 Reconstruction of part of the sanctuary at Khurha, Iran, 1st century BC. After Herzfeld 1941, fig. 383.

Fig. 23 Reconstruction of the west façade of the *iwan* cross-courtyard at Assur, Iraq, 1st century AD. After Andrae and Lenzen, 1933, pl. 14.

Square House, and their height allowed sufficient room for the walls to be decorated with two tiers of engaged columns. The lower register consisted of columns of the Doric Order, while the upper register was Corinthian. Large clay statues placed in niches in the upper register probably represented ancestors and illustrate a tradition parallel with that of the dynastic portraits of the Mausoleum or the Forum of Augustus in Rome.[25]

A typical Parthian building type was the *iwan*. In its early stages the *iwan* probably consisted of three sides of a courtyard, roofed perhaps with beams supported on columns. Early, relatively simple, examples have been found at Nysa and at Saksanakhyr, north of the Hellenistic city of Ai Khanum on the Oxus. Advanced structures are well represented by remains at the late Parthian sites at Assur and at the contemporary Arab trading city of Hatra. Assur was rebuilt by the Parthians in the first century BC, having been abandoned since Assyrian times, and a great palace was constructed there, dominated by a courtyard with large barrel-vaulted *iwans* on all four sides. A reconstruction of one façade is shown in figure 23. At the centre the principal opening of the *iwan* rises into the third storey of the façade; at either side the lowest storey is penetrated by two small openings, above which are placed niches in the shape of blind windows or openings. The remaining length of the three storeys is filled with engaged columns with debased Doric and Ionic capitals. Friezes of decorated stucco-work were set in the registers between the storeys of blind architecture. While this façade seems to owe much to the Hellenistic and Roman system of façade architecture, as suggested above, this

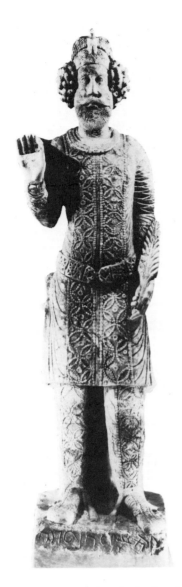

similarity may in part be due to the fact that such building incorporated elements that had a long standing in Mesopotamia.[26] Thus the strength of the tradition of façade architecture under the Parthians may have resulted from the convergence of ancient Western Asian building forms with versions of such buildings recently developed in the eastern Mediterranean.

A similar observation might be made about the remains of an *iwan* found at Hatra, some fifty kilometres from Assur. In place of mudbrick and stucco, the buildings at Hatra were constructed of fine limestone masonry. The façade of the Temple of the Sun (fig. 24) consists of a large *iwan* opening, divided from smaller openings by engaged columns with Corinthian capitals. Hatra is also remarkable for finds of lively portrait sculpture. Large figures carved in the round are dressed in Parthian clothes with short tunics over baggy trousers (fig. 25). The garments are often highly decorated, both with geometric patterns and with stylised acanthus, vine and flower scrolls. One of the figures wears a tall pointed cap or helmet, a characteristic of nomads from Central Asia, also seen on figures representing Sakas or Kushans from Mathura in India and Dalverzin-tepe in Russian Central Asia.[27]

The Kushans

Buddhist architecture of the Kushans is pivotal to the discussion of the borrowings of Hellenistic, Mesopotamian and Iranian architectural conventions. The Kushans came to dominate a number of Central Asian tribes who, together with a Scythian people, the Sakas, known to Western writers as the Sacaraucae, overthrew the Graeco-Bactrian state. (The Bactrians had seceded from the Seleucid empire in the third century BC.) The wanderings of

Fig. 25 Portrait statue believed to be that of King Sanatruq, Hatra, 2nd century AD. Baghdad, Iraq Museum.

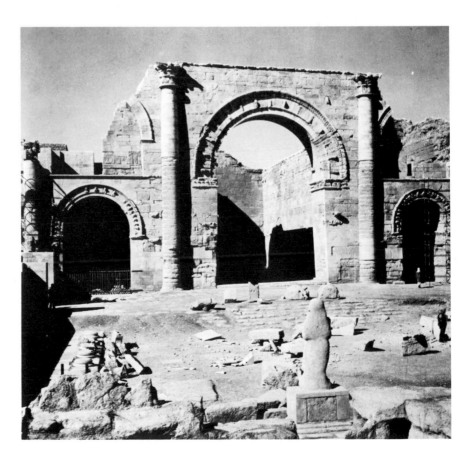

Fig. 24 Façade of the Temple of the Sun, Hatra, Iraq, 2nd century AD.

the Kushans and Sakas are best recorded in Chinese official histories: chapter 96 of the *Han Shu* describes how the Yuezhi, the Chinese name for the confederation of tribes that included the Kushans (Guishuang), were attacked and driven westwards to Bactria by the leader of the Xiongnu. As the Yuezhi reached the Illi region, they came into contact with the Sakas, named as the Sai in the Chinese texts, and by about 160 BC both the Yuezhi and the Sakas were poised on the borders of the Graeco-Bactrian state.[28]

The Sakas turned west to Seistan and then made their way into the Punjab more than a century ahead of the Yuezhi. Their rule in the area is known as the Indo-Scythian or Indo-Saka dynasty. In the uncertain chronology of the area, a fixed point is provided by the inauguration of the so-called Vikrama era in 57 BC, during the reign of Azes I. The Sakas were followed by a Parthian clan, who destroyed them and founded the Indo-Parthian dynasty early in the first century BC. The twenty-sixth year of the reign of the Indo-Parthian ruler Gondophares is known to have coincided with a 103rd year, which is referred to the Vikrama era, and therefore corresponds with AD 46. This date is important to a discussion of Kushan chronology.

Meanwhile the Kushans were moving steadily across the Hindu Kush and during the first century AD gained control of the Punjab plain. Chinese sources fill out the bare bones of the numismatic evidence. An expanded version of the text in the *Han Shu*, already mentioned, is set out in the late Han history, the *Hou Han Shu*, in the chapter describing the Western Regions:[29]

After the Yuezhi were defeated by the Xiongnu, they first moved to Daxia [Bactria]. They divided this country between the *xihou* [leaders] of five tribes, the Xiumi, the Shuangmi, the Guishuang, the Xidun and the Dumi.

After more than 100 years, the *xihou* of the Guishuang, Qiujiuque, attacked and defeated the four other *xihou* and set himself up as king. His territory was called Guishuang. He invaded Anxi and seized the territory of Gaofu. In addition he destroyed Puda and Qibin and took over their kingdoms. At more than eighty years old Qiujiuque died and his son Yangaozhen succeeded him as king.

Qiujiuque is regarded as Kujula Kadphises, the founder of the Kushan empire, and Yangaozhen is taken to be his son, Vima Kadphises. The date of the founding of the empire is hotly debated, but it is likely that its most famous ruler, Kanishka, lived during the first part of the second century AD. The Kushans lost their independence to the Sasanians before the middle of the third century AD. It is probable, but by no means certain, that the buildings and sculptures to be described were built during the heyday of the Kushans.

Kanishka I is renowned for his association with Buddhism;[30] but although Buddhist sources claim that he was a convert to their faith, his foundation of a dynastic temple at Surkh Kotal in present-day Afghanistan suggests that he may have supported more ancient religious practices, which reflected both Kushan and Iranian beliefs in ancestor veneration and fire-worship. However, Kanishka's court is said to have included Buddhists, and his reign probably saw significant royal patronage of Buddhism. Evidence of this development is found in Buddhist figures on Kanishka's coinage and in a Buddhist reliquary, inscribed with his name, from a stupa thought to have been built at his direction. The third Buddhist Council, convened in Kashmir, is also associated with Kanishka.

Kushan remains have been found in Russia, Afghanistan and above all in Pakistan, in the valley of Peshawar, also known as Gandhara. Styles of sculpture and architecture in the three areas differ somewhat, but some

Plate 1 (opposite)
The Bimran Reliquary, gold set with rubies, Gandhara, 2nd–3rd centuries AD. H. 6.5 cm. British Museum. For the lotus on the underside see figure 110. (The object has been greatly enlarged in reproduction.)

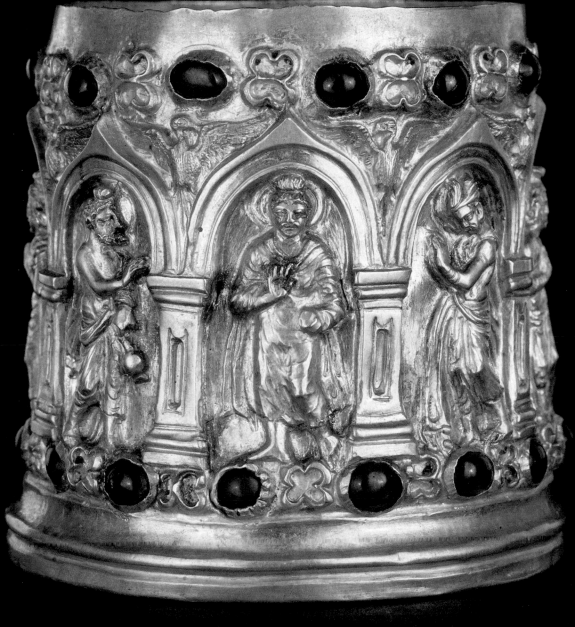

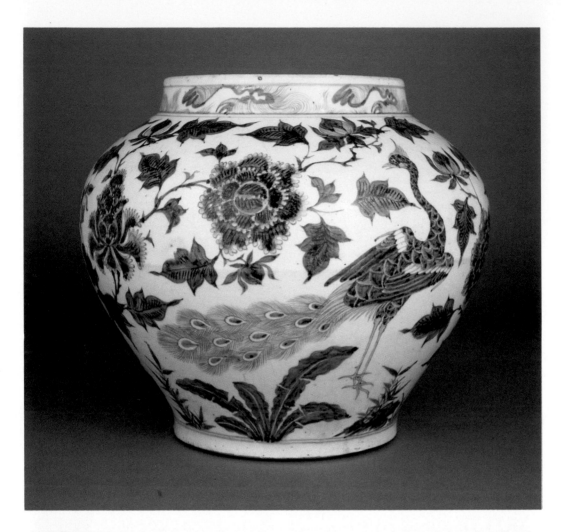

Plate 2
Porcelain jar decorated
with a peacock and a
peahen among flowers,
China, Yuan dynasty,
14th century. H. 31 cm.
British Museum. A detail
of the decoration is shown
in figure 87.

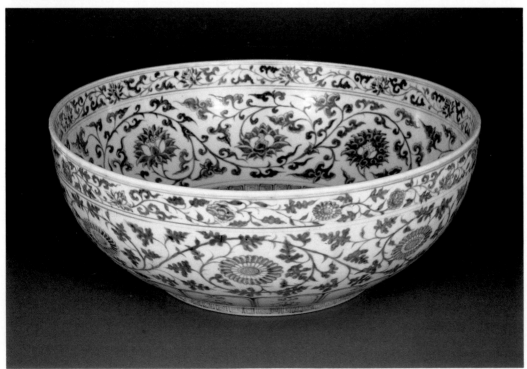

Plate 3
Deep porcelain bowl
decorated with lotus
scrolls, China, Ming
dynasty, *c.*1400.
Diam. 41.2 cm.
British Museum. For
further views of the bowl
see figures 7 and 66.

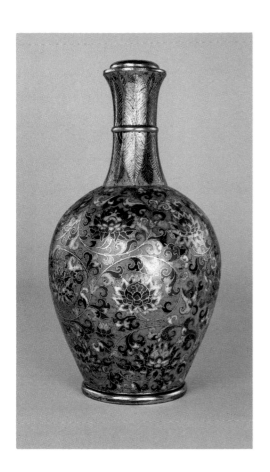

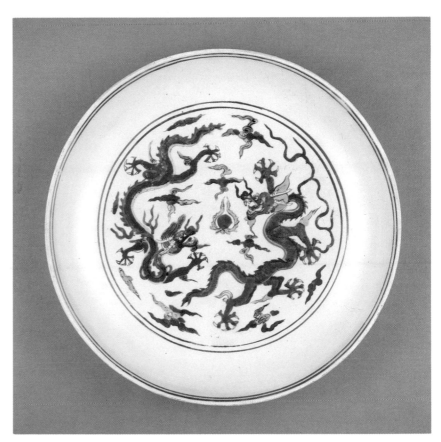

Plate 4
Cloisonné bottle decorated with lotus scrolls,
China, Ming dynasty, 15th century. H. 27.5 cm.
British Museum.

Plate 5
Porcelain dish decorated with two dragons in underglaze blue and enamels, China, Ming
dynasty, Longqing mark and period (1567–72), British Museum. Diam. 33 cm.

Plate 6 (left)
Detail of medallions,
cloud bands and
lotus patterns on the
Ardebil carpet, Iran,
1539–40. Victoria
and Albert Museum.

Plate 7 (right)
Lacquer binding for
the *Haft Paykar* in
calligraphy by Shah
Mahmud al-
Naysaburi, Iran,
Tabriz, *c.*1550.
British Library.

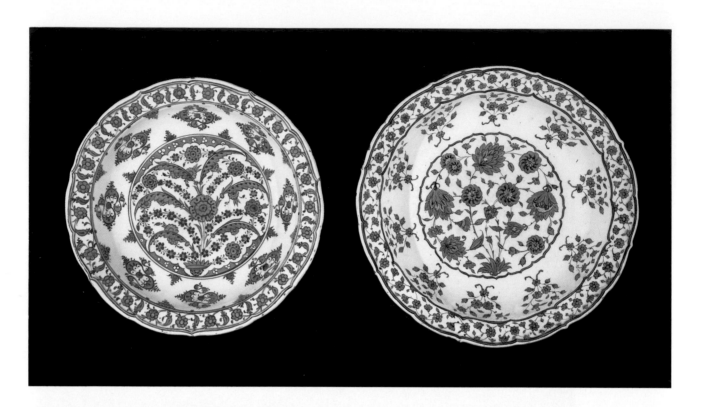

Plate 8 (left)
Left dish decorated with flowers with long leaves, Turkey, Iznik, *c.* 1540–50. Diam. 36 cm. British Museum; *right* dish decorated with flowers in blue and sage green, Turkey, Iznik, mid-16th century. Diam. 38.9 cm. British Museum.

Plate 9 (below left)
Dish decorated with fantastic flowers, Turkey, Iznik, mid-16th century. Diam. 35.8 cm. British Museum.

Plate 10 (right)
Tile decorated with a flower based on Iznik lotus-leaf designs, William De Morgan, 1888–98. 23 × 23 cm. Private collection.

Plate 11 (below)
Interior of a large basin, 'Abraham of Kütayha' type, Turkey, Iznik, early 16th century. Diam. 43.2 cm. British Museum.

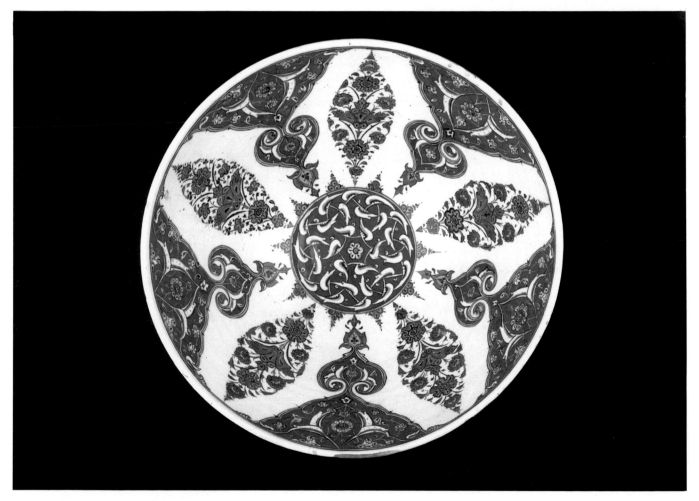

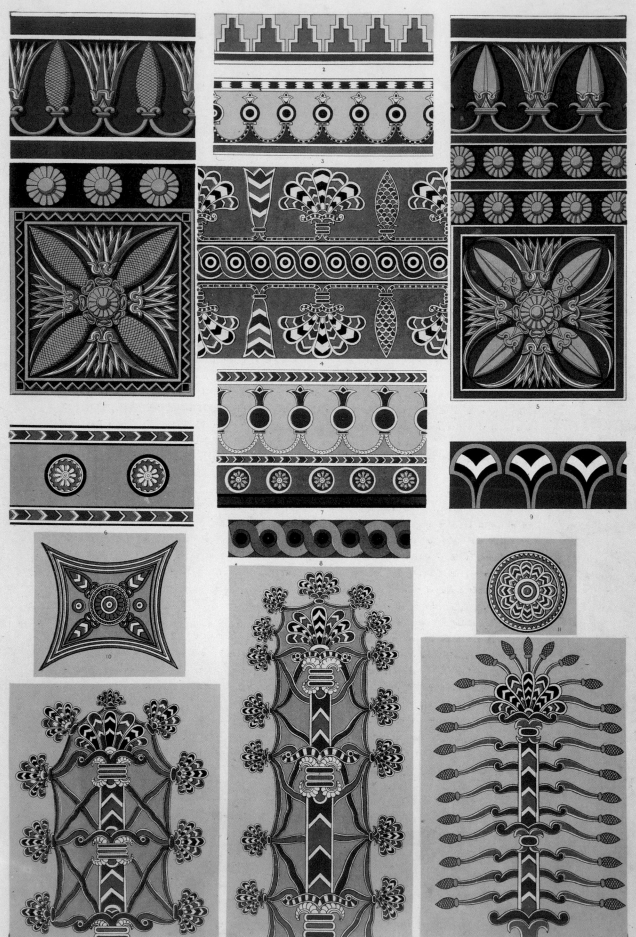

building plans and many decorative details are shared. At all sites Western Classical inspiration in both architecture and sculpture is very striking. However, there has not always been agreement as to the sources of architectural schemes and motifs. Excavations of the Graeco-Bactrian city at Ai Khanum on the Oxus have now provided evidence of a flourishing local Hellenistic school of town planning, architecture and sculpture which must have laid the foundation for Kushan architecture. Yet later Roman elements also seem to be present, and there is of course a considerable mixing of these Classical borrowings with earlier Indian styles and some Iranian features.

In Russia large buildings have been excavated at Kushan sites at Khalchayan and Dalverzin-tepe; a cave temple has been found at Kara-tepe.[31] Porticoes fronting the building at Khalchayan and the cave temple at Kara-tepe recall Hellenistic buildings and Iranian structures, such as the façade of the Parthian mausoleum at Nysa. Sanctuaries at Khalchayan and Dalverzin-tepe also resemble the dynastic shrine at Surkh Kotal. The shrines within the buildings are decorated with pilasters, which are indented at the centre and crowned by Corinthian capitals, some of which contain figures. Other ornament of the buildings is also Classical in character, including satyr figures and erotes holding garlands.

The most striking feature of Kushan building is, however, its use as a vehicle to display sculpture – portraits, figures of the Buddha and Bodhisattvas, and narrative scenes from the life of the Buddha. Related figured sculpture was already employed in India before the advent of the Kushans;[32] but as in later periods, Hellenistic models had provided some inspiration for this earlier development. Kushan figured sculpture shows a mixture of features taken from earlier Indian sculpture and from later Classical figures, known in provincial Near Eastern and Central Asian forms. A convergence of these different styles can be traced in Kushan portrait sculpture. Dynastic portraits from Surkh Kotal resemble both a headless figure inscribed with the name of Kanishka, found at Mathura on the Jumna River in India, and sculptures from Hatra mentioned above. Although figures of the Buddha and scenes from his life were earlier carved in central and northern India, in Kushan architecture they appear in a new style and in a new setting. Clinging folds of drapery on Kushan sculptures are directly descended from Hellenistic figured sculpture, while the framework of columns and arches and representations of buildings within narrative scenes owe even more to Near Eastern example.

Figures of both the Buddha and Bodhisattvas and narrative scenes were arranged on religious buildings and on stupas, in carefully organised tiers, echoing the organisation of figures within Hellenistic, Parthian or Roman architectural façades. Stucco sculpture on Stupa no. 5 at 'Ali Masjid in the Khyber Pass is set in niches, arranged in tiers on moulded plinths (fig. 26). The upper storey in the illustrated example is supported on brackets or modillions, while a row of lions emerges between the lower two storeys. Lions had been used as guardian figures in Mesopotamia from the third millennium BC and were adopted widely in Hellenistic architecture on the strength of both Mesopotamian and Iranian examples. Engaged columns in the lower two storeys are surmounted by Corinthian capitals, well known in the area from Hellenistic and Kushan sites. The capitals in the upper storey are composed of two beasts and reproduce the famous formula used by the Achaemenids at Persepolis. Capitals from Russian sites at Sultan-Uis-Dag and the palace at Kalaly-Gyr illustrate the same Iranian form,[33] and such Kushan versions must

Plate 12 (opposite)
Assyrian and Achaemenid lotus and palmette designs from Owen Jones, *The Grammar of Ornament*, 1856; Nineveh and Persia I, pl.XII.

49

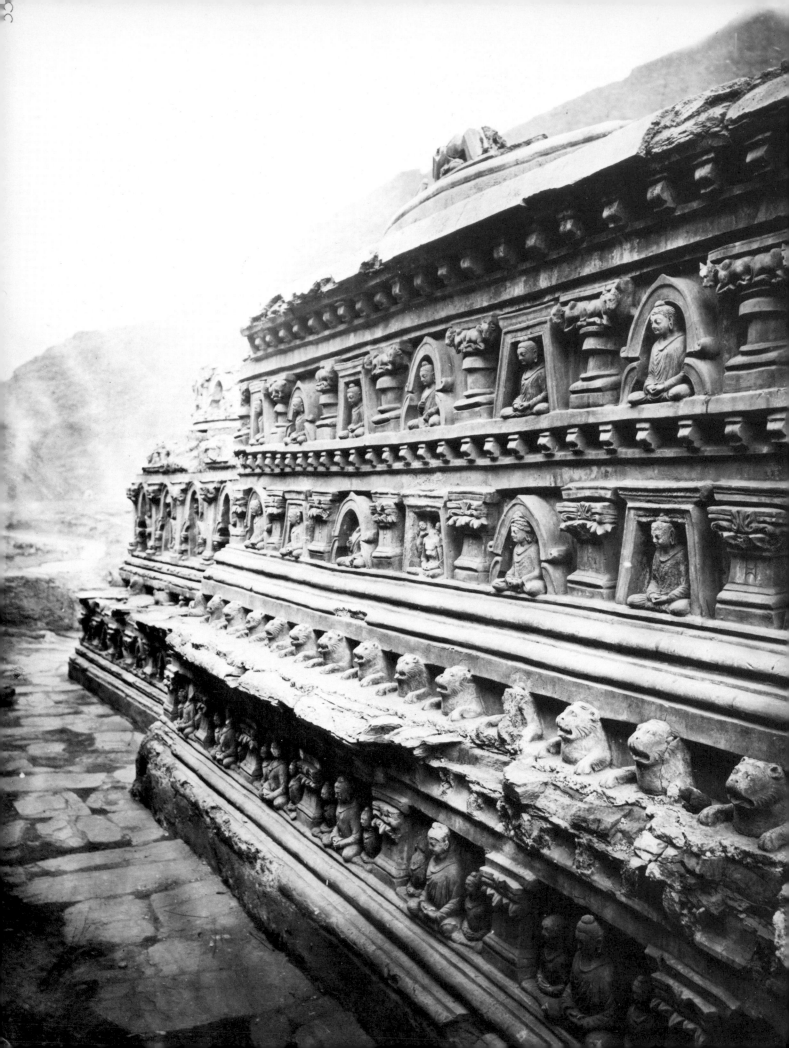

Fig. 27 Stone panel with figures of Buddhas and Bodhisattvas within *chaitya* arches, half-palmette scrolls along outer edges, Gandhara, 2nd–3rd centuries AD. H. 18.1 cm. British Museum.

have become known to the Chinese, for similar capitals are found in cave 12 at Yungang.[34]

The framing niches on the stupa had been taken from two different sources. Rounded niche frames rise to a point at the tip, approximating to the shape of the letter s. Frames of this shape, known as the *chaitya* arch, had been used to decorate openings of caves in India since at least the third century BC.[35] On the stupa, such arches rise above two smaller lobes, suggesting a cave opening in which a meditating figure sits. On some reliefs and reliquaries the pointed arch was combined with engaged columns (fig. 27, pl. 1).

On the stupa at 'Ali Masjid further niches have been devised between the pointed arches. These doorways have splayed uprights and a miniature entablature whose sides slope in a counter direction. This detail refers to building types popular to the west of the Hindu Kush. Massive doorways with splayed entablatures are seen in Iran, and related structures are also found much further west, in Egypt. The sequence of development that made these doorways known to the Kushans is not, however, obvious.

While doorway niches are useful in illustrating the varied sources of Gandharan architecture, they were not widely used further east. Angular niches, known as trabeated niches, also widely seen in Gandharan art, were more important to the development of Buddhist architecture in Central Asia and China. A small section of frieze, narrating the life of the historical Buddha, Sakyamuni, which illustrates the episode of the conversion of Nanda (fig. 28), presents a small crowd of people within a frame, defined by two columns supporting beams arranged in the shape of a truncated triangle (one of the two columns is now broken).[36] In searching out a model for this somewhat implausible structure, Hellenistic and Roman wall-paintings provide a possible source. A small section of wall-painting from Pompeii illustrates a bird on a fountain within a fenced garden. The fence is drawn in perspective, receding towards a vanishing point above the eye-level of the viewer (fig. 29), thus outlining a truncated triangle. In the same way the trabeated frame in the small Gandharan relief can be understood as delimiting the upper edge of a rectangular room in which the figures stand (fig. 28). It is of course not suggested that the Gandharan relief and the Pompeian painting are directly related; the comparison is intended to indicate a type of perspective painting

Fig. 26 Stucco sculpture within niches on a stupa at 'Ali Masjid, Khyber Pass, 2nd-3rd centuries AD.

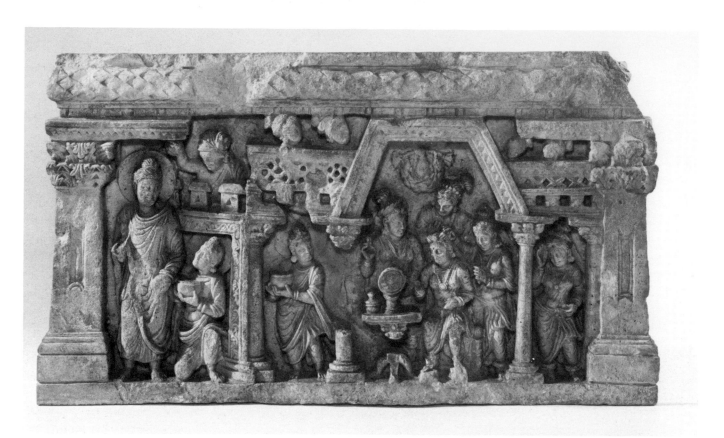

that might have suggested the form to the Kushans.

Rather later wall-paintings from the Central Asian Buddhist caves at Kizil near Kucha provide several examples of a similar receding outline to show a room or enclosure in which figure scenes are set (fig. 30). Although the detail illustrated is much later than the Gandharan relief, the currency of a Western perspective device in the Tarim Basin suggests that it may also have been known at an earlier date in areas occupied by the Kushans.[37] Wall-paintings at Khalchayan and Toprak-kala in the Soviet Union demonstrate Kushan concern with wall-painting generally.[38]

The small relief, in which the trabeated frame appears, also illustrates the popularity of eclectic border designs in Kushan building (fig. 28). Along the top runs an indented ornament based upon Hellenistic wreaths of leaves. The small zigzags along the trabeated arch and the beam above the Buddha on the left are seen in Achaemenid sculpture at an earlier date, while the openwork lattice may even be derived from Roman *opus reticulatum* (brickwork designed as a lattice resembling a net). The doorway on the left of the scene is enlivened with leafy scrolls whose sources lie in the acanthus.

Before considering this leaf pattern in more detail, another border consisting of rosettes enclosed by lotus petals, can be taken as illustrating the widespread use in Central Asia of a Mediterranean ornament. The example at the top of figure 31 is drawn from a stone fragment found in Gandhara, and an earlier form of this border appears below, taken from a fourth-century Italian vase in the British Museum (fig. 31b). Two slightly different flowers provide the rosettes between vertical petals which, as in many more ancient lotus and palmette ornaments, make a frame (figs 192e, f). When used in Gandhara, the pairs of lotus petals, one the right way up, the other upside down, were divided by a small fillet (fig. 31a).

Examples from territories between south Italy and Gandhara are relatively rare; however, a fragment of a sarcophagus found at Ephesus, dating from the second to third centuries AD, shows the same design interpreted in a new way, with the paired lotus heads now rendered as a bunch of acanthus leaves, tied at the centre by a small band (fig. 31c). This new version of an ancient design indicates that the pattern was widely enough known in the eastern Mediterranean to make such invention possible. The Gandharan and Ephesus examples may, therefore, both be descended from a common source.

The pattern was also sufficiently popular in Central Asia for it to have been reused by craftsmen carving beams for wooden buildings in the oases of the Tarim Basin. A fragment in the British Museum from the eastern oasis of Loulan provides yet another reworking of an ancient design (fig. 31d). Following the same path as the painters of lotus and palmette designs on some Greek vases (fig. 192g), Central Asian craftsmen seem to have lost all concern with the profile lotuses and to have replaced them with a binding that encircles the rosettes. Small fillets and single vertical strokes remain from the more faithful pattern used in Gandharan architecture.

Foliage patterns were as prominent as lotus ornament: small undulating scrolls are shown in miniature in the small relief depicting a scene from the life of the Buddha in figure 28; and a similar pattern lies vertically on the left-hand side of a section of ornament in which two figures of the Buddha stand within small *chaitya* arches (fig. 27). These Gandharan scrolls generally contain large single leaves in profile within an undulating stem. This is the half-palmette scroll that was to be so influential in both Central Asia and China (fig. 41

Fig. 28 Stone panel illustrating the story of the conversion of Nanda, from the life of the Buddha, shown within a trabeated frame, Hadda, Gandhara, 2nd–3rd centuries AD. H. 30 cm. British Museum.

Fig. 29 A fountain within a garden, from a wall-painting found at Pompeii, near Naples, Italy, 1st century AD. After London 1976b, no. 93.

Fig. 30 A scene from a wall-painting found at Kizil, Tarim Basin, showing figures within a room delineated by a trabeated outline, possibly 5th century AD. After Grünwedel 1912, fig. 117.

Fig. 31 Rosette and lotus bands

a from a stone relief, Gandhara, 2nd–3rd centuries AD. British Museum.

b from a south Italian vase, 4th century BC. British Museum.

c from a fragment of a stone sarcophagus possibly from Ephesus, 2nd–3rd centuries AD. British Museum.

d from a wooden architectural fragment found at Loulan, Tarim Basin, 3rd–4th centuries AD. British Museum.

Fig. 32 Acanthus and flower scrolls on ivories found at Begram, Afghanistan, 2nd–3rd centuries AD. After Hackin 1954, figs 550, 539.

below). As explained above, half-palmette scrolls do not seem simply to have been made up of half-sections of a palmette placed along a stem; in the West they seem to have been developed from debased versions of the acanthus, such as the ornament illustrated from the Syrian temple of Kanawat (fig. 13c).

However, it seems unlikely that the late debased acanthus scrolls described at the beginning of the chapter were the direct source of half-palmette borders illustrated on these Gandharan reliefs. It is not, for example, possible to trace the transmission of the Kanawat type of scroll across Iran to Central Asia. Instead, it is probable that the half-palmette was reinvented in Central Asia on the basis of both acanthus patterns and vine scrolls, for which there is ample evidence of borrowing from the West.

Relevant examples of acanthus and related flower scrolls are well illustrated on items found in a hoard at Begram, in present-day Afghanistan. The hoard is thought to have been buried at the time of the Sasanian invasion in the third century AD, and contains many items exported from the eastern Mediterranean, such as Syrian glass and metalwork of Hellenistic inspiration.[39] Intricate ivory carvings combine Indian and Classical elements: two borders illustrated in figure 32 are drawn from such carvings. The upper example is a small section of inhabited acanthus scroll, where deep undulations of the stem are lined with simplified acanthus leaves and additional leaves are turned backwards into the spaces to enclose a small bird

Fig. 33 Stone relief showing a figure amid a vine scroll, Gandhara, 2nd–3rd centuries AD. H. 14 cm. British Museum.

and a flower. The framework of this ornament parallels the scroll from Aphrodisias described above (fig. 13b) and, like it, must be descended from Hellenistic acanthus scrolls. Here, however, the leaves are not very realistic and approach the outline of half-palmette leaves in the Gandharan friezes, to which they may have contributed. The second detail (fig. 32) shows a flower scroll, presumably a lotus. Its interest lies in the combination of real flower heads with a more imaginary flower on the right of the illustration. This star-shaped bloom matches the leaf flowers in the upper border of the frieze from the Temple of Bel (fig. 13a).

Both these ornaments on the Begram ivories can be paralleled in decoration on Buddhist monuments of the first century AD at Amaravati in southern India. Work at Begram does not simply reflect late Hellenistic or Roman ornament but has possibly an earlier Indian source. However, even such southern Indian decoration was dependent on Hellenistic design for its inspiration. Ornament of acanthus scrolls on the Begram ivories may therefore have been borrowed directly from the Near East, or it may have been copied from Indian ornament that had taken its designs from the Hellenistic West at a slightly earlier stage.

In addition, vine scrolls seem to have contributed to the invention of simplified leaf scrolls. A small section of frieze illustrates a typical Gandharan vine pattern (fig. 33). In place of the angular vine leaves, seen for example on the vine from the Temple of Bel (fig. 13a), this pattern has simplified leaves, many of which are bent in half, following the example set by the acanthus. Indeed, it appears that this Central Asian vine has taken over features of a simplified acanthus. Local concern with vine scrolls may have established a secure place for designs in which leaves bent in half down the centre predominated. Thus the border ornaments reproduced in Gandharan Buddhist architecture (figs 27, 28) seem to owe their outlines and popularity to both the debased acanthus and the vine scroll. Such Central Asian leaf patterns employed in architecture were the immediate source of the foliage decoration

Fig. 34 Wooden architectural fragments recovered by Sir Aurel Stein from Loulan, Tarim Basin, 3rd–4th centuries AD. After Stein 1912, vol. I, pl. 122.

borrowed to embellish buildings, especially Buddhist temples, further east in the Tarim Basin and at Yungang.

The Tarim Basin and Yungang

The Tarim Basin lies between the Tian Shan mountains in the north and the Kunlun range, fringing the Tibetan plateau, to the south. Rivers flowing from these mountains give life to the oases along their foothills and then drain into and disappear in the vast wastes of the Taklamakan desert at the centre. Two trade routes, one each side of the desert, passed through these oases, linking the lands of the Parthians and Kushans to China. Traders and travellers crossing the high Pamirs above Kashgar had a choice of turning north or south. Those who took the northern route passed through Kucha, where the Kizil caves are to be found (fig. 30), Karashahr, Turfan and Loulan before entering the Jade Gate, Yumen. Turning south, the traveller traversed Yarkand, Khotan, and the ancient site of Yotkan, Niya, Charchan and Miran, before arriving at the Buddhist temples of Dunhuang.[40]

These sites were investigated by British, German, French and Japanese explorers early this century but have not been systematically excavated since. Much more work on the area has yet to be done. Early occupation layers, contemporary with the period that saw the borrowing of Kushan sculptural and architectural modes by the Chinese, have been found at Yotkan, Niya, Rawak, Miran and Loulan. On the evidence of surviving documents, it has been suggested that Niya was abandoned in the late third and Loulan in the

early fourth centuries AD. Because the Tarim Basin is so dry, and has become more arid over the centuries, large quantities of wooden architectual fragments have been preserved at these sites. The photograph in figure 34 was taken at the time of Sir Aurel Stein's expedition to Loulan and illustrates the range of decorated wooden architectural beams and fragments of furniture he recovered. The ornament is almost entirely of Near Eastern origin and includes the rosettes illustrated above (fig. 31), wreaths of leaves, and a variety of debased acanthus or half-palmette scrolls. Such ornament was borrowed from the Near East and must have reached this Far Eastern military post from areas to the west.

Although predominant artistic and religious influences seem to have been Western rather than Chinese, the fortunes of the oases were always at the mercy of military and diplomatic relations between China and the nomadic peoples on her borders. The confederations of the Xiongnu, who drove the Yuezhi westwards, have already been mentioned (see p. 38). These peoples caused equal anxiety to the Chinese. Wudi, the Martial Emperor of the Han dynasty (140–87 BC), conceived the idea of joining forces with other victims of the Xiongnu, hoping thus to attack them on several fronts. To this end he dispatched his ambassador, Zhang Qian, westwards to negotiate with the Yuezhi and to seek their help.

Zhang Qian spent several years on his mission, and it is from his account of the position of the Wu Sun, the Yuezhi and the Sai that we have contemporary information on the fortunes of these nomads in Central Asia. Zhang Qian failed to negotiate an alliance with the Yuezhi, however, and returned home with an alluring account of the excellent horses and exotic merchandise to be found in western lands. The Chinese were soon drawn into a series of campaigns and embassies to establish relations with the west. In 106 BC the first caravan trading mission was exchanged with Parthia. Fine horses were particularly desired by the Chinese for their campaigns against the Xiongnu, since the horses indigenous to China were of a small, weaker breed than those found in Central Asia. Therefore, in 104 BC, Wudi dispatched his general, Li Guangli, to wrest horses from the small states described by Zhang Qian, thought now to be Sogdia and Ferghana. When his first campaigns were unsuccessful, Li Guangli was forced by the emperor to return west again, this time with better results.

From AD 9 to 23 a usurper, Wang Mang, seized power from the Han dynasty, taking advantage of severe economic difficulties that followed as a consequence of the military and civil effort expended on the immense empire. In that period Chinese domination of the Tarim Basin waned. The Han dynasty was restored once more from AD 25, and the Chinese reasserted control over territories that had slipped from their grasp. In AD 73 the general, Pan Chao, was dispatched to attack the Xiongnu once again and to retake the Tarim Basin. From that date until the fall of the Han in AD 220, the Chinese effectively controlled the Tarim. These centuries of Chinese domination set a long-lasting pattern of Chinese government and bureaucracy in the area and strengthened trade from which so many of the oases gained their wealth.

After the fall of the Han, there are fewer mentions of the oases in the Chinese histories, and political relations may indeed have been remote. However, the introduction of Buddhism into China, perhaps as early as the Han period, ensured that, although formal political relations might have loosened, a continuous traffic of Buddhist monks, and possibly artisans, found their way along the trade routes between China and the west. Chinese pilgrims, notably

Fa Xian in the fourth century, travelled to the west to seek the true Buddhist sculptures, and Central Asian translators from Kucha and Turfan were eagerly employed in the monasteries of eastern China for their skill in interpreting original texts.[41]

The collapse of traditional Chinese rule helped the expansion of Buddhism, a foreign religion. Two states were particularly responsible for its propagation in the north – the small state of Liang, astride the Gansu corridor at Dunhuang, and the much larger state of the Toba, who ruled north China as the Northern Wei dynasty. Meng Xun, the devout ruler of the Liang, assembled a large body of religious men and artisans to execute his works in the service of Buddhism. In 439 the Liang were conquered by the Nothern Wei, who transported monks and artisans to their capital near the present-day city of Datong, and thus benefited from the assembled skills, both religious and artistic, of the Liang.

As the chapter of the *Wei Shu* on Buddhism and Daoism records: 'During Taiyan (AD 435–440) Liangzhou was pacified and the people of the country were moved to the capital. The *śramanas* and Buddhist works both went east.' The *Wei Shu* describes many temples and images, often mentioning veneration accorded to Buddhist figures imported from Central Asia or perhaps even India. 'Early in Tai'an (AD 455–460) five barbarian *śramanas* from the Lion country, Yeshe-Yiduo, Foutuo-Nanti and others, bearing three Buddha Images, arrived at the capital. They said they had crossed all the countries of the Western Regions and had seen the Buddha image and his top-knot. The kings of the foreign lands, one after the other, had all sent artisans to copy the *rong* [form] but none could equal that made by Foutuo-Nanti. If one stood ten paces away from it and looked, it appeared bright, but the closer one came to it the dimmer it became. A barbarian *śramana* from Shalou also went to the capital and presented the Buddha's begging bowl and portrait.' This description of an image which appears bright from a distance is derived from Fa Xian's earlier account of his pilgrimage. Such dependence on an earlier text illustrates the difficulty of using these documents as a source of detailed information on images and their settings.

Another entry is, however, useful in throwing light on the activity at Yungang. 'In the autumn of the first year of Xingguang (AD 454), the officials were commanded by Imperial edict to cast five standing Sakya-figures, each of one *zhang* and six *chi* in length, within the great five-storey temple, in memory of the five emperors beginning with Taizu. Altogether 25,000 *jin* of copper were used.'[42] While these five figures and most of the other pious works of the Northern Wei have disappeared, the cave temples at Yungang illustrate comparable sculptures. Five caves, each of which contains a massive figure of the Buddha, are thought to be the earliest caves at the site, constructed under the direction of the monk Tan Yao between 460 and 465. By analogy with the bronze figures described in the *Wei Shu*, it is suggested that these figures also were intended to show both devotion to the Buddha and respect to the former emperors. This practice of combining a religious with a dynastic shrine paralleled Kushan practice, as seen in the shrine at Surkh Kotal. The massive size of the figures also invites comparisons with the vast figures found at sites both in Central Asia and in the Near East.

Other caves, including cave 7, illustrated above (fig. 14), are even more interesting. Several caves were constructed in pairs: nos 7 and 8, 9 and 10 and 5 and 6, 1 and 2, with one group of three, nos 11, 12 and 13. Caves 7 and 8 and 9 and 10 are particularly well known for their Central Asian iconography

Fig. 35 Caves 9 and 10 at Yungang, showing columns in front of a highly decorated façade, late 5th century AD. After Mizuno and Nagahiro 1952, vol. VI text, plan 3.

and stylistic detail.[43] However, all the caves at Yungang show traces of influence from Central Asia or Afghanistan. Caves 9 and 10 are somewhat unusual in being hollowed out behind a colonnade standing in front of their entrances (fig. 35). This structure recalls the colonnades at Kara-tepe and at more western sites; indeed, the series of tall columns in front of a highly decorated façade is even reminiscent of Western buildings, such as the Temple of Bacchus at Baalbek (fig. 20). The figures decorating these two caves are all placed in a strictly ordered framework of niches, arranged in two storeys. Each niche is defined by columns supporting arches. Two very evocative capital types are used. A provincial form of Ionic capital, seen in both caves 9 and 10 (fig. 36), is immediately recognisable. The columns are faceted and decorated with fine relief scrolls below two large rolled volutes. The use of the Ionic order in Iran under the Parthians has already been noted (fig. 22): an example, intermediate between Yungang and Iran, is provided by a schematic wooden capital found by Sir Aurel Stein at Loulan, a Chinese military post which, he argued, was destroyed in the fourth century AD (fig. 37). Debased Ionic capitals were quite widely used in Central Asia, and examples have been found at Nysa, Khalchayan and Miran.[44]

Similarly, Corinthian capitals left their imprint on the Yungang caves. Figure 38c shows a drawing of a pier on the inner entrance of cave 7. This pier is divided into three tiers by small zigzag borders, long known from Achaemenid and Gandharan sculpture. In each tier small figures are carved in relief, reproducing an eastern Mediterranean convention, widely used in Gandhara reliefs, as shown in a small corner column (fig. 39). At the top of the Yungang pier, a small figure of the Buddha appears between two large leaves, which can be interpreted as those of a debased acanthus.

Inhabited Corinthian capitals had been known in the eastern Mediterranean from the first century BC, and are illustrated here by a pier capital, said to be from Greece, on which a figure of Leda and the swan are embraced by acanthus leaves (fig. 38a). Parthian sites also provide rich finds.[45] Terracotta examples have been found at Warka, while the drawing reproduces a large

Fig. 38 Pilaster capitals based on the Corinthian order:

a showing Leda and the swan, thought to come from Greece, 3rd century AD. British Museum.

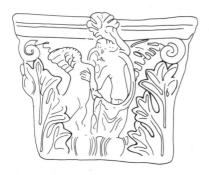

b showing a female figure between acanthus leaves, found at Hatra, Iraq, 2nd century AD. After Safar 1974, p. 114.

c showing a figure of the Buddha between acanthus leaves, above a pilaster decorated with dancing figures and zigzags, from the inner doorway in cave 7 at Yungang, 5th century AD. After Mizuno and Nagahiro, 1952, vol. IV plates, pl. 18.

Fig. 36 Niche from cave 9 at Yungang showing debased Ionic capitals and faceted columns decorated with simplified acanthus scrolls, late 5th century AD. After Mizuno and Nagahiro 1952, vol. VI text, fig. 14.

Fig. 37 Debased Ionic capital in wood, found at Loulan, Tarim Basin, 3rd–4th centuries AD. L. 84 cm. British Museum.

Fig. 40 Stone Corinthian pilaster capital,
Gandhara, 2nd–3rd centuries AD. W. 33 cm.
British Museum.

Fig. 39 Miniature stone corner pilaster,
Corinthian type, with figures against the sides.
Gandhara, 2nd–3rd centuries AD. H. 29.8 cm.
British Museum.

ornament from Hatra, in which a female figure rises from an arc of acanthus leaves (fig. 38b). In keeping with the new demands of Buddhism, these female figures were replaced by small figures of the Buddha in pilaster capitals in Kushan building (fig. 40). The capital illustrated is interesting for the combination of small flowers amid the acanthus leaves, a detail which reproduces the small flowers found in Hellenistic acanthus scrolls and Corinthian capitals (fig. 12).

The pier in cave 7 was perhaps found to be somewhat strange, for the scheme was rapidly modified. First, the number of tiers was increased to make the figures seem less sculptural and more ornamental. Secondly, the free-standing dancing figures were replaced by small Buddhas, first in rows and then in niches, thus making a Western model conform to the decoration of the caves. The pediments or arches, supported by these different piers or engaged columns, followed two of the types seen in Gandhara: pointed arches were based on the *chaitya* arch, and other frames were shown in the trabeated form. The combination of these two arch types with capitals based on Hellenistic orders is the clearest evidence of the dependence of the decoration of the Yungang caves on Central Asian versions of Hellenistic architecture. Indeed, widespread use of these Western architectural features demonstrates that the compositions of whole façades had been borrowed, bringing with them not only figures, piers, pilasters and niches but also decorative borders.

Such decorative borders are found in all the early caves. The cave wall illustrated shows these borders dividing regular tiers of niches and embellishing some piers (fig. 14). Similar borders were employed around doorways and to decorate plinths and niche frames. The motifs in these borders comprise zigzags, petals, leaves and vine scrolls. The zigzags were noted on Gandharan sculpture and were borrowed, it would appear, from Iran. Petals are often accepted as reproducing those of a lotus (fig. 14).[46] However, the pointed outline containing two lobes or lumps cannot be matched in a flower, and is probably best described as an Eastern version of enrichments used on *cyma reversa* mouldings. Petals of similar shape were used as the outline for a circular pedestal to support figures, and because this arrangement approaches more nearly the outline of a flower, we are inclined to accept the shape, without questioning it, as that of a lotus (fig. 106). Inhabited scrolls, vine

scrolls and erotes holding garlands were, like the *cyma reversa*, borrowed from Gandharan and Near Eastern architectural decoration.[47]

Half-palmettes are found in many forms in all the early caves. A typical arrangement of leaves and stems consists of a simple undulating stem with narrow lobed leaves. The sequence of designs that establishes a Gandharan or Central Asian source for the Chinese version is set out in figure 41. The upper

Fig. 41 Drawing of simplified acanthus or half-palmette scrolls:

a from a stone relief, Gandhara, 2nd–3rd centuries AD. Lahore Museum, Pakistan. After Ingholt 1957, fig. 408.

b from a wooden architectural fragment found at Loulan, Tarim Basin, 3rd–4th centuries AD. British Museum.

c from cave 8 at Yungang, Northern Wei dynasty, late 5th century AD. After Mizuno and Nagahiro, 1952, vol. v plates, pl. 41.

border is taken from a relief from Pakistan, now in the Lahore Museum; below stands the ornament of a beam, excavated by Sir Aurel Stein at Loulan in the Tarim Basin (a photograph of the same beam is shown in figure 34), and last comes a border from cave 8 at Yungang. A number of variations on the half-palmette, reproduced from the decoration of cave 9, are illustrated in the Introduction (fig. 11). At the top is a simple half-palmette scroll and below it a border of half-palmette leaves without a stem to bind them together. The stems in the next two examples are drawn in loops around a motif based on two half-palmettes. These several scrolls constituted the only vocabulary the Chinese needed to construct elaborate flower patterns.

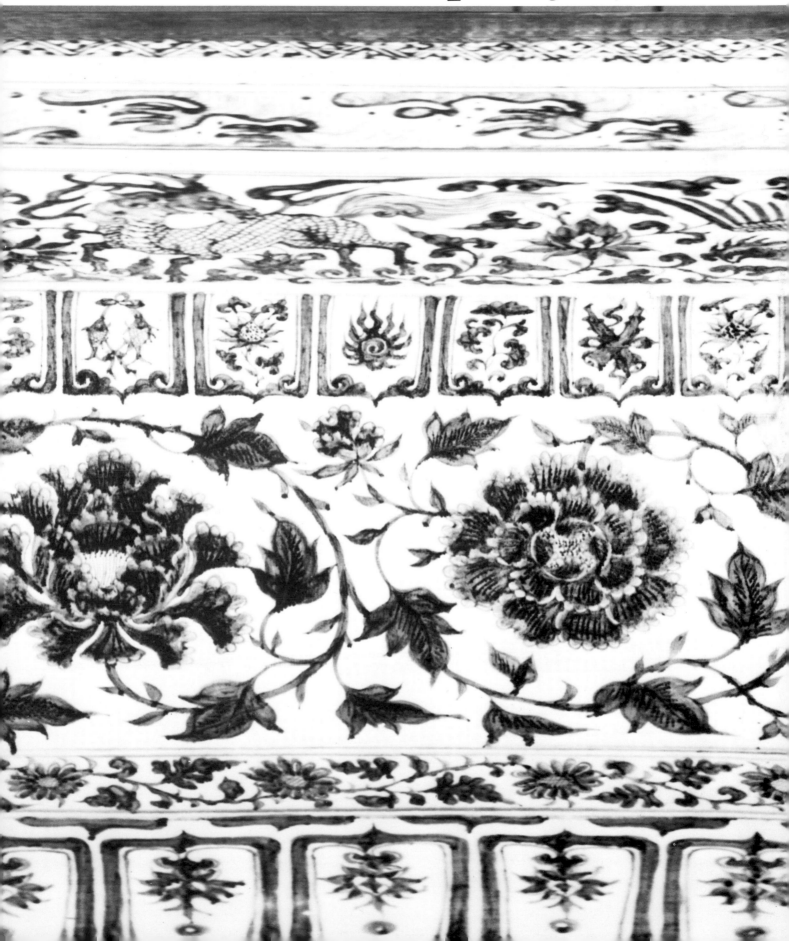

Architecture

Leaf scrolls, running in single lines, looped together, or packed into vertical rows were fashioned by Chinese craftsmen first into lotus and then into peony borders. The history of the invention of flower-scroll patterns, using elements imported from Central Asia, illustrates the extraordinary tenacity of inherited forms. For several centuries scrolls with simplified acanthus or half-palmette leaves were used with little change. Yet when religious or social needs demanded specific motifs, these conventions were reinterpreted and altered to provide patterns that referred to, even if they did not reproduce, real flowers. Attempts to reuse half-palmette scrolls as lotuses were responses to the demands of Buddhism; enthusiasm for the peony accompanied a new fashion

Fig. 42 Rubbing of the ornament on small stone bases found in the tomb of Sima Jinlong (d. 484), Datong, Shanxi province, Northern Wei dynasty. After *Wenwu* 1972.3, p. 25, fig. 6.

Fig. 43 Ornament from haloes of Buddhist figures

a from a Bodhisattva in cave 5 at Yungang, Northern Wei dynasty, 5th century AD. After Mizuno and Nagahiro 1952, vol. XVI, rubbing 6.

b on a gilt-bronze figure, Northern Wei dynasty, 6th century AD. After Tokyo 1976a, pl. 68.

for the flower that swept through Tang society in the seventh and eighth centuries.

Leaf scrolls, brought to China to decorate Buddhist architecture, seem to have remained tied to architecture and to the embellishment of Buddhist figures and implements. Many centuries were to pass before similar designs were widely used on secular utensils in metal or ceramics. This chapter starts with a discussion of ornament of cave temples and funerary architecture, and then turns to the decorative arts.

Wooden temples and palaces of the fifth, sixth and seventh centuries have almost all perished. The great Buddhist cave temples, with painted decoration or carved ornaments, are therefore precious survivors from the period. Likewise tombs with stone furnishings remain, while the buildings and furniture that they copy have disappeared. The common repertory of ornament of cave temples and funerary architecture, and by implication also wooden buildings, can be established by comparing borders of leaf ornament from cave 9 at Yungang (fig. 11) with borders on small stone bases found in the tomb of Sima Jinlong, dated 484.[1] A view of one of these bases is illustrated in figure 106, while rubbings from the sides are shown here in figure 42. The upper two borders, defined by looped stems which enclose half-palmette leaves, are similar to some of the complicated borders from cave 9 at Yungang, illustrated above (fig. 11). At the centre of each pair of leaves, either a small figure or a symmetrical lobed head has been placed. These symmetrical heads appear again in the lower two borders, where they are joined to undulating stems and thus take the place of the more usual half-palmette or simplified acanthus leaves. This small symmetrical lobed head was later to provide the source for simple flowers illustrated in figure 50 below.

Related combinations of figures and symmetrical lobed heads are found in the Yungang caves.[2] A similar comparison can be made between the decoration of cave temples and of tombs throughout the period under review from 400 to 1400. Funerary architecture provides very useful examples for discussion, as, in general, the tombs concerned can be exactly dated. Furthermore, the fine black stone, from which outer coffins, epitaph tablets and coffin beds were carved in both Shaanxi and Henan provinces, allowed great precision of design. Much of the decoration resembles exquisite drawing rather than stone carving.

Although throughout this book the persistence of established forms is emphasised, the ingenuity with which craftsmen and architects varied these motifs, or constructed new designs on an old framework, is also a continuous theme. In China, as in the West, the half-palmette was a fruitful source of new motifs. For example, haloes of Buddhist deities, such as that of a Bodhisattva in cave 5 at Yungang, were enlivened with half-palmette leaves (fig. 43). However, because the roundel had originally been intended to express the notion of a halo of light (a concept borrowed from Iran), a plant form was somewhat out of place. Half-palmette outlines were therefore often filled with flames. A small gilt-bronze figure of the early sixth century is surrounded by a halo in which the outline of the leaf provides the boundary for the flame; each leaping flame has one flat edge and one lobed side. Decorating haloes with half-palmettes thus determined flame patterns. Indeed, the long survival of half-palmette leaves and undulating scrolls was probably due to the fact that they were not specific and could be easily modified; leaves could be reinterpreted as flames or flowers, scrolls could be filled with flowers or clouds.

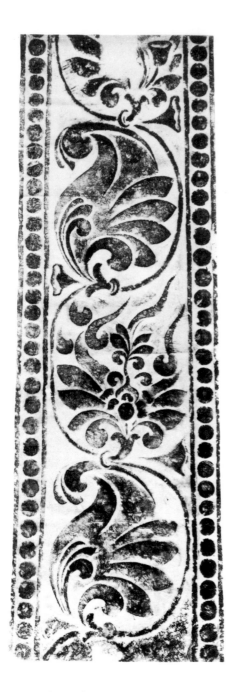

Fig. 44 above and opposite Decorative borders from cave temples at Xiangtangshan, Hebei province, 6th century AD. After Tokyo 1926, vol. III, pl. 79.

Many half-palmette borders were adapted to represent a lotus, the flower associated with Buddhism. In a vertical border at the sixth-century cave temple of Xiangtangshan, large half-palmette leaves alternate with a pseudo-flower, which consists of two half-palmette leaves, back to back, with the same element repeated again at the centre above a small pod (fig. 44). A flower has thus simply been invented using existing fragments of leaf designs.[3] Neither the leaf nor the flower looks remotely like a lotus. A more realistic lotus was devised by using a single ring of petals, as seen at the centre of many ceilings in caves at Yungang, or at Dunhuang.[4] In an example illustrated from cave 397 at Dunhuang, painted in the Sui dynasty (581–618), a central lotus is surrounded by a border of leaves and flowers in which the same lotus flower is set in a half-palmette scroll (fig. 48a). Although the flower head is much more like a lotus than the Xiangtangshan version, as usual the stems and the leaves continue to reproduce half-palmette shapes.

A second border is illustrated opposite the vertical ornament at the caves at Xiangtangshan and consists of a monster head, above which an interlace of lines is fringed by small dragons amid abstract curling shapes (fig. 44). These frilly edges are ancient cloud patterns, long popular in China. Such ancient cloud motifs provided details that could be usefully combined with leaves to vary half-palmette scrolls. Clouds had been used to decorate architecture and utensils in bronze and lacquer since the Han dynasty. The coffin of the wife of the Marquis of Dai, buried in the second century BC and found intact in her tomb at Changsha, is elaborately painted with cloud and animal motifs (fig. 45). The upper panel illustrated shows dragons and other mythical creatures surrounded by frilly clouds; in the lower panel abstract, almost geometric outlines are enlivened by small curling elements that represent clouds. This geometric layout was inherited from the inlaid ornament of the previous dynasty, the Zhou. Clouds were added to suggest the heavens and immortality that the Han sought after death.[5] The designs on the coffin are painted in lacquer, a natural resin, on a wooden base. As the lacquer flows quite easily, angular geometric ornament was gradually rendered in smooth lines, among which curling clouds were easily mingled.

The borders from Xiangtangshan demonstrate that Chinese cloud and dragon borders continued to exist alongside imported Western half-palmettes (fig. 44). With both designs to hand, some stone carvers combined the two. Thus a border on the epitaph tablet for Mu Shao (d. 531) is filled with bursts of cloud (fig. 46b). Small curling fragments resemble the puffy outlines on the Han dynasty coffin, but here clouds are not combined with the traditional geometric patterns of the Zhou, nor indeed with long slanting lines of later Han ornament; they are now contained within familiar undulating stems, borrowed from half-palmette scrolls. Indeed, sections of the cloud are attached to this stem as though they were parts of leaves.[6]

While both cloud patterns and leaf scrolls were available to Chinese craftsmen of the sixth and seventh centuries, the impetus for such florid combinations may have come from ornament developed in India in the Gupta period (AD 320–550). Although only limited evidence exists of contact with India in the sixth and seventh centuries, in the form of new figure sculpture styles, the frilly leaf designs certainly seem to present some of the energy of Gupta work.[7] This energy is particularly evident in early seventh-century decoration, such as the vertical borders or tablets engraved with the Tripitika (the Buddhist scriptures) in 653 (fig. 46c). The ambiguity of the border on Mu

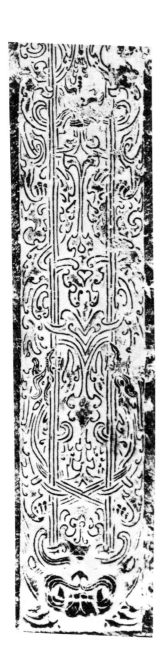

Shao's epitaph tablet has here been resolved: leaves rather than clouds are intended. Each undulation of the stem now contains a very frilly leaf, whose edges are folded back on itself. The original half-palmette is still evident in the small collars with which the leaf is secured to the stem, collars which appear on the scrolls from Xiangtangshan as well. While leaf and cloud combinations may initially have been intended to reproduce an exotic foreign border, in the longer term these inventions proved useful to suggest real leaves and flowers.

Improvised lotus scrolls at Xiangtangshan (fig. 44) are only a special example of a general use of pairs of half-palmette leaves to suggest flowers. A standard border, often seen in the Yungang caves, provides the starting-point of a large number of variations (fig. 47a).[8] Pairs of leaves, arranged about a central spine, are confined within oval enclosures. Such borders appear to be distant descendants of Greek and Hellenistic decoration in which lotus petals were reduced to a line framing palmettes (fig. 192g). Late examples are found

Fig. 45 right Decoration on the two long sides of the middle coffin from the tomb of the wife of the Marquis of Dai at Changsha, Hunan province. Han dynasty, 2nd century BC. After Beijing 1973, figs 25, 26.

in the Near East and Central Asia. Although these latter examples post-date the decoration of the Yungang caves, it must be assumed that a Western Classical source provided this form of palmette design. Invented first to fill looped stems, the principal device – a pair of half-palmette leaves surrounding a spine – was rapidly detached from this framework and combined with various other stem patterns. On a small fifth-century gilt-bronze figure, a pair of palmette leaves flourish on s-shaped stalks and support small pointed heads between them (fig. 47b). In cave 13 at Yungang, on the other hand, the same basic elements have been more inventively used to suggest a flower (fig. 47c). A stem undulates in the usual way about a central point, occupied by an elaborate version of the half-palmettes seen in figure 47a, while inside the main loops of the stem, flower heads have been suggested by decorating the central spine as though it were a head of stamens. Pairs of half-palmette leaves

are disguised by wrapping them round the stem. Following much more ancient examples, additional heads have been inserted in the spaces between the stems.

This formula remained popular for more than 100 years, and one of the most elegant versions of the scheme is seen in a border around the epitaph cover carved for Hou Gang, d. 526 (fig. 47d).[9] Although the design is designated as a honeysuckle by some authorities, it no more resembles a honeysuckle than earlier Greek ornament, similarly named. Again the undulating stem provides the framework, and pairs of palmette leaves suggest a flower head. At the centre of each pair, a small stem supports a few petals. Although well disguised, as before, the flower consists of well-established palmette sections set out in a slightly new arrangement.

In the second half of the seventh century, this composition of a pair of leaves around a central spine or point was to provide a new type of flower head, its arrival being signalled by changes in the decoration of Buddhist caves. In the sixth and much of the seventh centuries, many caves, especially those at Dunhuang, were decorated with a central lotus surrounded by palmette and lotus scrolls (fig. 48a). At some stage in the seventh century, this scheme was replaced by designs in which a central lotus was shown in outline, represented by a complicated interlace of stalks and nodes. Concurrently, a new kind of running scroll was provided in the outer border. These flower scrolls, seen for example in early Tang caves at Dunhuang such as cave no. 372, are the basis of peony scrolls that came to dominate Chinese ornament (fig. 48b).

The key element in the construction, both of a new form of central lotus and the running scroll around it, was the pair of palmette leaves divided by a central spine. Ornaments on late seventh-century tiles from Korea, which share the decoration of the Dunhuang ceilings, enable us to follow the way in which the new patterns were put together out of existing elements.[10] The upper tile in figure 49, recovered from the lake Anapchi, consists of a lion seen from the front, framed by a beaded border. Around the beading small flowers are set within enclosures defined by pairs of palmette leaves, each supporting a central pointed head. A detail from a second tile, also from Anapchi, displays a more complicated version of the same design (fig. 49). Here the eye is

Fig. 46 Borders showing combinations of half-palmette designs and cloud scrolls:

a half-palmette border from cave 8 at Yungang, Northern Wei dynasty, late 5th century AD. After Mizuno and Nagahiro 1952, vol. v plates, pl. 41 (see fig. 41c).

b border from the epitaph tablet of Mu Shao, Northern Wei dynasty, 531. After Taibei 1972, pl. 280.

c vertical border from one of the pair of stele engraved with the Tripitika, Tang dynasty, 653. Beilin, Shaanxi Provincial Museum. After Tokyo 1966, pl. 55.

Fig. 47 Borders of pairs of half-palmette leaves enclosed within stems:

a from cave 9 at Yungang, Northern Wei dynasty, late 5th century AD. After Mizuno and Nagahiro 1952, vol. VI text, fig. 28.

b from a gilt-bronze Buddhist figure, Northern Wei dynasty, 5th–6th centuries AD. After Tokyo 1976a, pl. 62.

c from cave 13 at Yungang, Northern Wei dynasty, late 5th century AD. After Mizuno and Nagahiro 1952, vol. X text, plan 9.

d border from the cover of the epitaph tablet of Hou Gang, 526. After Xi'an 1953, no. 33.

immediately drawn to the oval petals of the rosette and the small flowers within them, and the original unit of the composition – pairs of palmette leaves supporting pointed heads – is overlooked: these pointed heads have been left outside the edge of the large flower head.[11]

Details taken from these two tiles explain the sequence more minutely (fig. 50). The basic element, the pair of palmette leaves about a central point, drawn from the base of a fifth-century Buddhist figure, is set at the top (fig. 50a). The petals illustrated in the next row are all taken from the upper and probably earlier Korean tile (fig. 50b). On the left one unit of the circle is drawn to demonstrate its close resemblance to the earlier design. Then two units are repeated to show that when placed next to each other the leaves make an oval enclosure in which a secondary flower can be placed. In the third section from this same design, the outer petals of the two pairs have been omitted to illustrate the way in which a new unit – the large petal of a lotus (or rosette) – was created by using one leaf from each pair of half-palmettes.

An exactly parallel series of details from the second, more elaborate, Korean tile is illustrated in the next row in figure 50c. Again pairs of leaves define lotus petals. In this case both the outer leaves and the flowers within the petal-shaped enclosures are supported on a common stem, in an ancient arcaded arrangement. Flower heads within the oval enclosures on this tile consist of a pile of petals supported on two comma-shaped sepals. This shape was probably achieved by reading as flowers small palmettes scattered within late fifth-century scrolls, discussed in connection with the decoration on the small stone bases from the tomb of Sima Jinlong (figs 42, 50d(i)). When the central section of such palmettes was enlarged, the two commas were redefined as supports and then seem to have been redrawn as sepals.

By the end of the seventh century, two new elements had become available: fluffy flower heads on two commas, and the same head enclosed within two

Fig. 48 Lotus patterns on the ceilings of Buddhist cave temples, Dunhuang, Gansu province

Fig. 49 Lotus rosettes on Korean tiles from Anapchi, Kyongju, Unified Silla period, 7th century AD. National Museum of Korea, Seoul. After Goepper and Whitfield 1984, nos 100c, 106.

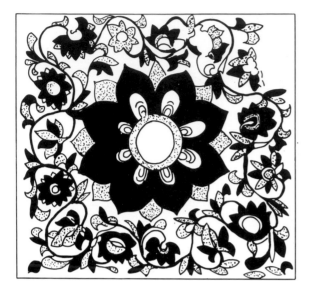

a cave 397, Sui dynasty (581–618), showing a central lotus and a half-palmette scroll enclosing lotus flowers. After Tokyo 1981a, vol. 2, pl. 153.

b cave 372, early Tang dynasty, 7th–8th centuries, showing a lotus outlined with parts of palmettes. After Tokyo 1981a, vol. 3, pl. 57.

a a single detail from the border in figure 47b.

b details from the Korean tile in figure 49a.

c details from the Korean tile in figure 49b.

i a palmette from the
borders in figure 42.

ii flower head, derived from
a palmette, in a border on
the epitaph cover for Wang
Gan (fig. 51a).

iii flower based upon a
palmette, from a reliquary
casket from Jingchuan
(fig. 51b).

iv flower head based upon a
section of a rosette, from a
reliquary casket from
Jingchuan (fig. 51b).

d various flowers

half-palmette leaves. Both flowers were detached from rosettes at the centre of
tiles and ceilings and used to embellish running scrolls. On the epitaph cover
for Wang Gan (d. 693), flower heads consist exclusively of the simple form,
with a lobed head on two commas (figs 50d(ii) and 51a).[12] Slightly later this
lobed head was combined with the other flowers adapted from the petal shape
of the rosette, as seen on a stone casket excavated at Jingchuan in Gansu
province (fig 51b). Around the lid of the box, the borders are divided centrally.
This central point is marked by a pair of half-palmette leaves, and then, either
side, two flowers are suggested by simple lobed heads, similar to those in the
border of Wang Gan's epitaph cover. Further flowers, consisting of a lobed
head framed by a pair of petals, are set in the outer corners (figs 50d(iv), 51b).
These flower heads are really no more than one petal from a rosette, such as
those on Korean tiles (fig. 49) or the Dunhuang roof (fig. 48b), in which a lobed
head is enclosed by a pair of palmette leaves.[13] Both this border and the
decoration on the side of the same casket include leaves alongside the flowers.
These leaves bear some resemblance to the lobed heads discussed but are folded
over themselves as though blown by the wind. In this respect they resemble the

Fig. 51 Borders containing flowers based on palmettes and sections of rosettes:

a border from the epitaph cover for Wang Gan, Tang dynasty, 693. Beilin, Shaanxi Provincial Museum. After Tokyo 1966, no. 175.

b two borders from a stone reliquary casket found at Jingchuan, Gansu province, Tang dynasty, late 7th–early 8th centuries. After *Wenwu* 1966.3, p. 10, figs 3, 4.

Fig. 52 Peony flowers from tomb architecture, Tang dynasty, early 8th century:

a details from the tomb of Prince Yi De, 706. After *Wenwu* 1972.7, p. 27, fig. 2; detail from the tomb of Princess Yongtai, 706. After Tokyo 1966, no. 210.

b details from a lunette from the tomb of Yang Zhiyi, Tang dynasty, 736 (see fig. 53).

leaves shown on the tablet of AD 653 above (fig. 46c). Without ever turning to draw flowers from life, craftsmen were able to give convincing impressions of real plants by making small changes to Western palmettes.

In the early eighth century, these basic outlines were improved with details that accurately conveyed the sense of real flowers. Tomb decoration of the first half of the eighth century provides many instances of flowers in which the two shapes described play an important part. In figure 52 details from the tombs of Prince Yi De and Princess Yongtai (buried 706) are shown above a row of flowers drawn from a lintel in the tomb of Yang Zhiyi (d. 736). (The whole half-moon lintel is shown in figure 53.) In the left-hand example, a detail from the tomb of Prince Yi De, a single flower is supported on its sepals. At the centre is a large round section and above it rise further petals. This flower is no more than the familiar lobed head, improved with details that suggest pollen heads and petals. The basic outline could be altered by tilting the head and by curling over the petals. These petal forms made use of devices first discovered by combining

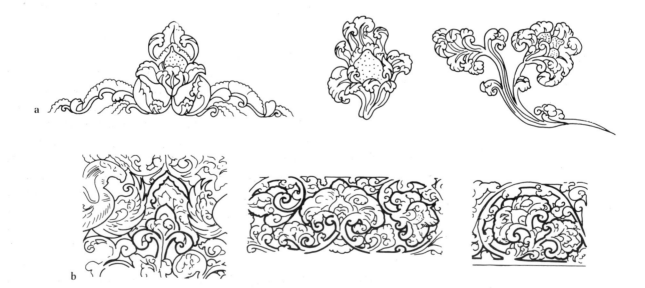

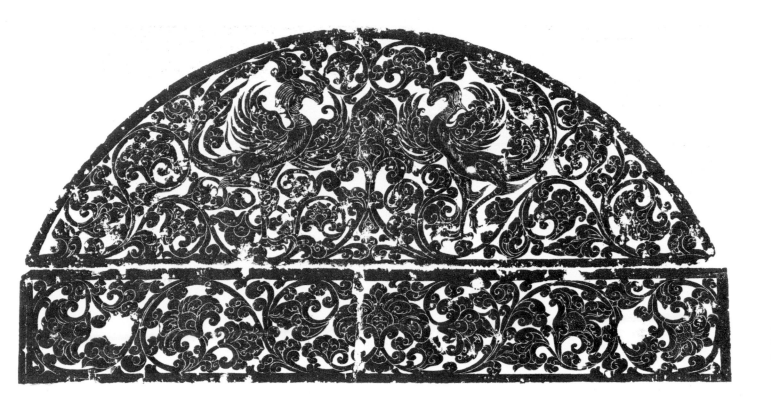

leaves and clouds. Indeed, the wind-swept impression of many Chinese flower patterns is probably due to borrowings from ancient cloud decoration.

In the lower three examples in figure 52 from the lintel in the tomb of Yang Zhiyi, the basic shape is provided by a flower in which a lobed head is surrounded by a pair of petals or leaves (it appears between the wings of the two phoenixes). Here the inner lobed head and its supporting volutes are very conspicuous. This underlying framework is disguised in the next two examples in which the lobed head is replaced by the central section of the flower, and the pointed outline of the pair of petals or leaves is replaced by a fuller circle of petals. The design on the Yang Zhiyi panel is quite elaborate, and numerous subordinate flower heads and leaves appear alongside the main flowers (fig. 53). Again the same basic units have been skilfully reused to suggest real flowers and leaves.

The eighth century was the heyday of these luxurious flower designs.[14] A border on the cover of the epitaph tablet of Cui Youfu (721–80), on which vast funds must have been expended, illustrates one of the most splendid examples (fig. 54). Four sloping sides on this exceptionally large epitaph cover are filled with compositions centred on large single peonies. From beneath these flowers, two stems rise up into the top corners supporting blooms turned away from the viewer. In the lower corners, two further flowers in profile are drawn out to fill the sharp angles of the frame. Spare space either side of the central head is occupied by small buds. As ever, this composition is based upon undulating stems of half-palmette scrolls, here arranged about a central point. The artist has made excellent use of this underlying scheme and the forms he has inherited. Petals and leaves, twisting and writhing like clouds, fill the space and deceive us into accepting the ornament as based upon a real peony plant.[15]

The transformation of the age-old palmette stems and lobed heads into

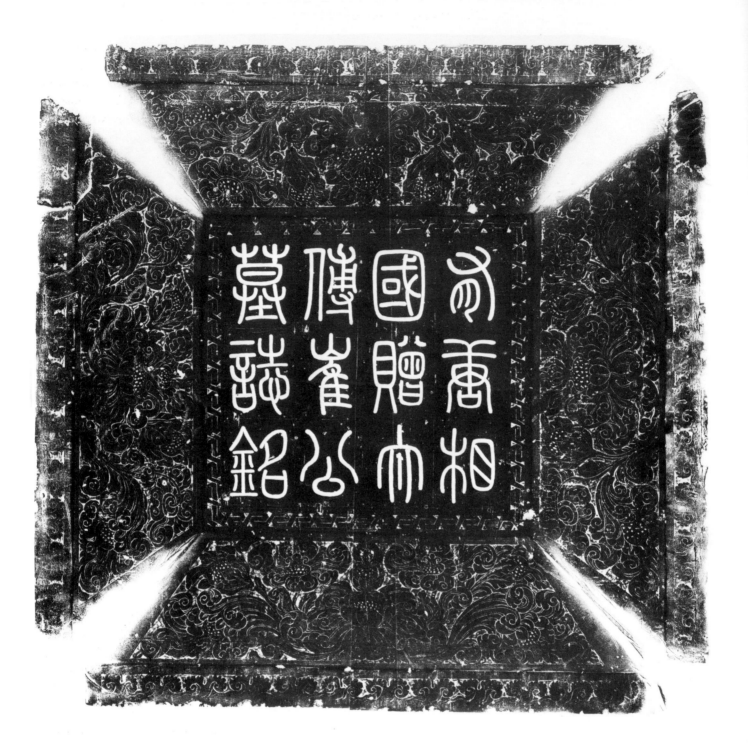

Fig. 54 Rubbing of peony scrolls on the epitaph tablet for Cui Youfu (721–80), Tang dynasty. British Museum.

convincing peonies was something of a *volte face*. If indeterminate designs had been satisfying for so long, why were they now altered so effectively to suggest real flowers? And why was the peony favoured over the lotus? The answer seems to be that in the second half of the seventh and early eighth centuries the peony came suddenly into fashion. Li Shutong has discussed this fashion in Tang society in some detail, dating its earliest manifestations to the activities of the Emperor Gaozong (650–84) and his notorious consort Wu Zetian, who after the death of her husband disposed of other claimants to the throne, seized power and ruled in her own right (685–704). Not only did she command the cultivation of peonies in her palaces, both at the capital Chang'an and at

Luoyang, but it is argued that her period of dominance also saw the introduction of a new name for the plant, *mudan*, which it bears to this day. Imperial enthusiasm for the plant was followed by a mania for cultivating peonies that swept through the ranks of high and low officials. The starting-point of this wider enthusiasm is dated by Li Shutong to an occasion when Gaozong presented peonies to members of his court at a banquet, as recorded by a later writer.[16]

As the officials sought out the precious plants necessary to advance their position, the cost of peonies rose dramatically. Farmers could give up growing grain and cultivate the peony with great profit. In one of his *xin yuefu*, bitter satires on the malpractices of government, the famous Tang poet, Bo Juyi (772–846), drew attention to the havoc the craze for peonies had wrought. In his poem the description of the flowers can be interpreted as a simile for a parade of beautiful girls. Indeed, some of the popularity of the flower may be attributed not just to the wealth that its possession implied but to the sexual overtones that accompanied references to it.

Although the decoration of tablets and caves with flower scrolls will not be pursued further, it should be mentioned that despite political disruption and many changes of dynasty peony scrolls continued as favourite subjects among the successors of the Tang. The flowers were not, however, necessarily rendered with greater accuracy. Indeed, borders from the eleventh-century epitaph tablets, found in tombs of the rulers of the Khitan Liao dynasty, provide examples in which peony flowers are displayed without regard to the true appearance of the plant. Tiers of petals are drawn out from the main blooms, and strangely convoluted leaves wind along the stems (fig. 55).[17] In the succeeding centuries, peonies and also lotus scrolls remained essential elements in architectural decoration. Like the Western acanthus scroll, invented and developed for the embellishment of buildings, these flower patterns, among the most enduring of all Chinese ornaments, were first developed for and most persistently used on architecture.[18]

Silver, lacquer and ceramics

There was a delay of many centuries between the introduction to China of foliage designs from the West to decorate Buddhist monuments and their exploitation on utensils of daily use, particularly ceramics. For example, elaborate floral decoration on Tang Buddhist and funerary architecture was not paralleled by similar ornament on ceramics of the same date. Only a few

Fig. 55 Peony design from the Liao imperial tombs at the Qingling, Barin, Liaoning province, Liao dynasty, 11th century. After Tamura and Kobayashi 1953, fig. 219:1.

pieces of white- or green-glazed ceramics of the pre-Tang and Tang periods are decorated with half-palmette designs. Not until the tenth and eleventh centuries were flower patterns widely exploited on the porcelains with which they were later intimately associated.

The only exceptions are a few scrolls and half-palmettes used alongside ornament of lotus petals carved on ceramics. With the inception of Buddhism outlines of lotus petals were readily employed on dishes and flasks. Furthermore, Central Asian pottery, decorated with appliqués of figures and palmettes, seems to have inspired one of the most florid of Chinese ceramic styles.[19] Large stoneware jars, with green glaze, are covered with small appliqués, reproducing elements of the carved ornament in the Buddhist caves. Thus a wine jar in the Ashmolean Museum is enlivened with several tiers of large tongues imitating single units from petalled borders at Yungang (fig. 56). Presumably these tongues are meant to suggest a lotus flower. Small beaded roundels, from which a palmette is suspended, hang between the largest segments. Around the neck, just above four loop handles, pseudo-lotus flowers are set; these mimic flowers in which two palmette leaves enclosing a small head represent a lotus. In fact, appliqué decoration had only a limited life. During the early Tang period, earthenware vessels, intended for burial, were also decorated with appliqués of figures, animals and floral rosettes,[20] but this industry declined after the rebellion of Anlushan in AD 755, and no further attempts seem to have been made to exploit ceramics modelled on this Western decorative style.

Apart from the demands of Buddhism, there were no compelling reasons why decorative motifs borrowed from the West to embellish Buddhist caves should be adopted by potters. Indeed, ceramics continued for several more centuries to be relatively untouched by the revolution in ornament wrought in architecture. Textiles were, however, another matter: fine woven and printed silks from China were highly prized in the West and were, in consequence, often decorated with motifs of Western origin, presumably pleasing to Central Asian and Western customers. A few of these textiles incorporated scrolling patterns already used on architecture. However, the design of textile decoration within the constraints of setting up a warp seems to have determined a preference of repeating roundels rather than for long horizontal or vertical scrolls. Thus few of the early palmette, lotus or peony designs are

Fig. 57 Silver cup, Tang dynasty, late 7th–early 8th centuries. H. 5.1 cm. Victoria and Albert Museum.

Fig. 56 Green-glazed jar, from north China, Northern Qi dynasty, 6th century. H. 50.5 cm. Ashmolean Museum. The foot is restored.

found on early textiles, although lotus rosettes and related motifs were certainly popular.[21]

Animal designs employed in architecture were also used on textiles, but lobed frames, with which they came to be associated on furniture, boxes and vessels, were not much used on woven or even printed textiles, although they may have appeared in some embroidery. It appears, therefore, that we cannot look to textiles as the principal intermediary between the ornament initiated for the decoration of architecture and the widespread use of a similar repertory on ceramics of the Song, Yuan, and Ming periods. The link between the ornament of buildings and of the decorative arts is provided by silver.

The vogue for silver vessels in the late seventh and early eighth centuries was something entirely new in Chinese history. Silver had, however, always been highly regarded in the Mediterranean area and Iran. In the fifth century, when some Central Asian and Near Eastern habits were influential, a few foreign silver and gilt-bronze vessels had been imported; a cup decorated with a vine scroll is illustrated in Chapter 1 (fig. 15).[22] Although some of these Western vessel shapes were copied in ceramics, a silverworking industry was not inspired by these pieces. Contact with Central Asia and Iran assumed a new importance in the early Tang period, when Chinese control of the Tarim Basin was reasserted, and the court eagerly imported Western luxuries and adopted Western fashions. Central Asian music and dancing girls, exotic fruits, precious stones, Syrian glass and Iranian silver were all sought out. Some of these rare and often delicate items are still preserved in the Shōsōin, the treasury of the Todaiji Temple at Nara in Japan. Much of the contents of the Shōsōin can be dated from inventories to the eighth, ninth and tenth centuries, and this corpus presents many pieces helpful to discussion, particularly furniture and containers in wood and lacquer, materials which have otherwise perished.[23]

Imported silver does not seem to have satisfied the demand, and the Chinese started to make silver cups, bowls and platters themselves. As silver and gold had been relatively little used in earlier centuries, there was no well-developed silverworking industry, with its own established traditions. Vessel shapes from territories to the west of China were copied to provide the forms for cups, bowls, dishes and ewers.[24] The sources of decoration were more varied: fine hunting scenes amid rocky landscapes were plucked from Chinese painting, lacquer design and tomb ornament, while bold animals in repoussé (see Chapter 3) emulated a Western fashion. In addition, as a small cup in the Victoria and Albert Museum illustrates (fig. 57), flower scrolls with blooms in the shape of lobed heads were borrowed from designs carved in stone in the late seventh and early eighth centuries.[25]

Silverworkers borrowed architectural ornament not merely because the inception of a new craft gave them freedom to choose their own designs but also because metalworkers were already reproducing the flower scrolls developed to decorate stone. The two crafts seem to have come together in the manufacture of Buddhist implements, especially reliquaries. Precious relics were frequently contained in small glass bottles, held within metal caskets; the most precious were made in gold, less sumptuous examples of gilt-bronze. These metal boxes were often preserved in a stone casket. Not surprisingly, stone caskets were decorated with leaf and flower scrolls similar to those used in Buddhist caves and on funerary monuments. Indeed, they may have been made by the same stonemasons. The inner containers in metal were decorated

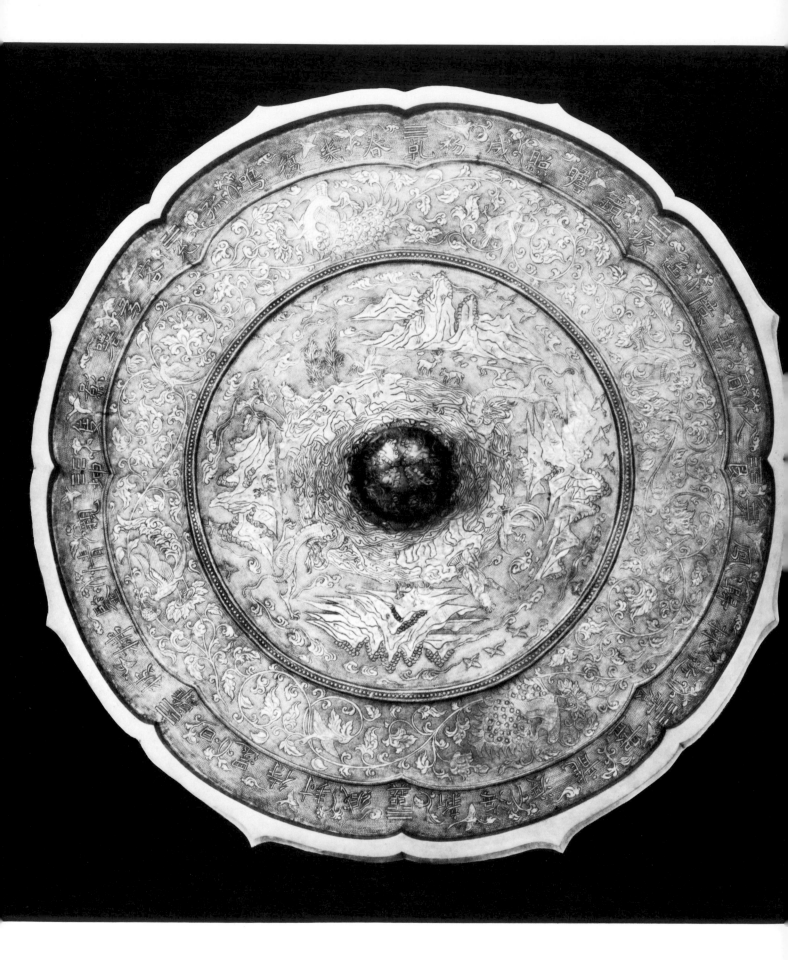

Fig. 59 Leather box painted in silver and gold,
Tang period, but possibly made in Japan,
8th–9th centuries. W. 19.6 cm. Shōsōin, Nara,
Japan.

to match the outer ones. Thus a stone casket from Jingchuan Xian in Gansu province, whose borders were discussed and illustrated above (fig. 51b), contained a small gilt-bronze box covered in similar running foliage scrolls.[26] In this way ornament was transferred from stonework to metal. Several similar reliquaries have been found, which, like the example from Jingchuan, share the repertory of designs developed in Buddhist caves.

As can be seen both from the casket from Jingchuan and a small cup in the Victoria and Albert Museum, flower scrolls became established on silver before the elaborate flowers of the first half of the eighth century were properly worked out. Many pieces of silver are decorated with running scrolls that enclose small lobed heads rather than with more explicit flowers. It may perhaps be assumed that much, though perhaps not all of this silver, was made in the late seventh century, during the reigns of Gaozong and Wu Zetian. If this is the case, the fashion for peonies, mentioned above, may also have contributed to the silversmiths' interest in a flower scroll, even though the flower designs available were not as yet very explicit.

A few pieces of silver, including a mirror back in the Shōsōin, show the more complicated flowers developed in the early eighth century (fig. 58). On this mirror flower heads and leaves resemble the ornament of the lintel from the tomb of Yang Zhiyi (fig. 53). Only a few pieces of surviving silver are decorated with such complex flower scrolls, and it seems that ornament consisting of sprays of flowers rather than scrolls came to be preferred by silversmiths in the later part of the eighth century (fig. 102). In the ninth and tenth centuries more confused scrolling patterns were also used (fig. 83).[27]

Fig. 58 Silver-backed mirror, Tang dynasty, 8th century. Diam. 40.7 cm. Shōsōin, Nara, Japan.

79

The elegant ornament of the Shōsōin mirror and similar pieces was, however, to leave a lasting imprint on decoration – first of lacquer and then of ceramics; for silver, a costly commodity, seems to have been widely copied in cheaper materials. Silverwork and lacquer production were particularly closely related. Lacquer is often coloured a dark brown, and silver inlay could be set into this dark base to provide contrasting ornament. Both broad sheets of silver and fine wire inlay are found on lacquer boxes of the Tang period preserved in the Shōsōin.[28] A lobed box (fig. 112), made to hold a mirror, is decorated with rosettes, first found in Buddhist contexts representing lotuses and then transferred to silverware. The delicate work on the Shōsōin box reproduces almost exactly the fine tracery on silver dishes.

It was both less expensive and less time-consuming to paint rather than inlay the design. A small octagonal box, also in the Shōsōin, but possibly of Japanese rather than Chinese manufacture, has a painted copy of a Chinese silver design (fig. 59). Pairs of birds (perched on a lotus flower at the centre of the box) are found on several pieces of Tang silver, and flowers encircling the main bloom are based on the arcaded design seen on some Tang mirrors. The fine stippling, set as a background to the birds and flowers, is the clearest indication of the silver origin of the whole composition. Such fine dotting is a translation of ring-punching, used on many pieces of silver to distinguish flower scrolls from their background. On silver a simple flower scroll chased in fine lines against a plain background would be in danger of being lost – there would be no difference of texture to separate the smooth petals and leaves from the undecorated surface of the cup. Fine ring-punching made the difference explicit. On lacquer dotting was not necessary to distinguish the motif from the ground; colour alone gave the necessary clarity. Indeed, dotting, if anything, confused the design.

Fig. 60 Lead-glazed pillow decorated with a half-palmette scroll against a stippled ground imitating silver, Tang dynasty, 8th–9th centuries. L. 16.8 cm. British Museum.

In the following centuries further techniques were developed to decorate lacquer with silver and more importantly gold. In the *qiangjin* technique gold is applied to a surface in which the design is incised. Precious metal trapped within incised lines catches the light at angles and produces gleaming decoration. Even with the invention of the *qiangjin* technique, possibly in the Song period, dotting to suggest ring-punching was still occasionally used, as on a group of lacquer boxes excavated at Wujin in Jiangsu province. References to ornament first established in silver thus lingered for several centuries in the decoration of lacquer.[29]

Potters adopted silver designs in several stages. During the Tang period, the largest production of copies of silver is found in lead-glazed earthenwares intended for burial. These pieces were cheap substitutes for items in precious metals. Generally only the vessel shapes and not their designs were fully reproduced. However, a number of lead-glazed pieces do copy the stippled backgrounds appropriate to silver decoration. Such stippling occurs on a small pillow in the British Museum, and provides a background for a tracery of scrolling based upon the lobed leaf forms of the half-palmette (fig. 60).

A similar imprint of silver shapes and decoration is found in the lead-glazed burial wares of the Liao (907–1125), who ruled over part of northern China after the decline of centralised Chinese control. Stonewares made in Hebei and Henan provinces in north China continued the bold decorative traditions established by the Liao and are given the general name of Cizhou wares; among them is found a large category, made in the early Song period, with decoration of flowers and other motifs against a ring-punched ground borrowed from silver. A floral scroll on a Cizhou jar in the British Museum (fig. 61) is one of these direct imitations of silver ornament.

Within this scroll, two flowers in profile should be considered first. These flower heads are built up of a pair of commas supporting lobed heads – the sort of flower seen on the epitaph tablet cover for Wang Gan (fig. 51a); three large petals, similar to the central lobed head, have subsequently been added to this foundation, following a formula seen on some Tang silver. The potter next may have decided that this flower, worked out in profile, might be seen from the front, and thus devised a new view of the flower, by describing an oval centre surrounded by petals similar to those used on the profile head. All the petals have small arcs punched along the edge, a device borrowed from metalworking. Pointed leaves attached to the stems were also taken from silverwork, such as the ornament on the cup in the Victoria and Albert Museum (fig. 57). Together with the flower heads, these leaves refer back to designs first worked out in stone.

It has been suggested that flower patterns on such highly decorated

Fig. 61 Flower scroll from a vase of Cizhou type, showing lobed flower heads against a ring-punched ground imitating silver, Northern Song period, 11th–12th centuries. British Museum.

stonewares made in north China contributed directly to the development of the flower scrolls on Yuan dynasty porcelains painted in underglaze blue, the most influential of all Chinese ceramic types. Some authorities have even gone so far as to argue that the burst of activity that gave rise to the beautifully decorated porcelains of the fourteenth century was stimulated by the migration southwards of potters from northern kilns to work at the great porcelain kilns established at Jingdezhen in Jiangxi province.[30] However, a comparison between the rather rough flower patterns on Cizhou ceramics (fig. 62a) with the fine detail achieved in the peony scrolls on Yuan porcelains (fig. 62b) demonstrates the weakness of the argument. The flower scrolls on the Cizhou stonewares are inadequately calculated and coarsely executed, while the decoration of Yuan porcelains is carefully arranged to fit the given space; details of the flowers and leaves in the two examples illustrated also differ considerably.

The sources of the ornament on Yuan porcelains cannot, therefore, be directly traced to bold northern designs, descended from silverware decoration of the Tang period. Instead, a parallel ceramic tradition of fine white high-fired wares and related green-glazed wares must be considered. The influence of silver on these wares, which can be given the general name of porcelains, is as strong or stronger than the influence of precious metal on burial wares and Cizhou stonewares. As with the burial wares, the model provided by silverware is first seen in the vessel shapes employed. Northern whitewares of the Tang and Liao periods, southern Yue-type wares, together with a few remarkable white porcelains from tombs in Zhejiang province, all show the imprint of metal shapes: bowls with folded rims or lobed and bracketed outlines copy shapes first seen in silver, as do tall ewers with narrow spouts, stepped handles and neatly fitting lids.[31]

The history of the whitewares of the Northern Song period (960–1127), and the period of divided rule, when the north was controlled by the foreign Jin dynasty (1115–1234) and the south remained under control of the Song, now known as the Southern Song period (1127–1279), is dominated by two main porcelain types, Ding ware from Hebei province and southern porcelains with a bluish glaze, known as *qingbai* or *yingqing* glaze. These southern porcelains were made at Jingdezhen, the great kilns in Jiangxi province, where the porcelains decorated with underglaze blue were manufactured from the fourteenth century. Early Song Ding ware continued the traditions already established by the Tang and Liao. In addition, stimulus was provided by the manufacture of items for Buddhist ritual which were often based on metal forms, generally in gilt-bronze. Court patronage of the Ding kilns probably reinforced the continued imitation of vessels in more sumptuous materials. Feng Xianming has pointed out that the *Wu-Yue lueshi* (outline of Wu-Yue history) records that 'the king went to pay his respects at the Zongde Dian and offered up 2,000 pieces of Ding ware decorated with gold'.[32] Some white Ding porcelains must, therefore, have been gilded, in direct imitation of a technique widely used on silver to bring motifs into prominence, seen, for example, on a silver dish illustrated in Chapter 3 (fig. 102).

Ding ware shows a renewed influence from silverware under the foreign Jin dynasty.[33] From the twelfth century, Ding wares were increasingly made in metal shapes, especially as shallow dishes with flat rims; at the same time they were decorated with very intricate designs, which paralleled the decoration of silver and related lacquer pieces. It was at this stage that ceramic decoration

Fig. 62 Flower scrolls on a Cizhou stoneware compared with flowers on a 14th-century porcelain from Jingdezhen, Jiangxi province:

a scroll on a Cizhou wine flask, Northern Song period, 11th–12th centuries. British Museum.

b peony scroll painted on porcelain in underglaze blue, Yuan dynasty, 14th century. British Museum.

first attained the detail and fluent lines that characterised the earlier decoration on stone and silver.[34] This new use of designs, long known in other materials, itself implies that potters must have found renewed inspiration in models offered by silver and lacquer. A peony scroll on a small Ding ware dish in the British Museum (fig. 64a) and a moulded scroll on a bowl in the Victoria and Albert Museum (fig. 63) show the impact of this increasingly detailed decorative style. On both pieces the peony heads are large and heavy. Importantly, both examples illustrated have long pointed leaves that are directly descended from the patterns worked out in stone and silver (see p. 85). Such idiosyncratically shaped leaves could not have been developed independently of the main tradition already described.

Before turning to the development of the leaves, it is necessary to mention the production of the southern porcelain kilns at Jingdezhen. In the Northern

Fig. 63 Porcelain bowl decorated with peonies, Ding ware, Jin dynasty, 12th–13th centuries. Diam. 20.6 cm. Victoria and Albert Museum.

Song period this area, remote from coast and court, supported a porcelain industry that developed only slowly. Porcelains made here from the tenth century show the same evidence of influence from metal prototypes, including rolled lips on bowls, foliate and lobed shapes for cups and ewers, and high foot rims on several vessel types. The flight of the Song court southwards to establish its capital at Hangzhou, as the Jin took over the north, gave the kilns a great boost. The Ding kilns were now out of reach of the Song court, and fine ceramics made at Jingdezhen increased in number. In parallel with Ding production, some pieces were made with flat rims borrowed from silver examples, and decoration of great complexity was developed. The themes of this ornament, like that of Ding ware, assumed the repertory first used on silver

Fig. 64 Peony designs on a Ding ware dish and sherd with *yingqing* glaze from Hutian, Jingdezhen, Jiangxi province

a decoration of a Ding ware dish, Northern Song or Jin dynasties, 12th century. Diam. 24.2 cm. British Museum.

b design on a sherd from Hutian, 13th century. After Liu Xinyuan 1983, fig. 6.

Fig. 65 Drawings to illustrate the development of pointed leaves on flower scrolls, culminating in the leaves on lotus scrolls on Yuan and Ming dynasty porcelains:

a border, Tang dynasty, 653 (see fig. 46c).

b leaves on a reliquary from Jingchuan, Tang dynasty, 7th–8th centuries (see fig. 51b).

c leaves and flowers on a lunette from the tomb of Yang Zhiyi, Tang dynasty, 736 (see fig. 53).

d leaves on a phoenix-headed ewer from south China, Song dynasty, possibly 11th–12th centuries. British Museum.

e leaves on a Ding ware dish, Northern Song or Jin dynasties, 12th century (fig. 64a).

f leaves on a porcelain dish, Yuan dynasty, 14th century (fig. 98).

g leaves on a porcelain flask, Ming dynasty, early 15th century. British Museum.

and lacquer. As on Ding ware, borrowings from silver are particularly evident in the use of fine stippling as background to foliate scrolls. Such references to silverwork are prominent not only in the early production at Jingdezhen but also on wares of the thirteenth century.[35]

Recent excavations at Hutian, one of the principal kilns at Jingdezhen, have revealed exceptionally fine designs. Such ornament anticipates some of the qualities of the underglaze-blue painting under the subsequent Mongol dynasty, the Yuan. Here mention must be made of advances in peony ornament, which paved the way for the peony designs found on Yuan dynasty porcelains already illustrated (fig. 62b). In figure 64 a peony design on a Ding ware dish of the late twelfth century is set above a peony spray on a rather later fragment excavated at Hutian. An important difference between the two designs is seen in the shapes of the leaves: those of the peony on the Ding pieces are long, pointed and curled; those on the Jindezhen fragment are both more substantial and realistic. This change was an essential preliminary to the drawing of the short jagged leaves on a design on the Yuan dynasty jar (fig. 62b). The sources of the leaf form on the Ding ware pieces are found in the combination of cloud forms seen on the tablet of 653 (fig. 46c) and palmette outlines current in the seventh century (fig. 51a). Figure 65 sets out the development of this influential shape, with which the leaves on the Hutian sherd and the Yuan dynasty jar must be contrasted.

The series starts with part of the leaf pattern from the border of the tablets engraved with the Tripitika, dated 653. Here the half-palmette has been varied by the addition of details from cloud patterns, perhaps inspired by the vigorous borders used in Gupta India (fig. 65a). The next detail is taken from

one of the borders on the casket from Jingchuan (fig. 65b). Leaves in this border have been constructed using the small foliate heads seen, for example, in the borders on the bases from Sima Jinlong's tomb (fig. 42) and on Wang Gan's epitaph tablet cover (fig. 51a). The leaves therefore rise out of a pair of commas and are then bent back on themselves, curling after the fashion of the leaves on the tablets of 653 (fig. 65a). Such leaves are mingled with peony flowers in the ornament of the lintel from Yang Zhiyi's tomb; one example lies along the bottom edge of the detail shown (fig. 65c). Similar leaves occur on silver (figs 57, 58) and were then transferred to ceramics. Details in figures 65d and 65e are taken from a southern porcelain in the British Museum[36] and from the Ding ware dish shown in full in figure 64a. Thereafter the leaf was no longer used for peonies. The next two examples (figs 65f, g) are drawn from fourteenth- and fifteenth-century lotus scrolls, for the pointed leaf, sprouting from two commas, continued to be employed in lotus scrolls. Indeed, similar leaves are seen in lotus patterns on many fourteenth-century dishes decorated with animals (see fig. 98), and in the lotus scroll on a basin made about 1400 (fig. 66). Thus a leaf first established for peony scrolls survived, albeit very inappropriately, for lotus scrolls (pl. 4).

Why was the pointed leaf no longer used for peonies, and where did the potters at Hutian find new forms to exploit? The answers to these questions are to be found in inlay work in different materials. For example, quite broad leaves are found in gilded overlays on a silver bowl illustrated in Chapter 3 (fig. 102). It can be shown that such ornament was based upon flower patterns executed in an inlay of shell, set in lacquer or wood. Because the designs had to be cut out of the shell, narrow lines and pointed leaves were avoided, giving rise to the development of flower sprays with large flower heads and broad leaves.[37] Very few examples of such shell inlay survive. However, a number of pieces in the Shōsōin, including mirrors, boxes and musical instruments, demonstrate that this technique was widely used. In addition, a sutra box, similarly decorated, has been excavated at the Ruiguang pagoda at Suzhou in Jiangsu province, dating to the period between 931 and 1017, suggesting that such work continued well into the Song period and was particularly associated with south-east China, within reach of Jingdezhen.[38] It is therefore possible that new canons of flower design were established by inlay in lacquer and that they provided examples of flowers with fairly realistic leaves which were known to and inspired the Jingdezhen potters.[39]

The carefully planned scroll on a Yuan dynasty jar in the British Museum is based on a complex tradition (fig. 62b): the potters had inherited a vocabulary of ornament built up over nearly 1,000 years. Undulating scrolls borrowed from the West contributed a framework that remained popular on the Yuan porcelains. The first flowers, consisting of lobed heads, were put together from parts of Western half-palmettes. While peonies and lotuses flourished in the gardens of China, they were not generally observed by the craftsmen, who continued to use particular formulae learned from their predecessors. Only when fashion, religion, or the demands of new techniques required new forms were these limiting conventions altered. In response to a fashion for peonies initiated by Wu Zetian, foliate heads were made into peonies. However, the flower patterns retained their palmette-shaped leaves, which lingered in the peony and lotus scrolls used on Tang silver and on later Liao, Song and Jin ceramics. This persistent detail confirms that all these flower patterns belong to a single tradition, and that neither the silverworkers nor the potters took a

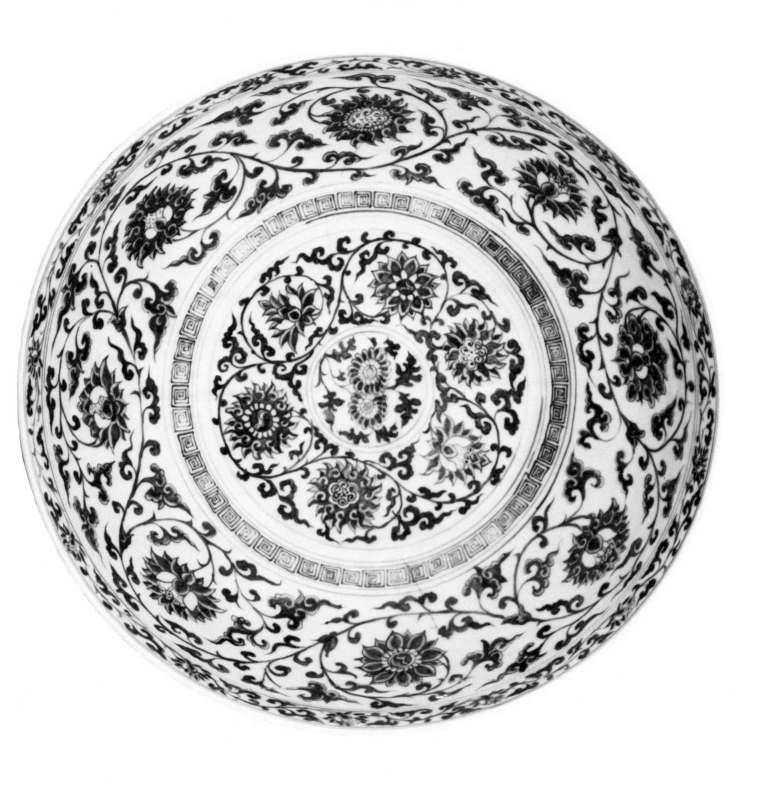

Fig. 66 Lotus scrolls on the inside of a large porcelain bowl. Ming dynasty. *c.* 1400. British Museum. For the whole bowl see plate 3.

fresh look at real flowers. In the later Song period, more realistic leaves were added to peony sprays and scrolls, possibly borrowing a feature of ornament worked out in inlay. However, no single prototype for the flower scrolls on the Yuan porcelain is available – these flower patterns appear to be the product of a number of different strands of development.

This early history of flower scrolls in China offers examples of several developments that have an application to Chinese ornament other than flower patterns. First, the sequence of designs illustrated demonstrates that craftsmen were more likely to exploit forms inherited from their predecessors than to search out new motifs. In particular, they were unlikely to devise ornament based directly on representations from life. However, social or religious demands might cause them to make radical changes to their existing repertory; when the peony came into fashion, palmette shapes were altered to make semi-realistic flowers, but they remained attached to the scrolling stems derived from the half-palmette; they were not initially drawn as real plants growing in the ground or placed in a vase.

The second point is the strong bond between flower ornament and architecture, and consequently the slow stages by which such ornament was borrowed for the embellishment of other materials, particularly secular utensils in metal and ceramics. Elaborate flower ornament in Tang dynasty tombs, for example, is not matched by a parallel series of designs on Chinese ceramics. Indeed, although a few pieces of ceramics copy details of ornament from stone or tilework, a considerable gulf seems to have existed between architecture and ceramics. The first step towards the decoration of secular utensils with the repertory of design used on stone and wood seems to have been initiated with the decoration of gold and silver. Thereafter adoption of these designs for the decoration of other materials can be described in terms of the manufacture of substitutes for precious items; in the Tang dynasty gold and silver seem to have been at the top of the hierarchy.[40] In the centuries that followed shortages of silver may have contributed to the copying of silver in lacquer and ceramics. It is noticeable that many twelfth- and thirteenth-century porcelains reproduce both the shapes and ornament of silver and that Ding ware offers the fullest range of such examples.

A description of the subsequent stages in the development of the repertory of ornament, particularly on ceramics, must take account both of the continuing importance of silver and lacquer and the destruction of the northern capital. The flight south to Hangzhou had left the Ding kilns inaccessible to the Song court, and thus, in parallel with the Ding production, porcelains were made in Jiangxi province at Jingdezhen. The large porcelains of the Yuan dynasty continued this tradition, and their designs in underglaze blue were also influenced by lacquer decoration (see Chapter 3). This account of a hierarchy of materials can be taken further by describing the manufacture of European pottery and porcelain decorated with Chinese designs as a late stage in a sequence in which copies of expensive items were produced in cheaper materials.

In Chapters 3 and 4 similar developments are pertinent. Ornaments of birds and animals were first employed in architecture and only in the Tang period were borrowed for the decoration of cups and bowls. Likewise frames and panels were first invented in cave and temple design and were taken several centuries later to embellish furniture, silver, lacquer and ceramics.

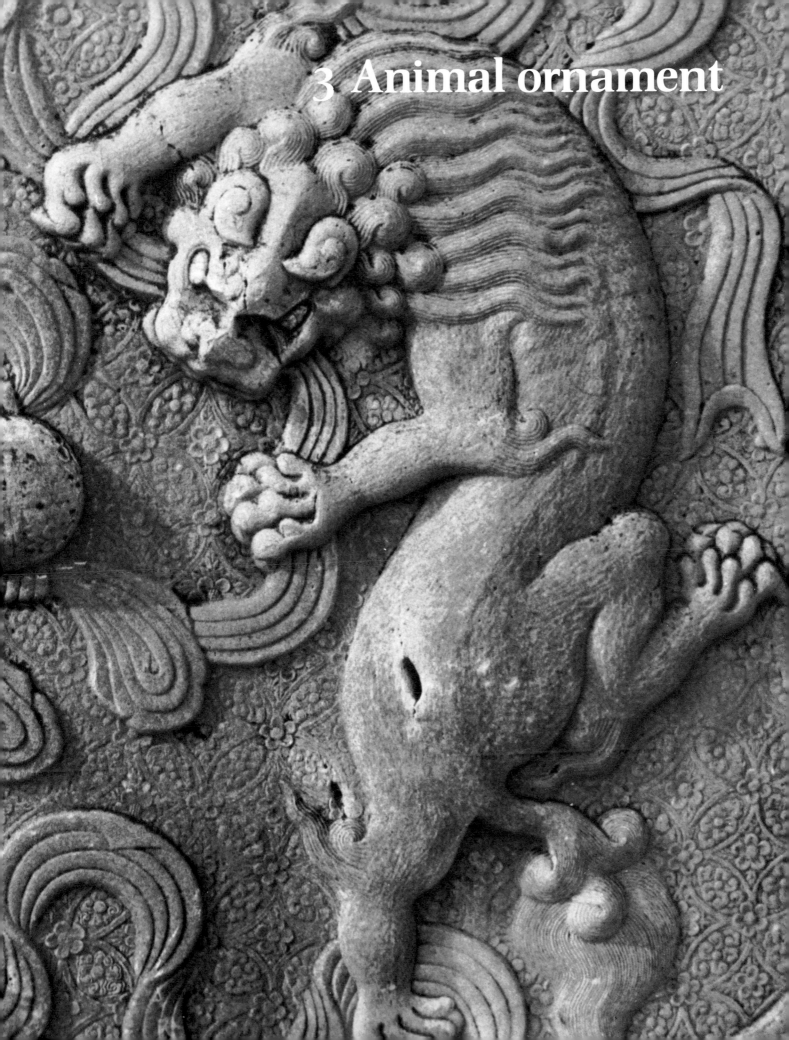

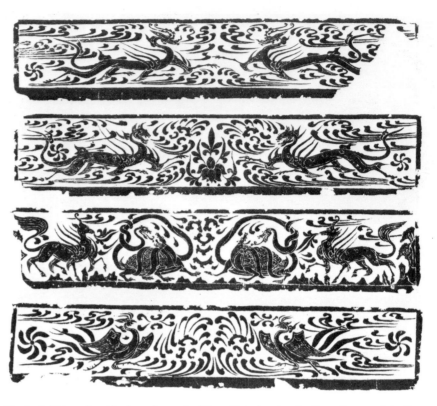

Fig. 67 Rubbing of a tablet from the tomb of Yuan Hui, showing the Green Dragon of the East, the White Tiger of the West, the Black Warrior of the North (the tortoise and snake), alongside a deer, possibly the *tian lu*, and the Red Bird of the South, Northern Wei dynasty, 520. Beilin, Shaanxi Provincial Museum. After Xi'an 1953, fig. 32.

First in architecture and later on silver and ceramics, animals were inserted among flower scrolls as, for example, on the lintel from the tomb of Yang Zhiyi, which displays two phoenixes amid peonies (fig. 53). More ordinary birds are set within medallions surrounded by flowers on Chinese porcelains and European imitations, discussed in the Introduction (figs 2–5).

Five creatures were used to the exclusion of almost all others: dragons, birds (especially the phoenix), deer, lions and fish. Their separate origins will be reviewed in detail below. Ornament of lions and fish owed their currency to associations with Buddhism, whereas the other three creatures had a much longer history in China. Here it is appropriate to mention the Han beliefs that brought the first three creatures into special prominence and ensured that they were often used together.

Fig. 68 Deer on the end of the coffin of the wife of the Marquis of Dai, found at Changsha, Hunan province, Han dynasty, 2nd century BC (see also fig. 45). After Beijing 1973, fig. 23.

Two slightly separate groups of four creatures are mentioned in texts and occur in decoration on coffins and tombs (fig. 67) of the early Han period (206 BC–220 AD). The first group of four are called the *si ling* and comprise the dragon, tiger, phoenix and deer; they are illustrated on the inner coffin of the wife of the Marquis of Dai (d. 186 BC). Two deer occupy one end (fig. 68), while the other creatures are seen on the long side where two dragons are enmeshed with a tiger and a phoenix (fig. 45). While these creatures continued to be venerated throughout the Han period and in later centuries, a new set became important, especially during the reign of the Emperor Wudi (140–87 BC). These were the animals of the four directions, known as the *si shen*: the Green Dragon of the East, the White Tiger of the West, the Red Bird of the South, and

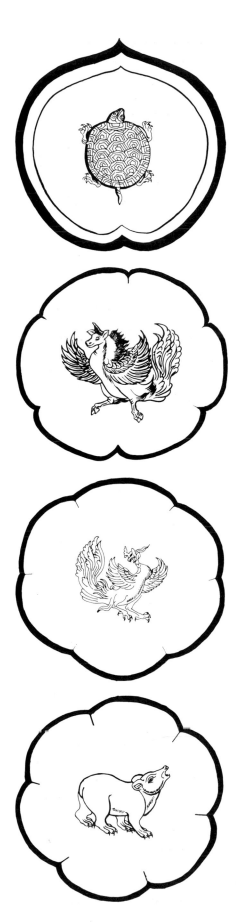

the tortoise, entwined with a snake, known as the Black Warrior of the North (fig. 67).[1]

The notion of gods of the four directions had a long history in China. Such deities are mentioned in the Shang oracle bones. They were not, it seems, at that date associated with a creature. Indeed, the deities of the directions and the animals symbolising the four quarters may have remained relatively separate concepts throughout Chinese history. The first signs of the notion of animals associated with directions are suggested in a mirror of the seventh century BC, from a cemetery at Shangcunling in Henan province, decorated with two tigers, a stag and a bird. Because mirrors were often used to represent the cosmos, such ornament may indicate a system in which these creatures symbolised parts of the heaven. A recent find of a casket, dating to the second half of the fifth century BC, is more explicit. It is painted in lacquer with a star map that includes a depiction of a tiger in the west and a dragon in the east. This map demonstrates that animal symbols for the directions were established long before the Han period.[2]

Animals next appear among the symbols set out by the philosophical school known as *Yin yang wu xing*. *Yin* and *yang* were regarded as the principal forces in the universe: *yin* is found in darkness, water and the moon, and is feminine; *yang* is contained in the sun, light and male energy. Harmony was achieved when *yin* and *yang* were in balance. The ideas behind this *yin yang* dualism were very ancient, but they were expounded by Zou Yan (*c*.305–240 BC) as part of a new systematic description of the world, and were also taken up by the great Confucian philosopher, Dong Zhongshu (*c*. 175–105 BC). The relationship between the universe and man's political history was explained in terms of five phases, associated with the *wu xing*, or five elements – earth, wood, metal, fire and water. Dynasties were represented by different elements and the five colours that matched them – yellow, green, white, red and black.

The Qin dynasty (221–206 BC), which preceded the Han, had followed this symbolic system and declared itself to be the dynasty of water and the colour black, assuming in this way the natural succession from the Zhou, matched by fire and the colour red. Water had quenched the fire. The Han, claiming to take over the authority of the Qin, had also adopted black as its colour. New cults were added to these ancient beliefs when, in 130 BC, the Han emperor Wudi had set up an altar to the Supreme Unity, Taiyi, at the capital Chang'an. Taiyi was assisted by five deities, representing the Sage Emperors, who were named by colour and thus corresponded to the elements and directions. Dissatisfied with the outcome of events, in 105/4 BC Wudi formally adopted the colour yellow and the element earth. Yellow stood for the centre, red for south, black for north, green for east and white for west. A correspondence with the elements, seasons, directions and their symbolic beasts was now generally recognised. Formal poems sung or recited at the ceremonies to Taiyi placed the creatures of the directions alongside Taiyi:

> The chariot of the divinity is made of clouds.
> It is drawn by winged dragons; innumerable are its feathered pennants.
> The divinity descends as though carried by chargers of the wind;
> to the left, the Green Dragon, to the right, the White Tiger.[3]

Inscriptions on contemporary mirrors give us a further glimpse of the role of

Fig. 69 Four dishes decorated with animals found at Hejiacun near Xi'an, Tang dynasty, 7th–8th centuries. After Beijing 1982a, p. 34.

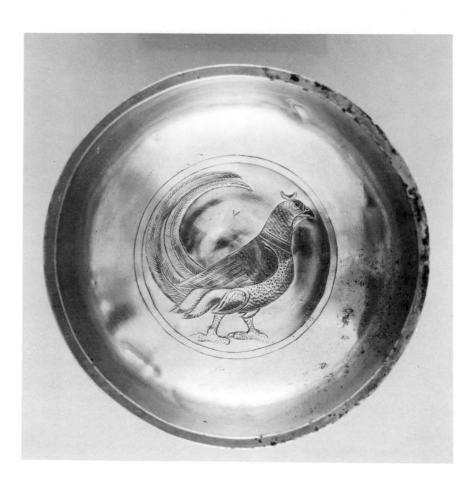

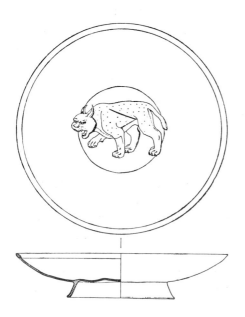

Fig. 70 Silver bowl decorated with a bird, Iran, Sasanian period or later, 4th–6th centuries AD. Diam. 16.9 cm. British Museum.

Fig. 71 Silver dish found at Lijiayingzi in the Aohan banner, Liaoning province, but possibly from eastern Iran or Central Asia, *c.* 6th–7th centuries. Diam. 18 cm. After *Kaogu* 1978.2, p. 118, fig. 3.

the four creatures in maintaining the harmony of the universe: 'The fine copper which the Xin dynasty possesses and which is drawn from Danyang has been mixed with (silver and tin) and the mirror is pure and bright The Dragon on the left and the Tiger on the right protect from harm; the Red Bird and the Black Warrior accord with *yin* and *yang.*'[4]

Tiles and bricks decorated with the animals of the directions have been found at the sites of Qin and Han dynasty palaces and tombs. Fittingly, some of the earliest large tomb bricks decorated with the creatures of the four directions have been found at the Maoling, the tomb of the Emperor Wudi.[5] Many other tombs of the first century BC illustrate the currency of the four animals in funerary architecture. Like the flower scrolls, early representations of the animals were closely tied to the ornament of buildings both above and below ground.

Not surprisingly, during the Han dynasty, these symbolic creatures were not employed as decoration on cups or bowls for daily use. Indeed, even in the succeeding period, animals were rarely, if ever, used to ornament vessels in either metal or ceramics. Thus animals shown in relief at the centre of a number of Tang silver dishes, found at Hejiacun near Xi'an, represent an entirely new departure (fig. 69).[6] This sudden appearance of fine bowls decorated with single creatures can only be explained as a new fashion imitating a Western practice. Prototypes for such dishes are found in Sasanian silver. For example, a fluted dish in the British Museum is decorated with a bird, neatly contained within the central roundel (fig. 70). We know that such

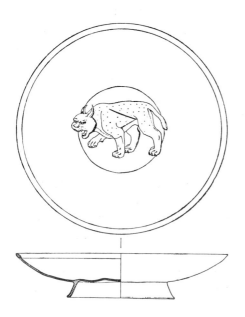

Fig. 72 Drawing illustrating the origins of the outline of the Chinese dragon:

a snake-dragon with bottle horns, from a Shang period *zun* found at Funan Xian, Anhui province, *c.* 14th century BC. After Akiyama 1968, fig. 43.

b jade dragon with bottle horns, from the tomb of Fu Hao, wife of the Shang king Wuding, 13th–12th centuries BC. W. 7 cm. After Beijing 1980a, col. pl. 27.

c inscription including the graph *long*, or dragon, from a Shang dynasty *zun*, 12th–11th centuries BC. Freer Gallery of Art.

d handle of a bronze *he*, in the shape of a dragon with bottle horns, Fufeng, Shaanxi province, Western Zhou period, 10th–9th centuries BC. After Beijing 1980b, fig. 108.

e handle in the shape of a dragon with a crest, Xinzheng, Henan province, Eastern Zhou period, 6th century BC. After Sun Haibo 1937, 2.108.

f handle in the shape of a dragon, Eastern Zhou period, 5th–4th centuries BC. British Museum.

g harness plaque in the shape of a tiger, Ordos Region, 2nd–1st centuries BC. British Museum.

Iranian bowls, or provincial versions of them, were exported to the Far East; a bowl decorated with a feline, a lion or tiger, excavated from a later context at Lijiayingzi in the Aohan banner in Liaoning province, appears to be a Central Asian or provincial Iranian vessel (fig. 71). Similar bowls probably inspired the decoration on the pieces found at Hejiacun. However, decoration of bold-relief animals did not accord particularly well with Chinese taste; vacant space seems to have demanded a filling, first with flowers and later with some hints of a landscape.[7]

These Tang silver dishes were the starting point for the use of animals, both with and without a background, to decorate eating vessels and containers. The principal animal motifs will be considered in turn and the influence of silver on both lacquer and ceramics will be explored.

Dragons

More than any other creature, the dragon is identified with China. Strange monsters decorate the earliest ritual vessels cast in bronze, during the early Shang period (*c.* 1400 BC), to hold food and wine offered as sacrifices to dead ancestors. Creatures shown in profile with prominent beaked heads are sometimes described by modern writers as dragons, but there is no way of knowing whether they were so recognised by the Shang. Indeed, such motifs may have been no more than decorative devices; they seem to have little identity outside bronze ornament. While birds and other animals, also used in the ornament of bronze vessels, appear separately as small discrete jade carvings, these beaked monsters do not seem to be found independently of the decorative schemes on bronze containers.

A creature with a long wriggling body marked with diamonds, a large head and pair of short rounded horns, used on later Shang bronzes, can be much more reliably called a dragon. This creature appears both among the ornament of bronze ritual vessels (fig. 72a) and on its own, represented in small jade carvings (fig. 72b). It can be identified as a dragon because its principal features are reproduced in the character for *long*, the Chinese word for dragon. The example illustrated is taken from a Shang dynasty bronze inscription; the dragon has a large head in profile crowned by a short horn, known as a bottle horn, and a long sinuous body (fig. 72c). In this inscription the character *gong* (to offer) is made up of a dragon held by two pronged elements which indicate hands. To the right is the character *zi* (son). In earlier graphs incised on bones used for divination, known as oracle bones, the dragon often appears by itself.[8]

While a monster with a long slinky body, a large head and bottle horns can be recognised as a dragon because it resembles the pictograph for dragon, we must consider how, in the first place, the Shang came to decide that this was an appropriate shape for a dragon. Describing an imaginary creature either in words or in a depiction is always a problem. One of the main ways this dilemma is resolved is found in many stories in which descriptions of fantastic creatures simply resort to listing their features, comparing each one to a different animal. Thus a monster is said to have horns like one animal, the mane of another, the legs of another, and so on. In the same way, drawings of strange beasts are often made up of parts of known animals; so too with the Chinese dragon. Snakes appear on very early Shang pottery, and from the similar arrangements used for both snakes and dragon ornament we can infer that the outline of a snake may have provided the foundation for the first

Fig. 73 Rubbing of a dragon on a brick found at the Maoling, tomb of the Emperor Wudi, Han dynasty, 1st century BC. L. 75.6 cm. British Museum.

representations of a dragon. Furthermore, many early representations show a small heart-shaped tip to the upper jaw. This heart-shape first appeared in the very earliest depictions of snakes. Diamond patterning, regularly used on early dragon motifs, also seems likely to have been borrowed from snake designs or even real snakes. Other reptiles may have suggested the bottle horns. The fierce jaws, on the other hand, were taken from the formula worked out for a quite different monster, known to later scholars as a *taotie*.

During the Shang period, the dragon was sometimes given one pair of legs and sometimes two; the bottle horn was altered into a spiky projection, or even made into a plume. When vessel handles were cast in the shape of dragons, feet were very useful in attaching the long snake body to the container. The example illustrated shows a dragon that retains its original bottle horns (fig. 72d). During the seventh to fourth centuries BC, abstract ornament and intricate interlace on bronze vessels and jades ousted many of the ancient dragons and monsters. However, the now traditional dragon shape or outline survived in the formula used for vessel handles and jade pendants. Bottle horns on earlier dragons were abandoned in favour of quite elaborate crests and plumes (fig. 72e). While most bronze examples have legs and claws, examples on jade pendants were often shown with fins only. Just occasionally, dragons were supplied with wings, appropriate for beasts who were described in poetry of the third century BC as winged steeds of chariots that could carry magicians to the distant Kunlun mountains (fig. 72f).

The three handles in figures 72d, e, f illustrate dragons with their heads turned back looking over their shoulders, a scheme which was to prove very influential. To nomadic peoples inhabiting the borders of China, the dragon motif was alien; their beliefs did not necessarily reserve a special place for the

Fig. 74 A dragon incised on a stone slab from the Qianling, tomb of the Emperor Gaozong and his consort Wu Zetian, Tang dynasty, 7th–8th centuries AD. After *Kaogu yu wenwu* 1983.1, p. 29, fig. 1.

long. However, real animals, especially tigers, stags, and horses, were of profound importance in their lives, and these creatures were frequently depicted on their bronze harness plaques. The formula for the *long*, with a long sinuous body, extended legs and claws and a head reversed looking back over the body, was borrowed by the nomadic peoples as one of the outlines they used for a tiger (fig. 72g).[9] In this way tigers and dragons came to share several features. While the tiger gained some of the characteristics of a *long*, the dragon acquired a feline appearance.[10] In the Han period, and succeeding centuries, the outlines of the two creatures remained rather similar.

A lively dragon on a brick found at the Maoling, the tomb of the Emperor Wudi (fig. 73), retains the s-shaped outline of many small bronze dragon figures. A virtue has been made of this traditional stance, and the dragon seems to be twisting its head to gaze around with piercing eyes. In other representations of the four creatures of the directions in tombs, both the dragon and the tiger are drawn facing forwards, as though racing through the heavens. The calligraphic line of the Han animals was retained for several centuries, and reused on a tablet from the tomb of Yuan Hui, d. 520 (fig. 67). Here the similarity of the outlines of the dragons and tigers is very pronounced, both creatures sharing the same feline body shape and long legs. For the sake of symmetry, pairs of animals are shown on all four sections and are surrounded by a filling of clouds. Similar representations appear on mirrors of both the Han period and succeeding centuries.

By the Tang dynasty, two of the creatures, the Tiger of the West and the Black Warrior of the North, had diminished in importance, leaving the field to the dragon and the Red Bird. This shift does not suggest that the representations of the creatures of the directions ceased to have a role, but rather that further symbolic qualities accrued to the dragon and bird. Both were especially auspicious creatures: the dragon represented the forces of both *yang* and creation, and controlled the heavens and the rain; the Red Bird stood for the most auspicious direction of all, the south – buildings of every sort were aligned north-south with their doors facing south. Such especially auspicious creatures were readily used to ornament the buildings, furnishings and dress of the emperor and high officials. At some stage the dragon came to symbolise the emperor. The history of this symbolism has yet to be written, but it would appear that from at least the Han period texts equate the emperor with the dragon. However, this symbolism was far from exclusive; dragons could be used on buildings, dress and utensils that were in no way connected with the emperor. By analogy with the dragon, the bird, or later the phoenix, came to stand for the empress; but similarly, architecture or textiles and porcelain decorated with extravagant birds did not necessarily belong to or even refer to the empress.

Nevertheless, dragons were inevitably displayed on buildings constructed for the emperor, especially tombs. The following examples are taken from two of the most prominent. The first is drawn from a stone carving found at the Qianling near Xi'an, the tomb of the Emperor Gaozong (r. 650–84) and his consort Wu Zetian (fig. 74). The early s-shaped stance of the dragon from the Maoling (fig. 73) is reused here, but so skilful is the composition that the constraint of the traditional formula is not apparent. The head of the creature is greatly enlarged, with long horns and a viciously pointed tongue. Of the four legs, two are lifted off the ground, diminishing the feline qualities remarked above, and conveying the impression that the creature could twist and turn

through the air, now indicated by small puffs of cloud. The fringes of flames or foam that lie along the limbs of the dragon had been in use from the post-Han period and have remained a convention employed on mythical creatures to the present day. Such long pointed flames were more popular than wings, possibly introduced to China from the Near East. When these flaming tips and fringes are attached to beasts depicted in Islamic miniatures and illumination (fig. 150), they are evidence of Chinese influence.

In a square or circular, rather than a rectangular frame, dragons were often shown in confronted pairs, leaping through clouds. It obviously proved convenient to arrange the dragons in a circle, apparently chasing after each other, as in decoration from the eleventh-century Liao mausoleum at the Qingling in Liaoning province (fig. 75).[11] This circular, rather than confronted, composition was very versatile; it did not have a right or a wrong way up and could therefore be adapted to many positions in a complicated architectural scheme. Furthermore, such panels could be varied in shape from a square, to a circle, or a diamond. In this new position, the artist has made cunning use of the line of the spine to convey the lively movement of the dragons through the air. They are less fierce than that from the Tang tomb.

Following the import of Western silver cups and bowls decorated with animals in repoussé, animal subjects, including dragons, were transferred from architecture to utensils, first in silver and later in other materials. Dragons, of course, did not appear on foreign pieces of silver. When the Chinese made their own versions of foreign silver, they added creatures which particularly interested them. The formula they adopted for the dragon was not necessarily taken directly from depictions in architecture; instead, mirrors

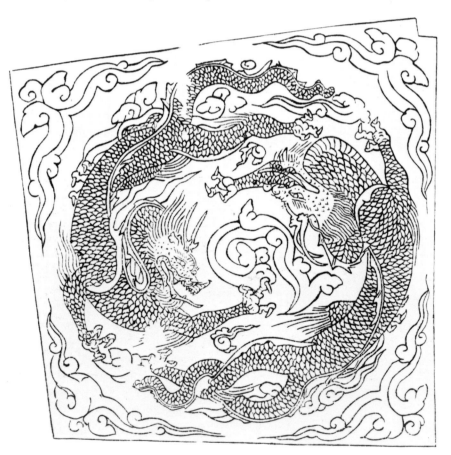

Fig. 75 A pair of dragons from the Liao imperial tombs at the Qingling in Liaoning province, Liao dynasty, 11th century. After Tamura and Kobayashi 1953, fig. 214.1.

may have offered convenient examples which could be easily adapted. Auspicious creatures had been used on mirrors from the Han period, and perhaps even earlier. In the Tang period dragons and the bird or phoenix dominated mirror design to the exclusion of all other creatures. On the mirrors in figure 76 a dragon and a bird are shown within lobed frames, an outline shared with silver dishes of the same date. To fit the approximately circular area, the long pacing creatures of the Han and Six Dynasties period have been slightly twisted and their legs turned up into the air. Exactly the same stance is seen in a dragon chased in a silver dish of the late eighth century excavated at Dingmaoqiao in Dantu Xian Jiangsu province.[12]

There are very few dishes or other utensils decorated with dragons surviving from the period between the Tang and the Song periods. Silver is scarce, and lacquer also. Because examples decorated with the phoenix survive (figs 84, 85), we can infer that all the other animal motifs, including dragons, were used on both silver and lacquer. Later ceramics are also helpful. Ding ware of the Song period, with fine incised decoration, appears to be directly based on silver, for both the shapes and ornament of this fine white porcelain are anticipated in silver of the Tang and Five Dynasties periods. A dragon rising elegantly within the frame of a Ding ware dish in figure 77 was possibly intended to match the decoration of a bowl in a more precious material.

Ornament painted in underglaze blue on the southern porcelains of the Yuan period, while perhaps inspired by the repertory of Ding ware, was based neither on Ding ware nor directly on silver. A dragon at the centre of a dish in the Topkapi Museum is shown in white against a dark blue sky filled with small puffs of cloud (fig. 78). This is an unusual way to use cobalt blue to depict a dragon. The creature and clouds had to be neatly defined in cobalt, and then

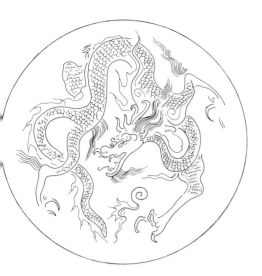

Fig. 77 Dragon from a Ding ware dish, Northern Song period, 11th–12th centuries. Diam. 30 cm. Carl Kempe collection. After Wirgin 1970, pl. 68.

Fig. 76 Two bronze mirrors decorated with a dragon and phoenix, Tang dynasty, 8th century. Diam. 15.8 and 16 cm. British Museum.

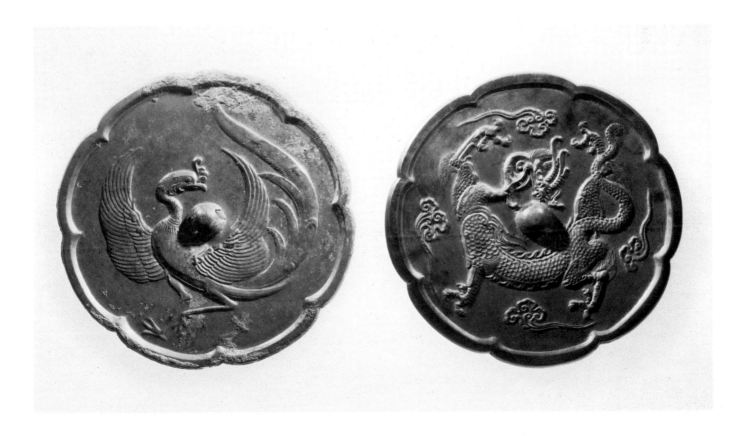

the spaces between had to be carefully filled. When painting in a dark colour, it would have been more natural to fill in the dragon and clouds in blue against a white ground, as, indeed, later potters were to do. The white clouds and dragon seem intended to reproduce a design in silver or gold on a dark ground. The source of this reversal may have been textiles embroidered in gold thread, but it seems more likely that lacquer painted in gold or silver, or decorated in the *qiangjin* technique, inspired the design. The continuing importance of lacquer as an intermediary between silver and ceramics in the period from the Tang to

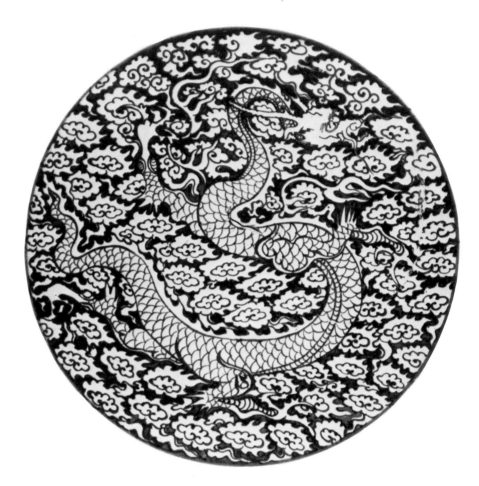

Fig. 78 Central medallion from a large porcelain dish, showing a dragon and clouds reserved in white against a blue ground, Yuan dynasty, 14th century. Topkapi Saray, Istanbul.

Fig. 79 Dragon ornament from a porcelain *meiping*, Yuan dynasty, 14th century. British Museum.

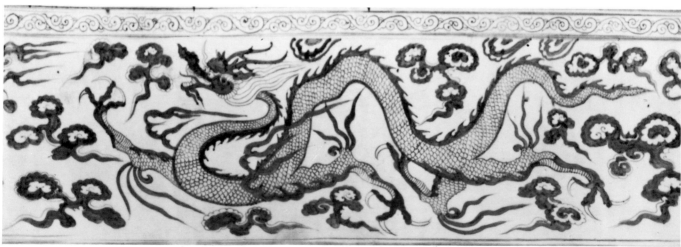

the Yuan dynasty has already been mentioned, and this role is underlined by the many surviving large porcelain dishes decorated with flower and animal motifs in reserve. For the phoenix design, there are examples of gold-decorated lacquer that pre-date porcelain with underglaze blue ornament. No pieces of lacquer with dragon ornament have survived from such an early date. However, a number of lacquer boxes, excavated from early Ming tombs, illustrate the same contrast of a light dragon and clouds in gold on a dark ground. Such boxes almost certainly belong to a long series of lacquers with similar ornament, probably going back as far as the Tang dynasty.[13]

The decoration of porcelain in underglaze blue was soon so successful that silver and lacquer models were now finally relinquished. Dragons and other creatures were thereafter shown in blue against a white ground (fig. 79). As control of enamel colours developed, many more vivid combinations were devised (pl. 5).

The Red Bird or phoenix

It is perhaps misleading, although customary, to call lavishly plumed birds in Chinese tomb reliefs and on mirrors phoenixes, for legends about the Western phoenix, born again from the ashes, were of course unknown to the Chinese. Our word phoenix is used to describe two different Chinese birds, the Red Bird of the South, the *zhu niao*, and another mythical bird, the *fenghuang*, a bird with lavish plumage, which was later paired with the dragon. Except when all four animals of the directions are present, it is not known whether a particular example of the bird is intended to represent the *zhu niao* or the *fenghuang*. There do not appear to be any graphic conventions that distinguish the two; similar shapes were used for both. Indeed, there was probably no fixed division between the two; they were possibly interchangeable.

Like dragons, birds appear very early among the decoration of Shang ritual vessels, and particularly elegant birds were used on the bronzes of the early Western Zhou period, around 1000 BC. From the seventh century, birds with widely stretched wings appeared on the lids of bronze wine vessels, and by the fourth century birds attacking snakes were included in the decoration on the surface of ritual bronzes. Quite fantastic sculptured birds, with wings made out of antlers, seem to have acted as guardians in southern tombs, where they were placed in front of coffins, their feet sometimes entangled with snakes.[14] It is possible that these guardian birds provided the model for the bird adopted as the symbol of the south in the Han period. The Red Bird of the South may also have been associated with the good omens that the appearance of red birds was thought to signify.

A mythical bird presented the same problems as a dragon; no one could possibly know what it looked like. Thus representations of the Red Bird of the South borrowed some features from other birds: for example, one of the bricks from the Maoling is moulded with a bird with large droplets hanging at the ends of its plumes, suggesting the eyed tail-feathers of the peacock (fig. 80). Perhaps because such details did indeed indicate a peacock, many other depictions of birds have simplified tails, their wings dominating the composition, as in the examples on the lintel from the tomb of Yuan Hui (fig. 67). In architecture, especially over doorways opening to the south, we can assume that birds represent that direction, as on the lintel from the tomb of Yang Zhiyi (fig. 53). When the same bird appears alone on a mirror, we do not know whether we are faced by the *zhu niao* or the *fenghuang*.

Fig. 80 Rubbing of the Red Bird of the South, from a brick found at the Maoling, tomb of the Emperor Wudi, Han dynasty, 1st century BC. L. 1.6 m. British Museum.

Fig. 81 A pair of phoenixes and flower patterns, from a coffin, Liao dynasty, 1018. After Tamura and Kobayashi 1953, fig. 118.

As with dragons, mythical birds were made more decorative and less awe-inspiring after the Tang period. In a roundel carved on a Liao-dynasty stone coffin dated to the eleventh century (fig. 81), two extravagant birds swirl about each other with flaming discs at the centre. These discs are late stylised versions of Buddhist emblems, such as lotus flowers or jewels, which were frequently placed between pairs of confronted creatures on earlier epitaph covers.[15] Small clouds fill up any other vacant space. The birds have very broad leafy tails; by the Yuan period, two quite different tails had been devised for the pairs of birds. A relief from the site of the Yuan capital at Peking, known as Dadu, illustrates a pair of birds within a lobed panel: one has a tail of long feathers with a serrated edge, the other trails much more hooked plumes, whose outlines can be traced back to palmette-shaped leaves and other foliage (fig. 82). The doubling of the bird motif had perhaps first been determined by symmetry and the need to fill panels within a decorative scheme. When the two birds were thus distinguished, a narrative or explanatory element also entered into the representation. Craftsmen, and no doubt their patrons, then treated the birds as a pair, a male and a female. Throughout Ming and Qing art, phoenixes were customarily shown in such pairs, but single birds do also appear confronting a dragon, the two different creatures referring to the empress and emperor respectively.

In discussing the way in which the phoenix, originally confined to symbolic display in buildings, was borrowed to decorate metal and ceramic vessels, the sequence first described in connection with the dragon is relevant (fig. 76). Just as it had proved convenient to double the birds in tomb decoration, so too a given field within a silver dish could often be effectively filled by two creatures. Sometimes two birds appear confronted, but more frequently they are represented chasing after one another. A small diamond-shaped silver dish in the British Museum, dating from much the same period as the Liao tomb design, has an incised design of two circling birds (fig. 83). They are rather small, but in general outline they are similar to phoenixes. They have the same outstretched, almost triangular, wings but somewhat slight tail plumes. Their rounded beaks perhaps indicate that they should be interpreted as parrots, but these small, almost insignificant, birds are merely mass-produced copies of phoenixes. Because they are so small – indeed, they are almost lost within the large diamond-shaped field available – the surplus space has been filled with leaf scrolls of an indeterminate nature; the Chinese seem to have abhorred empty space in decorative schemes.

Such scrolling tendrils may have seemed incomprehensible to some craftsmen. How could birds fly through a tangle of leaves? On an early fourteenth-century lacquer sutra box stored in a Japanese temple, the Daitokuji, the space around similar birds is filled with clouds (fig. 84).[16] This design is particularly close to silver ornament because the birds and clouds

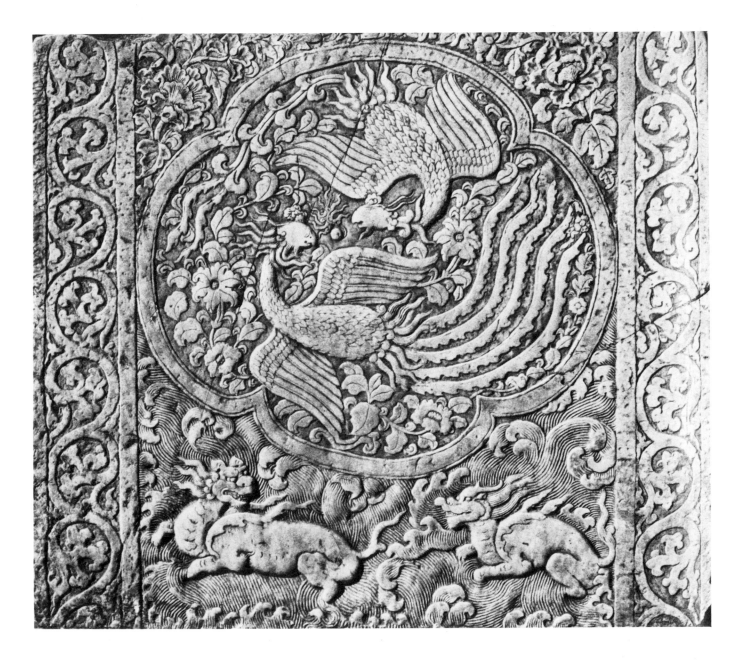

Fig. 82 Stone relief, found at the site of the Yuan dynasty capital, Dadu, at Peking, Yuan dynasty (1280–1368). W. 1.05 m. After Beijing 1972a, p. 82.

are contained within a diamond-shaped frame. Bound together in this way, the ornament on the box seems to have been lifted whole from a silver dish. It was useful to retain the outline of the dish on the lacquer box to prevent the two birds getting lost on the larger rectangular surfaces. An even closer relationship between silver and lacquer is seen in a later foliate box, decorated again with a pair of phoenixes (fig. 85). Deep three-dimensional foliations were particularly easy to produce in soft metals such as silver and were used for boxes in silver and later lacquer from the Tang dynasty.

Just as the outline and ornament of a silver box might be reproduced on a lacquered panel, so the same procedure seems to have happened again in the decoration of porcelain. A dish from the Ardebil Shrine (fig. 86) is decorated with a pair of phoenixes within a lobed panel, as if the top of a foliate box, similar to the example in figure 85, had been copied on to the dish. The reversal of the motifs and ground, so that the phoenixes show white against a dark

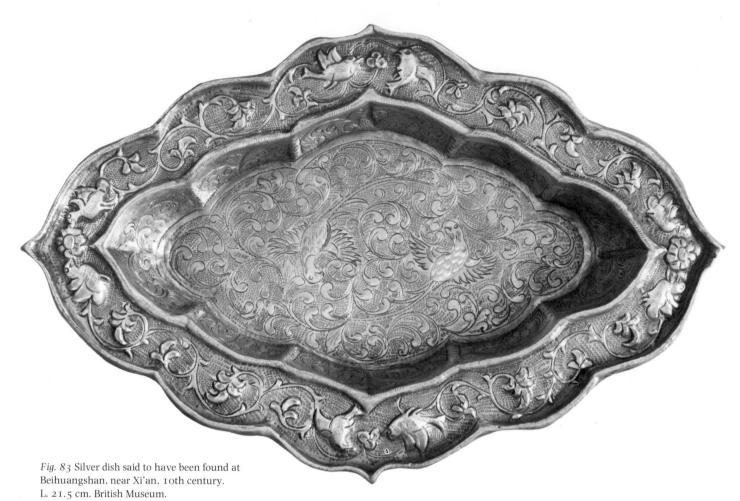

Fig. 83 Silver dish said to have been found at
Beihuangshan, near Xi'an, 10th century.
L. 21.5 cm. British Museum.

Fig. 84 Lacquer box decorated in *qiangjin*, Yuan
dynasty, early 14th century. H. 25.5 cm.
Daitokuji, Nara, Japan.

Fig. 85 Foliate lacquer box decorated in *qiangjin*
with two phoenixes, Ming dynasty, 15th
century. Diam. 12.1 cm. British Museum.

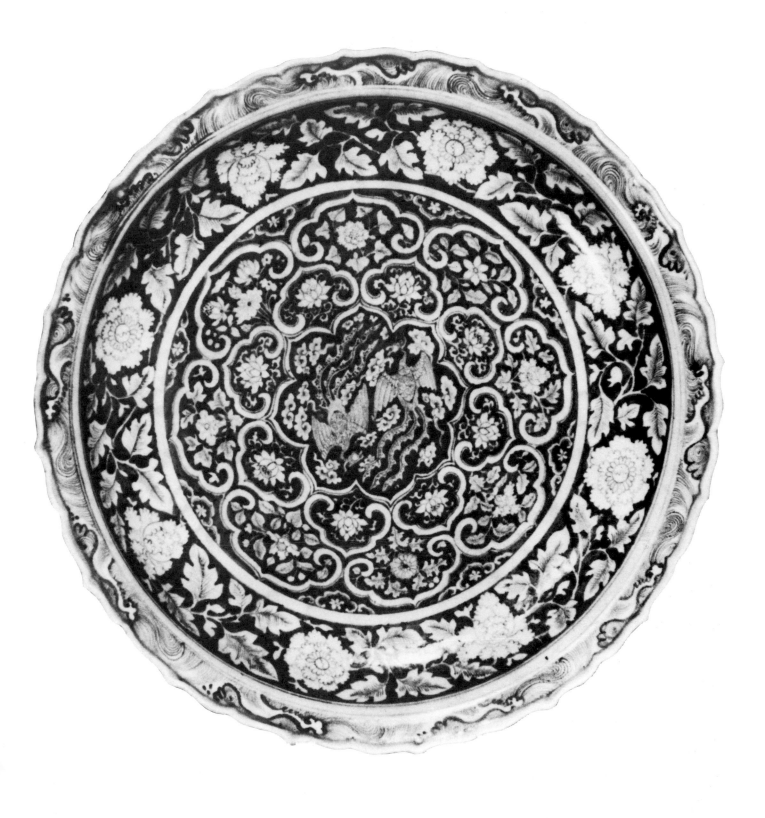

Fig. 86 Porcelain dish decorated in underglaze blue, with a pair of phoenixes among clouds within a lobed and pointed frame. Yuan dynasty, 14th century. Diam. 46 cm. Ardebil Shrine, Iran.

backcloth, repeats the effect seen on the dragon dish already illustrated (fig. 78). As in that case, the model for the ornament seems likely to be a material in which the birds were shown in gold or silver on something dark. While it is possible that this material was a textile, the repeated use of lobed frames with such reserved decoration makes this proposition rather unlikely. On textiles phoenixes and dragons were much used, but generally without frames peculiar first to silver and later to lacquerwork.

A lobed or pointed frame, borrowed from the outline of silver dishes, was a convenient way to define the area that the phoenix was to occupy at the centre of flat surfaces. Problems of organisation arose when phoenix or related bird designs were to be placed around jars. Dragons could just be stretched out to fill the given space, by elongating an already sinuous body (fig. 79). Phoenixes, peacocks or other birds were less elastic. Of course, extra space could be filled with clouds or flowers, and this device was widely adopted. In addition, not very successful attempts were made to place lobed panels enclosing phoenixes around flasks or jars. The difficulty could be resolved by abandoning the flying birds which seemed to require a defined space. When the two birds were allowed to stand side by side, amid a profusion of flowers, designs of various formats could be contrived. Scenes of birds in a garden landscape were used on Ding ware in a circular or lobed field.[17] They could also be accommodated in a long horizontal design as illustrated in figure 87. This ornament has been photographically unrolled from a large fourteenth-century jar in the British Museum. Flowers, which within a circular frame of a dish might have been allowed to wind among the birds, are here set in a sketchy landscape. Two large vertical rocks are provided, from behind which peony flowers, like those used in the undulating scroll in figure 62b, are allowed to grow. Additional rocks, some long banana leaves and a few sprays of bamboo fill out the line of the ground. This arrangement was no more drawn from life than the peony scroll; it was composed of stock motifs developed for the decoration of ceramics. This invented landscape provided a decorative scheme, centred on two birds, which could now fill the whole horizontal space available on a large jar.

Rocks and flowering plants distributed over the jar are recombined into a new circular composition on a large dish in the Victoria and Albert Museum, described in the Introduction (fig. 2). The decoration of this dish shows different birds, pheasants in place of peacocks, but in other respects the designs

Fig. 87 Decoration of a peacock and peahen with a rock and plants, from a porcelain jar, Yuan dynasty, 14th century. H. 31 cm. British Museum. For whole jar see plate 2.

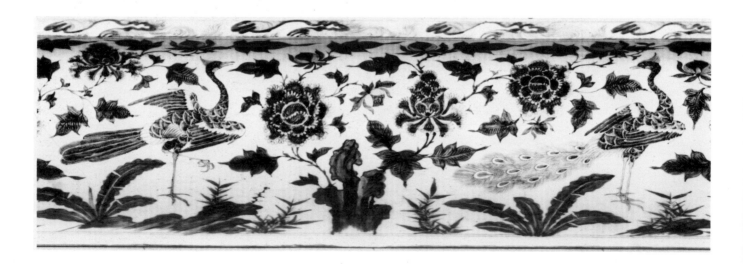

are very similar. Two almost horizontal rocks, on which the birds stand, give away the source of this new scheme in a design similar to that on the jar. They are identical with upright rocks from the jar but have now been laid on their sides. If the decoration had been worked out from observation of nature or had been taken from a painting or print, such irregular arrangements would probably not have arisen; but because the patterns were contrived with an existing vocabulary of motifs, and were also bound by the limited space available in the dish, slightly strange compromises were allowed. Although, like the rocks, the plants and trees are made up of stock elements, they convey an impression of a tangle of foliage and successfully suggest a landscape of some depth within the small field.

The history of the design of birds in a landscape on porcelain was uneven. In the early fifteenth century, while paired dragons and phoenixes continued to play a role, birds and rocks were much less prominent than large-scale decoration of flowers and fruit. Birds in a landscape returned to favour in the sixteenth century. A small jar in the British Museum is painted with a careful design of birds, rocks and plants (fig. 88) but it lacks the verve of the fourteenth-century examples. Alongside, ornament of deer and fish was also revived.

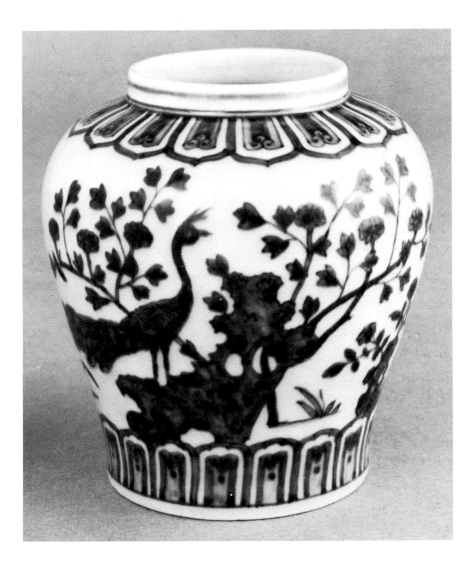

Fig. 88 Porcelain jar with decoration of a bird and rock, Ming dynasty, Jiajing mark and period (1522–66). H. 13 cm. British Museum.

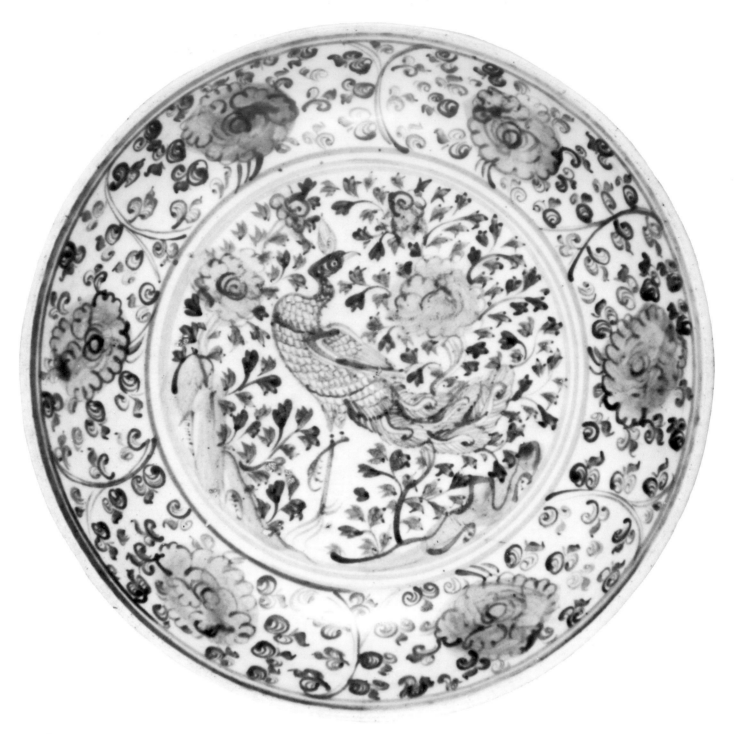

Fig. 89 Porcelain dish with cursory decoration of a bird on a rock, Ming dynasty, *c.*1500. Diam. 32 cm. British Museum.

It would appear that the export of large fourteenth-century porcelain dishes had created a taste abroad for porcelains decorated with birds, lions, deer and fish. Many export porcelains made at Jingdezhen revise the earlier themes in vigorous but often careless designs (fig. 89). In addition, potters elsewhere seem to have taken advantage of this demand. Copies of Chinese subjects were made by potters working in Annam, and later the potters of Fujian drew the same subjects on rough porcelains, now given the name of Swatow ware.[18] Indeed, the profusion of these later dishes with traditional Chinese subjects can only be explained by a demand abroad that Jingdezhen was unable or unwilling to satisfy in the sixteenth century.

In the later part of the Ming dynasty, animal motifs were used more widely at Jingdezhen, but again mainly on porcelains intended for export. A small dish of the Wanli period (1573–1619), made for export to Europe, illustrates certain changes. While the bird and the rock are certainly less elegant than the Yuan peacocks and pheasants, a quite complicated landscape has been achieved (fig. 3). Large towering cliffs in the background have been borrowed from landscape painting or rather from woodblock prints based on fine painting. Perspective in such landscape scenes was imperfectly understood by the potters, and the plants, rocks, water, cliffs and clouds are not entirely convincing.

These various versions of the bird on the rock established the motif firmly in the potters' repertory. Their continued use probably also reinforced the taste for such designs among customers in China and abroad, with the result that the design remained current throughout the Qing period. European copies were based on originals of different dates, providing quite a range of different interpretations of this one Chinese design.

This sequence of illustrations of the bird on the rock can be matched by similar series for the deer, lion and fish motifs discussed in the next three sections. Because the later use on porcelain of these other creatures parallels the history of the bird on the rock, they will not be separately considered and illustrated; instead, attention will be concentrated on the earlier development of these motifs.

Deer

By the Han period deer were fully assimilated to the range of creatures the Chinese regarded as powerful. They appear on the coffin of the wife of the Marquis of Dai (fig. 68) and on the tablet from the tomb of Yuan Hui, alongside other auspicious creatures (fig. 67). However, unlike the dragon and the bird,

Fig. 90 Drawing of a silver dish with gilded decoration of deer and flowers, excavated in the Karachin banner, Liaoning province, Tang dynasty, 796. Diam. 46.6 cm. After *Kaogu* 1977.5, p. 332, fig. 8.

deer had been employed rather unevenly in ancient Chinese ornament. There are only a few late Shang and early Zhou bronzes on which motifs explicitly suggesting an antlered deer are found; deer appear more often among small jade amulets popular at the same time.[19] They were, however, prominent on bronzes made by nomads living on the northern borders of China. When deer were used to decorate Chinese ritual bronzes of the late fifth and fourth centuries, it seems likely that the motif had been reintroduced as a result of contact with the nomads.

However, while deer were not always depicted on bronzes or other materials, they were prized as sacrificial animals. Their remains have been found in pits along with other sacrificial animals, and Han texts provide further evidence of the importance of deer in sacrifices. At the ceremonies for the dedication of an altar to Taiyi, a deer was slaughtered. The Han emperor also hunted deer ceremonially.[20] Interest in sacred deer is seen in the specialised vocabulary developed to name deer thought to have miraculous powers. The principal deer-like creatures are the *qilin*, the *tian lu* and the *bixie*.[21]

As with all fantastic creatures, these animals were composite beasts whose appearance and powers are now almost impossible to define. The *qilin* is mentioned in poetry of the Han dynasty:

> The king of Qi rode forth with a thousand carriages . . .
> the ranks of men filled the marshy land;
> their nets and snares covered the hills;
> they seized hares and ran down deer,
> they shot the *mi* (tailed deer) and snared the feet of the *lin*.[22]

Here the word *lin* refers to the female of a pair of mythical creatures, known with the male as the *qilin*. The *qilin* was thought to have a single horn.

Reference to the *tian lu* and *bixie* is found in a commentary on the chapter on the Western Regions in the *Han Shu*, where a particular charm is defined as being 'shaped like a deer; those with one horn represent the heavenly deer (*tian lu*), those with two can ward off evil (*bixie*)'.[23] The heavenly deer, the *tian lu*, was thus simply a sacred deer. Perhaps even its single horn may be due to an accident of representation. Shown in profile, a deer might appear to have only a single horn. When confronted with an image of a deer with a single horn there is today no certain way of knowing whether a *tian lu* or a *qilin* was intended.

In the passage cited, the other term, *bixie*, seems to refer to the powers of a deer rather than its name. In subsequent centuries, the term was, however, treated as a name and different descriptions of the *bixie* were offered. It was generally understood as a powerful feline with horns, and not a deer. The *Hou Han Shu*, the history of the later Han dynasty compiled in the fifth century, mentions that both the *tian lu* and the *bixie* were placed among the protective beasts lining the path to tombs.[24] Although it is difficult to identify the creatures represented in the surviving guardian figures, many are powerful lion-like creatures with horns, rather than deer. Thus the original outline of a deer, known as a *bixie*, was rapidly lost. Late representations of such mythical creatures are composites. Bodies and manes of fantastic lions were combined with the horns and hooves of a deer. Those creatures with one horn are probably *tian lu* or *qilin*, those with two may be intended to represent *bixie*.[25]

A stone slab from the site of the Yuan capital at Peking, already illustrated for its decoration of two phoenixes, is carved with two mythical creatures

leaping over waves (fig. 82). The beast on the left has no horns and may be intended as a lion; the creature on the right has a single horn and should perhaps be recognised as a *qilin*. Another slab from the same site is decorated with more realistic but, none the less, mythical deer (fig. 126). As they prance through a tangle of magical fungus (see Chapter 4), the viewer appreciates that they too have miraculous powers.

Like the other creatures discussed, from the Tang period deer were also used to decorate silver. A famous dish in the Shōsōin treasury has a pacing deer at the centre,[26] and a dish with a deer seated among flowers has recently been excavated in the Karachin banner area of Liaoning province. It is inscribed with a date equivalent to AD 796 (fig. 90). The popularity of deer on silverware may have been stimulated by the example of Sasanian and provincial Iranian silver which portrayed lions and deer prominently.[27]

The influence of this silver ornament can be followed on several types of ceramic. Both stoneware and porcelain of the Song and Jin periods provide examples of deer motifs surrounded by circles or raised dots imitating the ring-punching of silver. A dense composition on a moulded Ding ware dish in the Victoria and Albert Museum shows two deer amid luxuriant flowers and foliage, as though leaping through an exotic forest (fig. 91). Around the sides of the dish lotus plants are set against a stippled background, which reproduces the ground of decorated silver. (A similarly punched surface is found on a mould, possibly used for producing Ding ware, now in the Freer Gallery in Washington.)[28] The light-hearted character of the deer on the Ding ware dish contrasts with the ponderous mythical beasts, incorporating features of sacred

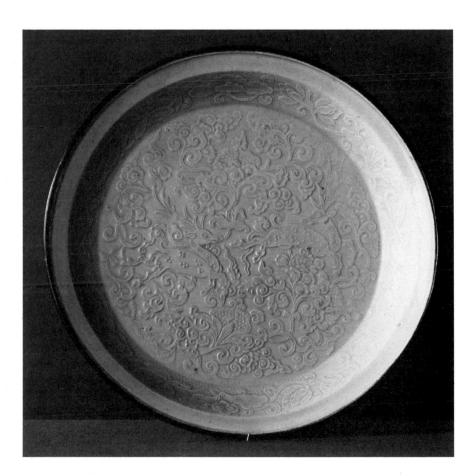

Fig. 91 Ding ware dish decorated with deer amid foliage and plants, with a border of lotus plants against a stippled background, Jin dynasty, 12th–13th centuries. Diam. 21.4 cm. Victoria and Albert Museum.

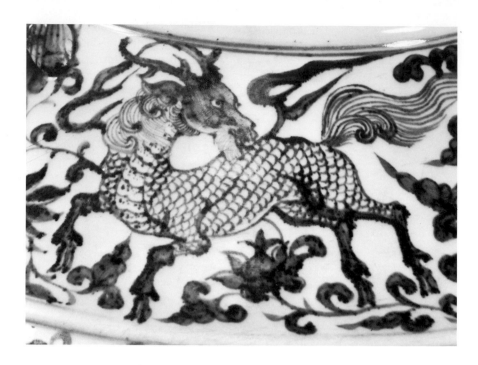

deer, used to guard approaches to tombs. Only a few examples of the deer motif on porcelain retain any trace of the fierce aspect of the tomb guardians. Elements of the ancient powers of the deer are, however, captured in a motif on a large fourteenth-century jar (also decorated with a bold peony scroll, fig. 62b), where a horned beast glares fiercely as it turns to look at us (fig. 92). However, unlike the ponderous stone *qilin* or *bixie*, this deer has slender legs and appears to bound lightly across the surface of the jar.

Lions

The lion is a striking example of an animal theme brought into China from the West. There are no lions in China and so no opportunities for artists to draw them from life or even repute. However, they were well known in the Near East and Mesopotamia, where they were treated as symbols of power and authority, or as guardians of sacred buildings. Mesopotamian cylinder seals of the third millennium BC show muscular heroes grasping pairs of lions in their bare hands. Much later, lion hunts were used to glorify the Assyrian kings. Stone or clay figures of lions, placed as guardians in front of sacred buildings, had a history of equal length. Clay sculptures of lions were found at the entrance of the temple at Tell Harmal near Babylon, dating to the second millennium BC.[29] For the next 3,000 years, such guardian lions were established at buildings in many parts of the Near East. In the period under discussion, lions are found guarding the Mausoleum at Halicarnassus, at Hatra, and on the stupas of the Kushans (fig. 26).[30]

Figures of both crouching and pacing lions seem to have been introduced to China as part of the changes made in burial practices during the late Zhou and Han periods. It has been suggested that the Chinese adopted from the nomads of the steppe the practice of placing large earth mounds over tombs.[31] Similarly, it is possible that they took over guardian animals from the Near East or Iran. Stone guardian figures are found at tombs in Sichuan province, dating to the second century AD, a time when other Western traits were also borrowed

by the Chinese. It is not always easy to identify the animals represented on the stone carvings: they are generally mythical and none of them resemble lions very closely. However, large powerful felines with a hint of a mane were probably intended to represent lions.

With the fall of the Han and the upsurge in imperial patronage of Buddhism, lions were depicted in new contexts. In India and further north among the Kushans, lions, so long used in Mesopotamia and Iran as symbols of temporal power, were adopted as symbols of religious might. Very early and striking uses of lions in a Buddhist context are found among the animals crowning columns set up in the third century BC by the King Aśoka, as part of his mission to propagate Buddhism in India.[32] These lions stand on a lotus support on top of tall stone columns, which in outline resemble the great columns with animal capitals at Persepolis. Such columns must have become known to pious Chinese, either through texts or through accounts of pilgrimages, for in the fifth to sixth centuries AD, members of the Liang dynasty ruling in south-east China, near the present-day city of Nanking, set up tall columns near their tombs. The columns are neatly faceted, rather like columns of the Doric order, and support small lions standing on lotus petals.[33] The same tombs are guarded by large stone animals. Although these beasts often have wings, their powerful heads and bodies resemble the outlines of the creatures on the columns, and it can therefore be assumed that they were interpreted as lions. When reproduced on moulded bricks from tombs in the same area, lions approach ornament more closely. The illustrated bricks show the substantial bulk of the stone lions of the Liang translated into a flat composition of curving lines (fig. 93).[34]

Following Kushan practice, Buddhist figures carved in the great cave temples of north China were often seated on thrones with a lion at either side (fig. 36). From this custom derived small guardian lions that accompanied figures of the Buddha. Diminutive but very fierce lions stand below the feet of the figure of the Buddha preaching on the Vulture Peak, shown in a large

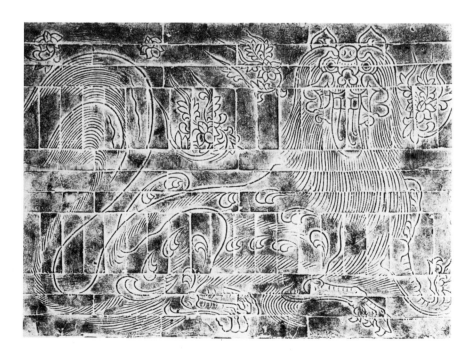

Fig. 93 Decoration of a guardian lion in relief on bricks, from a tomb at Jingwangchen, Jiangsu province, Southern Dynasties period, 6th century. After Beijing 1981b, fig. 201.

Fig. 94 Detail showing one of a pair of lions guarding the Buddha, from an embroidery of the Buddha Sakyamuni preaching on the Vulture Peak, found at Dunhuang, Tang dynasty, 8th century. British Museum.

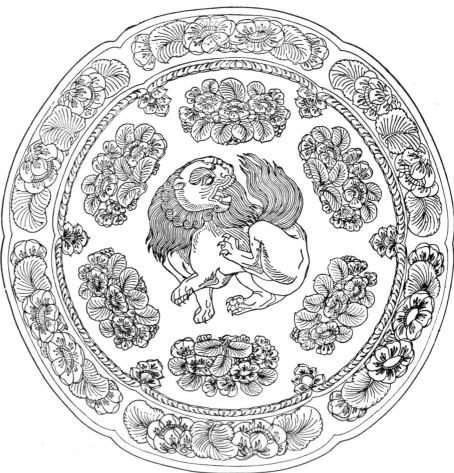

Fig. 95 Drawing of a silver dish with gilded decoration, excavated in the Karachin banner, Liaoning province, Tang dynasty, late 8th century. Diam. 46.6 cm. After *Kaogu* 1977.5, p. 330, fig. 5.

embroidery from Dunhuang (fig. 94). Lions were also employed as the mounts for the Bodhisattva Samantabhadra, and in this role they appear as striding beasts, adopting the model or formula used for the stone animal guardians at tombs.

As with all the other animals described so far, lions were not employed to decorate vessels, however precious, before the Tang. Along with the other creatures they were then placed at the centre of large platters. The earliest examples of such vessels, imitating Iranian models, are silver dishes which show single lions, or sometimes pairs, without any other ornament at the centre. [15] Before a century had passed, however, even lions were surrounded by flowers, as on a dish from the Karachin banner hoard, which was found with the platter decorated with a deer described above (fig. 95). Whilst this lion is quite fierce, it was only a short while before a much less ferocious motif was devised. Two quite playful lions appear in an openwork plaque in silver, formerly applied to a wooden or lacquer box, from the tomb of Wang Jian, d. 918 (fig. 96). The lions chase one another around a flaming pearl amid a trellis of flowers. The creatures have comic ruffs rather like the lions that are now used in circuses and street celebrations.

Lions seem to have been rather less popular on Song and Yuan ceramics than dragons and phoenixes, possibly because they retained their position as powerful guardians rather longer. Indeed, although paired lions were developed as a decorative motif for lacquer and porcelain, they were equally common in stone and bronze sculptures. Two lions appear on the base of one of the large uprights of the ceremonial gateway to the Ming tombs (fig. 97). The

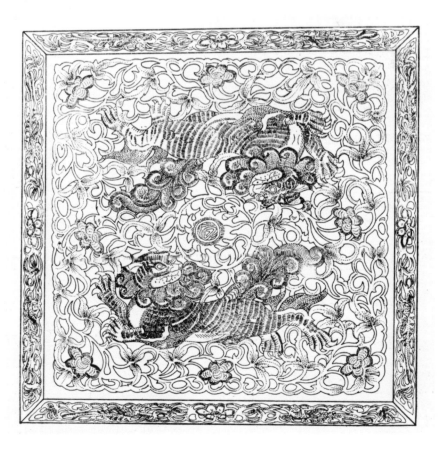

Fig. 96 Drawing of a silver overlay from a box, showing a pair of lions in pursuit of a flaming pearl, found in the tomb of Wang Jian (d. 918), Sichuan province, Five Dynasties period. After Beijing 1964, fig. 37.

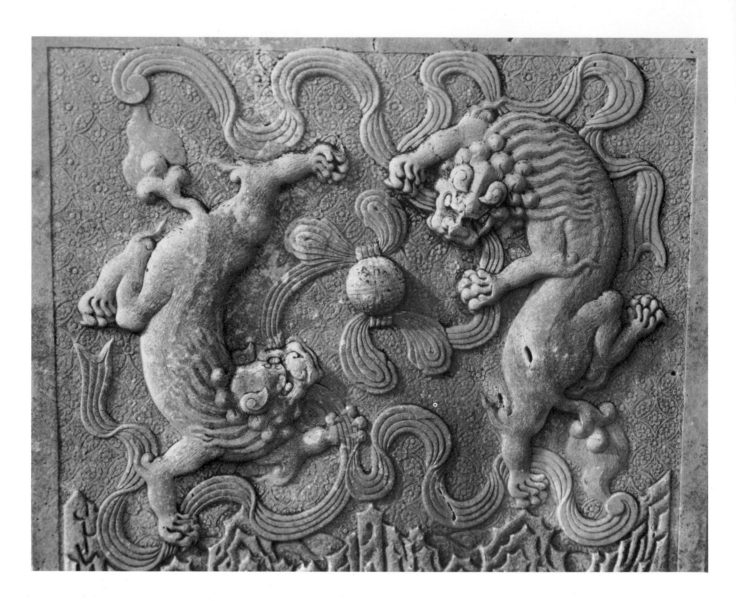

Fig. 97 A pair of lions chasing a ball with long streamers, carved in stone, from the foot of one of the piers of the ceremonial gateway (*pailou*) at the Ming tombs, Ming dynasty, 15th century.

panel is carved in relief, with the two creatures chasing a ball with long ribbons in place of a flaming pearl. Once again a new interpretation has been given to an old motif. When the lions were set as guardian figures in front of buildings, they were like phoenixes, interpreted as a male and a female. A ball was placed below the paw of the male, while a cub was given to the female. The lions guarding the courtyards of the Imperial Palace do not, therefore, give expression to ancient Chinese symbolism. These lions have been acquired through the accidents of Chinese history, tamed and given a Chinese aspect. Here a Western Asian form had priority, and suggestions of power and protection within a Chinese context have accrued to it. Meanwhile, the playful character of many Chinese lions reminds us how far they have travelled from their ancient home.

Makara or fish patterns

Fish, widely used in the central medallions of large porcelain dishes of the Yuan dynasty (fig. 98), have had a most unusual history in Chinese art. As early as the Han dynasty, pairs of fish were used to decorate bronze and pottery

Fig. 98 Porcelain dish decorated with a pair of fish amid water-weeds, Yuan dynasty, 14th century. Diam. 40.2 cm. After Sotheby's auction catalogue, 21 June 1983, lot 241.

Fig. 100 Drawing of the decoration of a *makara* on a sherd of Yue ware, said to have come from Jiuyan, Zhejiang province, Five Dynasties period, 10th century. L. 25.2 cm. British Museum.

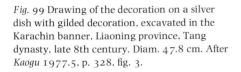

Fig. 99 Drawing of the decoration on a silver dish with gilded decoration, excavated in the Karachin banner, Liaoning province, Tang dynasty, late 8th century. Diam. 47.8 cm. After *Kaogu* 1977.5, p. 328, fig. 3.

basins.[36] The source of this motif is uncertain – perhaps it was simply thought that representations of fish were particularly appropriate in basins intended to hold water. After the third century, fish designs seem to have become less important. However, in their place appeared the *makara*, a fierce water spirit widely revered in India.

This creature, which has a head like an animal with sharp teeth and tusks, and a body like a fish, is carved in early Buddhist caves at Ajanta in India.[37] Although the *makara* was known to Chinese craftsmen executing Buddhist commissions and also occasionally appears in tomb decoration, the most interesting example of a *makara* is a tiny representation of the creature, plunging through waves, at the centre of a deeply lobed dish.[38] This dish was found in a fifth-century hoard at Datong, which contained the stem cup illustrated in Chapter 1 (fig. 15), and seems likely to have been made in northern India or Central Asia. While the design is much less common than the lions previously described, many examples of the *makara* must have been known in China, for a number of Tang dynasty silver dishes have now been found that represent pairs of extraordinary fish. These fish can only be explained as based upon the *makara*. One of the platters from the hoard found at the Karachin banner is decorated with a pair of these fierce creatures (fig. 99). They betray their source by their large tusks and upturned snouts, although their bodies are certainly very fish-like. Another dish with a similar design has been found at Dingmaoqiao in Dantu, Jiangsu province.[39]

Fig. 101 Porcelain dish, Ding ware, with two fish at the centre and lotus patterns around the sides, Jin dynasty, 12th–13th centuries. Diam. 20.1 cm. Victoria and Albert Museum.

This south-eastern province of China butts on to the province of Zhejiang, where the sherd in figure 100 was found. A green-glazed stoneware or porcelain of the type known generally as Yue ware, the sherd is incised with one of a pair of these extraordinary fish.[40] The creature has the same teeth, tusks and upturned snout of the *makara* on the dish from the Karachin banner, while its butterfly-like wings are also seen on the bowl from Dingmaoqiao. It is one of the most vivid examples of a silver design copied on to a ceramic.

The outline of the *makara* survived the transfer from silver to ceramics, but thereafter it disappeared from the repertory of decoration for secular utensils.[41] Possibly the *makara* was no longer comprehensible, or perhaps it was regarded as inappropriate for such uses. Its place was therefore taken by ordinary fish. A Ding ware bowl has a neatly moulded design of a pair of fish within its small central medallion (fig. 101). Gone are the plunging lines of the solid *makara* on the Yue ware sherd, gone too are the tusks and the teeth. These are neat slender semi-realistic fish. On this foundation, a new tradition of porcelains decorated with fish was established. Fish appear on Cizhou ware and above all on porcelains made at Jingdezhen. In many cases only one of the pair of fish now remained, surrounded by luxuriant water weed. The Yuan dynasty dish illustrated has an unusual complement of two (fig. 98). On later porcelains these fish were replaced by leaping carp. Such ornament was popular in export markets, as were other animal designs, and a long series of porcelains decorated with fish were made at other kilns besides Jingdezhen.

Flower sprays

Although flower sprays and related designs may seem something of a misfit in this chapter, they are treated here because they occupy a central position on Chinese silverware and porcelain, taking the place, in many instances, of animal subjects. Unlike animals, flower sprays do not seem to have had any ancient symbolic significance. Large flowers, which appear on silver of the late eighth and ninth centuries, were developed in the decoration of mirrors, particularly mirrors inlaid in shell. This work in shell provided the model for bold layers of gilded silver, employed for both leaves and blooms on the silver bowl in figure 102.[42] The small border of petals along the lip of the bowl is especially characteristic of the genre.

Silver decorated in this way inspired a whole range of flower patterns, both on white porcelains and on green-glazed wares from Yaozhou in Shaanxi province.[43] Often, as on silver, single sprays were placed alone at the centre of porcelain dishes. However, on a few late Song or Jin porcelains of the twelfth to thirteenth centuries, the flowers were placed in a garden, or in a vase, settings borrowed from pictorial representations.[44] Such settings were sometimes employed on Yuan porcelains, but flowers were as frequently used as fillers for lobed panels. Once such panels declined in importance, single flower sprays were reintroduced, and the process of providing settings for these sprays started again. Indeed, like the animal designs, flower patterns on Song and Yuan porcelains were often shown in surroundings that hinted at a picture rather than simply a decorated surface.[45]

One design in particular, prunus sprays, seems to have had a very close relationship with paintings.[46] Early examples used as ornament are found on silver vessels excavated from a late twelfth-century tomb at Huayueling in Jiangsu province.[47] A related cup in the British Museum is illustrated in figure 103. The asymmetrical arrangement of the design suggests that it may have

Fig. 102 Silver dish with gilded decoration of large flower sprays and petalled border, Tang dynasty, 9th century. Diam. 24.3 cm. After Sotheby's auction catalogue, 12 December 1978, lot 245.

Fig. 103 Silver cup decorated with a spray of prunus blossom and a crescent moon, Southern Song dynasty, 12th–13th centuries. Diam. 7 cm. British Museum; celadon-glazed dish with a prunus tree, crescent moon and bat, Yuan dynasty, 13th–14th centuries. Diam. 12 cm. British Museum.

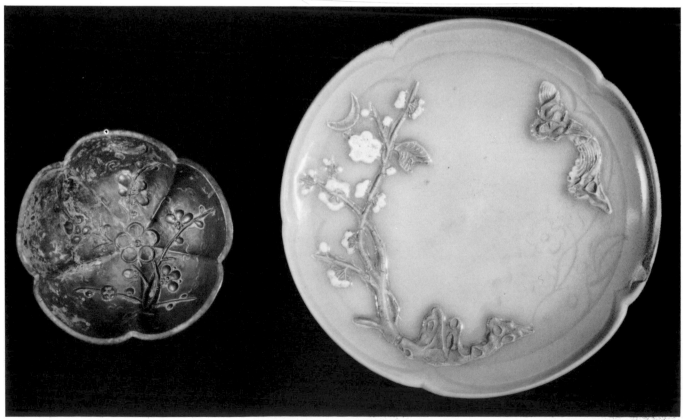

Fig. 104 Decoration on a porcelain bottle of plants, including the Three Friends of Winter, prunus, pine and bamboo, in underglaze red, late Yuan or Ming dynasty, late 14th century. H. 26.7 cm. British Museum.

been borrowed from painting and was not simply developed from Tang-dynasty flower sprays. At a similar date, prunus sprays were used on the southern stonewares, known as Jizhou ware, and may also have been employed on lacquers, inlaid in shell, now lost.

In the following century, single prunus sprays were used as ceramic ornament in both north and south China, culminating in the decoration on a celadon dish in figure 103.[48] The design achieved a new prominence in the latter part of the fourteenth century, when flower patterns of several kinds replaced many of the animal subjects on the finest Jingdezhen porcelains. Decoration on a late fourteenth-century porcelain bottle is typical of a new formula in which the prunus was associated with other garden plants, in particular the pine and bamboo, to make a trio later known as the Three Friends of Winter (fig. 104). This assemblage is somewhat like the compilations of plants used as settings for animals (fig. 87). The plants have been added one after another, until a planted garden is suggested, but we are not truly led to believe that we are looking at a real garden. A later example of the same subject is more sophisticated and appears to have benefited from examples of the same composition in paintings. On an early fifteenth-century flask, pine, prunus and bamboo spread freely over the surface (fig. 105). Their branches are, however, interrupted by the boundaries of the decorated field, a device very popular in Chinese flower and bird painting. This last example achieves most closely the suggestion of a picture of the real world.

Indeed, all the animal subjects and flowers described in this chapter convey an impression of a real scene or even of an illustration to a narrative, feelings that are not aroused by the flower scrolls described in Chapter 2. We understand both animals and plants as having an existence outside the decoration of the buildings and bowls on which they appear. Furthermore, the implied movement of the creatures and the settings of the plants lead us to suppose that we are glimpsing only a detail of a scene or an episode that continues out of our sight; but we should not allow ourselves to be deceived by this effect. When, for example, animals and flowers were painted on porcelains, very little narrative was intended. It is unlikely that the vestiges of the ancient animal symbolism were of any significance, otherwise these creatures would not have been employed to decorate dishes intended in the main for export. Such ornament was probably chosen because it was pleasing and deemed appropriate to the item on which it was used. Moreover, unknown to themselves, the potters were exploiting our wish to explore and understand

Fig. 105 Decoration of prunus, pine and bamboo, from a porcelain flask painted in underglaze blue, Ming dynasty, Xuande mark and period (1426–35). British Museum.

what we see. Animal and flower subjects are particularly effective because they are evocative of creatures and plants of the world in which we live. When they are supplied with settings, such themes approach a narrative picture and engage our attention as we endeavour to read them. However, in inventing such designs, the potters had turned neither to narrative painting nor to real life for their inspiration. Just as the craftsmen who had invented the flower scrolls had in the main used existing ornaments as the basis for new designs, so the potters who exploited the animal and garden motifs also used existing ornamental tradition as their source. We are looking not at narrative or symbolic depictions but at ornament that achieves its effect by exploiting responses developed for reading narrative or symbolic images.

4 Flowers and frames

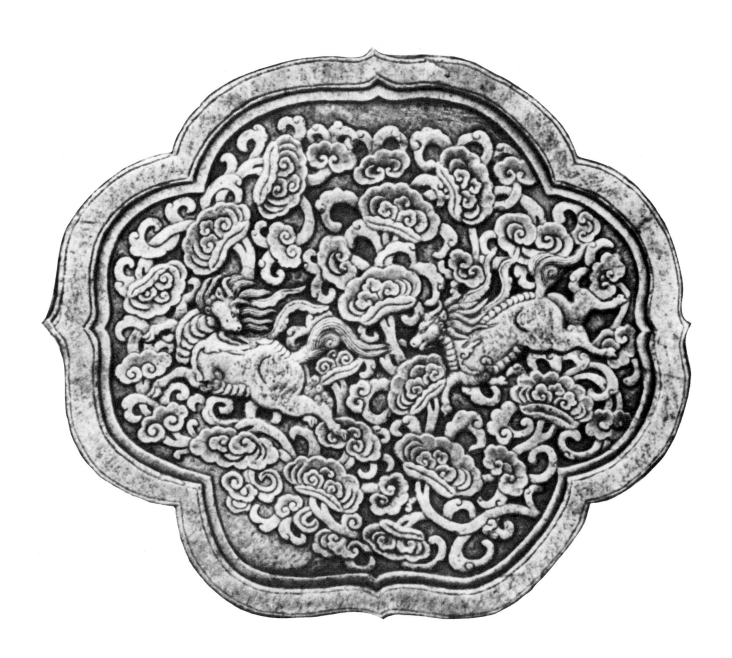

The lotus

The lotus has already been incidentally described as one of several flower scrolls on Chinese porcelain. When attached to long twining stems, lotus flowers with small pointed petals were no more than an alternative to peonies fitted into the framework of a half-palmette scroll. However, another lotus pattern, derived from a separate source, was employed at the same date or even earlier. From the time Buddhism was introduced to China, large single lotus heads, their petals spread out in a circle, were used in cave decorations, on ceilings (fig. 48a) and as pedestals for Buddhist images.

Lotus pedestals were usually quite unlike the real flower. For example, a small stone base, found in the tomb of Sima Jinlong at Datong (fig. 106), which is similar to many bases that support figures of the Buddha and Bodhisattvas, consists of a ring of large petals, each divided by two rounded ridges. Such petals were allied to the lobed and pointed outlines seen in horizontal borders in the Yungang caves (fig. 14).[1] These borders had derived their shape from the enrichment of a Western moulding, and not from a plant. However, when the petals of these long horizontal borders were reused in a circle, they were easily interpreted as lotus flowers.

Lotus flowers on ceilings were generally slightly more realistic. The practice of decorating ceilings with lotus flowers, often contained within a grid framework, was, together with the arrangement of niches, their frames and borders, borrowed from Western architecture. Imitations of wooden coffered ceilings framing small flower heads were widely used in the Hellenistic and Roman world: especially complex examples were constructed in the temples at Palmyra. Flowers within these Near Eastern ceiling grids were not true lotus heads: generally a small flower was displayed with four petals alternating with acanthus leaves. In China early caves at Yungang were similarly decorated with lotus flowers within a rather florid interpretation of a coffered ceiling. These geometric arrangements do not always seem to have suited local taste, and ceilings with single large lotus flowers were also carved. By the sixth century, they had come to dominate ceiling design, as illustrated in a detail from a cave at Dunhuang (fig. 48a). Such flowers generally have large petals, uninterrupted by the lobes seen on the stone base in figure 106.

Single lotus flowers were borrowed at quite an early date for the decoration of ceramics, as on a bottle dating from the fifth century found in Rui'an Xian in Zhejiang province (fig. 107).[2] On the shoulders, large petals alternate with small points, suggesting a glimpse of a second layer of petals. A significant detail of this outline is the sharp point into which the s-shaped outline of each petal is drawn. This is not, however, a conspicuous feature of the lotus; it was related to the sharp point of the Indian *chaitya* arch. This pointed outline, which is seen on the base of a gold casket known as the Bimran reliquary (fig. 110), was often employed by the Kushans to depict the petals of a lotus. Thus the Chinese gained from Central Asia both the shape of the niche and a distinctive outline for the lotus.

Production of ceramics decorated with lotus petals was probably influenced by the prestige of Buddhism. They were particularly popular on early fine green-glazed stonewares made in Zhejiang province, and on later celadons from Longquan, also in Zhejiang, which perpetuated the southern greenware tradition. An exotic greenware vessel made in the north has already been mentioned (fig. 56). Lotus petals on Northern Song porcelains, particularly Ding ware, reflect the high regard for Buddhism in that period. Deposits of Ding ware vessels have been excavated from the bases of two pagodas in Ding Xian;

Fig. 106 Stone base with lobed petals arranged in the shape of a lotus, from the tomb of Sima Jinlong (d. 484), excavated at Datong, Shanxi province, Northern Wei dynasty. W. 32 cm.

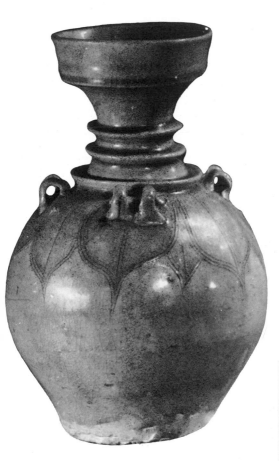

Fig. 107 Green-glazed flask, decorated with incised lotus petals, from Rui'an, Zhejiang province, Southern Dynasties period, 5th century. H. 26 cm. Zhejiang Provincial Museum.

a dish from these deposits is inscribed with a date equivalent to 977.[3] These early Song Ding wares included incense burners, water sprinklers and conch shells, all made for use in the worship of the Buddha. A ewer in the British Museum belongs to this early Song tradition (fig. 108). Shaped as a gourd, it is carved with several tiers of petals. These petals are narrow, replacing the broad pointed forms seen in Buddhist architecture with an outline that attempted to suggest the petals of a real flower.

At the same time, and perhaps for the same reasons, depictions of the lotus were used as ornament. Such motifs differed radically from lotus scrolls, shown on half-palmette stems with small pointed leaves, as they seem to have been intended as fairly realistic representations. Incised ornament on a Ding ware bowl of the Northern Song period can be taken as an example (fig. 109).

The design is dominated by a large flower head with pointed petals attached to a coiled stem, which also supports a lotus leaf shaped like a shallow wide cup with a deeply undulating edge. When seen in profile, the large round leaf of the lotus often takes on this form, as illustrated in the Introduction (fig. 9). Before such lotus leaves were used in ornament, they had already become familiar

Fig. 108 Porcelain ewer with carved lotus petals, Ding ware, Northern Song period, 11th–12th centuries. H. 22.8 cm. British Museum.

through decorative painting. Other features of the ornament on the Ding ware bowl can be compared with the peony scrolls discussed in Chapter 2, notably the small curling fronds along the stalk and the two pointed petal groups at the right-hand side of the motif. These latter devices appear at first sight to represent flower heads. However, a flower limited to two short petals at right angles to one long one is not found in the natural lotus plant. This pseudo-flower seems to be a new reading given to the pointed leaves derived from palmette forms, illustrated in detail in figure 65. The two short petals replace the two volutes of the pointed leaf, while the long petal takes over the position of the main part of the elongated leaf. This pair of tri-petalled flowers survived as part of the lotus designs used on later ceramics, as illustrated by a fourteenth-century dish, painted in underglaze blue, discussed in Chapter 5 for its comparison with Islamic designs (fig. 152). The dish is decorated with two lotus plants, each of them displaying two small flowers at the outer edges of the decorated field which have nothing to do with real lotuses. All these minor flowers are shown with three pointed petals, apparently descended from the flower-like interpretations of a pointed leaf, seen first on decoration of Ding ware.[4]

Between the Northern Song, which saw depictions of the lotus plant adopted as a central motif in porcelain decoration, and the fourteenth century, when the design was once again given considerable prominence, realistic lotus motifs seem to have receded in importance, being replaced at the centre of

dishes by peonies. In the thirteenth century, lotus plants were used in subordinate positions, filling the cavetto or side of a dish, rather than the main field, as shown on Ding ware dishes discussed in connection with deer and fish motifs above (figs 91, 101). Later, fourteenth-century designs were particularly influential in the Near East and are discussed in Chapter 5.

Frames

The use of the lotus flower outline as a frame is a quite separate development. A dish in the Ardebil Shrine, already illustrated for its design of phoenixes, displays both a complete foliate frame and two tiers of detached lobed outlines (fig. 86). The frames used in complicated decorative schemes on fourteenth-century porcelain may be divided into two types: complete lobed enclosures and separate lobed sections. These two forms were available from different sources: complete lobed enclosures were taken from the outline of silver dishes and silver and lacquer boxes; separate lobed sections were derived from openings developed first in architecture and later in furniture, lacquer, and silver. These two sources will be considered in turn. Cloud collars, although part of this same development, will be described later (see p. 132).

The history of complete lobed frames starts, rather surprisingly, not with silver dishes or ceramics, as we might expect from the previous discussion, but with mirrors. For although, from the Tang period, the outline of a lotus was occasionally used for silver and ceramic dishes,[5] it was on mirrors that the shape was most widely employed. Han dynasty mirrors, used to symbolise the universe and the forces within it, have already been mentioned (see p. 92). Tang dynasty mirrors cast in the shape of a lotus, similar to the lotus outline on the Bimran reliquary (fig. 110), combined the symbolic associations of these more ancient mirrors with the demands of a new religion. A mirror in the British Museum, undecorated save for a small ring of lobed heads around a central knob, illustrates this lotus form, the petals of which are sometimes described as bracket-shaped (fig. 111).

Mirrors were always regarded as precious and were often held in boxes made of silver or lacquer. A few lacquer examples are preserved in the Shōsōin in Japan (fig. 112). Such boxes follow the shape of the mirrors contained within them very closely and were therefore made in the shape of lotuses with bracketed rims. Both silver and lacquer boxes were decorated with similar ornament – indeed, lacquer boxes were often inlaid or painted in silver to match the silver ones more closely.

Lobed and bracketed forms could take several other shapes. Simple lotus outlines could be altered by adding an additional lobe either side of each bracket (fig. 113a). This shape was often used for mirrors and the boxes that contained them. Alternatively, a lozenge shape could be produced by adding an extra lobe to one pair of brackets on a dish with four points and not to the other one, as on the silver dish, decorated with a pair of small birds, described above (fig. 83). A quite different effect was achieved by depressing the point of a bracket and enlarging its lobes. A silver dish in the British Museum is outlined by four such brackets; because the points are much reduced in size, attention is drawn to the curves, and the original bracket shape is thus disguised (fig. 113c). Related shapes were widely used both for the outlines of lacquer containers and as panels on boxes and trays. They were well matched with another type of enclosure composed of simple arcs, seen both in the adjacent figure (fig. 113b) and on mirrors discussed above (fig. 76). These arcs were not

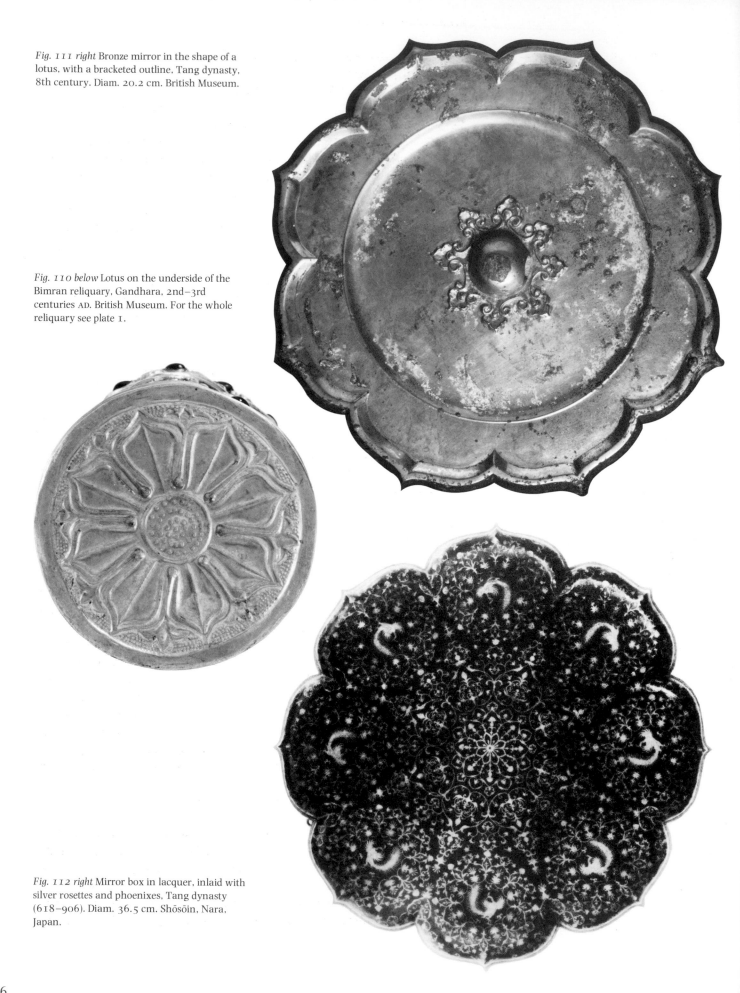

Fig. 111 right Bronze mirror in the shape of a lotus, with a bracketed outline, Tang dynasty, 8th century. Diam. 20.2 cm. British Museum.

Fig. 110 below Lotus on the underside of the Bimran reliquary, Gandhara, 2nd–3rd centuries AD. British Museum. For the whole reliquary see plate 1.

Fig. 112 right Mirror box in lacquer, inlaid with silver rosettes and phoenixes, Tang dynasty (618–906). Diam. 36.5 cm. Shōsōin, Nara, Japan.

Fig. 113 Lobed outlines

a bronze mirror, Tang dynasty (618–906). British Museum.

b bronze mirror, Tang dynasty (618–906). British Museum.

c silver dish said to come from Beihuangshan, near Xi'an, 10th century. British Museum.

derived from the bracket shapes, but were borrowed from the outline of a common type of silver bowl. Panels with rounded outlines were, however, used alongside the bracket shapes as frames for animals and birds.

Constant repetition of birds or other Chinese creatures on lobed boxes and dishes seems to have established a link between the bracketed outlines and creatures. Lobed and bracketed shapes may even have become an integral part of the animal ornament. Indeed, the dense compositions developed within the panels probably encouraged a continued use of frames as every corner of the panels defined by foliate frames was filled with flowers or clouds as a background to the creatures. Had these intricate designs been used without a border, there would have been no compelling reason why the clouds or foliage should have remained densely wrapped around the animals. It would appear that some ornament of birds or other creatures came to require a frame to define the composition. The strength of this convention is demonstrated by the use of lobed panels to enclose animals or birds in the decoration of larger areas. Several examples have been illustrated, including a fourteenth-century lacquer sutra box, now in the Daitokuji Temple in Japan (fig. 84), and a stone slab from the site of the Yuan capital of Dadu at Peking (fig. 82).

When repeated on a single item, the panels, rather than the motifs they contain, seem to demand our attention. This effect can be examined on a number of Yuan porcelains, including a jar in the Fitzwilliam Museum (fig. 114). Lozenge-shaped panels fill the central area of the jar, and their complex outlines are balanced by further panels around the shoulders and the foot. All the panels are filled by small intricate designs, and the background is covered by tight scrolling. The outlines of the panels are essential to subdivide this almost confusing ornament. Indeed, their curves provide the most stable element in the restless design, with the effect that the viewer is inclined to concentrate on the lobed outlines rather than on the details of individual motifs. A similar effect is seen on the dish from the Ardebil Shrine, described above (fig. 86). Here a regular rhythm is established by the repetition of small lobed sections around the main foliate frame.

These subsidiary frames were first used as openings and ornaments in architecture. To complete the description of the sources of the varied lobed frames, which make up these dense compositions, it is therefore necessary to consider the early uses of such frames. The starting-point coincides with the introduction of Buddhism and the use of the Indian *chaitya* arch to outline niches that contained Buddhist figures. As a frame for a figure, the bracketed shape defined an opening rather than a solid panel. Examples from cave 7 at Yungang are illustrated in Chapter 1 (fig. 14). At the same time related openings were outlined by s-shaped scrolls, also borrowed from the West, which were combined with tiny brackets in openings of sixth-century stands, and are illustrated at the head of a series of niche and furniture panels in figures 115a, b, 140b.[6]

By the Tang period, brackets had been established as the upper boundaries of openings on both large and small stands. In paintings we find examples of large stands used for sitting on.[7] These seats consist of a flat platform with a series of arched openings between the upper surface and a lower bar. A similar arrangement was used for small boxes, chests and tables, of which examples are preserved in the Shōsōin. Several alternative arrangements of lobes are shown in figure 115c. The sides of the openings are drawn inwards towards a lower rail, which braces the whole construction. Lobed and pointed openings

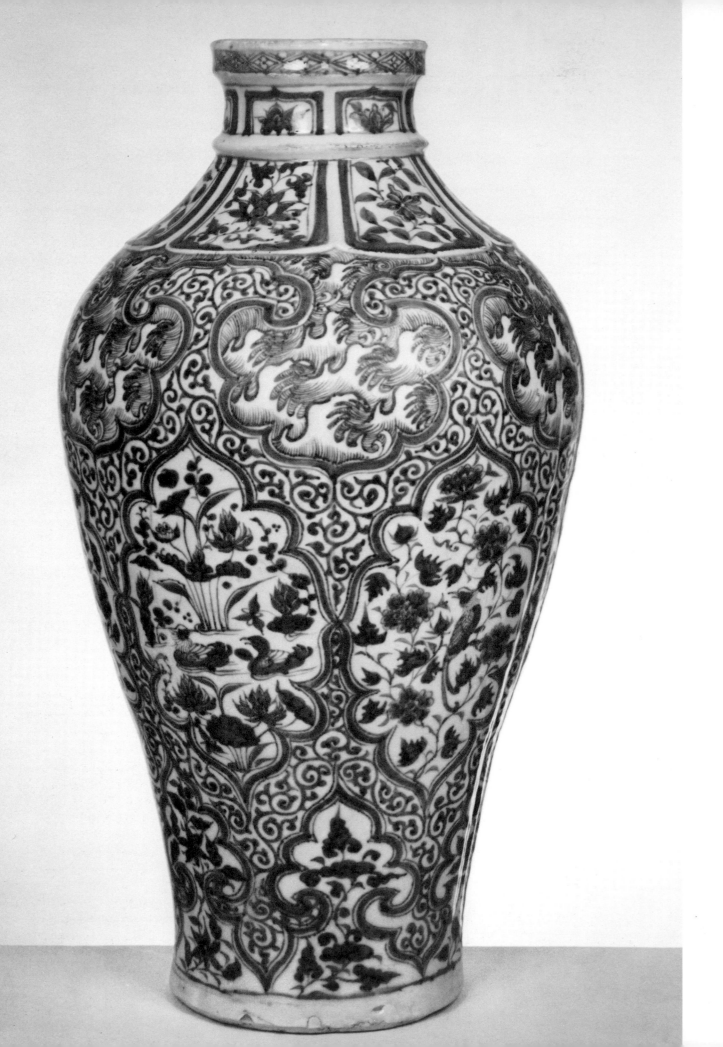

Fig. 115 Lobed openings in stands, boxes and architecture:

a opening in a stone base, Northern Qi or Sui dynasties, 6th century. Freer Gallery of Art. After Tokyo 1972, pl. 51.

b opening in a stand for a gilt-bronze figure of the Buddha, Sui dynasty, 593. Museum of Fine Arts, Boston. After Tokyo 1972, pl. 50.

c three openings in wooden stands for furniture and boxes, Tang period, 8th–9th centuries. Shōsōin, Nara, Japan. After Tokyo 1978b, figs 22, 96, 108.

d opening in a stone stand from the tomb of Wang Jian (d. 918), Five Dynasties period. After Beijing 1964, fig. 39.

e opening in the stand for an outer coffin in the form of a house, excavated at Yemaotai at Faku Xian, Liaoning province, Liao dynasty, late 10th century. After *Wenwu* 1975.12, p. 53, fig. 7.

f four details from a replica of a wooden interior, from a tomb at Jishan, Shanxi province, Jin dynasty, late 12th century. After *Wenwu* 1983.1, pp. 45–63.

Fig. 114 Porcelain jar with motifs enclosed in various lobed panels, Yuan dynasty, 14th century. H. 45.2 cm. Fitzwilliam Museum.

were more easily carved in wood than in stone, and in the softer material could be much elaborated. Some of these more complicated shapes appeared as ornamental frames on musical instruments. Figure 121 illustrates two examples from the Shōsōin, together with a small trefoil-shaped panel taken from a silver stand of the same period, the Tang dynasty. Such decorative outlines anticipated the shapes of doors and panels in wooden architecture of the twelfth century.

While very few pieces of wooden furniture or boxes have survived from the period between the late Tang and the Song and Jin dynasties, we know from a number of pieces of tomb furniture that bracketed openings were widely used. A stone support from the tomb of Wang Jian (d. 918) reproduces the outline of a large piece of furniture, with openings shown within the stand forming frames for animals and figures (fig. 115d).[8] Openings of the same shape were also employed on a stand for a replica of a small house, which served as the outer coffin in a late tenth-century tomb in Liaoning (fig. 115e).[9]

Tombs of the twelfth and thirteenth centuries, constructed in north China under the foreign Jin dynasty (1115–1234), show a sudden flowering of ornament based upon decorative woodwork. Wooden architecture was

reproduced in considerable detail in tombs in Henan and especially Shanxi province. A brick tomb from Jishan, dated to the second half of the twelfth century, is one of the most complex examples discovered so far (fig. 115f). Not only are all the doors decorated with small lattice patterns, but lobed panels, often filled with figures, are set in the lower sections of the doorways and also on the representation of the platform, on which the replica of the wooden building stands. The most complicated shapes are reserved for arched openings framing pairs of panels. By the twelfth century, a complex vocabulary of lobed panels and openings was thus widely used in furniture and wooden architecture.[10]

Many of the distinctive panels used in architecture appear on Chinese ceramics. Lobed panels, similar to the many openings in wooden stands, were particularly popular on northern stonewares as frames for animals and

Fig. 116 Lacquered casket with appliqué and gold painted designs from the Huiguang pagoda, Rui'an in Zhejiang province, Song dynasty, before 1042. H. 41.3 cm. After Beijing 1972b, pl. 182.

figures; horizontal panels lobed across the short ends are found in the same ceramic type (fig. 117). However, potters are unlikely to have adopted these shapes directly from wooden buildings. As with panels described earlier, an intermediate stage between architecture and ceramics was probably supplied by silver and lacquerwork.

Boxes from the foundation deposit of a pagoda dating to before 1043 at Rui'an in Zhejiang contribute to the discussion. Although a number of boxes intended to hold sutras (Buddhist scriptures) were recovered, only one has been published in a clear photograph. The box, which is vertical in format and placed on a low stand (fig. 116), is made of sandalwood and covered with a thin layer of lacquer. Appliqué flowers, which anticipate wood carved in openwork, seen in Jin and Yuan tombs, surround a generously lobed panel, pointed at the top and bottom with rounded lobes between. The main panel is unusual in having only two pointed ends and not the customary four, seen, for example, on the silver dish with birds in figure 83. It is possible that this outline was devised by butting together the outlines of two niche openings, similar to those in figure 115a, b, to make a single enclosure.[11] Further panels are defined on the top of the lid, on its sloping side and on the lower stand. These panels take the straight edges of the container as upper and lower boundaries, with small vertical lobed sections joining them.[12] Floating panels of filigree are placed within the upper lid panels, while small animals appear in the lowest frames.

A lobed panel on a northern stoneware pillow in figure 117 is based upon shapes similar to the frames employed on the stand for the sutra box from Rui'an (fig. 116). This panel is used to frame a figure scene illustrating an ancient story of the journey of a Chinese princess, sent for political reasons to marry a nomadic chieftain. Outside the boundaries of the panel, the surface of the pillow is filled with dense lines representing flowers. Not only the lobed outline of the frame but also the decorative principle of combining a figure scene and dense flower ornament parallel the balance of the decoration on the sutra box.

Figure scenes were widely employed in religious contexts, and similar icons were used in temple painting, text illuminations and on containers such as the Rui'an box; but figures were much less common as decoration on articles of daily use. It would appear that the borrowing of whole decorative compositions, flowers, frames and figures from lacquer boxes (or possibly architecture), brought figure scenes into the repertory of ornament available for use on ceramics such as the pillow in figure 117. On secular items, the

Fig. 117 Stoneware pillow with decoration painted in brown on a white slip, Cizhou type, Jin or Yuan dynasties, 13th–14th centuries. L. 41.7 cm. British Museum.

religious scenes were exchanged for figured compositions illustrating popular stories and dramas.[13]

Architecture, silver and lacquer also contributed another panel shape for the division of porcelain decoration. Small trefoil-shaped openings based on the outline of a single bracket, with or without a lobe on each side, are illustrated from a silver vessel (fig. 121c). This outline reproduced the shape contained within petals of a lotus rosette (fig. 49). Similar openings, also used in architecture and above all lacquer boxes and trays, seem to have provided the model for small detached panels surrounding the frame, enclosing phoenixes, on the Ardebil dish (fig. 86).[14] Heads of the same shape were later used to tip the sceptres, held by figures of Daoist deities and termed *ruyi* sceptres, taking their name from the description of a magical sceptre in a text of the post-Han period.[15] It is unlikely that the lobed and pointed shape was used at that early date. Indeed, surviving sceptres with this outline post-date the Tang silver, Song lacquer and Yuan porcelains that exploit this shape as a decorative frame. A sceptre shape, derived from a widely used ornament, thus acquired an ancient name. While the sceptre may be termed a *ruyi* sceptre, it is misleading to describe the panels as *ruyi* panels, for the name refers to the powers of the sceptre and not to the lobed and pointed shape.[16]

Cloud collars

Lobed and pointed panels, such as those around the neck of the Yuan dynasty vase in the Fitzwilliam Museum (fig. 114), are known as cloud collars, or *yun jian*, because they are thought to be based on the outline of a garment of this name, having four lobed hanging sections joined by a narrow band. A Qing dynasty example (1644–1911) is shown in figure 120c. The panels on the shoulders of the Fitzwilliam jar are similarly arranged. There is, however, some difficulty in establishing an early prototype in textiles for this shape; surviving garments seem to be no earlier than the porcelain ornament, and the majority are much later.

The pre-Qing history of the cloud collar is not straightforward: it is difficult, in fact, to establish at what date such collars were regularly worn. Lobed panels were certainly incorporated into dress from at least the Tang period, when they are found represented on Buddhist guardian figures in painting and sculpture.[17] A painting of the Buddhist Guardian of the North, Vaiśravaṇa, painted in Dunhuang in the ninth century, shows part of a figure with a tiger skin cut in the shape of cloud collar panels around his waist (fig. 118). Other Buddhist figures wear such panels incorporated in their armour. From the Song period, we can find similar panels in the dress of attendants, carved in stone to guard the spirit roads at the tombs of the Song emperors of the eleventh century. On some of these figures, the same outline is used for the hems of tunics.[18] Buddhist images of the twelfth and thirteenth centuries were also adorned with overlapping panels and pendants of this shape.[19]

Although, from the Tang period, lobed panels were widely used in dress, they do not often seem to be shown joined together as a collar either in paintings or on sculpture, exact prototypes in dress for the linked panels of the Fitzwilliam flask are difficult to trace. Uncontroversial textual evidence is also limited. Some Western writers have noted the use of the term *yun jian*, literally 'cloud-shoulder', in the *Jin Shi*, the history of the Jin dynasty.[20] However, their sources seem to be ambiguous. Chinese authorities generally cite a sentence in the chapter on dress in the *Yuan Shi*, the Yuan history, as a reliable source for

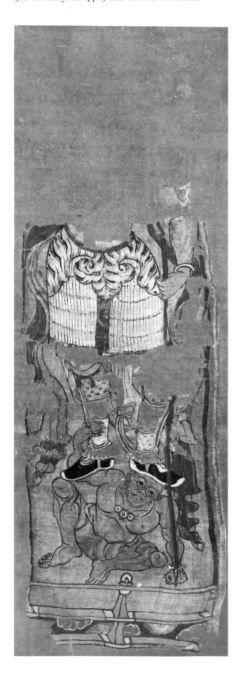

Fig. 118 Fragmentary banner painting of Vaiśravaṇa, Guardian of the North, from Dunhuang, Gansu province, Tang dynasty, late 9th century. H. 47.5 cm. British Museum.

Fig. 119 View of the upper half of a wooden figure to show the lobed collar around his neck. Ming dynasty, 15th–16th centuries. British Museum.

a description of a *yun jian*. Here it is said to consist of four hanging clouds of varied hues, decorated with gold, and is mentioned as a garment or ornament worn by women.[21] As yet no Yuan dynasty examples of *yun jian* have been found. One of the earliest surviving cloud collars seems to be a gold lobed design embroidered on a garment recovered from the tomb of the Ming Prince Zhu Tan (died 1389).[22] Even at that date illustrations in paintings and sculptures are rare. A cloud collar as a garment is shown here carved as part of the dress of a small attendant figure from a group of images of the Ming period (fig. 119).

It is, in fact, misleading to compare lobed ornament on Yuan dynasty flasks and dishes with textile collars. A source in a particular garment is rather

Fig. 121 Lobed panels, Tang period, 8th–9th centuries:

a linked panels on a musical instrument. Shōsōin, Nara, Japan. After Tokyo 1976c, fig. 25.

b complex panels on a musical instrument. Shōsōin, Nara, Japan. After Tokyo 1976c, fig. 34.

c trefoil-shaped opening in a silver stand found at Dingmaoqiao, Dantu, Jiangsu province. After *Wenwu* 1982.11, p. 20, fig. 13.

unlikely for a vessel ornament that is so well integrated with the other lobed panels with which it is used. The lines which delimit the panels around the shoulders of the Fitzwilliam jar consist of lobes and s-shaped curves exactly like those used to define the panels already described. Indeed, the shoulder panels match the outline of the principal lozenge-shaped panels in the body and the small pendants around the foot of the same jar.

The history of lobed linked panels as a decorative outline on vessels can be traced at least as far back as the Tang period. Similar shapes occur as small pierced openings in stands of the Tang period, as illustrated by a detail taken from a silver vessel excavated at Dingmaoqiao in Jiangsu province (fig. 121c).[23] When such small frames were drawn in outline and joined together, a series of linked enclosures was produced, as shown in inlay on a musical instrument in the Shōsōin (fig. 121a). Quite complicated frames of related shapes are illustrated from a second musical instrument in the Shōsōin (fig. 121b). Similar lobes, radiating like the petals of a flower, were frequently used on silver bowls (fig. 120b) and often enclosed small animals and plants.

More elaborate constructions of small lobed and bracketed shapes were also used as the outline of a wooden tray in the Shōsōin (fig. 120a). At the centre stands a four-lobed dish surrounded by four more similar dishes. Each of these outer trays consists of three lobes, the fourth being replaced by one of the lobes of the central dish. The complicated shape and the carved surfaces of the tray indicate that this wooden example was based on a metal prototype. Linked lobed outlines were therefore already available in both metal and wood during the Tang dynasty, well before cloud collars seem to have appeared as part of dress. In later centuries, lobed panels were widely exploited in lacquerwork, as for example in the outlines of canopies suspended above Buddhist figures. It seems likely, therefore, that panels on dishes (fig. 123) and around large flasks (fig. 114) were borrowed from vessels and other utensils in silver or lacquer rather than from textile decoration.

The earliest surviving examples of lobed panels on the shoulders of jars are

Fig. 120

a outline of a complex wooden lobed tray, Tang dynasty, 8th century. Shōsōin, Nara, Japan. After Tokyo 1975, fig. 15.

b lobed panels on a silver bowl found at Hejiacun near Xi'an, Tang dynasty, 8th century. After Beijing 1982a, p. 13.

c outline of a textile cloud collar, Qing dynasty, 18th century. After Cammann 1951, fig. 1.

a

b

c

Fig. 122 Two celadon wine jars decorated with lobed panels inlaid in slip:

a wine jar decorated with ducks and lotus inside a lozenge-shaped panel, Korea, Koryo dynasty, 13th century. H. 29 cm. National Museum of Korea, Seoul. After Goepper and Whitfield 1984, no. 172.

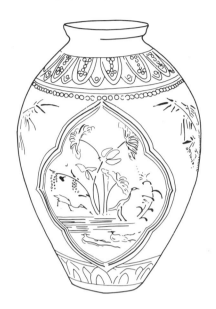

b wine jar decorated with peony and lobed panels around the neck, Korea, Koryo dynasty, 13th century. H. 34.8 cm. Duksoo Palace, Museum of Fine Arts. After Kim and Gompertz 1961, pl. 46.

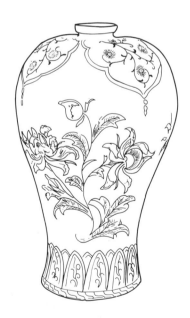

found in Korean flasks, or *meiping* (fig. 122b).[24] At the same time, lozenge-shaped panels were used in similar wine containers (fig. 122a). As these panels are inlaid on the celadon jars in contrasting colours of slip, it seems likely that panels of both shapes were copied from inlaid metalwork or just possibly inlaid lacquer. While it is unlikely that potters at Jingdezhen, who made the Fitzwilliam jar, were familiar with earlier Korean celadons, it is possible that potters in the two areas were stimulated by a common prototype, for southeast China and Korea were closely linked by trade, as shared traditions in the manufacture of green-glazed ceramics demonstrate.

An unusual dish in a private collection illustrates a Yuan dynasty example in which lobed panels are employed as separate motifs, rather than as a linked series making a collar (fig. 123). Six large panels hang from the rim towards the centre of the dish, where a further six frames are butted together to provide a medallion containing a scene of birds in a lotus pond (see Chapter 5). The six outer panels are each filled with small dense patterns. In both positions, the frames are made up of independent lobed sections. Although it is not known whether the dish has priority of date over the jar in the Fitzwilliam Museum, it certainly refers to earlier and less sophisticated uses of the panels. Sherds of Chinese porcelain found at Delhi demonstrate that these combinations of lobed and pointed panels, which do not necessarily suggest the outline of a later textile collar, were quite common.[25]

Indeed, even when the well-spaced panels on the shoulders of the Fitzwilliam jar are drawn as though they were joined to make some sort of collar, it is interesting to observe that they coexist with a different arrangement of frames around the foot of the same container. Although closely related to the upper panels, the lobed outlines that project from the base, containing a plant in blue against a white ground, are not linked in the same way and therefore do not resemble the layout of the upper series.

These varied uses of lobed and pointed panels on Yuan dynasty porcelains indicate perhaps that they are the products of an experimental stage, in which a variety of arrangements was tried out. In this series, it would appear that the cloud collar, that is to say four lobed panels linked by a thin band lobed in the reverse direction, was only one of several possible schemes.

Densely organised decoration on Yuan dynasty porcelains, to which these lobed and pointed panels contributed, has sometimes been treated as evidence of Islamic influence on the Chinese porcelain industry.[26] However, lobed and pointed panels were as Chinese as dragon and flower motifs. Indeed, their regular use alongside Buddhist and Daoist symbols underlines their Far Eastern origins. Similarly, the vessel shapes can be explained in terms of traditional Chinese metalwork and ceramic shapes.[27] Neither the shapes nor the decoration, therefore, are directly based on Islamic prototypes. On the other hand, it seems likely that both the manufacture of dishes of very large diameter and the use of underglaze blue were stimulated by demands made by foreign traders.

Dishes of large size and the use of underglaze blue required some changes in the approach to porcelain decoration. A large vessel surface needed careful ordering, which could be supplied by divisions arranged in concentric circles. This system simply extended the decorative schemes already available on silver, ceramics and even bronzes.[28] Combinations of panels, widely available in the decoration of silver and lacquerware and in a variety of ceramics, offered an alternative approach. In both lacquer and ceramics with coloured glazes,

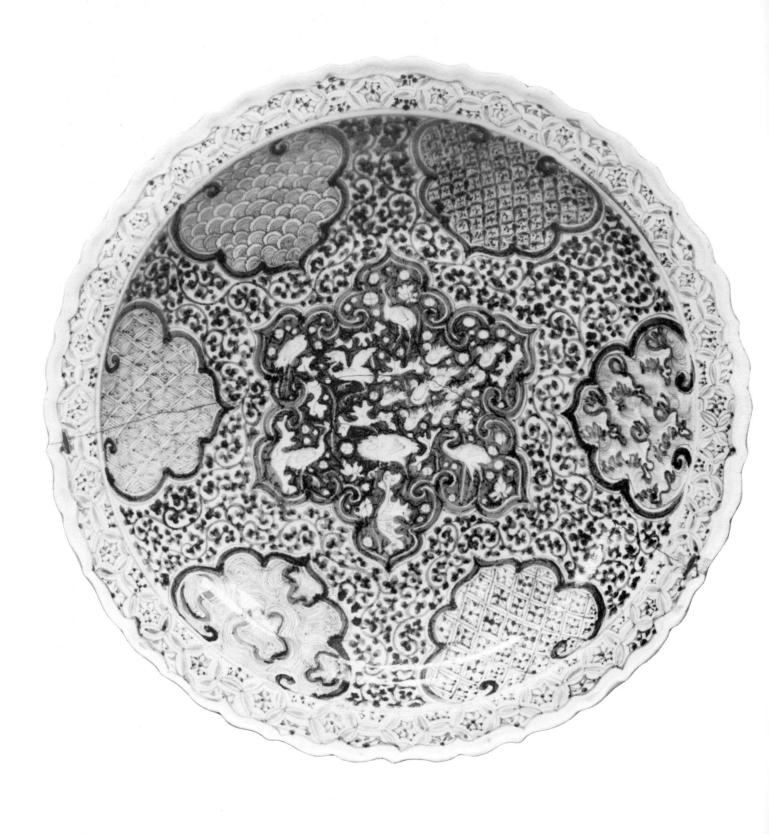

Fig. 123 Porcelain dish decorated with lobed panels around the rim and at the centre in underglaze blue, Yuan dynasty, 14th century. Diam. 46 cm. Private collection.

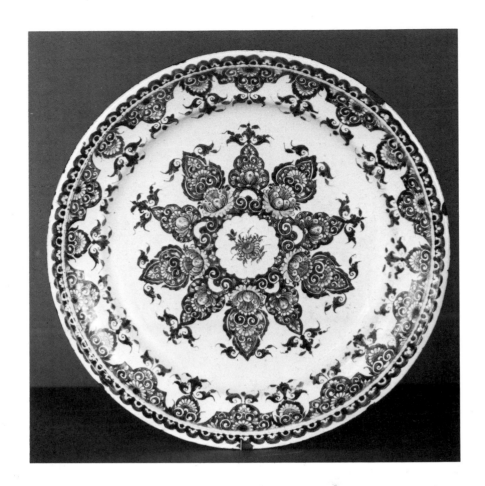

Fig. 124 Earthenware dish, decorated in blue, with lobed panels enclosing flowers, on a white glaze, from Rouen, France, 18th century. Diam. 24.2 cm. Victoria and Albert Museum.

contrasts of colour were also already in use to emphasise designs.[29] When, therefore, a demand arose for large porcelain vessels decorated in blue, the potters at Jingdezhen turned, perhaps, to lacquerwork and materials with related decoration, on which designs of lobed panels and contrasting colours were well known. These innovations in porcelain decoration were certainly popular abroad: almost all surviving examples of porcelains with complex decoration defined by lobed panels have been found in South-East Asia, India or the Near East, many preserved in the great collections of the Ardebil Shrine and the Topkapi Saray.

Chinese porcelains decorated with lobed panels inspired potters in both the Near East and in Europe to make their own versions. A large bowl from the Ottoman kilns at Iznik, made in the early sixteenth century, was loosely based on a Chinese porcelain of the fourteenth century (pl. 11). Five large panels hang from the rim towards the centre of the dish basin and, as with the many Chinese examples, they are joined along the rim. This detail, in particular, suggests that the ornament must have referred to a Chinese prototype; however, the outline of the pendant lobes is entirely of local inspiration. Each section consists of a third of a well-known panel type, used in the Near East on metalwork and book-bindings.[30] Examples from binding are described in Chapter 5 (fig. 143). Thus the plan of the ornament is Chinese, but the detail is Islamic. Alternating with the lobed pendants, diamond-shaped panels enclose Chinese motifs (see Chapter 5). It may be supposed that this combination of panels was intended to contribute a dense and fragmented effect similar to the compositions on Yuan dynasty porcelain.

In the same way, the lobed panels of Chinese ornament provided a framework that was imaginatively adapted by European potters. The sources of European motifs, seen for example on a small tin-glazed dish made at Rouen (fig. 124), were provided not by fourteenth-century dishes themselves, but by eighteenth-century Chinese porcelains, which perpetuated the tradition by reproducing the by now well-established textile collar as a border for dishes and saucers.[31] A border of pendant lobes around the rim of the Rouen dish is based upon an eighteenth-century pattern. Such pendants are also freely used at the centre of the dish to make a flower shape. Within these different panels, white flowers emerge as a new reading of this unfamiliar Chinese design. Heavy dark borders on many blue decorated wares were enriched with a variety of small patterns. As the Chinese collar was domesticated in Europe, its source was forgotten and attention was concentrated on the motifs within the panels.

Filler patterns

Multi-lobed panels on Yuan dynasty porcelains were enthusiastically filled by potters with a number of small textured patterns. Indeed, the lavish use of boundaries to divide the surface first of lacquer and then of porcelain may have stimulated an interest in repetitive designs that could be used to fill up the areas these frames defined. Nowhere is this better illustrated than on the dish described above (fig. 123). Apart from the scene of water birds and lotuses at the centre, the six other panels around the cavetto of the dish each contain a different motif; another design covers the rim. Such small ornamental devices had been used in China for some time, but they achieved a new prominence on Yuan dynasty porcelain.[32]

Clouds and waves

Crested waves, drawn within the lobed panels on the shoulders of the Fitzwilliam jar, were also widely exploited around the rims of large dishes. A discussion of waves cannot be separated from an account of clouds. Clouds, among which immortals could ride above the earth, became a favourite motif as the cult of immortality gathered pace under the patronage of the formidable Qin emperor (221–209 BC). Early depictions of clouds were achieved by adding small curls and scrolls to long-used geometric designs, as illustrated already in connection with the ornament of the Han dynasty coffin from Changsha (fig. 45). As the art of lacquer painting progressed, such angular motifs were exchanged for long sweeping diagonal lines, tipped, as before, with small scrolls. When carved in stone, the extended lines were difficult to carve and perhaps confused the pattern. Thus on sixth-century bricks representing the animals of the four directions (fig. 67), the Heavens are suggested by small, dense comma-shaped strokes. Additionally, at the centre of the section of the tablet for Yuan Hui depicting the Tiger of the West, a small flower is placed, constructed as always from parts of half-palmettes. At its centre, a full palmette rises above a lotus; at either side are half-palmettes, and further half palmettes are attached to the base of the lotus. In the fifth and sixth centuries, similar half-palmette flowers were used in place of clouds, as though the air was full of blossoms. Thus small flowers surround the lion in figure 93.

As with so much else in Chinese ornament, the invention of peony scrolls in the late seventh century made available completely new forms on which clouds could be based. For example, the flowers on the cover of the epitaph

Fig. 125 Drawings to illustrate Chinese cloud patterns

a lobed flower head from the border of the epitaph tablet for Wang Gan, Tang dynasty, 693 (see fig. 51a).

b lobed heads treated as clouds in the outer border of the epitaph cover for the wife of Yang Zhiyi, Tang dynasty, early 8th century. After Xi'an 1953, no. 55.

c clouds from a stone slab found at the Qianling near Xi'an, Tang dynasty, 7th–8th centuries. After *Kaogu yu wenwu* 1983.1, p. 29, fig. 2.

d clouds on a slab now in the Gugong in Peking, Tang dynasty (618–906). After Beijing 1982a, p. 69.

e clouds on a porcelain stem cup, Yuan dynasty, 14th century. British Museum.

tablet for Wang Gan (fig. 125a) provided new shapes that could be detached from the stem and laid out as a row of separate heads (fig. 125b). Some epitaph tablets of the early Tang period show these same lobed heads, first attached to scrolling stems representing flowers, and then also separated as clouds. The second detail in figure 125 is taken from the epitaph tablet cover for the wife of Yang Zhiyi, carved in the early eighth century.[33] The outer border on the tablet consists of a row of separate lobed heads, each supported on two commas, as though they were flowers with dependent sepals.

To make such lobed heads into convincing clouds, internal commas were omitted, and the lobed head was drawn in outline only. This device was already widely adopted in the late seventh and early eighth centuries. Single clouds in a row, rather like the row just illustrated, appear as a border to peony scrolls on an incised stone slab from the Qianling, the tomb of the Tang emperor Gaozong and his consort, Wu Zetian (fig. 125c). A dragon on a stone from the same site is surrounded by more elaborate versions of similar clouds (fig. 74). Here the internal outlines are more than doubled; they have been increased in one instance to three concentric lines. In addition, several lobed heads have been joined together to make a large cloud. Below the dragon's foot the lobed heads are turned back on themselves.[34]

The new interpretation of the lobed heads on the dragon relief is very sophisticated. It was more usual to pile up a number of mushroom-like heads to indicate a dense fog of cloud, as on a carving in the Palace Museum in Peking (fig. 125d). These tiers of mushrooms remained the idiom for clouds in the succeeding centuries. Clouds were particularly popular as vehicles for immortals. A bank of clouds wafts the figures over the waves on the box from the Rui'an pagoda (fig. 116). In a wall-painting from a fourteenth-century temple, the Shui Shen Miao (see Chapter 5, fig. 137), figures in the foreground are surrounded by a curtain of clouds put together from a series of lobed heads, with slight texturing of the edges to suggest a puffy shape. These ornamental clouds are quite sharply differentiated from more realistic patches of clouds and mist used in the background of this painting, and were employed continuously from the Tang dynasty as a decorative device on silver, porcelain and other materials. An example taken from a Yuan dynasty porcelain stem cup in the British Museum is shown in figure 125e.

This lobed shape was also given a new reading as a fungus. For this reason the clouds are sometimes described as fungus-shaped, or indeed as actual fungus. The magical fungus known as *lingzhi* is illustrated as the background to two deer on a stone slab excavated from the site of the Yuan dynasty capital at Peking, Dadu (fig. 126). These plants retain the lobed shape and even the concentric outlines of clouds; stems and tendrils, however, enable us to interpret this configuration as a plant rather than as a cloud. A new reading was thus provided for an old motif.

Cloud conventions also provided inspiration for wave patterns. A detail from an eighth-century painting of the Buddha preaching, now in the British Museum, shows a small figure of an *apsaras*, a heavenly being, sailing down on a bank of clouds alongside a canopy over the Buddha's head (fig. 127).[35] Most of the bank consists of a neatly angled row of lobed heads; but at the front, the clouds tumble and writhe, with two sections interlocking, one upright and the other upside down. This interlocking movement was the main contribution that cloud patterns were to make to wave ornament.

In pictoral scenes derived from painting or prints, such as the illustration of

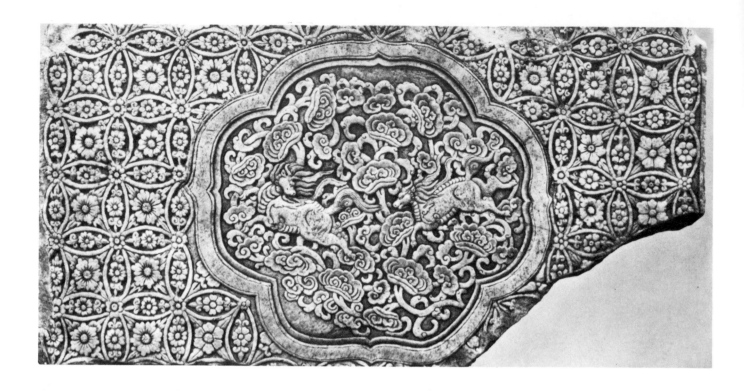

Fig. 126 Stone slab excavated at the site of the Yuan dynasty capital, Dadu, at Peking, Yuan dynasty (1280–1368). After Beijing 1972a, p. 83.

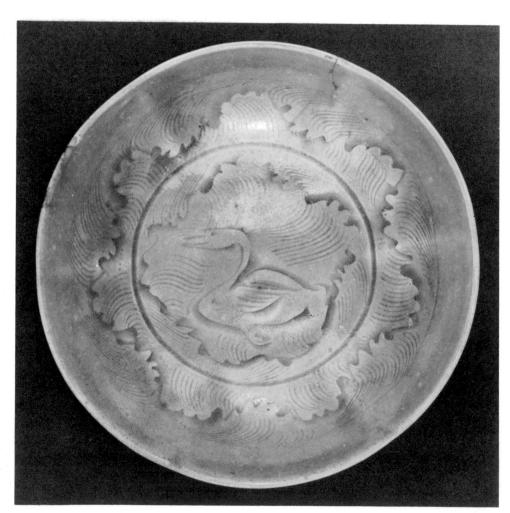

Fig. 128 Northern celadon dish, with an incised design of a duck and waves, Song or Jin dynasties, 11th–12th centuries. Diam. 17.2 cm. British Museum.

Fig. 127 Detail showing an *apsaras* on a bank of clouds, from a banner showing the Buddha preaching, Dunhuang, Gansu province, Tang dynasty, 8th century. British Museum.

gold-painted figures rising on clouds above waves, seen on the eleventh-century lacquer box (fig. 116), the waves are quite realistically shown with small regular peaks. However, in the decoration of some ceramics, waves are not shown by this pictoral convention, but are drawn as lobed outlines alternating in direction, like the clouds. On a celadon dish in the British Museum, breaking waves surround a duck at the centre and fill a narrow outer border (fig. 128).

On later ceramics, perhaps inspired by gold-painted or *qiangjin* lacquer, contrasting colours were used to clarify this design. Waves in the panels of the Fitzwilliam jar consist of upper lobed heads which have been left white to suggest breaking crests, while the lower painted lobes have become the dark hollows of the waves. This formula was also widely used to decorate borders of jars and dishes, but did not survive into the Ming dynasty. In the fifteenth century, the lobed heads in alternating positions were abandoned and waves were indicated in broad undulating brush strokes. Sprays of foam were inserted among the undulating lines. This later convention seems to have been borrowed from painting.

Yuan dynasty wave patterns were later used at the Ottoman kilns at Iznik. However, the potters either misunderstood or wilfully distorted the wave formula, for the results are bizarrely different (pl. 9).[36] A further wave pattern, also seen on Yuan ceramics, was also influential at Iznik. One of the panels on the Yuan dynasty dish in figure 123 is filled with waves represented by small arcs. These neat waves seem to be a pattern based on the fine peaks of water seen, for example, on the lacquer box from the Rui'an pagoda (fig. 116). Such waves are rendered in precise parallel lines. In later paintings with a narrative or religious theme, and on some porcelains, these slightly pointed waves were given a rounded outline. They were likewise reinterpreted by Iznik potters; Ottoman potters replaced the blue of the Jingdezhen porcelains with red or green. With these bright glazes, the blue Chinese waves had been transformed into a shimmer of colour.[37]

Interlacing circles and hexagons

When the Chinese were converted to Buddhism and adopted from Central Asia both the appropriate images and their correct settings in framed niches, they seem to have borrowed a number of minor ornaments at the same time. Two of these ornaments, interlacing circles and hexagons, were to have a wide use in later times.

It is, of course, possible that the Chinese may have invented these simple geometric patterns themselves, without any outside influence. However, there is no evidence for their use before the introduction of Buddhism. Interlacing circles can be seen in the Mediterranean area, painted in the Theban tombs of the New Kingdom in Egypt; the pattern was also known at a very early date as an illustration to ancient Babylonian mathematical texts. The origins of the motifs are less important than their widespread use in the eastern Mediterranean during the Hellenistic and Roman periods, on buildings and in pavements. The same designs were exploited in architecture by the Parthians; examples in stucco have been recovered from Kuh-i Khwaja in Iran and at Seleucia on the Tigris in Iraq.[38] Stone figures from Hatra are clad in elaborately decorated textiles: the tunic and trousers of the individual illustrated in figure 25 are ornamented with interlacing circles. As one of the earliest examples of this ornament in China is seen in a representation of a textile in an early fifth-century cave at Dunhuang, it is possible that the motif first reached China on textiles rather than as architectural decoration. Fragments surviving in the Shōsōin and illustrations of dress in paintings suggest that circles remained popular in textiles.[39]

Fields of interlacing circles became more widely used when included in the repertory of ornament for carved woodwork in the Song and Jin periods. Tombs of the twelfth and thirteenth centuries represent details of domestic buildings that include doors decorated with interlacing circles.[40] A very elaborate example surrounds the panel of deer and fungus on the relief from the Yuan site of Dadu at Peking (fig. 126). Intricate embellishment of tiny rosettes in all segments is paralleled on much earlier Near Eastern examples such as the decoration at Palmyra.

While this type of ornament was thus widely used in architecture, it continued to be important as a textile design. The pattern became equally popular in Japan on all materials, and to meet Japanese taste such ornament was applied to porcelains exported from Jingdezhen to Japan.

Hexagons were used alongside interlacing circles on Hellenistic and Parthian buildings in the Near East.[41] In the Far East, however, hexagons, like the circle pattern, seem to have been closely associated with textiles. Hexagons engraved on a sixth-century coffin bed in the Boston Museum of Fine Arts are outlined by a binding, as though a textile had provided the model for the design. An animal or bird stands within each hexagon. A very similar design features on a piece of silver imported into Korea from Central Asia or Iran, again hinting at a textile binding.[42] Such ornament may therefore imitate textiles with appliqué designs, such as those carved on the portrait sculptures at Hatra, and also reproduced on some stucco sculptures at Dunhuang.[43] Textiles in the Shōsōin illustrate the popularity of the motif in Tang silks, and we may assume that the motif continued in use on textiles of later centuries.

A bronze mirror, probably made in Liaoning in the tenth or eleventh century, appears to represent a textile or perhaps even two textiles (fig. 129). A small mat, decorated with peonies in relief, lies across a background filled with

Fig. 129 Bronze mirror decorated with hexagons, Liao dynasty, 10th–11th centuries. Diam. 16 cm. British Museum.

hexagons. A comparable mirror excavated in Liaoning province is decorated with a field of circles.[44] Once textile patterns had been borrowed to decorate bronzes, casters continued to use such designs to good effect. In the succeeding centuries, hexagons were employed as a background pattern on bronzes, reproducing the impression, but not the correct detail, of the fine cast decoration of ancient ritual vessels. Like the interlacing circles, hexagons seem to have entered the repertory of ornament for woodwork in buildings of the Song and Jin dynasties.[45] Similarly, they were employed in the decoration of porcelains intended for export to Japan.

Classic scrolls and meander patterns

Classic scroll is the name given to a scroll of lines of constant width. In place of leaves contained within half-palmette scrolls, the waves of this scroll were filled with tendrils. Examples are seen on the Yuan dynasty ceramics already discussed (figs 114, 123). As the comparison with the half-palmette implies, the classic scroll was no more than an abstract version of the foliage patterns described in Chapter 2. The undulating stem of the half-palmette scroll provided a very versatile skeleton that was adapted to all sorts of purposes; it was filled with small or large leaves, with clouds or flowers. Alternatively, the leaves could be reduced to semi-abstract lines. This option was frequently adopted, perhaps to avoid designs that referred explicitly to plants. Thus the border around the rim of the Ding ware dish in figure 64a is filled with a small leaf scroll that has been reduced to an abstract pattern. Often such simple

borders were enlivened by joining lines to the simplified leaf within the wave, or by adding frills to the lines. When such designs were rendered in a narrow fine line, the classic scroll of Yuan porcelains resulted (fig. 152). On some of the pots illustrated, it was adapted to provide a dense background (figs 114, 123), but this use did not survive the fall of the Yuan dynasty.

Meander patterns are sometimes called key-fret ornament. As with the interlacing circles, the meander was widely available in the eastern Mediterranean: it was extensively used in Greek and Hellenistic architecture and wall-painting, and it was brought to China as part of the decoration of the interiors of Buddhist cave temples. Painted versions of the meander are especially prolific in the caves of Dunhuang, and a continuous sequence from the Tang period to the Yuan dynasty can be illustrated from such examples.[46] A meander of the Tang period appears in the epitaph tablet for Cui Youfu, shown in figure 54 for its florid peony scroll.

The meander had several distinct phases of popularity. It appears quite prominently in the decoration of porcelain and stoneware from the thirteenth century. Bold borders on Cizhou stoneware were used to define the shape of major panels of figure and flower ornament.[47] On underglaze blue porcelains, meanders were shown in a thin unvaried line, and they therefore approach the fine lines achieved at the same date in bronze casting.

As a result of this concern with dense background patterns and narrow abstract borders, craftsmen seem to have turned to other materials seeking new designs. The leather sections of early Chinese armour offered a surface texture of interlocking ys, seen from the thirteenth century on lacquer and porcelain. Similarly, wooden lattice ornaments in doorways were borrowed for the decoration of ceramics and textiles both in China and Japan. These motifs were also exploited in the Near East from the thirteenth century and provide the first intimations of contact between China and Iran, contact that was to be of much greater importance in the fourteenth and fifteenth centuries.[48]

5
Chinese motifs
in Iranian and Turkish art

Following the Mongol conquests of the thirteenth century, painting styles and decoration in much of the Near East were modified and even transformed by the introduction to Iran of Chinese motifs and painting styles. Under Mongol rule, China and Iran were joined; indeed, for more than half a century, the Il-Khans, the Mongol rulers of Iran, were ultimately subordinate to the Great Khan, who ruled first from Karakorum in Mongolia and then from China. Like their predecessors in northern China – the Khitan, who ruled under the title Liao, and the Jürchen, who took the name Jin for their dynasty – the Mongols seem to have been captivated by the material wealth of the Chinese and to have adopted their dress, furniture and fine utensils in silver, lacquer and porcelain. Such Chinese luxuries may have been the source of Chinese motifs that now became current in Iran. Although the new repertory contains constant references to the flower and animal motifs discussed in previous chapters, these Iranian and later Turkish designs cannot be mistaken for anything Chinese. The introduction of Chinese motifs sparked off a whole chain of new inventions that transformed them into new, almost unrecognisable, decoration. This chapter will first outline the main political changes, from the Mongol conquest to the mid-sixteenth century, that made possible the introduction and dissemination of Chinese painting styles and decorative motifs, and will then consider the separate histories of animal, flower and frame designs inspired by Chinese examples.[1]

Immediately prior to the Mongol invasion, western Iran and Anatolia were ruled by a number of minor dynasties, the successors of the Seljuk Turks, who had themselves entered the Iranian world from Central Asia. Eastern Iran and western Central Asia formed the empire of the Khwarizmshahs. In the thirteenth century, the peace of Central and Western Asia was threatened and then overturned by the Mongols. The awe-inspiring campaigns of Jenghiz Khan are legendary. Following his conquests in Mongolia and the steppes, he turned first towards China, not Western Asia. As he secured control over the northern borders of China, he was drawn to attack the Kara-Khitay, a sinicised Mongol people in eastern Central Asia, and then the State of Khwarizm. Futile attempts by the cities of eastern Iran to deflect the Mongols led to their complete devastation. After Jenghiz had reached the borders of India, however, he withdrew to the Central Asian steppes, and it was left to his sons and grandsons to consolidate his conquests by taking over China and Iraq.[2]

The fate of Western Asia was at the mercy of the successors of Jenghiz. The title and position of Great Khan were first gained by Jenghiz' third son Ögedei, and after Ögedei's death by his great-nephew Möngke, who dispatched his brother Hülegü to subdue the west. First Hülegü took control of the lands to the south of the Oxus and then, in 1258, he sacked Baghdad, the capital of the 'Abbasid Caliphs. In Iran the Mongols ruled from capitals in the north, first at Maragha and later at Tabriz. Their rule was known as the Il-Khanid dynasty, and for much of the thirteenth century they exercised authority in the shadow of the Mongol empire controlled from the Far East. In that time the Il-Khans did not adopt the Islamic faith but patronised both Christianity and Buddhism. Later followers of Islam were careful to suppress all traces of the Buddhist faith. However, excavations of a *vihara*, a Buddhist hall of worship, near Sultaniyya, have revealed a very Chinese-looking dragon, and it may be surmised that similar monuments to Buddhism were widespread in Iran during the early years of Mongol domination.[3] This support for Buddhism may have been one channel whereby Chinese and other East Asian influences reached Iran.

Ghazan, succeeding to the Il-Khanid throne in 1295, was converted to Islam and ended his allegiance to the Great Khan. In 1335, the Il-Khanid empire broke up, and the lands were in due course divided between the Jalairids who ruled the north from Tabriz, and the Injüs, followed by the Muzaffarids, who ruled the south. In the latter part of the fourteenth century, a new threat was posed by the conquests of Timur, a Barlas Turk, whose capital was at Samarkand, in what is today Soviet Central Asia. More than once Timur invaded Iran and Iraq, and in 1398 even reached the banks of the Indus. The period of Timurid rule with which we are concerned is associated with the names of his son Shah Rukh, who ruled over Herat and Tabriz, his two grandsons Iskandar Sultan, who ruled Shiraz, and Ulugh Beg, who ruled Herat and later Samarkand. These particular rulers are of interest because they were great patrons of the arts at a time of renewed interest in all things Chinese. A number of embassies were exchanged by the Ming emperors and the Timurids. In 1407 Shah Rukh returned to China the embassy detained by Timur since 1397; further Chinese embassies reached Herat in 1413 and 1414. A large embassy was sent to China in 1420. In consequence, as Basil Gray has pointed out, a second distinct phase of interest in Chinese styles developed in Iran during the early fifteenth century.[4]

The control of the Timurids was disrupted by the incursions of the nomadic Turkoman tribes. First the Black Sheep, the Qaraqoyunlu, under their ruler Jahan Shah, invaded Herat. After the death of Jahan Shah, the White Sheep, the Aqqoyunlu, seized control. In 1501 power passed to Shah Isma'il, the first ruler of the Safavids. In the mean time the Ottomans, Turkish tribal chieftains, established themselves in Anatolia. In 1324 they conquered Bursa from the Byzantines, gained control of the Balkans, and in 1453 captured Constantinople. The Safavids were defeated in 1514 at the battle of Çaldiran; Syria and Egypt were conquered in 1517.

The Ottomans borrowed from Iran much of the decorative repertory employed in book illustration and on ceramics, textiles and metalwork. This process was intensified when, after their victory at the battle of Çaldiran, the Ottomans sacked Tabriz and captured Iranian craftsmen and works of art. This episode, and subsequent campaigns in Iran, ensured the adoption in Turkey of the Chinese painting styles and decorative motifs already established in Iran.

Ornament and painting under the Il-Khans

In the late thirteenth and early fourteenth centuries, Chinese animal and flower motifs appeared on Near Eastern tiles, metalwork and ceramics, while trees, plants and landscapes in Chinese style were employed in Mongol painting produced in Iran. Such early interpretations of Chinese designs recreate some aspects of the originals fairly precisely and must have been based on the import of items from China, or on material from the lands of Mongolia and Central Asia where Chinese styles were influential. It is also possible that Chinese motifs and styles were disseminated by Chinese and other East Asian craftsmen employed at the cosmopolitan Mongol courts of Karakorum and Maragha.[5]

Tiles decorated with lotus flowers in gold against a dark blue ground are among the earliest surviving examples of the use of Chinese motifs in Iran. Specimens, similar to the tile in figure 130, have been excavated at Takht-i Sulayman, at a hunting lodge constructed for the Il-Khan Abaqa (1265–81).[6] While both the lotus motif and the contrast of gold against a dark ground are

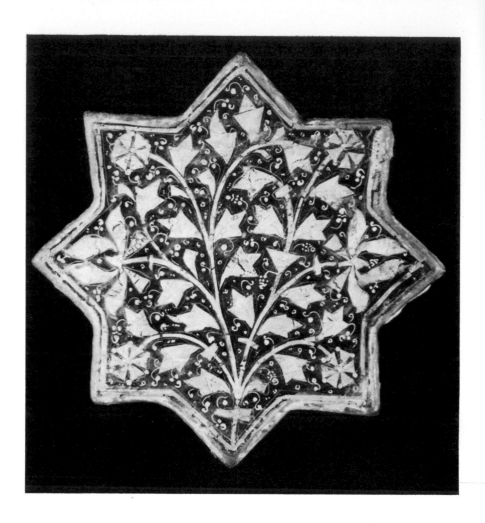

Fig. 130 Tile decorated with lotus flowers on long stalks in gold against a blue ground, Iran, 13th century. W. 19.8 cm. British Museum.

Chinese in origin, the way in which the lotus is depicted departs significantly from Chinese models. Here two lotus flowers are shown on long stalks from which sprout small pointed leaves. In China the lotus was either drawn realistically, with large curly leaves, as on the Ding ware dish in figure 109, or included in a scroll alongside stylised leaves derived from palmettes (fig. 66). The present combination of long stalks and pointed leaves was used in China for peonies rather than for lotuses. Rather later tiles, painted in lustre, were widely decorated with Chinese dragon and phoenix motifs.[7]

Similar creatures are drawn among the decoration of a large early fourteenth-century basin from Iran, now in the Victoria and Albert Museum (fig. 131). These designs are illustrated here alongside similar motifs found in the eleventh-century Liao mausoleum at the Qingling in Liaoning province. At the top of figure 131, the dragon and phoenix are drawn from the decoration of the tombs at the Qingling; below are the same motifs from the basin.[8] The twisted body of the dragon and the plunging flight of the bird are identical in the pairs of examples. Similar dragon and phoenix motifs can be paralleled on many Tang, Song and Jin items in metal, ceramics and textiles. However, the comparison with the decoration of the Liao tombs is particularly interesting, as it is possible that motifs known to the Liao, or the Khitans, were transmitted to other inhabitants of the northern fringes of China, including the western Khitan tribes, the Kara-Khitay, whom the Mongols attacked and destroyed in the thirteenth century.

Fig. 131 Drawing to compare dragon and phoenix designs from the decoration of the 11th-century Liao mausoleum at the Qingling, Liaoning province, with similar ornament on a brass basin of the Mongol period, Iran, *c.*1300. Victoria and Albert Museum

a

c

a, c After Tamura and Kobayashi 1953, p. 201, p. 92.

b

d

b, d After Melikian-Chirvani 1982, no. 93.

In discussing the transmission westwards of motifs and painting styles of manifestly Chinese origin, we are concerned not only with direct borrowings by Iranian craftsmen from China herself, but with a general use of Chinese traditions in Liaoning, Mongolia and Central Asia. Just as Hellenistic architectural schemes were borrowed and transformed in different parts of Asia in the early centuries AD (the period surveyed in Chapter 1), so in this later period, following the Chinese expansion under the Tang (AD 618–906), Chinese culture dominated East Asia; her products were traded and copied in many areas north and west of the Great Wall. There is clear evidence of the borrowings of Chinese artefacts and styles by the inhabitants of the northern borders of China, including the Mongols themselves, in two painted tombs recently excavated near Ulanhad, in present-day Liaoning province, on the eastern edge of Inner Mongolia.[9] A wall-painting from one of these tombs is illustrated in figure 132.

This tomb, which is dated to the Yuan dynasty on the evidence of Chinese ceramics excavated from the tomb, is decorated in the Chinese manner, showing the deceased with his wife, attended by their servants. The man is seated on a chair with a horseshoe-shaped back, his feet resting on a low stool. His wife is sitting on a chair or stool with cusped decoration on the underside, which is typical of certain items of Chinese furniture (see p. 158). Behind the man and his wife, whose dress combines Chinese and Mongol features, stand their similarly clothed servants. Despite some slightly exotic details, this wall-painting lies squarely within the Chinese tradition of tomb decoration. From the Han period, Chinese tombs were decorated to illustrate the life of their occupants, often showing the deceased seated at a banquet or at home with his retainers around him. Markedly domestic scenes were particularly popular in tenth-, eleventh-, and twelfth-century tombs, as known from excavations in north China.[10]

The influence of such compositions, found also in a few rolled paintings as well as tomb decoration, can be traced in important manuscripts produced in Iran under the patronage of the Il-Khans.[11] In the early fourteenth century, an academy of book production was set up by Rashid al-Din, grand vizier of the Il-Khan ruler Ghazan, at Rabʿ-i Rashidi, outside the capital of Tabriz. Under the direction of Rashid al-Din, an illustrated 'World History' was compiled. Several copies were prepared and presented to major cities. Sections of different copies survive, including leaves in the Topkapi Saray Library in Istanbul, well-published portions in the University Library in Edinburgh, and a version formerly in the library of the Royal Asiatic Society in London.[12]

The illustration in figure 133 is taken from the Edinburgh copy. It shows the *Hushang* ('King of the World'), seated beneath a tree, surrounded by advisers and attendants. Sections of the composition are immediately reminiscent of the wall-painting from Ulanhad. Thus the ruler on his chair, with its horseshoe back, and his attendant standing a pace behind him, reproduce the relationship of the occupant of the Mongol tomb and his attendant. Other details of the Edinburgh painting are also Chinese in origin, especially the landscape of trees and plants, and the use of the line of the frame to cut across the top of the trees, thus suggesting a larger scene that continues beyond the boundary of the painting.

Several paintings in the Edinburgh manuscript show rulers on elaborate thrones (figs 140d, e), taking up the same theme, seen in many Chinese tombs, of a ruler or landowner seated on a fine piece of furniture. Some paintings of the

Fig. 132 A wall-painting from a tomb excavated at Yuanbaoshan, near the city of Ulanhad, Liaoning province, China, Yuan dynasty period, 13th–14th centuries. After *Wenwu* 1983.4 pp. 40–6, col. pl.

Fig. 133 Hushang ('King of the World') from the *Jami'al-Tawarikh* ('World History') of Rashid al-Din, Tabriz, early 14th century. University Library, Edinburgh.

same period show the throne empty, with a coffin in front of it, as illustrated in a miniature from an album in the National Library in West Berlin (fig. 134). Dragon finials, cusped outlines and panels of clouds or lotuses decorating these thrones are derived from China.

Indeed, in addition to the tomb paintings discussed, models for some of the subjects and styles of early Mongol painting in Iran can be found in Chinese religious paintings, both in banners and on temple walls. Such forms of painting were themselves, in part, of Central Asian origin. Precursors of the many landscape details employed in Iranian miniature painting are found, for example, in earlier banner and wall-paintings from the great Buddhist site of Dunhuang. Narratives of the life of the historical Buddha, Sakyamuni, are particularly rich in scenes of mountains, rivers, trees and buildings that recur in both the manuscripts produced in Rab'-i Rashidi and in the rather later manuscripts of the second half of the fourteenth century, now preserved in the library of the Topkapi Saray. A banner painting from Dunhuang in the British Museum shows Sakyamuni fasting in a cave in the desert (fig. 135). The pictorial convention here used, in which the cave is represented by a curly fringe of rocks, was later widely exploited in Iranian miniatures to indicate a

Fig. 134 Scene of mourners, possibly from an episode in the *Shahname*, second half of 14th century. National Library, West Berlin.

hollow in a landscape in which a ruler might sit or fugitives might hide (fig. 171).[13]

Dissemination of painting themes and styles exploited in temples in China is illustrated by a comparison of a wall-painting from a temple, the Shui Shen Miao in Shanxi province, painted in the early fourteenth century, with a miniature painting of similar date in an album in the Topkapi (figs 136, 137). In both paintings a setting of pine trees and hills is employed as a background to a narrative scene. The painting in the Shui Shen Miao illustrates an episode from the flight to Sichuan in the mid-eighth century of the Tang emperor Ming Huangdi (fig. 137). The Iranian miniature takes its subject from the epic story of brave deeds recounted in the *Shahname* (fig. 136). At the front a dragon crouches, about to attack. The dragon, the twisting pine trees above and the towering hills fringed by trees are based on Chinese motifs.

The fact that prototypes for the decorative motifs and painting subjects employed in Iran can be found in tombs on the northern borders of China and in northern Chinese temples has two implications. First it is likely that this decorative tradition was already widely current in East Asia before the Mongol conquest, and that therefore the artefacts and paintings on which the Mongol work was based may have come from Inner Mongolia or Central Asia as well as from China. Secondly the paintings discussed belong to a narrative tradition, used in tombs, in religious buildings and in banners,[14] which can be differentiated from the better known and widely discussed painting styles patronised by the Chinese literati. Recognition of these styles is helpful in providing an explanation for the popularity in Iran of at least two motifs, the

Fig. 136 'Isfandiyar fights with the dragon', from the *Shahname*, Tabriz, second half of 14th century. Topkapi Saray Library, Istanbul.

Fig. 137 Wall-painting illustrating the flight of the Tang emperor, Ming Huangdi, to Sichuan, Shui Shen Miao of the Guangsheng Temple, Shanxi province, China, Yuan dynasty, early 14th century. After *Wenwu* 1981.5, pp. 86–91, pl. 1.

lotus and the cloud-band. Both regularly appear in Chinese narrative paintings: the lotus as a Buddhist emblem, and cloud-bands and banks as supports for immortals and other heavenly beings. Indeed, the wide use of these motifs alone suggests that Chinese or East Asian painting of devotional scenes and narratives must have been known in Iran.

Chinese influences on Iranian art are particularly evident in miniatures in four albums in the library of the Topkapi Saray in Istanbul. The miniature in figure 136 comes from one of these albums. A further related series of albums, containing the miniature in figure 134, were acquired in Istanbul by the Prussian diplomat Heinrich Friedrich von Diez during his residence there in the period 1784–91. The volumes are now in the National Library in West Berlin.[15] All the material in these albums is thought to have reached Turkey following the victory of Sultan Selim over the Persians at the battle of Çaldiran in 1514. In addition to the large and bold miniature paintings and a wide range of calligraphy, the albums contain a number of ink sketches of Chinese subjects. Designs of lotuses, ducks and mythical Chinese animals, such as *qilin* and dragons, are particularly relevant (fig. 150). A few of these designs seem to copy Chinese models directly, but many are improvisations compiled from Chinese motifs.[16] Such fantasies merit, perhaps, the term 'chinoiserie'.

Frames and panels

Frames and panel boundaries are related to the decoration of furniture already mentioned in connection with the portraits in the 'World History'. Elaborately framed doorways and windows, with both rounded and pointed lobes, have traditionally been associated with the countries of Islam. It may, therefore, seem slightly perverse to suggest that the widespread use of frames and panels combining lobes and points owed more than a little to the stimulus offered by Chinese examples. However, as explained in Chapter 4, such devices had a very long history in China, and so the question of the connection between lobed frames found in Iran and Turkey and the panels used in China seems worth pursuing.

Lobed panels without points were employed in all Islamic countries long before the Mongol invasion. The origin of these panels lies in the guilloche, an ancient Near Eastern motif described in the Appendix. Early examples are illustrated from wall-paintings of about 1450 BC (fig. 184). The motif was originally constructed by putting a series of spirals against each other – the result was a design that looked like two pieces of rope twisted together. These twists of rope could be notionally loosened, so that larger enclosures appeared in each roundel. This framework was used in mosaics and in ceiling designs in the countries of the Mediterranean under Roman and Byzantine rule. With the advent of Islam, the enclosures were sometimes provided with a multilobed outline.[17] A ewer in the British Museum, dated 1232, illustrates a typical arrangement, with small round enclosures dividing much larger lobed frames (fig. 138a).[18] All the enclosures share a common outline, which is also twisted into the upper and lower boundaries. Although the background patterns on this ewer suggest some Chinese influence, the ordering of the enclosures is typical of Islamic, not Chinese designs.

However, even before the Mongol invasions some changes were made to this arrangement. Sometimes the lobes at the top and bottom were twisted so firmly that small points were introduced. Occasionally the panels were detached from one another. Such developments seem likely to have been

Fig. 138 Inlaid metalwork illustrating panel shapes:

a linked and lobed panels from an inlaid brass ewer, Mosul, 1232. British Museum.

b niche-shaped panel on a brass bucket, eastern Iran, 13th century. British Museum.

a

b

c

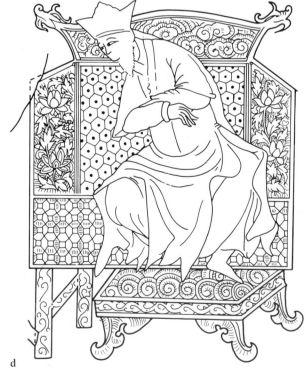

d

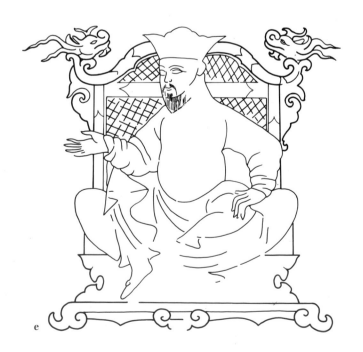

e

Fig. 139 Outline of the lobes on a bronze mirror, Iran, 13th century. Fogg Art Museum. After London 1976a, no. 201.

Fig. 140 Illustrations of Chinese and Iranian representations of thrones:

a throne for a deity from wall-paintings at the Yongle gong, Shanxi province, China, Yuan dynasty, 13th–14th centuries. After Tokyo 1981c, fig. 44.

b miniature wooden throne recovered from the tomb of the Prince Zhu Tan (d. 1389), Shandong province, China. Shandong Provincial Museum. After Sickman 1978, pl. 10a.

c panelled screen or throne from a miniature in the *Jami'al-Tawarikh*, c. 1390. Topkapi Saray Library, Istanbul. After Gray 1979, fig. 67.

d, e details from folios 18 and 5 in the *Jami'al-Tawarikh*, early 14th century. University Library, Edinburgh. After Talbot Rice 1976, pp. 75, 49.

variations made in Iran or Mesopotamia without any reference to foreign work. From the eleventh and twelfth centuries, small panels, flat at the bottom and pointed at the top, are found in the repertory. Such pointed panels, which often enclose figures, are seen on a bucket in the British Museum from eastern Iran (fig. 138b). Because such panels resemble very closely the niche outlines used in Buddhist architecture, it is possible that this detail was adopted from Buddhist sites in Central Asia, Afghanistan or eastern Iran. Its use parallels the lobed openings on Chinese furniture and doors (fig. 115). Later widely used in architecture, this outline is known as an ogee arch.[19]

When a new series of frames and panels was introduced with the Mongol invasions, they were thus imposed upon a vocabulary already rich in lobed frames of many kinds. The first hint of the use of modified panels dependent on Chinese examples is seen on metalwork such as a thirteenth-century bronze mirror (fig. 139). While the wavy petals follow the outline of the pointed niche already observed on an Iranian bucket, the compressed height, the deep line of the lobes and the increasingly generous curves suggest that an existing scheme has been modified by reference to a Chinese design (fig. 120b).[20]

Although metalwork may have provided one of the avenues by which Chinese frames became known in Iran, a major source of new frames and panels seems to have been furniture and related items, such as boxes and chests. It is not clear whether actual furniture was imported or whether copies and adaptations of Chinese furniture were simply known from paintings, such as those which inspired the depictions in the 'World History' discussed above (fig. 133). Thrones and tables in such Iranian painting can be compared with the representations of similar items in Chinese wall-painting and a few surviving miniature pieces made for burial.

The similarity has already been noted between the horseshoe-backed chair on which the *Hushang* is seated (fig. 133) and the chair occupied by the Mongol painted in his tomb in Liaoning province (fig. 132). Other thrones in the 'World History' consist of flat seats, surrounded on three sides with decorated panels, surmounted by dragon or phoenix finials or other projections. A similar throne, shown in the mourning scene in figure 134, is characterised by a lobed outline to the sides and back. In addition, a small lotus appears at the top. These curved outlines, the dragon and phoenix finials and the lotus decoration all refer to Chinese prototypes. Related thrones were painted in Chinese temples. Two drawings of thrones from the 'World History' are therefore shown alongside one reproduced from a wall-painting in a Yuan period temple, the Yongle gong in Shanxi province (fig. 140a). This throne has curved sides decorated with phoenixes on the panels and with phoenix finials on the stepped back.[21] The Iranian thrones have dragon finials, and one of the two examples is decorated with cloud patterns in Chinese style (fig. 140d, e).[22]

The particular interest of these thrones lies in cusped and lobed outlines below the seats, at the sides and under the footstools (figs 134, 140d, e). These features can be compared with Chinese models. Similar shapes are, for example, found below the seat of a replica of a wooden throne excavated from the tomb of the Ming prince Zhu Tan, died 1389 (fig. 140b). An angle of wood, joined by an indented and cusped line, braces the seat and legs. Persistent use of cusped shapes on the undersides of seats, stands and stools on both Chinese furniture and on representations in Iranian painting was derived from the elaborate openings developed to embellish the earlier stands and doorways discussed in Chapter 4 (fig. 115).

Lobed outlines and elaborate brackets in furniture are particularly well shown on tables. Figure 141 provides a range of illustrations, headed by two examples drawn from miniature burial pieces recovered from the tomb of one Yan Deyuan, buried in 1189 in Shanxi province. A rectangular example (top right) has plain brackets bracing the legs and the table top. This form is exactly paralleled by the table drawn below it, taken from the mourning scene in figure 134. The other pieces all have more complicated brackets. A round table from the 1189 tomb, with a cusped underside joining the legs, is also illustrated (top left). Similar cusped outlines probably provided the models for the curly brackets used on the tables in the next two examples (figs 141c, 141e), drawn respectively from a miniature in a Diez album and from a volume dated 1390 in the Topkapi Saray library.²³ The last example in figure 141f is taken from another manuscript in the Topkapi dated 1445–6. It is decorated with cusped brackets on the underside, a lobed rail and with a cartouche on the flat side. A comparison with the openings and panels in figure 115 above demonstrates that all these brackets and panels reproduce forms that were first used in China.

Figure 140c shows a throne from a miniature in a manuscript of 1390 (which also includes tables in Chinese style). The back and sides of the throne are ornamented with floating lobed panels contained within rectangles, whose corners are filled with brackets similar to those used as braces for the tables. This arrangement of a floating lobed panel within a rectangle, decorated at the corners, was employed in China on boxes – such as the sutra box from the deposit at the Rui'an pagoda (fig. 116). Similar panel designs were to play a large part in the decoration of Islamic book binding.

A page from the Anthology, dated 1410–11, illuminated for Iskandar Sultan, a nephew of Timur, provides examples of the kinds of experiments that must have been carried out to test the decorative uses of these cusped and lobed sections, drawn perhaps from furniture (fig. 142). The page is filled almost randomly with lobed panels, each containing Chinese motifs. The two lowest sections are the most revealing: bounded on two sides by straight lines and on the third by an indented bracket, these designs simply reproduce the outline of some of the more complicated braces seen on furniture in the miniature paintings. Their combinations of positive lobes and deep reversed indentations are unlikely to have been generated from lobed panels available in Iran before the Mongol conquest.

Moreover, the position of the two triangular panels suggests that they were not entirely familiar to the artist. They do not fit well into the rectangular frame on the page, giving the impression that the artist had traced or copied them from another source and was not yet sufficiently familiar with the vocabulary to be able to manipulate them to fit the given space correctly. Four of the other panels were derived from lobed shapes available in Islamic metalwork from at least the beginning of the thirteenth century. The other two frames, which show reversing of the lobes so that they cut into the panel, are constructed from parts of the cusped shapes seen on furniture or lacquer.

Triangular and diamond-shaped panels were particularly popular in the decoration of leather bindings. The drawings in figure 143 illustrate two different bindings of the early fifteenth century now in the Topkapi Museum. On the left-hand binding (fig. 143a), made at Yazd in 1407, the panels are based on triangular sections similar to those used in the Anthology of Iskandar Sultan; on the right (fig. 143c) the outer triangular panels are derived from

Fig. 141 Illustrations of Chinese tables and representations of furniture in Iranian miniature painting

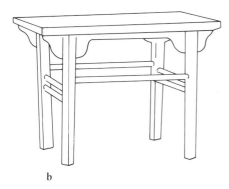

a b

a, b two miniature wooden tables excavated from the tomb of Yan Deyuan, buried at Datong, Shanxi province, China, Jin dynasty, late 12th century. H. 13.8 and 16.3 cm. After *Wenwu* 1978.4, pp. 1–13, p. 9, figs 18, 20.

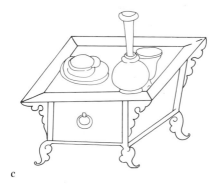

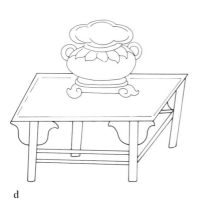

c table illustrated in a miniature of the second half of 14th century, Iran. From an album in the National Library, West Berlin.

d table illustrated in the mourning scene in figure 134 above.

c d

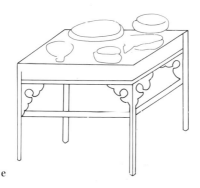

e table in a miniature in a copy of the *Jami'al-Tawarikh, c.*1390. Topkapi Saray Library, Istanbul. After Gray 1979, fig. 67.

f table in a miniature from the *Khamsa* of Nizami, Herat, 1445–6. Topkapi Saray Library, Istanbul. After Titley 1983, fig. 13.

e f

sections of the niche shapes employed on metalwork in the twelfth and thirteenth centuries (fig. 138b).

Comparison of the two bindings draws attention to the peculiarly complex shape that could be achieved using outlines that we recognise in representations of furniture. The deep indentations of such panels created not only elaborate corner panels but when repeated could be used to generate new forms of lobed medallion. A small four-lobed medallion filled with motifs in filigree, at the centre of the inner cover of the binding of 1407, consists of four triangular panels butted together (fig. 143b); one of the small panels on the page of the Iskandar Sultan Anthology (fig. 142) was made by putting together upper lobed sections of two triangular brackets. In following centuries, a large

Fig. 142 Decorative panels from the Anthology of Iskandar Sultan, Shiraz, dated 1410–11. British Library.

Fig. 143 Drawings of lobed panels on leather bindings:

a outer cover of an anthology, Yazd, 1407. Topkapi Saray Library, Istanbul. After Gray 1979, fig. 33.

b medallion filled with filigree from the same binding. After Gray 1979, fig. 32.

c outer cover of *Mihr u Mushtari* of 'Assar, Tabriz, 1482–3. Topkapi Saray Library, Istanbul. After Gray 1979, fig. 50.

a

b

c

number of medallions and borders of different shapes were constructed from multiples of these triangular brackets: in a manuscript of 1566, a medallion surrounded by phoenixes is outlined as a star with eight main points; each of these points is composed of a pair of brackets (fig. 144).

Most of the floating panels shown at the centre of bindings were shaped as elongated diamonds, with two pointed ends joined by evenly lobed sides (fig. 143c). This shape had been available on metalwork before the Mongol conquest. Like the more exotic panels in the Anthology of Iskandar Sultan, many of these local frames were filled with Chinese creatures – dragons and phoenixes. Indeed, the consistent use of Chinese animal motifs within many types of lobed panels perhaps indicates that these panels were accepted as an important element in a chinoiserie style. Moreover, when panels were combined with openwork designs, as on the binding of 1452 below (fig. 151), they seem to recreate the effect seen on Chinese lacquer boxes (fig. 116), again suggesting that some sort of Chinese example may have stimulated their manufacture.

In addition to bindings and furniture, lobed panels of all sorts are seen in architecture, and on canopies, tents and dress.[24] The Mongol miniature in figure 136 shows an individual wearing the cloud collar so elusive in China. Collars of related shapes are shown in many miniature paintings, generally filled with motifs of a Chinese character, dragons, phoenixes and flowers. Most textiles have perished. However, the use of lobed medallions in carpets, such as the Ardebil carpet in the Victoria and Albert Museum (pl. 6), usually dated to 1539, may reflect the decorative schemes used in canopies and tents.

Cloud patterns

Clouds painted in miniatures and employed in the ornament of ceramics, carpets and bindings have long been recognised as a Chinese motif;[25] but as with all the other designs discussed, these clouds were subtly altered in Iran. Indeed, some of the long trailing bands bear little resemblance to the puffs of clouds on Chinese lacquer boxes and porcelain (fig. 125). Chinese clouds have already been examined in some detail, and their mushroom-like outline traced to the borrowing of the shapes of flowers based on palmette heads (fig. 125a). These isolated small rounded puffs reappear in Iran and in Turkey, especially in illumination and miniature painting (fig. 144). However, clouds were also rendered in two other equally prominent forms: piled together to make a large bank on which a legendary hero or a religious figure could travel, or drawn out in long curling ribbons.

Cloud banks and cloud bands are really two quite separate motifs, but even in China they were sometimes combined. Cloud banks were developed in narrative painting, not as decoration. In China such banks were always associated with individuals with miraculous powers. They are seen, for example, as the vehicle for a small heavenly being in a Tang dynasty banner painting from Dunhuang (fig. 127), in the illustration of immortals crossing the waves (fig. 116), and in the fourteenth-century wall-painting from the Shui Shen Miao (fig. 137). Related Iranian depictions of clouds carrying heroes or the Prophet through the sky must have been borrowed directly from Chinese narrative scenes.[26]

Sometimes these banks of cloud trail behind them a ribbon of cloud, which is not part of a cloud at all but, literally, a ribbon. Ribbons were widely used in China as the scarves of Bodhisattva figures. When this device first appeared in

Fig. 144 Medallion and phoenixes from the *Kulliyyat* of Sa'di, Shiraz style, 1566. British Library.

the early fifth century, it was, like so much else in Buddhist art, borrowed from the Near East.[27] From the fifth century, ribbons remained a persistent element of the dress of Buddhist figures, but similar conventions were also used for ribbons attached to other items, such as the drums in a detail of a Tang dynasty banner illustrated in figure 145.[28] The drums seem to be falling through the air, and the ribbons twist and turn as they fall – thus showing both the full width of the ribbon and a narrow edge as the direction of the ribbon was reversed. Although in China such ribbons generally remained distinct from the banks of cloud, there was always a possibility that the scarves of a Bodhisattva riding on a cloud might become confused with the cloud. This has happened in a detail from a Yuan dynasty cave at Dunhuang (fig. 146). A heavenly being sits on a small bank of cloud, his own scarves curled neatly around his shoulders. Behind rises a long streamer of cloud that takes the form of a textile ribbon. This combination of cloud bank and ribbon also occurs in Islamic miniatures, and it is from such a source that the detached cloud and flame bands come.

Cloud bands had been adapted for manuscript illumination by the early fifteenth century. Their source is likely to have been the clouds on which heroes and angels were shown to ride in narrative illustrations. Figures

Fig. 145 Fragment from a paradise of Amitabha, banner painting, found at Dunhuang, Gansu province, China, Tang dynasty, 8th–9th centuries. British Museum.

Fig. 146 Detail of an *apsaras* on a bank of cloud, trailing a ribbon of cloud, from cave 3 at Dunhuang, Gansu province, China, Yuan period (1280–1368). After Beijing 1980e.

Fig. 147 Border illumination of figures and clouds from the Anthology of Iskandar Sultan, Shiraz, 1410–11. British Library.

mounted on clouds were compressed into decorated margins around texts in the Anthology of Iskandar Sultan (fig. 147). The artist or artists who worked on this Anthology, and a similar compilation of texts and illustrations now in Lisbon, used the same details for the edges of the clouds as for the edges of the rocks, with the result that the clouds seem rather solid – indeed, rather like rocks. In other illustrations in the Anthology, ribbons in Chinese style are shown; for example, narrow ribbons are wrapped around the dragon in the folio in figure 149.

At about the same time, cloud bands were used simply as decoration, divorced from cloud banks in narratives. An anthology of Chaghatay poems in Uighur script, executed at Yazd in 1431, and now in the British Library, provides a standard example (fig. 148). Narrow ribbons with pointed tips and puffy lobed clouds are used together around two of the corners. A large lobed head occupies the angle, and each band incorporates two more such heads. Such cloud bands could be easily varied as the space available or the inclination of the artist demanded. Small, rather neat cloud bands are shown in the outer borders of the Ardebil carpet; further clouds are woven into the flowers in the oval medallions (pl. 6). In the medallion of the illumination in figure 144, cloud bands are used as boundaries between areas of different colours and thus contribute to the lobed form of this complex medallion. Generally, cloud bands proved a convenient device for binding together

یا هرن خط آن آن خویش دشتری بذه ناطم فتند درمیجی ثابت خاصت اسه دیانه نژ بود
ازار ل واخر حبترست دعقرب نشابذ دهانهای عطاره چون دوشینه بنو دراست دبر
نظر ذره بابذ دهذربابذکرد ن ازبودن دنب درخانه فرزندان دراتن شابذ وبرج طالع
بصورت مردم دراست و تحمر دشتری وزهره بر نظر دوسنی بیکدیکن نکرند وعطاره مسعود
بوذه خنک رفتن طالع خانه ازانکه کوکب علوی بابذ دازهم خانه تنغ اسبذیذه ترفت بر نظر دوه
او دبابذ که فذاوند طالع دورمجی دوجسبذین بود دوطالع یادم وازجهاردم وهفتم عذدبایذکرد
واکربتوانی که فذاوند طالع حدیکی ازین خانها بوذ دفذاوند نطیز متصل بذ ذینک بوذ والابابذ
که فذاوند هفتم اندرطالع ایدوم بوذ متصل سبتا ذه ساقط دیا منفرق ناشبور ل دفذربابذکرد
ازاتصال فذاوند هفتم برن کنده بوذه که ازدکردیم به طالع دیلی لئلت خنک خوا عذر فتن دوم یادراد
دهفتم ذیله ثمن دهشتم یا دراو دهوکام مامل هبت با نبذ فوت او رابوذ دیوستن فذاوند طالع
خذاذند هشتم ناسبذیذه است واکرخذاذند هفتم را انقالی بوذ بدوم شابذ که هشتم ادست والابنت
صلاح ستا کان خبف نکاح داشتن وآن من دعطاده دفرست و بودن ذمنع دوشن یا استاذ کارای
نظی دنیبی بوذ دطالع اسبذیذه ادست ازبرجبک دتشریق فذاوند طالع دفوت ادم جنین دفوت
سهم سعادت نکاح بابذ داشتن واتقال فذاوند طالع دهفتم بیکدیگر ازنظر دوسنی دیل صلح خوذ
صلاح خریدن بابذ که تنغ درخانه خویش فوبقق بوذ دسبذیذه ات بوذن تمر رتلث خویش
یاینع دراخرماه طلب کرمه کردن بابذ که تمر ناطع بوذ باخذاذند طالع ازبر نظر دوسنی دفوی الارض
بوذ دنحوس نبابذ دیم دوخت الارض ناشبذ دمجتران بوذ دان اتصال درمتط ثمابا شذ دفذاذنم
طالع اورانخوس کند دانما علم ۵ باب نهم ازبرج هشتم کیف

دمیذه کردن قذا اندرمیجی ثابت بابذ ه اکرمتلب بوذ دلیک که ان وقت بکرقه دوطالع
فذاذنذش مسعود بوذه دمتصل سبذ بوذه دبابذ که قرقت الشعاع بوذ دجار بزوذی بیمه دجذده
بابذ کردن جون تمر باطع بوذ یا بر نظر دوشنی دوا دابابذ که دورباشذازخوس واللہ اعلم ۵
باب دهم ازبرج نهم جهاربذل اذل سفرکردن انده مقذمه
کفتیم که اختیار مواقق طالع اصل بابذ بشاک که طالع اصل معلم نیاشذ بابذ که ضیری کندازبحر
سفد ذنیکی دیذی آن معلم کرده انذان آن وقت اختیارکردن واجب بوذه دبترین آنست کفتم
دربع طالع بوذه دبا در دوسط سمایانم زایذ دهذوک متصل سبوه دبابذ جیذن تا معقعه رفتن

sections of scattered decoration. In a large Turkish tile panel of the latter part of the sixteenth century, a cloud band in red functions rather like a ribbon tying together the flowers and leaves (fig. 169). The upper section encircles a large imaginary flower, while the two extensions run amidst the florid lotus blooms. The success and long survival of the cloud band can in part be explained by its usefulness in adding linear rhythms to designs composed of large flowers.

Animal ornament

Chinese animal motifs, dragons, phoenixes, deer and lions, appear in two different contexts in Islamic ornament. Pairs of creatures were used to fill lobed medallions, and compositions of birds or beasts amid a landscape of trees and rocks were employed as manuscript illumination.[29] These two forms of decoration take up two separate Chinese ornamental traditions, namely paired creatures in defined enclosures (fig. 84) and, later, more elaborate compositions of creatures in landscapes, put together from stock plant and tree designs (fig. 87).

The common association of bracketed and lobed frames and the creatures enclosed by them has already been noted. As this combination was used so consistently in Iran, especially from the early fifteenth century, it seems likely that such designs were based on Chinese models. The nature of these models is not known, but it is possible that some designs were taken from embroidered textiles, which might well have offered prototypes for decoration on dress, canopies or tents. However, paired creatures within lobed medallions were also popular on book bindings, and a model in textiles for this usage seems unlikely. It is more probable that leather bindings copied other leatherwork exploiting Chinese designs, or just possibly decoration of lacquer boxes or chests in other materials including metal. Neither leather nor lacquer seems to have survived; but it is likely that the nomads inhabiting East Asia possessed both. Accustomed to a nomadic life, they must have employed leather widely; boxes and chests must also have been familiar to transport their possessions. Boxes, similar in shape to Chinese sutra boxes surviving in Japan (fig. 84), are depicted in Chinese tomb paintings of the Liao period.[30] If such containers were employed by the Khitan tribes, it is likely that other peoples inhabiting the same area at a later date also used them. Familiarity with Chinese boxes, or copies of them, might have introduced to the Mongols the combined ornaments of creatures within panels.

Animals in a landscape that filled the margins of texts must have had a separate source. The earliest examples of Chinese creatures employed as border illumination seem to be found in Timurid manuscripts. In the Anthology of Iskandar Sultan the creatures within medallions (fig. 142) can be differentiated from dragons or phoenixes or other animals shown in margins (fig. 149). While the animals in the medallions are neatly contained within lobed outlines, marginal decoration spreads more widely than the space allowed. A dragon in figure 149, for example, occupies the lower boundary of the page and climbs up the right-hand side. Its body is cut by the text, suggesting to the viewer that the dragon is part of a larger composition. Such effects, which are commonplace in the Anthology, indicate that this ornament was understood to refer to larger chinoiserie compositions, hinting at a narrative or at the least a representation.[31] Yet the repetitive use in Islamic manuscripts of Chinese animals, usually rendered in gold amid fictional landscapes, does not really seem to have been based on illustrations to a story.

Fig. 148 Border illumination of decorative cloud bands from an anthology of Chaghatay poems, Yazd, 1431. British Library.

The text at top right is Persian/Arabic script in the manuscript border.

Fig. 150 Sketch showing two *qilin* and other animals amidst a landscape of rocks and plants, Iran, 15th century. From an album in the Topkapi Saray Library, Istanbul.

Fig. 149 Border illumination of a dragon and a leopard entwined with ribbons, from the Anthology of Iskandar Sultan, Shiraz, 1410–11. British Library.

Such ornament exploits perceptions developed for narrative painting to provide intriguing and attractive ornament.

Sketches in chinoiserie style in the albums of the Topkapi illustrate the sort of composition implied by the illumination. In an example in figure 150, two *qilin* confront each other at either side of a pair of rocks. Other animals and small plants fill spaces between a number of larger trees. In this composition, the *qilin* have been surrounded by plants and animals to give them a context suggestive of a real scene. However, identical elements are put together to make alternative compositions in the same albums. Their purpose seems to be the provision of varied decoration rather than the illustration of narrative. A closely comparable illumination in gold, covering a whole page, is found in a copy of the epic, the *Shahname*, prepared for Ibrahim Sultan in about 1435.[32] The manuscript is now in the Bodleian Library, Oxford. The use of gold is significant, as almost all later illumination containing similar animal and landscape scenes is executed in gold, for example, the phoenixes surrounding a medallion in figure 144. Gold may have been employed simply because it suggested wealth and luxury. Alternatively, in the minds of illuminators, gold may also have been associated with chinoiserie designs. A few surviving manuscripts of the fifteenth century, written on coloured paper, are decorated with plants and landscapes in gold, clearly executed by a Chinese hand.[33] Such decorated paper, either imported from China or prepared by Chinese in Central

Asia, is an unusual variant of the paper illuminated and written in gold or silver that was used in the Far East for the transcription of sacred texts.

Bindings that are decorated with related animal scenes have survived from the mid-fifteenth century. A number of different techniques were used, including openwork or filigree, as it is termed. A binding decorated with animals and plants in filigree, dating to 1452, is shown in figure 151. Dragons are confined to the corners and central medallion, and a full scene of animals and trees is achieved within the flap. The outer cover is decorated in gold tooling. One whole side is devoted to a scene of animals and plants. Plate 7 shows a comparatively late example from Tabriz, now in the British Library, which represents the continuing use of the genre. As ever, the Chinese beasts – dragon, phoenix and *bixie* – are depicted amid luxuriant trees and plants.

While the outline of the animal subjects reproduces familiar Chinese creatures, it seems to be the case that in all Islamic paintings, illumination and binding, such mythical beasts take on an aggressive character unknown in their original context (fig. 6). The depiction of two creatures locked in mortal combat was an ancient Near Eastern convention, surviving in manuscript illustrations to fables, known as the *Kalila wa Dimna*. In addition, ferocity may have been transferred to these decorative examples from the beasts that were the adversaries of heroes in the great epics of Iran – the *Shahname* and the *Khamsa* of Nizami. Indeed, because the Chinese symbolism of the dragon or phoenix was unknown, some explanation for their presence, however general, may have seemed attractive. Small vignettes of animal attacking animal may not have been linked to a particular story, but they hinted at a narrative none the less. Two quarrelling creatures entice the onlooker to explore the scene further, to see if anything else of interest is happening in another corner of the design. These aggressive creatures were therefore a most effective decorative device.

Lotus patterns

Iranian and Turkish manuscripts, textiles, carpets, tilework and ceramics are all alive with flower patterns. Among the flowers dominating the designs, heavy lotus heads, both on long coiling scrolls and as single plants, are pre-eminent. More than any other feature of the decorative repertory developed in Iran following the Mongol invasions, these flowers are signs of the influence of Chinese models.

The long scrolling stems with which these flowers were often combined were not, however, a new import. Large tightly scrolled stems were widely used by the Seljuks to decorate metalwork, wood and tiles. Such scrolls were enlivened by a semi-abstract leaf derived from leaf palmettes and their ancestor – the acanthus – described in Chapter 1 and the Appendix. The leaf has a broad outline of v shape. Ornaments composed both from this split leaf and related descendants of the Classical palmette are known as the arabesque.[34] When employed on long coiled stems, arabesques are sometimes described as *rumi* scrolls. Such designs survived in late Iranian decoration and are seen, for example, on the Ardebil carpet (pl. 6).

The prominence of lotus flowers in Iranian art is itself very surprising. In the thirteenth and fourteenth centuries, peonies rather than lotus flowers dominated Chinese art. Only associations with the Buddhist religion can explain the popularity in Iran of the lotus rather than the peony. The ways in which the lotus was first used suggest that, rather than typical Chinese ornamental designs, single flowers – emblems of some sort – were the source of the motif (fig. 130). In China lotus flowers were used either in scrolls accompanied by distinctive pointed leaves (fig. 66) or in scenes of lotus ponds, when the full round lotus leaf was represented, as for example, on the Yuan dynasty dish in figure 152. However, as the tile in figure 130 illustrates, in Iran lotus flowers were first combined with straight stalks and serrated leaves, and not with either a pointed palmette-derived leaf or with a naturalistic round leaf. This mixing up of plant forms implies that only the flower head was available or of interest, and that it had to be supplied with leaves and stalks from another source.

Lotus flowers on straight stalks with serrated leaves were used for about a century and a half. During the early fifteenth century, a new flower was added,

Fig. 151 Inside cover of a binding for the *Diwan* of Khwaja Kamal Khujandi, decorated with animals in filigree, Herat, 1452. Topkapi Saray Library, Istanbul.

which is misleadingly known as a leaf-palmette.[35] In fact, the new device was based on the proper leaf of a lotus plant. Before considering its general use in lotus scrolls, first in Iran and later Turkey, the connection between the lotus leaf and the new flowers will be established through the particular case of designs on early sixteenth-century pottery from Iznik in Turkey.

Comparison between lotus plants on Chinese porcelain and those reused on early sixteenth-century Iznik wares is instructive because Iznik vessels refer clearly to Chinese designs. A large bowl (pl. 11) has already been contrasted with Yuan dynasty porcelains (fig. 123) for its Ottoman interpretation of a Chinese 'cloud collar'. Equally Chinese is the ornament of small diamond-shaped panels, alternating with the hanging lobes (fig. 153a). Within each panel, a new interpretation of a Chinese lotus plant design is placed. The prototype for the design is seen on a small dish in the Victoria and Albert Museum (fig. 152). At the centre of the dish, a lotus plant rises out of a pond, on which two mandarin ducks swim. The lotus has a large central leaf, which is seen from the side; above it spread stems supporting two small groups of three leaves and two lotus flowers. Another lotus flower appears at the very top. A similar arrangement occupies the lower half of the dish. This time the main lotus leaf is tipped more towards the viewer and appears as an oval; the other flowers and leaves are compressed into a small area. With the ducks omitted, it can be seen that the disposition of the flowers in the diamond-shaped panels on the Iznik bowl follows the arrangement of the Chinese lotus design. At the top, an open flower replaces the uppermost leaf, and below, on either side, two more flowers occupy the positions of the Chinese lotus flowers. The large Chinese lotus leaf has been given a new interpretation: it has been made into an exotic flower, divided into three tubular sections from which additional small petals emerge. The underside of this flower retains the rounded heart shape of a real lotus leaf at the point where it joins its stem. Below the exotic flower appears another pair of flowers, picking up the position of the second lotus plant. The main leaf of this second lotus is again turned into an open flower.

The new flower head, invented to replace the lotus leaf, is further elaborated in the design around the outside of the basin. In a second detail, reproduced next to the diamond-shaped panel (fig. 153b), two flower heads simply copy the central head from the panel. The larger bloom is a new creation; it is an imaginary flower, laid out in the framework of a lotus. Small sprays of petals alternate with pointed petals. At the centre, a rounded central section mirrors the shape of similar details in Chinese peonies. Thus, although the large flower head is understood as another view of the two small flowers, it is developed from sections of different motifs. More elaborate constructions built up from the same standard elements are found on other bowls of a similar date.

This example, which reveals a standard Chinese lotus design made into an entirely new flower pattern, can be taken as a model for a much more elaborate sequence. As before, the original Chinese pattern consisted of a lotus plant in a pond with water birds. Among the earliest surviving examples of this subject are wall-paintings in a tomb of the Liao dynasty, and no doubt these paintings emulated earlier Tang tomb decoration.[36] In date such painting is followed by designs on Chinese Ding ware described above (fig. 109) and in due course by the scene in the central medallion of the Yuan dynasty dish in figure 123. In all these examples the lotus is realistically depicted. Large flat leaves are often shown in profile, so that the long round edge appears to undulate, as it does in

Fig. 152 Porcelain dish decorated with lotus plants and mandarin ducks in underglaze blue, China, Yuan dynasty, 14th century. Diam. 15.8 cm. Victoria and Albert Museum.

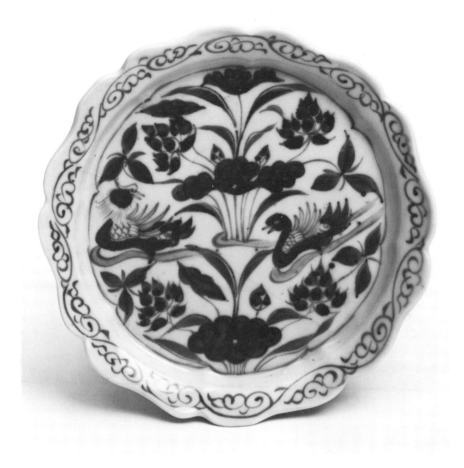

Fig. 153 Details of lotus-leaf flowers, based on a Chinese lotus composition, from the inside and outside of a bowl, Iznik, early 16th century. British Museum. For the complete inside see plate 11.

the real plant (fig. 9). Holes in the leaves, typical of the lotus as it ages, are also visible. However, porcelains are not likely to have been the main source for the motif used in Iran. Chinese textiles with lotus patterns in gold on a dark ground, which often include large ragged leaves, are just as likely a source.[37] (A lotus leaf from a Yuan dynasty textile is redrawn at the top of figure 164 showing invented flowers based on the leaf shape.)

As with other ornaments, the changes made to Chinese lotus patterns can be documented most clearly in miniatures of the Il-Khanid period and in the illumination of Timurid manuscripts. In the earliest paintings produced under the Il-Khans, large lotus flowers hang in space or are attached incongruously to trees.[38] In other words, representation of lotus flowers in manuscript illustration presented the artist with problems similar to those which arose in the decoration of tilework, metalwork and glass. What was a lotus? How did it grow? The fact that the lotus is a water plant seems to have escaped the artists, for they gave the flower long stalks and small leaves.

Such hybrid lotus plants were integrated into manuscript illumination in the Timurid period. A number of borders in the Anthology of Iskandar Sultan are filled with lotus plants, wherein the lotus is supported on tall stems with small spiky leaves and some additional small flower heads. However, in the lower border of folio 410a, both a lotus flower and a lotus leaf are attached to an undulating stem, which also embraces other small flowers and leaves (fig. 154). This large leaf is described by an arc, broken by several vertical fissures. The underside of the leaf is held by a small cup joining it to the stem. The flattened bell, with vertical fissures, reproduces the lotus leaf seen, for example, in the lowest lobe of the central medallion of the Yuan dynasty dish in figure 123 and the drawing in figure 164a. The Iranian miniature painters had no familiarity with the lotus and made no attempt to draw it from life. It seems that this strange shaped leaf had, therefore, to be tamed and given a new, and acceptable, interpretation.

On folio 44v of the Chaghatay anthology of 1431 from Yazd, already mentioned for its cloud-band decoration, a lotus plant is the subject of the central illumination (fig. 155). At the top is a large lotus flower, drawn in the idiom of Chinese decoration of the fifteenth century. Small flowers based on the lotus leaf shape, seen in the Iskandar Sultan Anthology, are attached to the coiling stems. These flowers are simplified and have only three sections. Their junctions with the stem are marked by small rounded heart shapes lingering from the original lotus leaf outline. At the centre of the lower scroll there is, however, a much more adventurous flower. Using the profile view of the lotus

Fig. 154 Detail of an illumination showing lotus heads, lotus leaves and other flowers, from the Anthology of Iskandar Sultan, Shiraz, 1410–11. British Library.

leaf with its several fissures, the artist has invented a new flower; it would appear that in his mind's eye he has taken the outline of the flower (based on the leaf in profile), turned it through ninety degrees, and drawn it head on. The small bell shape thus became a round flower with narrow spreading petals, pointed at the tips, taking up the outline of the fissured leaf. A small crown of stamens was placed at the centre of the flower head.

Further illuminations in the same manuscript illustrate the versatility of this new flower. On folio 61b it fills a border rather than the centre of a page. When using this invented flower, the artist was not constrained by the need to reproduce a shape given in nature (fig. 156); to fill the corners of the border he could stretch out the petals of the flower so that it almost resembled a much serrated leaf. Meanwhile, the original lotus flowers were redrawn in a reduced size, and small profile flowers based on the lotus leaf were also used.

Drawings or sketches of chinoiserie motifs in albums in the National Library, West Berlin, and the Topkapi Saray library provide ample examples to demonstrate that exotic flowers with fissured and serrated edges, in use in the mid-fifteenth century, were indeed based on a lotus leaf. The first example shows a full lotus pond with an enormous leaf overshadowing the small water birds of the Chinese design (fig. 157). Holes in the leaf have been regularised and filled with tiny birds. Alongside, a second example shows the leaf opened out with a small lotus flower set within it (fig. 158). This arrangement was widely exploited in Iranian decoration. A third example, a running scroll, incorporates several views of the lotus leaf: a profile and then a frontal view of the leaf provide the principal flowers on the stem (fig. 159). Thus the motif generally called a leaf palmette is really a fantastic flower based on a Chinese lotus leaf. Such imaginary flowers are seen alternating with real lotus heads across the main field of the Ardebil carpet (pl. 6). Their ragged outline and bell shape betray their origin. Some of these leaf-shaped flowers embrace a smaller flower head within their fronds. This latter scheme parallels the drawing in which a lotus bloom is shown framed by a lotus leaf (fig. 158). Such devices opened the way for further inventions based on this composite flower of lotus leaf and lotus head.

The flowers on the stems running across the Ardebil carpet are combined with small unassuming leaves. Only in the large medallions are the heavy blooms balanced with split-palmettes inherited from the arabesque. Because the lotus leaf had been turned into a flower, there were no substantial leaves available to accompany the blooms. Furthermore, as these lotus motifs had been derived from depictions of lotuses in ponds and not from Chinese lotus scrolls, small pointed leaves based upon the lobed palmette leaf were also not available. Split palmettes were therefore used instead. They were eventually reinterpreted as a feathery leaf with a serrated edge to match the outline of the lotus leaf flower. This change can be followed in bindings and miniatures of the late fifteenth and early sixteenth centuries.[39]

A border from a binding produced at Herat in 1496 (fig. 160) consists of undulating scrolls on which flowers alternate with large leaves. The flowers are versions of the lotus-leaf flower, neatly serrated at the edges, with a bunch of small petals at the centre. The leaves consist of split palmettes of Seljuk ancestry, alternating with a large pointed leaf, possibly achieved by joining two split palmettes, or possibly referring distantly to the Chinese pointed leaf. The only realistic leaves are tiny, but they have neat serrated edges picking up this detail from the flowers. An elaborately illuminated copy of a *Khamsa* of

Fig. 155 Illumination from an anthology of Chaghatay poems, showing a lotus flower and fantastic bloom based on a lotus leaf, Yazd, 1431. British Library.

Fig. 156 Illumination of flowers, including blooms based on lotus flowers, and a fantastic bloom based on a lotus leaf, from an anthology of Chaghatay poems, Yazd, 1431. British Library.

Fig. 157 Sketch of a lotus plant and ducks with a fantastic lotus leaf, Iran, 15th century. From an album in the National Library, West Berlin.

Fig. 158 Sketch of a lotus plant, with a central lotus flower shown against a fissured lotus leaf, Iran, 15th century. From an album in the National Library, West Berlin.

Fig. 159 Sketch of a decorative border, with flowers invented using the outline of lotus leaves, Iran, 15th century. From an album in the Topkapi Saray Library, Istanbul.

Nizami in the British Library, dated 1539–40, shows a more advanced form of lotus scroll (fig. 161). The flowers comprise both true lotuses and those developed from the lotus leaf; but now bunches of fissured leaves with serrated edges are inserted in the scroll. Such leaves can simply be understood as new versions of the split palmettes, altered so that they harmonise with the flowers. The leaves are, indeed, painted in the same colours as the flowers, contributing further to the rhythmic balance of the scrolls. Small flower heads peep between the split leaves. Combinations of lotus flowers, invented flowers based upon lotus leaves, and transformed split-palmettes provided a highly flexible vocabulary that was widely exploited in Iran in the following centuries.

Lotus flowers on Iznik wares

Large flower heads based on Chinese lotus flowers and leaves reappear on ceramics made in Turkey. Generally described as Iznik wares because they are thought to have been made at Iznik, these ceramics embrace several separate groups which are defined by their different ornaments. A large bowl (pl. 11, fig. 153) belongs to the first of these groups, known as Abraham of Kütahya ware, and is dated to the early sixteenth century.[40] In parallel, rather more direct copies of fifteenth-century Chinese porcelains were also made (fig. 163). Although such pieces differ from their Chinese models in detail, the divisions of the decorative fields and the subjects of the motifs resemble those of the

originals quite closely. Such ceramics may have been made throughout the first half of the sixteenth century. At some stage, these versions of Chinese designs contributed to the development of a much more exotic group known as 'Damascus' wares (pl. 9),[41] but the date of such dramatic pieces has proved difficult to establish. Finally, the last major group to be mentioned comprises a large production, which can be dated to the second half of the sixteenth century, of tiles and tablewares with decoration that includes a red colour.

Tiles in a mosque at Edirne, whose foundation inscription is dated 1438 in the reign of Murad II, provide examples of decoration in blue on a white ground that precedes in date the main production at Iznik.[42] Two of several schemes used on the tiles are illustrated in figure 162. On the left, a design is arranged

Fig. 160 right Border from the outer cover of a binding of the *Hasht Bihisht* of Amir Khusraw Dihlawi, showing flower scrolls with leaves in the shape of split palmettes, Herat, 1496. Topkapi Saray Library, Istanbul. After Gray 1979, pl. XVII.

Fig. 161 far right Floral border from an illumination to the *Khamsa* of Nizami, Tabriz, 1539–40 or later. British Library.

Fig. 162 Designs on two tiles from the mosque of Murad II at Edirne, mid-15th century, showing (**a**) a design based on a Chinese lotus pattern, as in figure 23, and (**b**) a flower scroll based on a Chinese prototype (cf. fig. 34). After Carswell 1972, E11 and E29.

a

b

about a vertical axis; it consists of a large central bloom surrounded by several minor flowers and leaves. The whole composition is anchored by a further flower, or bunch of leaves, at the bottom centre. This arrangement follows the composition of Chinese lotus plant design, seen in a typical form on a small dish in the Victoria and Albert Museum (fig. 152). The large central leaf of the original design is replaced on the tile by an imaginary flower. It has small round petals supported on pointed sepals. The flowers around the edge are similarly constructed. At the foot, a further flower replaces a lotus leaf in the original composition. The tile pattern also displays prominently long leaf sprays that take up the position of waving fronds placed among the lotus plants on the Chinese original (fig. 152).

The other tile is decorated with a flower scroll (fig. 162b) based on ornament developed for the decoration of large Chinese porcelain dishes in the early fifteenth century (fig. 163a). The flowers are much simplified, but the pointed leaves, characteristic of a Chinese lotus scroll, are very clearly reproduced and proclaim the Chinese origins of this design. Versions of this second design are also found on dishes made at Iznik, thought to date from the first decades of the sixteenth century (fig. 163). The composition of the ornament on the dish in figure 163b refers to, but does not directly copy, the decoration of the tile; it is itself quite a careful copy of a fifteenth-century Chinese dish. However, such Iznik pieces continued the tradition established by tiles, relying on Chinese ceramic decoration for the sources of their designs.

Circular compositions did not seem to hold long-lasting attractions for Ottoman potters. Within a short time, these rotating designs were superseded by flower ornament arranged about a vertical axis. On a dish decorated in blue and turquoise, a vertical flower spray with long drooping leaves is combined with a ring of flowers linked by an encircling stem (pl. 8 left). A large central flower, the long leaf sprays and the small tuft of leaves at the foot of the composition all mirror the vertical arrangement of the design on the tile from the Edirne mosque (fig. 162a) based on a Chinese lotus pattern (fig. 152). At the same time, the circle of flowers on the dish (pl. 8 left) retains the imprint of the patterns on the previous Iznik dish and its Chinese model (fig. 163). The underlying ring of flowers gives a swirling movement to this otherwise vertical pattern. A combination of a vertical layout with a rotating movement was to

remain a feature of later, more adventurous Iznik designs.

The next stage in the development of bold flower patterns is found on a dish with related decoration (pl. 8 right). Like the previous two dishes, a distinction is made between the ornament of the rim, cavetto and central field. This shared composition groups the pieces together as representing several related stages in the exploitation of a Chinese decorative scheme. However, a significant change is signalled by the introduction of another colour, sage green. Furthermore, changes have also been made to the arrangement of the flower heads in the central field. The vertical axis has again been strengthened at the expense of the circle of flower heads. A small tuft of flowers and leaves remains from the previous example, occupying the position originally given to the lowest lotus leaf in the Chinese prototypes. A pair of round flowers at the centre draws the eye from this lower point to the large flower at the top. Stems and flowers, falling at either side of this central head, take up the position of the earlier circle of flowers. The small pointed petals of which the main flowers are constructed reflect the piled up petals upon pointed sepals seen on the earlier Edirne tile. So far both the composition of the ornament and the construction of the elements of the design were developed using Chinese ceramic ornament modified in Turkey.

Sage green employed on this last dish is regarded as the defining characteristic of a group of ceramic wares known as the 'Damascus' group.

Fig. 163 A comparison of a Chinese and an Ottoman dish with similar flower scroll decoration:

a porcelain dish decorated in underglaze blue, China, 15th century. Diam. 35.8 cm. British Museum.

b dish decorated in blue, Iznik, early 16th century. Diam. 34.2 cm. British Museum.

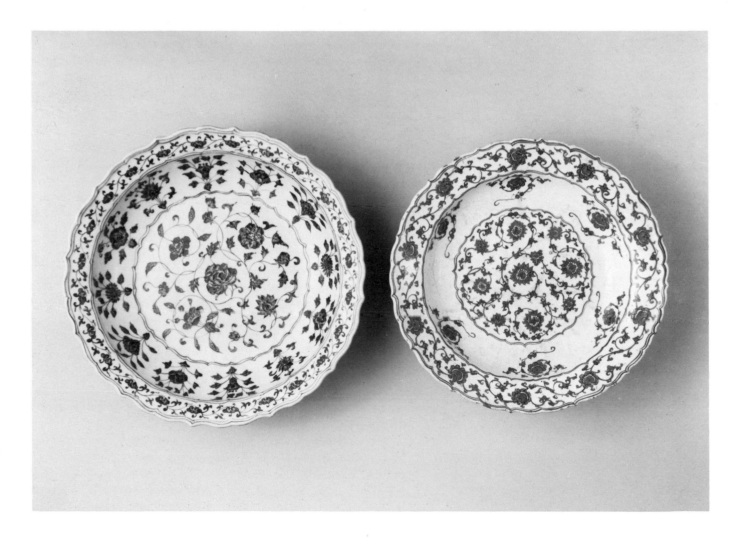

Only rarely do dishes of the 'Damascus' group refer so clearly to a Chinese ceramic scheme. More usually, the flower ornament is greatly enlarged and arranged in an emphatically vertical scheme, as on a dish in plate 9. Here the tuft of leaves at the foot of the earlier composition is retained, but the flowers are magnified. The central bloom and two of the smaller flowers are based on the flower heads seen in the previous example, on which small pointed petals were piled together to make flowers. Indeed, this shared characteristic enables us to view this bold design as the last stage in a series of developments that transformed standard Chinese flower patterns into something new and quite different.

The small petals of the flower in plate 9 could be varied by including small pods among them. New types of flower were added to the composition. These increasingly suggested plants from a garden; however, elements of fantasy remained prominent in the construction of the principal flower heads. Despite these changes, the underlying framework provided by Chinese lotus patterns determined the arrangement of the design. Thus many of the most elaborate 'Damascus' ware dishes display the following features: a combination of a design with a prominent vertical axis with some circular movement of the composition, especially around the edge of the main field; large fantastic flowers, often taking up a central position, occupying the space used for the Chinese lotus leaf and the main flowers on the Edirne tile (fig. 162); a series of small subordinate flowers, often around the edge of the composition, taking the place of the real lotus flowers and buds; a series of sweeping leaves, derived ultimately from the narrow fronds incorporated in the original lotus motifs (fig. 152, pl. 8 left); and a small tuft of leaves at the base of the composition, taking over the position of the secondary lotus leaf. Many of the 'Damascus' ware dishes are also bordered by a free interpretation of the Chinese wave design, which confirms their distant dependence on a Chinese prototype.[43]

An alternative version of Chinese lotus patterns is illustrated in the final group mentioned at the beginning of this section, namely, tiles and table wares decorated with red among the various coloured glazes. The first uses of the red glaze are found on tiles employed in the Süleymaniye mosque, dated to between 1550 and 1557, and the Rüstem Pasha Mosque of 1561, both in Istanbul. A prominent feature of these tiles is a large fantastic flower with narrow serrated petals joined in a continuous cup, seen, for example, on a lunette of tiles in the Victoria and Albert Museum (fig. 169). Various forms of this flower are illustrated in figure 164.

A flower in figure 164c, which consists of a lotus bloom against a serrated leaf, can be directly compared with one of the drawings of chinoiserie designs based on the Chinese lotus patterns, illustrated in the albums of drawings from Iran now in the Topkapi Saray (fig. 158). This composite flower appears on a dish decorated only in blue and sage green with a very detailed delineation that in itself suggests a source in a sketch or drawing.

A connection between these elaborate lotus-leaf flowers (fig. 164c) and chinoiserie drawings can be established by an examination of the decoration of a pair of very elaborate tiles at the Circumcision Kiosk in the Topkapi Saray (fig. 165).[44] A large composite flower appears half-way up the florid design and has been redrawn in figure 164d alongside the flower just described. This bloom is more complicated than any of the others in the same drawing, but like them it consists of petals serrated at the edges and joined as part of a continuous cup. As already seen in the Iranian examples (fig. 155), this outline is derived from a

a lotus leaf embroidered in gold on a dark textile found at the site of the ancient city of Ji'ninglu, Inner Mongolia, Yuan dynasty (1280–1368). After *Wenwu* 1979.8, pl. 5:4.

b fantastic flower from an Iznik bowl, early 16th century (see fig. 153).

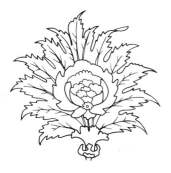

c detail of a fantastic flower based on a lotus leaf and lotus flower, from a dish decorated in green and blue, Iznik, second half of 16th century. Private collection. After Welch 1972, fig. 7.

d composite flower based on a Chinese lotus leaf, from the tile panels at the Circumcision Kiosk, Topkapi Saray, Istanbul, mid-16th century (see fig. 165).

e, f details of composite flowers from a tile panel decorated with colours that include bole red, second half of 16th century. British Museum.

Fig. 164 Fantastic flowers, based on Chinese lotus leaf designs, on Ottoman ceramics

lotus leaf. On the tiles, this lotus-leaf flower is embedded among long swirling leaves and other flowers. Two deer-like creatures or *qilin* appear at the foot of the composition.

This combination of Chinese creatures among swirling fantastic flowers refers to many chinoiserie drawings such as those in the albums of the Topkapi Saray, in which dragons in particular, and also other creatures of Chinese origin, are woven among lotus flowers and leaves. A sequence of Chinese lotus patterns (fig. 166), a chinoiserie drawing of lotuses (fig. 167) and a dragon among leaves (fig. 168), illustrates the type of development that may have given rise to the decoration of the panels of the Circumcision Kiosk.

The first example is taken from a southern Chinese stoneware flask, decorated around the neck with lotus flowers and leaves reserved against a dark ground (fig. 166). The leaves show the flat, slightly bell shape of the true lotus leaf. Although such southern stonewares are unlikely to have been exported to Iran or Turkey, related Chinese decoration probably inspired the drawing in figure 167 – a sketch, intended to fill a medallion, of interlaced

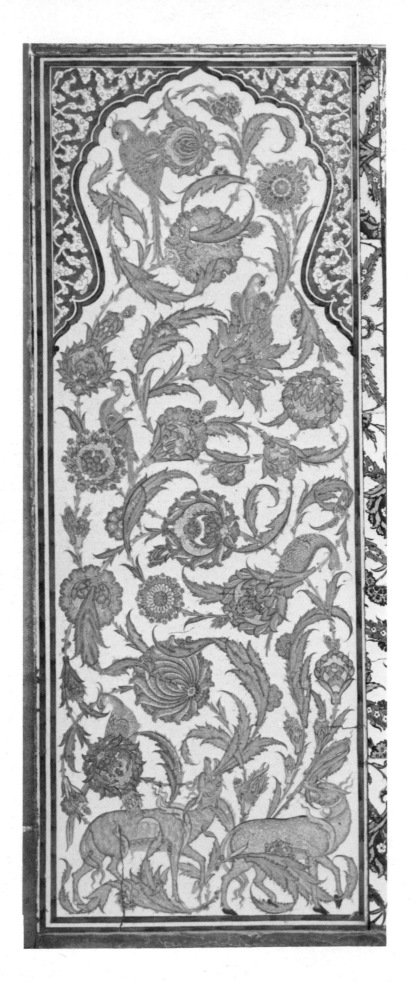

Fig. 165 Tile panel decorated in blue, Circumcision Kiosk, Topkapi Saray, Istanbul, mid-16th century. *Right* Detail.

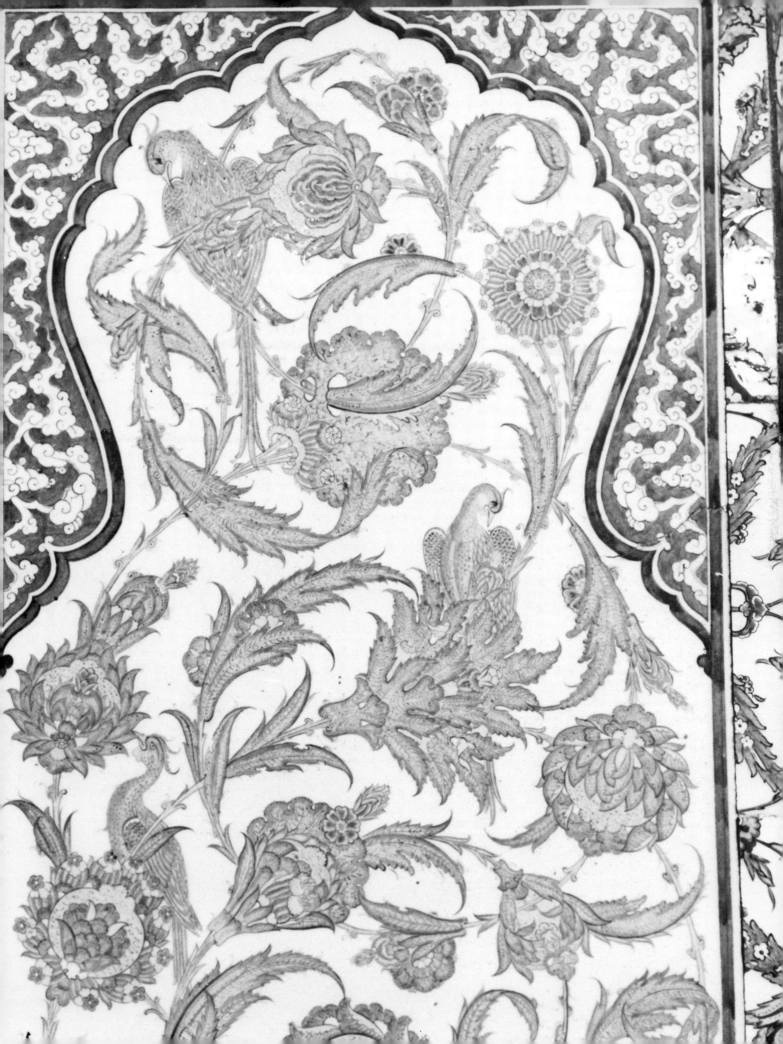

Fig. 167 Sketch for a medallion filled with lotus flowers and lotus leaves, Iran, 15th century. From an album in the Topkapi Saray Library, Istanbul.

Fig. 166 Lotus decoration on a stoneware flask, Jizhou type, Jiangxi province, China, Yuan dynasty, 13th–14th centuries. British Museum.

lotus leaves and flowers. The small lotus flowers filling the medallion are very like Chinese ceramic decoration, but the leaves have been enlarged and now have deep ragged indentations; they have taken on a fantastic aspect, which is assisted by the repetition of small holes in the leaves and by the threading of stalks through these holes. Some of the stalks are sharply broken.

The Topkapi albums are full of drawings which show similar lotus forms interwoven with dragons and phoenixes. Some of these creatures are even threaded through the holes in the leaves and represent therefore the next stage in fantastic compositions based on Chinese motifs. A rather unusual version of this type of drawing is illustrated in figure 168, in which a dragon strides through a forest of swirling leaves. The drawing, which is attributed to an Iranian artist working in the second half of the sixteenth century, belongs as squarely to the chinoiserie tradition as the previous drawing.[45] Indeed, on

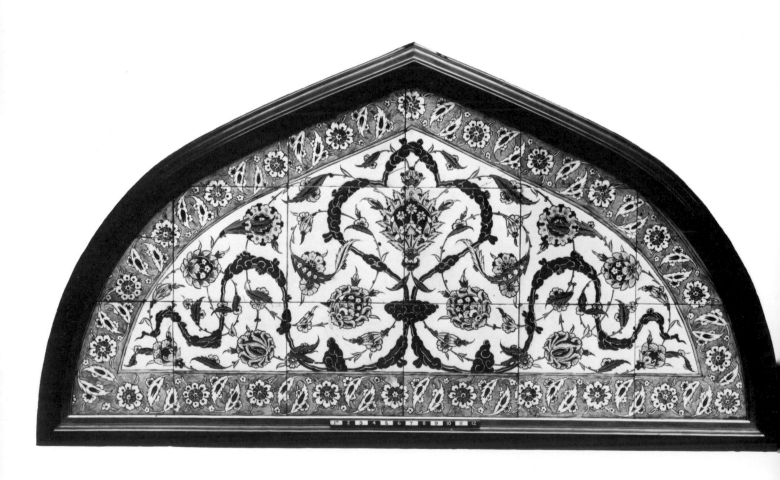

examination, the leaves prove to be those of a lotus – now reused as elegant foliage, as though their tough tissue has been suddenly changed to fine silk. The thin leaves retain the multiple serrations and indented outline of the previous lotus leaves. Like them, they are pierced with holes through which stalks penetrate. These are sharply bent as in the previous drawing.

The leaf forms used in this dragon drawing are remarkably similar to the leaves drawn on the tiles at the Circumcision Kiosk. Indeed, several features of these tiles suggest that they were dependent on decorative designs first worked out in chinoiserie drawings. Elaborate leaves, broken stems, small holes in the leaves, and the combination of creatures and lavish flowers parallel the effect achieved in such sketches as those in the Topkapi Saray library.[46]

While the date of these elaborate chinoiserie compositions has yet to be established, they are interesting in suggesting the sorts of development that may have made Chinese lotus leaves available to Iznik potters manufacturing tiles and dishes decorated with coloured glazes that included red. For in the second half of the sixteenth century, Iznik potters made use both of fantastic flowers based on lotus leaves (figs 164e, f) and of flowers taken from 'Damascus' wares. On table wares rather tame versions of the 'Damascus' ware flowers were used, while much bolder blooms based on the lotus leaf were widely exploited on tiles. In addition, motifs such as large split-palmettes, cloud bands and ribbon designs were borrowed from other sources.

The tile panel in the Victoria and Albert Museum already mentioned (fig. 169) illustrates a typical scheme, with a large composite flower at the centre. Additional small flowers have been placed within the deep cup to add detail and variety. As with earlier Iranian flowers, the use of an invented flower gave the potters great freedom in their design, allowing them to vary the shape, colour and details as the shape of the panels and the composition of the ornament demanded.

In the late nineteenth century, such flowers had a new lease of life in the tile designs of William De Morgan.[47] A large flower on a tile in plate 10 copies the deep cup shape and the serrated outlines of the lotus leaf borrowed by the Ottoman potters as the framework for their invented flowers (fig. 164e, f). As in the Ottoman examples, De Morgan has established additional small flowers within the main blooms. His design is rather flatter and more graphic that the example illustrated on the Victoria and Albert Museum's tile panel. The serrated and fissured edge of the bloom is particularly prominent, and it is possible that interest in this shape contributed to the bold divided outlines employed by both De Morgan and William Morris for their luxuriant flower and acanthus patterns. The ramifications of the influence of Chinese lotus patterns are thus surprisingly wide.

Pine, prunus and garden plants

To complete the description of Chinese designs employed in Iran and Turkey, it is necessary to conclude with a few observations on the use of the prunus and other plants that accompany it in Chinese porcelain design – the pine and bamboo. Examples of this trio have been illustrated from late fourteenth- and early fifteenth-century Chinese porcelains (figs 104, 105). On the earlier example, the full height of the plants is shown, while on the second piece, the scene is broken by the boundary line of the frame. This latter example is interesting for the large bushy clusters of needles on the branches. Both designs may have been based upon compositions worked out in paintings.

Fig. 168 Drawing of a dragon among lotus leaves attributed to Mir Sayyid Muhammad Naqqash, 16th century. Fogg Art Museum, anonymous loan.

Fig. 169 Lunette tile panel of lotus flowers with a cloud scroll in red, Iznik, second half of 16th century. L. 157.9 cm. Victoria and Albert Museum.

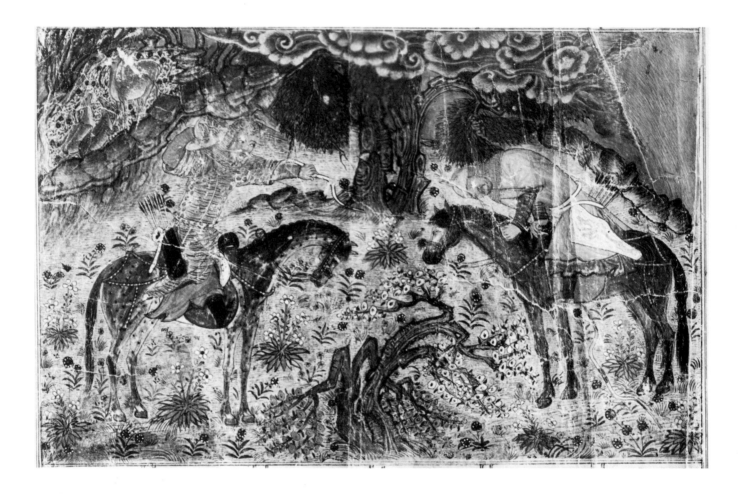

Fig. 171 'The Death of Isfandiyar', from the Demotte *Shahname*, Iran, *c.*1330. Fogg Art Museum.

Ornament on a small Chinese fifteenth-century jar should also be mentioned (fig. 170). Around the circumference small plants are ranged. Similar plants are sometimes combined with larger trees in the decoration of substantial porcelain dishes. Such major pieces of Chinese porcelain are known from the collections in the Ardebil Shrine in Iran and the Topkapi Saray, and it is possible that the Islamic world became familiar with these plant and tree motifs from porcelains. However, as some of the earliest Iranian miniatures that include prunus trees pre-date the more elaborate porcelain designs, it is possible that these plant subjects were transmitted to Iran on decorative painting or embroideries.[48]

Prunus and other plants, but rarely the bamboo, are found in both miniature painting and in manuscript illumination in Iran. An example, now

Fig. 170 Plant ornament from a porcelain jar, China, Ming dynasty, early 15th century. British Museum.

in the Fogg Art Museum, from a famous Il-Khanid manuscript, known as the Demotte *Shahname*, illustrates a twisted prunus in the foreground of the composition (fig. 171). Scattered over the hillside are small plants which follow the 'schema' used in Chinese designs. At the back, beneath lowering clouds, stands a tree with tufts of greenery on the ends of its branches. Such trees are sometimes designated 'bushy-topped' and appear in many manuscript illustrations, including a sketch in a Topkapi album (fig. 150). Clusters of greenery at the ends of the branches are not unlike the clusters of needles on Chinese pine trees (fig. 105). It seems possible that this imaginary tree was based upon some Chinese representations of pines, and was then separately developed by Iranian artists.

Two facing folios in the Chaghatay anthology from Yazd (fig. 172) demonstrate the currency of the Three Friends in a more ornamental form. One folio is devoted to the prunus and the other to a rather straggly pine. Slight waving fronds are possibly an interpretation of the bamboo. The needles of the pine seem somewhat spindly alongside the heavy cypress trees included in the composition. These angular, straggling branches were probably less appealing than the invented bushy-topped tree. Prunus, bushy-topped trees and various cypresses were widely used to suggest gardens and planted landscapes. Prunus trees are often glimpsed through open windows depicted in buildings.[49]

Chinese trees and plants also had a role in the decoration of Iznik wares. Prunus trees are particularly easy to identify: they were used both on dishes

Fig. 172 Two folios from an anthology of Chaghatay poems, illustrating the prunus and pine after Chinese models, Yazd, 1431. British Library.

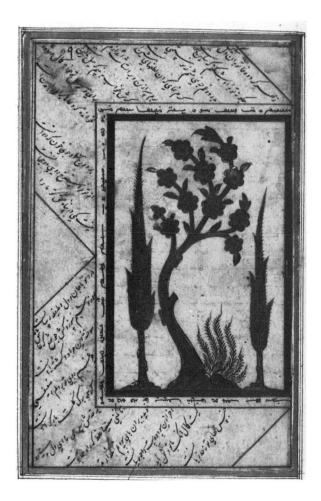

Fig. 173 Tile decorated with a bird and a prunus tree within a lobed medallion, Iznik, 16th century. H. 24.8 cm. Victoria and Albert Museum.

and in spectacular tile compositions. On such panels in the Topkapi Saray and the Rüstem Pasha mosque, the prunus trees spread across a large number of tiles; a dark blue ground was used to highlight the pink flowers.[50] In these examples, great care was paid to the arrangement of the branches. Small tufts of leaves were used to anchor the trees at the foot of the panels. A small tile in the Victoria and Albert Museum also conveys some of the fantasy with which the subject was exploited (fig. 173). This tree is also rooted to the ground by a small tuft of leaves similar to those used with the lotus designs described in the previous section (fig. 152). Regular blossoms, which evoke the tree in the

Chaghatay anthology, set up their own momentum, while a bird, threaded around the trunk, recalls the Chinese origin of the motif, as does the detached lobed frame.

On Ottoman pottery, the pine is generally suggested by a conventional cypress. However, bushy-topped trees make a new, if rare, appearance. Ornament on a dish in the Victoria and Albert Museum consists of large round heads on each of the several branches (fig. 174): this arrangement seems to reflect the layout of a bushy-topped tree. The soft foliage has been replaced by a circular, almost vegetable-like growth. Such forms were not invented in Iran but first appear among the many plants used on fifteenth-century tiles found at Damascus. As ever, the Ottoman designs include an element of fantasy that contrasts with the lyrical ornament employed in Iran.[51]

A dish in the Louvre, decorated both with a strange vegetable-like plant and an array of other flowers, displays these fantasies at their best (fig. 175). The distant Chinese origins of the motifs are made explicit in the small peacock included among the exotic plants, while towering flowers and a free composition add new exotic qualities. Such compositions are as inventive as the peony scroll that the Chinese had concocted on the basis of Western half-palmette designs.

Indeed, the history of plant forms in the ornament of Iran and Turkey parallels some of the developments observed in China 1,000 years before. In both areas, an initial stimulus was derived from a foreign decorative tradition,

Fig. 175 Dish with a peacock among plants, Iznik, mid-16th century. Musée du Louvre.

and in both areas foreign motifs were rapidly assimilated and developed in new inventive ways. Above all their origins were rapidly disguised. So well camouflaged are the fantastic plant designs of Iran and Turkey that we think we recognise real plants in them and therefore do not ask ourselves questions about their sources and history. Yet as we have seen, these flowers are inventions of the mind, not of nature. Because Chinese flower scrolls and Iranian and Ottoman lotus-leaf flowers were inventions, they had to be sustained by traditions which each generation could mine, elaborate and extend. However, once such inherited forms were abandoned, invention ceased. During the twentieth century, in parallel with the rejection of Classical architectural ornament in the West, the traditions that supported these flower patterns were finally set aside;[52] for this reason Eastern flower design is no longer a living art.

Appendix: Lotus and papyrus designs in ancient Egypt, Mesopotamia and Greece

This appendix surveys the history of flower ornament in the lands around the eastern Mediterranean, which preceded the invention of acanthus patterns, the source of Chinese flower designs. As with the Chinese flower borders, acanthus scrolls were not simply invented by drawing real acanthus plants; they were designed by adding spiky acanthus leaves to much more ancient motifs. Inevitably, the imprint of these older patterns was retained in the Hellenistic and Roman acanthus borders illustrated in Chapter 1. Indeed, the undulating scrolls, of which there has already been so much discussion, arose out of these ancient models.

The history of the acanthus has preoccupied many scholars. Foremost among these is Alois Riegl, whose contribution to our understanding of the ornament of the Mediterranean area has already been mentioned. As indicated in the Introduction, Riegl had taken account of the work of W.H. Goodyear who had explored the relationship of lotus and palmette motifs in the search for a universal symbolism. Riegl's approach, however, was to concentrate instead on the formal development of borders of lotus, palmette and acanthus found in Egypt, Mesopotamia, Syria and Greece. Details of the present description differ from Riegl's analysis; however, the general outline proposed follows his fascinating account.[1]

Three distinct motifs are essential to the discussion: lotus flowers, the pseudo-flower known as a palmette, and stems in the shape of spirals. These separate motifs were developed in Egypt with perhaps some influence from the Aegean. The combination of these three elements into a series of ornamental borders can be followed through three separate stages. In the Egyptian private tombs of the New Kingdom, at Thebes, lotus and spirals were joined both in borders and across large expanses of wall. Occasionally palmettes were added to the designs. The Mesopotamian kingdoms of Mitanni and Assyria took over some motifs formulated in Egypt and elaborated them, giving special prominence to palmettes. In turn these Mesopotamian patterns were extended and varied in the islands of the Aegean and on the Greek mainland. Such borrowing of motifs depended on exchanges brought about through trade and conquest. During the period of the Middle Kingdom (2040–1633 BC), Cretan wares were exported to Egypt and both Egyptian and Cretan products were acquired in Syria. Although this period of interchange may have laid the foundation for the sharing of certain decorative motifs, the time with which we are most concerned follows the establishment of the New Kingdom in Egypt in the sixteenth century BC. The Egyptians, having overthrown their alien Hyksos rulers, aggressively reasserted native Egyptian rule and turned their attentions beyond Egypt to Syria. Military expeditions under Tuthmosis I (1525–c.1512 BC), Tuthmosis III (1504–1450 BC), and Amenophis II (1450–1425 BC) brought much of northern Mesopotamia under Egyptian authority. This was an era of intense diplomatic and commercial activity which seems to have introduced Egyptian styles of decoration to the Near East.[2]

Similarities between later Mesopotamian decoration and ornament employed in Greece and other parts of the Mediterranean from the seventh century can also be attributed to exchanges that followed in the wake of political activity. In the late eighth century, the Assyrian ruler Tiglath-Pileser III (744–727 BC) conquered much of Syria as far as the coast. From the eighth century, metalwork and ivory worked in or at least traded from Syria were decorated with borders of lotuses and palmettes and with palmette trees, all motifs that were popular in the great Assyrian palaces.[3] Export of metalwork,

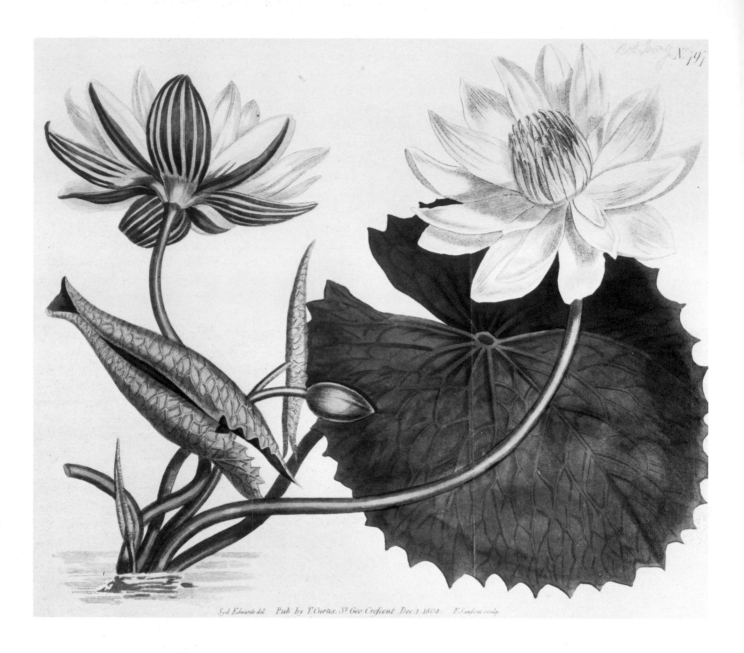

Within the image: *Syd. Edwards del Pub. by T. Curtis, St. Geo. Crescent, Dec. 1 1804. F. Sansom sculp.*

Fig. 176 The white lotus, *Nymphaea lotus* L.
Curtis's Botanical Magazine t. 797 (1805).

and ivory, and possibly also glazed pottery, introduced this range of designs to the islands of the Aegean, Greece and even Etruria. Thus behind the development of Mediterranean plant decoration that combined Egyptian, Mesopotamian and Aegean designs lay a series of political and commercial encounters which made the motifs of one area available to another.

Egypt

This section is concerned with the sources of the principal elements of Mediterranean ornament, the lotus, the palmette, and the spiralling stems, and with their combination as borders and in large areas of decoration. The earliest Egyptian designs were founded upon stylised depictions of lotus flowers. Two principal species of lotus are thought to have flourished in ancient Egypt – the white lotus, *Nymphaea lotus*, and the blue lotus, *Nymphaea caerulea* (fig. 176). Both plants have relatively narrow petals held within green sepals and a large flat leaf, larger and rounder than that of a water-lily.

The flowers were used to decorate monuments and were illustrated in wall-paintings. Garlands were also placed on coffins in tombs. The popularity of the lotus was due not only to its wide distribution in Egypt but also perhaps to the symbolic role it seems to have acquired. Because the petals of the flower closed at night and reopened in the morning, the lotus was regarded as a symbol of the sun, and it also came to represent the resurgence of life. At Heliopolis, where the sun was worshipped, priests explained the origin of the world as the emergence of the god Re – a personification of the sun – from a lotus growing out of primordial waters. They taught that at sunset the god entered the flower, which folded its petals down on him, and that he was reborn as the flower unfolded, morning after morning.[4]

The lotus was represented in Egyptian art from the third millennium BC.[5] However, we are concerned not with such early manifestations but rather with later paintings of the New Kingdom period (c. 1567–1085 BC). During the New Kingdom, high officials were buried at Thebes in tombs with extensive

Fig. 177 A nobleman hunting in the marshes: wall-painting from an unidentified Theban tomb, Egypt, New Kingdom period, c. 1425 BC. British Museum.

painted decoration. Lotuses are depicted in representational scenes, and appear profusely among the ornaments – crowning capitals, aligned in horizontal borders, and spread out across large areas of walls and ceilings.

A well-known wall-painting in the British Museum, from an uncertainly identified Theban tomb, executed possibly during the reign of Amenophis III (c. 1417–1379 BC), illustrates the lotus in its natural habitat (fig. 177). Lotus flowers with large and broad leaves grow in the marsh over which a nobleman rides in his boat. The flowers appear to the right of the boat. A bunch of lotuses hangs over his arm and another spray is held by his wife. In these three separate instances, all the blooms are rendered with the same conventions. The heads of the flowers are approximately triangular in shape, shown in profile with white petals framed by green and grey sepals. Most important of all, buds alternate regularly with open flowers. No attempt was made to vary this sequence, to show, for instance, two buds or two open flowers side by side in place of the rhythm of one bloom followed by one bud. Nor are any flowers shown with tilted heads or broken stems, or with heads of different sizes, features with which we, inheritors of a sustained attempt to reproduce nature realistically in paintings, might regard as necessary to a naturalistic treatment. By the period of the New Kingdom, a satisfying convention for the depiction of the lotus had been established to which artists rigorously adhered.

In the same wall-painting fragment, a bank of papyrus stands in front of the nobleman. Although the papyrus is clearly distinguished from the lotus by its green fronds tipped with red and by its long stems, some of the conventions already noted are repeated in representing papyrus: like the lotus flowers, papyrus heads appear as truncated triangles, and full open papyrus heads alternate with closed ones. This bank of plants is highly stylised. In nature the papyrus is rather untidy, its long flat fronds bending and drooping very easily, while its tall stems often break as the plant head falls towards the water. In the wall-painting, the papyrus has been neatly arranged with two single serried rows of regular stems and heads. The similar conventions used for both lotus and papyrus are seen in paintings and decorated artefacts of the New Kingdom. Both plants occur, for example, on glazed composition bowls, and the lotus is generally raised on a long straight stem like the papyrus. In such designs, the plants retain both the triangular outline and the bud and open head sequence already noted.[6]

While the sources of the lotus and papyrus used in ornament are thus readily identified in representational paintings, the origin of the third plant, the palmette, is less easy to trace. In outline, the palmette consists of a fan of graded spines, generally supported on large volutes.[7] The name we now use appears superficially to refer to the outline of palm fronds first employed in Egypt to decorate column capitals, and illustrated at a much later date in stone reliefs in Assyrian palaces. However, the ways in which the palmette was used in both Egyptian and Mesopotamian ornament suggest that the palmette did not correspond to a large tree but rather to a smaller plant, equivalent in size to a lotus or papyrus.

Furthermore, examples can be found of stylised plants that seem to anticipate the typical outline of a palmette in Aegean representations of papyrus. Such papyrus ornament is illustrated on a large jar, known as a Palace Style jar, found at Knossos and made by Cretan craftsmen, perhaps under the influence of Mycenean taste (fig. 178a). The plants exhibit the Egyptian formula of open head and bud. From the tall stalks, fine sprays of

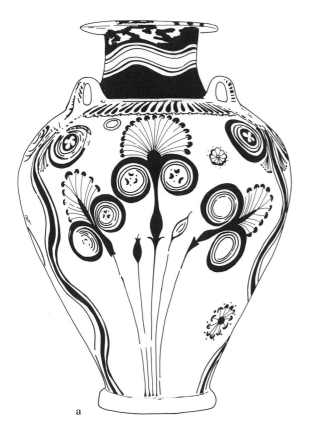

a

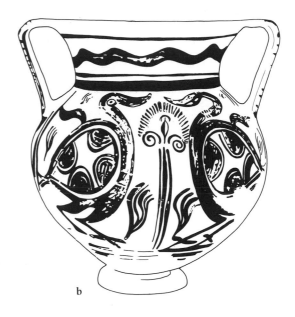

b

Fig. 178 Earthenware jars with papyrus decoration:

a Palace Style jar, *c.* 1425 BC. H. 70 cm. After Marinatos 1960, pl. 91.

b jar from Enkomi, Cyprus, *c.* 1300–1200 BC. British Museum.

fronds spread like fans, suggesting some of the delicacy of the true papyrus head. Pairs of spiralling volutes, which support the fronds, are a peculiarity of the design on the Palace Style jars. So large are these volutes that there is space for small rosettes within each one; they recall both spiral patterns popular in Aegean decoration and the large volutes that are also used in Cretan wall-painting to suggest lilies.[8] On a rather later jar from Cyprus, a less elegant version of the same plant appears by itself between two birds (fig. 178b). Although the drawing is somewhat cursory, the fine spray of fronds and the pair of volutes of the previous example are retained.

Palmettes appear in Egyptian tomb painting, both in large decorative schemes covering extensive areas and in narrow borders. These borders to which palmettes were sometimes added were based on the lotus and bud formula described above. In Theban tomb no. 90, the tomb of Nebamun, an official under Tuthmosis IV (1425–1417 BC), there is a row of lotus heads and buds which hang downwards on short stalks (fig. 179a). The widespread formula used for representing flowers in scenes is here borrowed to provide a simple ornament. Several variations of this scheme are found in the same tomb and in other tombs of the same date. Along the east wall of the tomb of Nebamun, the alternating lotus heads and buds are linked by looped stems, which from now on will be described as arcaded stems (fig. 179b). Spirals, enclosing rosettes, link flowers in a border from the tomb of Amenhotpe si se, Theban tomb no. 75, also of the period of Tuthmosis IV (fig. 179c). In a later Theban tomb, no. 68, the tomb of Nespneferhor (*c.* 1000), different flowers or fruits alternate with the lotus heads (fig. 179d). Here the long-standing scheme of lotus head and bud has been modified to include other plants in place of the buds, among them palmettes. Such apparently small changes were to make it possible to vary the lotus and bud border. Ornaments in which lotus

Fig. 179 Borders of lotus and buds from Theban tombs

a, b from Theban tomb no. 90, tomb of Nebamun, an official under Tuthmosis IV (1425–1417 BC). After Davis 1923, pls XXIV, XXI.

c from Theban tomb no. 75, tomb of Amenhotpe-si-se, period of Tuthmosis IV. After Davis 1923, pl. XXIV.

d from Theban tomb no. 68, tomb of Nespneferhor, *c*.1000 BC. After Davies 1936, pl. CIV.

Fig. 180 Ornament of spirals and palmettes from a Theban tomb, New Kingdom period, Eighteenth Dynasty (*c*.1567–1320 BC). After New York 1922, pt 2, pp. 50–1, fig. 1.

buds were replaced by palmettes became ubiquitous, and their further development in Western Asia is described in the following section. Palmettes are also found in a larger area of decoration in a fragmentary painting from a Theban tomb, where flower heads, consisting of small spines, spring from a pair of volutes that resemble the outline of lilies (fig. 180).[9]

It has sometimes been argued that the long spiralling stems on which these stylised flowers or palmettes were supported were borrowed by the Egyptians from earlier Aegean work. Recently such an approach has been contested.[10] Spiral designs are found in Egypt at quite an early date, for example, on scarabs of the first Intermediate period (2181–2050 BC); further simple patterns based on paired spirals were used in the tomb of Hepdjaefa, constructed at Asyut in the reign of Sesostris I (1971–1928 BC). Thus spiral designs were already present in Egypt before the Eighteenth Dynasty, and these simple patterns are generally deemed sufficient to provide the elements exploited by craftsmen decorating such tombs as Theban tomb no. 71, tomb of Senenmut, adviser to the formidable ruler Queen Hatshepsut (1503–1482 BC). As illustrations of the tomb of Senenmut are somewhat limited, spiral patterns typical of many Theban tombs are illustrated from Theban tomb no. 40, the tomb of Huy, who was Viceroy of Nubia in the reign of Tutankhamun (1361–1352 BC) (fig. 181a). Groups of four spirals are used to define small, approximately square

a from Theban tomb no. 40, tomb of Huy, period of Tutankhamum (1361–1352 BC). After Davies 1926, pl. 1.

b from a ceiling in the north-west basement corner of the Palace at Knossos, Crete, late Minoan IA (*c.*1550–1450 BC). After Evans 1930, pl. xv.

Fig. 181 Decoration of spirals

fields in which a flower head is placed. This arrangement of spirals was also popular in Crete. It has been suggested that painted wall decoration in Cretan palaces, such as the spiral ornament from a ceiling in the north-west corner of the palace at Knossos, dated to late Minoan IA (*c.*1550–1450 BC), was undertaken in imitation of Egyptian designs (fig. 181b).[11]

Spirals within the more complex pattern on the ceiling in Theban tomb no. 50, the tomb of Neferhotep (*c.*1350 BC), are arranged rather differently (fig. 182). In the section reproduced, pairs of rows of linked spirals run vertically, multiplying the scheme seen in a border of the tomb of Nespneferhor, illustrated in figure 183b. These pairs of running scrolls have then been joined horizontally by further spirals. Similar bowed lines with spirals at each end are also found in Cretan art.[12] The resulting framework of spirals was then filled by the usual lotus and bud combination and with rosettes, to be understood perhaps as lotus flowers seen from above. In addition, where the spirals come together at an acute angle, lotus heads were tucked into the corners. This same device also appears on less complicated designs in the tomb of Nespneferhor already mentioned (fig. 183b). In later centuries, continuing use of running spirals filled with flowers in the corners provided the underlying framework for a design of borders of running spirals combined with palmettes rather than lotuses (fig. 193b).[13]

Several other designs in the Theban tombs will be mentioned as they had some influence on later architectural decoration in the Near East.[14] In Theban tomb no. 82, the tomb of Amenemhat (*c.*1475 BC), a lotus flower and buds are arranged on a circular plan (fig. 183a). Interlacing circles, filled with rosettes, were also very popular (fig. 183c). Another widely distributed pattern, the rectilinear spiral, or meander as it is generally termed by Western art historians, is illustrated in a detail taken from the tomb of Senenmut (fig. 183d). Rectilinear meanders had been known from the Middle Kingdom period, and it has been suggested that they were modified versions of spirals, adapted to complement other geometric ornament.

While the surviving examples of this series of designs are best preserved in tombs, we know from the decoration of the Malkata Palace of Amenophis III

(*c.*1400 BC) that similar decoration was used in buildings to accommodate the living.[15] The medium through which such designs were taken to the Near East has perished, but some knowledge of Egyptian ornament is implied by the widespread use of lotus and palmette decoration found in Mesopotamia.

Syria and Mesopotamia

Ornament in Syria and Mesopotamia following the Asiatic campaigns of the Egyptians is fascinating in its own right. However, it will only be briefly treated here, and discussed only from the point of view of the evidence it provides of the new interpretations of Egyptian motifs already illustrated. The episode is important to the history of Mediterranean motifs because the ornament developed in the Near East between the sixteenth and the seventh centuries BC provided the vocabulary later exploited in the islands of the Aegean and in the

Fig. 182 Lotus and spiral ornament from Theban tomb no. 50, tomb of Neferhotep, *c.*1350 BC. After Davies 1936, pl. LXXXIII.

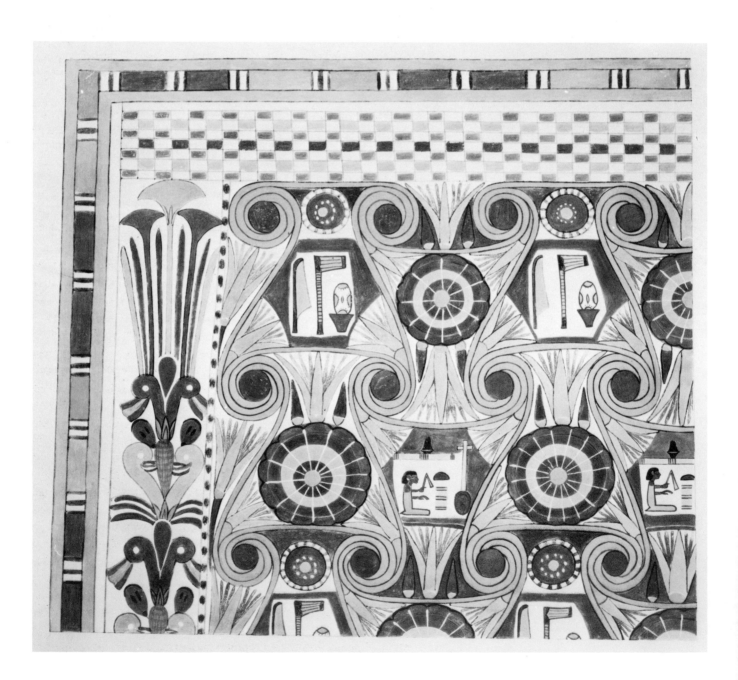

Fig. 183 Ornament in Theban tombs of the
New Kingdom period

a pattern of lotus and buds, arranged in circles, from Theban tomb no. 82, tomb of Amenemhat, *c.*1475 BC. After Jéquier 1910, pl. XXVII.

b running spirals and lotus from Theban tomb no. 68, tomb of Nespneferhor *c.*1000 BC. After Jéquier 1910, pl. XXXVII.

c interlacing circles from Theban tomb no. 68, tomb of Nespneferhor, *c.*1000 BC. After Jéquier 1910, pl. XXXIII.

d meander from Theban tomb no. 71, tomb of Senenmut, period of Queen Hatshepsut (1503–1482 BC). After Jéquier 1910, pl. XXV.

mainland of Greece. Lotuses, palmettes and rosettes recur, being used in borders and more especially in strange tree-like constructions, which were dependent on an Egyptian source and are particularly interesting for the prominence they gave to palmettes.

Both the borders and the trees are well illustrated in the wall-paintings at the palace at Nuzi in the State of Mitanni (*c.*1550–1400 BC) and in the rather later Assyrian palace of Tukulti-Ninurta. Motifs formulated in these early buildings were widely exploited in the later Assyrian palaces at Nimrud and Nineveh.[16]

In the remains of the early palaces, the wall-paintings are divided into panels. At Nuzi, the panels are frequently defined by running borders of linked spirals which, unlike their Egyptian counterparts, are drawn very tight with round links butted against each other (fig. 184). Mesopotamia, like the Aegean and Egypt, had a long tradition of spiral designs, and this ornament may have been quite independent of Egyptian or Cretan designs. Today these Mesopotamian spiral designs are known as the guilloche. In both simple and quite complex forms, this design was passed on to craftsmen on the Greek mainland and islands and was later taken up by the Romans and Byzantines.

Trees occupy prominent positions in the wall-paintings at Nuzi and in all Assyrian palaces. Indeed, such centrally placed trees, often designated as sacred by modern authorities, had a long history in Mesopotamia and Syria.[17] In a detail from an earlier palace at Mari, a fairly realistic tree is shown with a tall trunk and short branches (fig. 185a). Foliage at the tips of the branches suggests papyrus heads, but otherwise such depictions of trees do not seem to have been influenced by the ornaments described so far. Stumpy trees or plants in the wall-paintings from Nuzi represent a departure from the earlier Mesopotamian convention (fig. 184). One of the trees in the wall-paintings from the Mitanni palace has a short spreading trunk that rises into a pair of

Fig. 184 Wall-painting from a palace of the State of Mitanni at Nuzi, Iraq, 15th century BC. After Starr 1937, pl. 128.

Fig. 185 Trees in Mesopotamian palace decoration

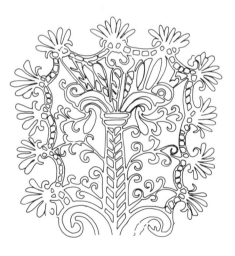

a from a palace at Mari, Syria, before 1760 BC. After Stevenson Smith 1965, fig. 127.

b from an alabaster jar found at Assur, Iraq, *c.* 1400 BC. After von Bissing 1940, fig. 23.

c from a pottery sherd found at Assur, Iraq, 13th century BC. After Stevenson Smith 1965, fig. 151.

bumps supporting two volutes, which in turn enclose a row of petal-like spines. The section of wall-painting illustrated shows two alternative constructions. In the second plant motif, petals are enclosed within a pair of volutes balanced on a further pair of branches.

Both plants appear to refer to stylised garlands or bouquets in materials such as precious metals represented in Egyptian tombs of the New Kingdom. A well-known example of such representations is illustrated among the New Year's gifts to Amenophis II, painted in the tomb of Kenamun, Theban tomb no. 93;[18] a rather later bouquet is shown to the left of the spirals in the section of the painting from the tomb of Neferhotep in figure 182. These bouquets usually emerge from a pair of large volutes, based on the outline used for lilies in both Egypt and Crete. In the garland from the tomb of Neferhotep, the base of the lower portion contains two lily volutes, with another pair of volutes between them turned inwards rather than outwards. At the top sprouts a row of papyrus. The trees in the Nuzi panel seem to be abbreviated versions of these garlands: volutes taken from Egyptian wall-painting are combined with a row of spines, perhaps derived from a row of papyrus heads and leaves, with papyrus heads omitted. It seems likely that these Mesopotamian versions of an Egyptian motif were a product of contact with Egypt, following the Egyptian campaigns.

In other examples of trees with trunks topped by volutes, palmettes play a particularly prominent part. Two examples are illustrated on finds from Assur: an alabaster vase of about 1400 BC, and a painted fragment of pottery, dating to the thirteenth century BC (figs 185b, c). The vase is decorated with a tree standing between goats modelled in relief. Pairs of confronted animals are an ancient Mesopotamian convention, known also in Crete and other islands of the Aegean, perhaps through the medium of gem carving. (A pottery jar decorated with a palmette or papyrus between two birds has been illustrated above in figure 178b). The plant between the goats on the alabaster vase grows on a short trunk capped by two neat volutes, from which emerges a row of broad leaves alternating with stalks supporting neat palmette heads. These stems and leaves parallel the papyrus sprays in the Egyptian bouquet and confirm the equivalence of the papyrus and palmette. Additional stems and palmettes sprout from half-way down the tree trunk.

The ornament of the second example is similar to the first. The tree has a short trunk emerging from a pair of volutes on the ground. At the top, another pair of widely splayed volutes encloses a row of leaves, similar to the leaves or petals on the Nuzi tree. A new element is added, however, in an arcaded border that encircles the tree supporting palmettes. Trees related to the designs on the alabaster vase and the pottery fragment are included in the decoration of the palace of Tukulti Ninurta I (fig. 186). In one of the panels a single tree is placed between two goats. Its trunk is divided into tiny segments and it is crowned by a generous palmette. Additional branches emerge from the foot, following the ornament of the vase from Assur (fig. 185b). The other trees resemble the ornament on the pottery fragment more closely. A palmette is placed at each end of a trunk, which is encircled by an arcaded stem supporting small palmettes.

Once this formula of a palmette tree surrounded by a stem or border of palmettes had been invented, it remained in use up to and during the height of Assyrian power in the ninth to seventh centuries BC. Such trees were carved in stone or painted in palaces at Nimrud and Nineveh.[19] Examples reproduced by

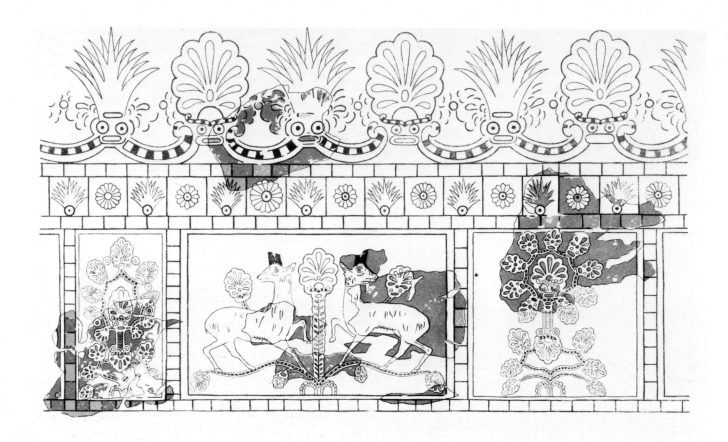

Owen Jones in *The Grammar of Ornament* are illustrated in plate 12.

Above the trees and the confronted goats in the panels of the wall-painting in figure 186, lotus heads, seen in profile, alternate with rosettes, possibly understood as lotus plants seen from above. Both these motifs have early histories in both Egypt and Crete, and might have been borrowed from either. A border of lotuses and palmettes on arcaded stems, more easily ascribed to Egypt, takes over the rhythm of similar ornament in the tomb of Nebamun (fig. 179b); but in the Assyrian example lotus buds have been replaced by palmette heads and the whole sequence has been turned the other way up. This series of alternating palmettes and lotuses remained prominent in Assyrian art, and was also taken up by Greek potters and architects.

Other sequences of flowers on arcaded stems were equally or more popular. On a fragment of a stone carpet from the North Palace of Ashurbanipal at Nineveh, two different borders encircle the central grid (fig. 187). The outer border consists of familiar lotus flowers alternating with buds, while the inner border is confined to palmettes. The two registers are separated from one another by small rows of rosettes, and these flowers also fill the main grid across the centre of the carpet. The motifs at the centre of the squares, a group of four lotus heads alternating with four buds, or possibly pods, recall the Theban tomb patterns (fig. 183a). The enormous influence of this decorative scheme is best appreciated by noting that the design on the carpet found in the frozen tombs, constructed at Pazyryk in the Altai mountains in eastern Siberia in the fifth century BC, was laid out in an exactly comparable form, with parallel borders surrounding squares containing lotus designs.[20] Many

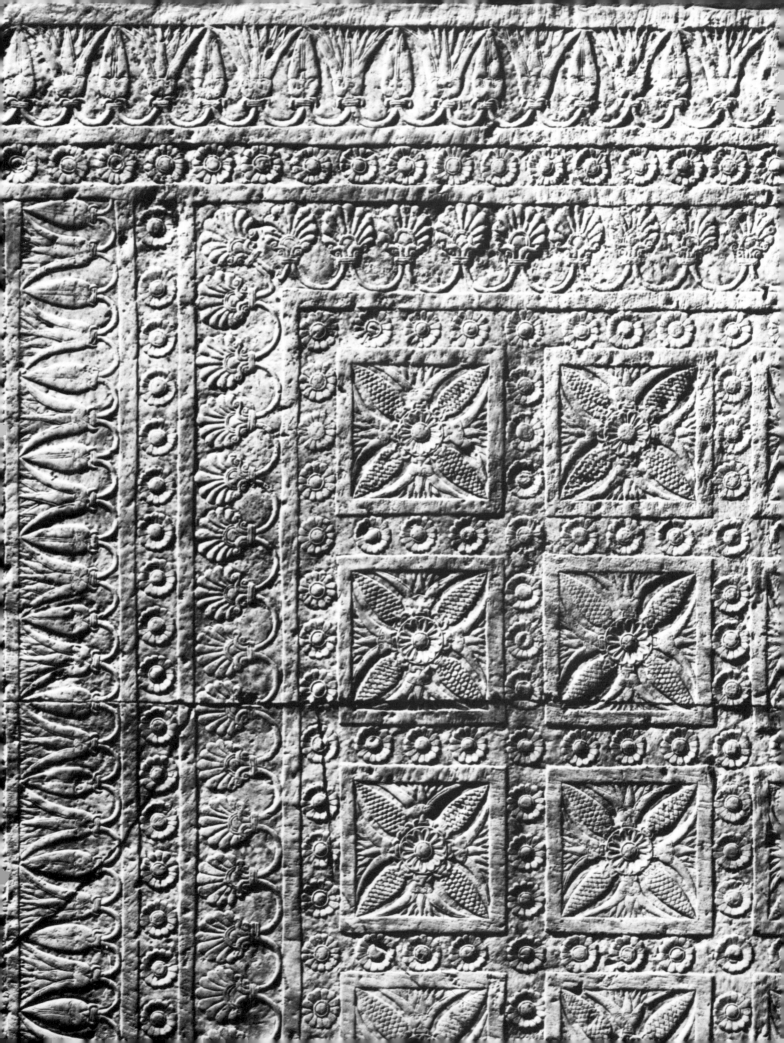

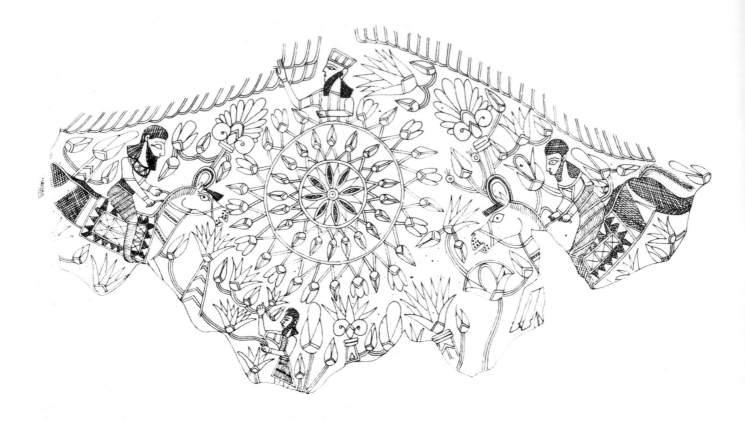

Fig. 188 Tridachna shell, engraved with lotus patterns and palmette trees, from Sippar, Iraq, 8th–7th centuries BC. W. 25.5 cm. British Museum.

wooden harness plaques carved in the shape of palmettes have been found in burials in the same area.

The route from Assyria to both Pazyryk and the Tarim Basin lay across Iran, where the border designs just described were used by the Achaemenids in the decoration of their palaces. Among their new inventions was a tree or plant consisting of tiers of enclosed leaves culminating in a single palmette head.[21] This plant appeared to give the palmette some botanical credibility but was no more real than the palmette tree in Assyrian wall-painting. Arcaded borders were equally popular, and both palmettes and lotus and bud forms were widely used.

Greece and the eastern Mediterranean

Plant ornaments, which employed both lotus and bud borders from Egypt and fantastic palmette trees from Assyria and the Syrian coast, are found engraved on *tridachna* shells. Dating to the eighth and seventh centuries BC, these shells were probably carved along the coasts of Lebanon and Syria (fig. 188). Phoenician ivories originating in the same area are similarly decorated.[22] The wide currency of such ornament at centres along the coasts and on Mediterranean islands is confirmed by the use of strange volutes and palmette trees on bronzes unearthed as far west as Italy, in the tombs of the Etruscans. At the same time lotus and palmette borders seem to have come to the attention of potters in the Greek islands.

Most of the flower patterns of the Minoan and Mycenaean periods appear to have been lost after the collapse of Mycenaean civilisation about 1100 BC. During the next three centuries, pottery was decorated with increasingly elaborate geometric designs: birds and animals sometimes occurred, and by the eighth century scenes of small pin-like figures were occasionally employed.

In the seventh century, palmette and lotus patterns reappeared on several large *amphorae* said to have come from Melos, presumably as a result of influence from Assyria by way of the Syrian coast.[23] Ornament on a small seventh-century cup from Rhodes can be compared with the Assyrian designs considered in the previous section (fig. 189). A pair of goats is placed at the centre of the main panel of the cup, which is divided by a short tree. On inspection, it can be seen that the tree has a thick trunk like the Assyrian examples and a rolled top that supports a large palmette. Further trees are placed at the extreme ends of the design. Both the shape of the trees and the general composition of two confronted animals divided by a plant betray a Near Eastern source, although the decorative scheme had also been known to the Cretans at a much earlier date. On other early Greek pottery, lotus and palmette borders were widely used. A sixth-century jug from Melos is decorated with a central band of goats, bordered above and below by lotus flowers and buds in red (fig. 190). On a Rhodian *amphora* of similar date, a complex of spirals related to the guilloche (but often called a cable pattern) encircles the neck, while a design around the body consists of large volutes supporting palmettes (fig. 191). These simple palmettes seem to be greatly inflated versions of small, discrete palmettes on volutes, found earlier on the Melos *amphorae*.

On the Melos jug and the Rhodian *amphora*, lotus and palmette designs occupy very prominent positions. In the following centuries, as Greek vases were taken as vehicles for scenes from myths and from daily life, flower patterns were relegated to subordinate positions. They remained important, however, as borders to delimit the figure compositions and to fill areas, such as the sections below handles, in which it was difficult to accommodate more elaborate scenes. The clarity and elegance of these flower patterns, 'florals' as they are often called, present us with a readily accessible sequence of the lotus and palmette designs used in Classical Greece.[24]

While borders based on Assyrian designs in which lotuses and palmettes alternate on an arcaded stem (fig. 187) are found on a few vessel types, such as Caeretan *hydriai* of the sixth century (fig. 192b), designs in which palmette heads were combined with s-shaped stems were much more common and

Fig. 189 Detail of decoration of goats and palmette trees on a miniature *krater*, Camirus, Rhodes, 675–650 BC. British Museum.

Fig. 190 'Wild goat' jug, with borders of lotuses and buds, Melos, East Greek, 6th century BC. H. 33 cm. British Museum.

Fig. 191 Amphora with cable, ivy-leaf, and palmette patterns, 'Fikellura' style, Camirus, Rhodes, 6th century BC. H. 30 cm. British Museum.

more important to the invention of later running leaf scrolls. A small eastern Greek dish provides a convenient example (fig. 192a). As on the two vases just mentioned, the motifs on the dish appear in black and purple pigment against the buff ground of the fired clay. Large palmette heads stand on s-shaped scrolls, descended, it may be suggested, from the many s-shaped spiral patterns already considered. The use of an s-scroll in place of an arcaded stem allows the heads to appear first above and then below the series of stems. This arrangement is new to the present discussion, although alternating bands of colour within the palmettes suggest that they, like all other palmette and lotus motifs, were based on Near Eastern examples, where contrasting colours were often used for related designs (pl. 12).

A large number of decorative schemes were contrived in the sixth century with two borders of flower heads (palmettes and lotuses) attached to s-shaped scrolls. Around the neck of a sixth-century *amphora* in the British Museum (fig. 192c), a zigzag of palmettes on s-shaped stems is combined with lotus flowers on similar stems. These stems cross one another, and locate the flowers they support in alternate positions. Two rows of flower heads, one the right way up and the other upside down, now contain both lotuses and palmettes. Additional stems are used to join the lotus heads together. The design is painted in two colours, with the stems shown in black, and parts of the flowers in red.

By the mid-sixth century, the independent sources of the two series seem to have been forgotten, and the undulating s-shaped scrolls were reduced to neat loops between the flower bands, as on a black-figured vase illustrating the

Fig. 192 Lotus and palmette borders on Greek vases

e double lotus and palmette borders from a black-figured *amphora* (fig. 194), Athens, 540–530 BC. British Museum.

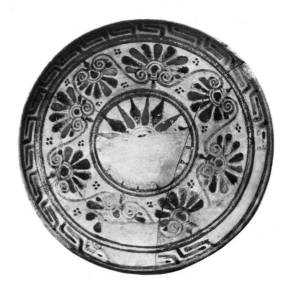

a palmettes and s-shaped stems on a dish, Naukratis, Egypt, East Greek, 6th century BC. British Museum.

f single lotus and palmette border, from a red-figured *hydria*, Athens, 460–440 BC. British Museum.

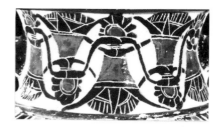

b lotus and palmette border on arcaded stems, from a Caeretan *hydria*, Etruria, 6th century BC. British Museum.

g palmette and stem border from a red-figured *hydria*, Athens, 480–470 BC. British Museum.

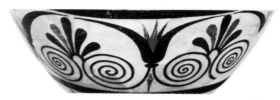

c double lotus and palmette borders on s-shaped stems, from a black-figured *amphora*, Athens, 6th century BC. British Museum.

h palmette and lotus border on complex stems, from a red-figured *hydria*, Athens, c.480–470 BC. British Museum.

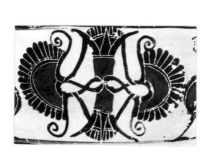

d ornament of two lotuses and two palmettes, from a black-figured *amphora*, Athens, 6th century BC. British Museum.

i border of palmettes on a running stem, on a black-figured *hydria*, Athens, 510–500 BC. British Museum.

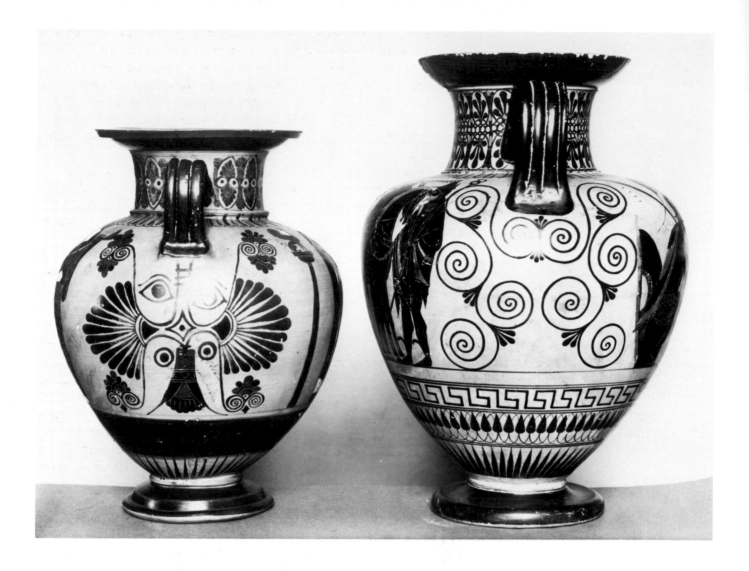

Fig. 193

a black-figured *amphora* with a grotesque face
amid palmette ornament, Athens, *c.*550 BC.
H. 39.5 cm. British Museum.

b black-figured *amphora*, Athens, *c.*530.
H. 46.7 cm. British Museum.

story of Herakles and the boar (fig. 192e). The tight loops are rather like a net of string, or a cat's cradle of thread, drawn tight to bind the flowers together. Although the alternating lotus and palmette pattern is maintained in this example, palmettes have come to dominate the border, with lotuses squeezed between them. Indeed, the lotus appears as a boundary for an oval field, in which the palmette sits, rather than as an independent element.

This effect was more pronounced in borders on later red-figured vases of the fifth century. On a *hydria* decorated with a scene of music-making, a single bold border of lotuses and palmettes encircles the belly of the vase (fig. 192f). Although scrupulously painted, this series of flowers again gives emphasis to the palmette, with the two outer petals of the lotus seeming to provide a boundary for enclosures. Many other red-figured vases are less neatly designed, and the lotus between the palmettes is reduced to a simple dash, leaving the edge of the lotus shape as a pair of stems looped around the palmette (fig. 192g). On slightly later vases, there was, it seems, a deliberate return to the lotus and palmette scheme, as seen on a red-figured vase illustrating a scene from the death of Nessos (fig. 192h). Here neat palmette heads appear alongside less convincing lotuses. In reviving this pattern the artist seems to have been unaware that originally the edges of the lotus petals

provided the boundary for enclosures containing palmettes. Now independent stems bound the area around the palmette, and additional tendrils have been provided to enclose the lotus heads, making for a slightly fussy effect.[25] This late attention to the lotus flower had, however, little subsequent effect on the repertory of ornament available in later centuries. Both in the West, and in Central and East Asia, borders in which stems define oval enclosures containing palmettes (figs 11, 47) were elaborated on the basis of the earlier design seen in figure 192.

The borders described so far do not include narrow running scrolls which might be interpreted as the ancestors of the running acanthus scroll; some narrow borders used in Greek vase painting do, nevertheless, contain undulating stems to which palmettes are attached as though they were flowers (fig. 192i). Such scrolls were not particularly important to the development of acanthus scrolls, nor were the much earlier running plant designs singled out by Alois Riegl.[26] The main source of elaborate leaf and flower scrolls can be found in the combinations of s-shaped scrolls and palmettes that were elegantly invented to fill the area around the handles of Greek vases.

Returning to the sixth-century *amphora*, whose neck design has already been considered, an enlarged detail of the palmette and lotus combination can be observed at the centre of the belly (fig. 192d). Here the s-shaped stems have been twined together to hold two lotuses and two palmettes in a rectangular arrangement. This neat and regular shape had to be modified when placed below the handle of a vase, as on a black-figured *amphora* (fig. 193a). Two of the palmettes retain their previous position, as does one lotus head, but the other flower head has been replaced by a dividing line, perhaps suggesting a nose between two eyes. The pattern is elaborated by extending the lines, which bound the palmettes, into a scroll, from which a further short line branches; small palmettes are balanced on the resulting paired scrolls.

The scheme is much elaborated on a black-figured vase illustrating the tale of Herakles and the boar (fig. 194), whose neck ornament is illustrated in figure 192e. The pattern is laid out with four large s-shaped spirals as the main framework. At the outer corners, these spirals are extended, as in the previous example, by an added spiral. Palmettes are balanced on paired scrolls, both at the centre of the design below the handle and at the outer extensions. A reminder of the original composition, in which palmettes were paired with lotus heads, is found in four rather neat lotus heads tucked into the corners between the extended arm, which reaches out to the outer spiral, and the principal rounded spirals.

On rare occasions, the composition of paired s-shaped scrolls was subordinated to a longer scroll of fine tendrils, as on the right-hand vase in figure 193b. Here a pair of s-shaped scrolls initiates the design below the handle. Long hanging stems built up of single scrolls are attached to these two s-shaped lines. Small palmettes have been inserted in the junctions of the stems. This method of extending s-shaped scrolls was later used to provide stems for acanthus scrolls (see p. 222).

In red-figured vase painting, arrangements of paired s-shaped scrolls with additional side extensions were further elaborated. Parts of the main stems were lengthened, making loops which could enclose whole palmette heads within them.[27] On large vessels, the arrangement was generally based on four large scrolls, already seen on black-figured vases, but where the container provided a more restricted surface, only parts of the scheme could be fitted in.

Fig. 194 Black-figured *amphora*, with palmette and lotus ornament, Athens, 540–30 BC. H. 43 cm. British Museum.

Shallow cups could accommodate only part of these complex patterns. On the example in figure 195, a single central palmette appears balanced on a pair of s-shaped scrolls, while further small palmettes decorate the end of additional branching sections of stem.

The reason for singling out this example is that it provides a bridge between the scrolls constructed on black and red-figured vases and the related designs in stone to which acanthus leaves were added. The arrangement of the design in figure 195 can be compared with ornament on a fourth-century memorial tablet in the British Museum (fig. 196). On this tablet, a chalice of acanthus leaves anchors the whole composition and contains within it one end of a pair of s-shaped volutes which supports the palmette. This large palmette is, by implication, divided into two halves by its acanthus sheaths. Further scrolls carry smaller palmettes into the upper corners of the tablet. Not only can the composition be compared with the design on the red-figured *phiale* (fig. 195), it also contains references to earlier black-figured ornament (fig. 194). Tiny buds emerging from the blank stone between the palmettes seem to be a reminder of lotus flowers that linger between the palmettes on vase painting (fig. 194). This vestige of an earlier composition seems to indicate that such acanthus ornaments were not separately invented but were devised by adding leaves to well-established decorative schemes.[28]

The design on the memorial tablet was already quite advanced. More elementary ornament was used in the fifth century, at which time tiny leaves seem first to have been carved on the volutes supporting large palmettes in architectural decoration. Acanthus leaves were also added to the ancient design of lotuses and palmettes bound together by an arcaded stem. A Greek version of this Assyrian border is carved in fragments of decoration surviving from an Ionic Treasury at Delphi, now in the Delphi Museum (fig. 197a). While the coiled stems employed here are slightly different from those in the border at the palace of Tukulti-Ninurta (fig. 186), the same sequence of lotuses and palmettes recurs. The two plants are easily distinguished: the lotus has broad heavy petals, while the palmette is described by a narrow fan of spines. On the Erechtheion, a temple constructed on the Athenian Acropolis in the late fifth century BC, the same border is used, altered now by the addition of acanthus leaves (fig. 197b). Although the lotus, deprived of its firm outline, has here disintegrated into a series of spines, somewhat like those used for the palmette, the balance of the earlier motif is retained: the lotus petals are splayed

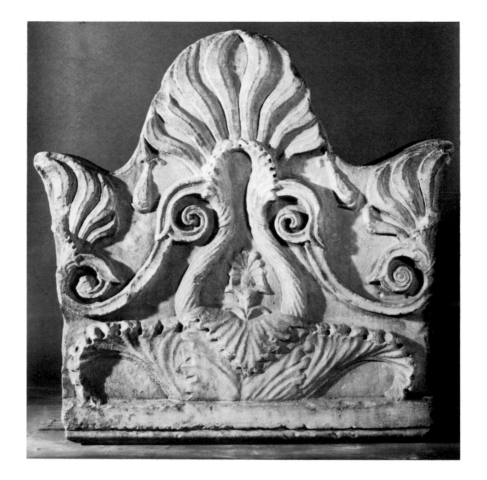

Fig. 196 Upper part of a stele, decorated with a palmette and two half-palmettes springing from acanthus leaves, found in a cemetery at Maritsa, Rhodes, 4th century BC. H. 68 cm. British Museum.

Fig. 197 Border of lotus and palmettes showing the use of acanthus leaves

a from an Ionic Treasury, Delphi, Delphi Museum, 6th century BC. After Lawrence 1957, pl. 34a.

b from the Erechtheion, Athens, late 5th century BC. British Museum.

c from the Tholos, Epidauros, 4th century BC. After Roux 1961, pl. 45.

outwards, and the spines of the palmette are arranged like a fan. Stems on the Erechtheion border also follow the arrangement seen on the fragment from Delphi, emerging from the base of the lotus and providing a pair of rolled ends to support the palmettes. Where the two borders differ, however, is in the addition of acanthus leaves to the Erechtheion scroll to support the flowers. The lotus flower rises out of a chalice of leaves, two of which turn up around the blossom, while two further leaves bend outwards on either side; one more is shown at the front, turned towards the viewer. Leaves around the palmette are treated somewhat differently: the rolled ends of the formerly abstract line remain clearly visible, but they are given a slightly more plant-like appearance by two leaves that act as a platform for the palmette, which also is held by a small upstanding leaf. A later version of the same scheme appears on the Tholos at Epidauros (fig. 197c). The illustrated example shows an additional stem rising from the palmette base, with a small palmette at its tip. This extra stem is also seen on some of the borders of the Erechtheion and seems to have been inspired by more complicated designs, such as those available to potters who readily joined several s-shaped stems to suggest the tendrils of a plant.[29]

In both the later examples in figure 197, acanthus leaves contribute the illusion of a real plant, disguising the stylised nature of the ornaments. Indeed, the borders are sometimes considered as representing some particular plant: the design on the Erechtheion, for example, is often called a honeysuckle.[30] Such persistent attention to sources in real plants on the part of the observer, and an accompanying lack of concern with origins in the ancient ornament of the Near East, may suggest one of the reasons why acanthus leaves were added in the first place and why, once used, they persisted.

It would appear that the effect sought and achieved by the use of acanthus leaves was to give the impression that a real plant was depicted in the ornament. Chalices in the form of acanthus leaves appear to explain how the different blooms come to be growing out of the stem: once the leaves have been added, we can almost accept the stylised Mesopotamian border as representing real plants.[31]

However, a combination of ancient lotus and palmette ornament with acanthus leaves was not at any stage entirely credible as a realistic flower. Various commentators have therefore provided explanations for its presence. Among the earliest is Vitruvius' description of the origins of Corinthian capitals on which acanthus leaves are used to cover the base of a framework of palmettes supported on volutes – often termed helices in this context. Vitruvius suggested that the first Corinthian capital had been carved by the sculptor, Kallimachos, who had noticed a basket of toys, left on a tomb of a girl by a nurse, that had subsequently become wrapped in an acanthus plant. Charming though the story is, it must be treated as apocryphal. Corinthian capitals do not seem to display the earliest examples of acanthus ornament; they are a special and quite late case of changes made to existing schemes of palmettes on volutes.[32]

While the very earliest examples of acanthus leaves may have been added to ancient palmette or lotus designs for a visual effect, acanthus ornament perhaps endured because it had or had acquired some symbolic meaning. For example, early acanthus capitals, including one known capital from the Temple of Apollo at Bassae, were so placed as to suggest that they had some particular role in relation to cult images. Furthermore, acanthus leaves are often prominently illustrated in the ornament of *lekythoi*, small juglets used

especially in burials. Several later writers have gone so far as to suggest that such uses of the acanthus should be explained in terms of its associations with death and mourning.[33]

Apart from being used as a support for blossoms based on lotuses and palmettes, the acanthus had a further role: its leaves were used to cover the junctions in sections of scroll put together to make a running plant stem, as Ernst Gombrich has pointed out.[34] Although in Greek vase-painting small running borders were used, the main scrolling areas were devised by adding small single scrolls to a central unit consisting of a pair of s-scrolls. These junctions were ignored or filled with a small palmette. However, when related

Fig. 198 Pebble mosaic of a stag hunt surrounded by a floral border based on an acanthus scroll, signed by Gnosis, Pella, Macedonia, 3rd century BC. H. of central panel 3.1 m.

scrolls carved in stone were interpreted as a plant rising out of an acanthus calyx, small leaves were placed over the junctions in the stems.

Here it is appropriate to refer to the decoration on a pier capital from the cella of the Hellenistic Temple of Apollo at Didyma, already discussed in Chapter I. This example displays an invented plant design founded on a pair of s-shaped scrolls (fig. 12). Two main stems rise out of a central acanthus calyx; from these stems branch two small tendrils which take a pair of half-palmettes up above the line of the frieze. The underlying construction is similar to that of the palmette and acanthus design on the fourth-century memorial tablet (fig. 196). This framework consists of a pair of large s-shaped scrolls, of which the lower half is concealed within the acanthus calyx. On each side, small scrolls have been added, whose junction with the main scroll is covered by a small acanthus leaf. Each small leaf is secured by a small ring or collar – this neat junction of the leaf and stem persisted on many Western acanthus designs and even recurs in leaf scrolls used in China (fig. 46c). In the two upper corners of the capital, small palmettes are attached to the stems, echoing the palmettes seen at the outer corners of the memorial tablet (fig. 196). The ornament has been improved, however, by inserting small trumpet-like flower heads in the scheme, taking the place perhaps of the small lotus heads seen in figure 194. These heads contribute the sense of a real plant design, but neither the acanthus leaves, disguising the branching stems, nor the inserted flowers do more than create a fantastic plant founded upon a long-standing framework; the continuing use of s-shaped scrolls and palmette heads determined the disposition of the ornament.

Decorative schemes laid out with paired scrolls emerging from a central acanthus calyx were extremely versatile. They could be infinitely extended by adding another scrolling section and covering the joint with another acanthus leaf. The facility with which such changes could be made ensured the ornament a wide use in many different guises. A particularly delightful example is seen in a mosaic from Pella in Macedonia (fig. 198).[35] At first sight this mosaic appears to be freely designed, with its undulating scroll suggesting a real trailing plant. However, the old formula persists even here. An acanthus calyx is placed in two of the four corners of the square pavement border, and these leafy hearts do not, therefore, obstruct the main running scrolls along the four sides. These scrolls freely interpret plants already seen on the capital from the Temple of Apollo. Many more curling tendrils have been inserted along the length of the scroll, yet the half-palmettes of the original design still linger at the tips. The palmette spines are so widely splayed that at first glance they resemble the tendrils crowding the border. Small trumpet-shaped flower heads, seen from several angles, are similar to those on the capital just considered. Again small acanthus leaves cover the junctions of the branching stems with the main stem. This pavement illustrates the deceptively realistic ornament which could be based on an earlier framework, represented here by the memorial tablet in figure 196, and before it in vase decoration.

Alternatively, the regular undulating stem supporting large acanthus leaves could be allowed to dominate the design. Such patterns were illustrated at the beginning of Chapter I and represent the later history of acanthus designs. This ornament provided the basis for the foliage patterns used in architecture in Iran, Central Asia and China. In this context, the ornament in the Buddhist cave temples of China is the easternmost extension of the range of influence of ancient Mediterranean lotus and palmette designs.

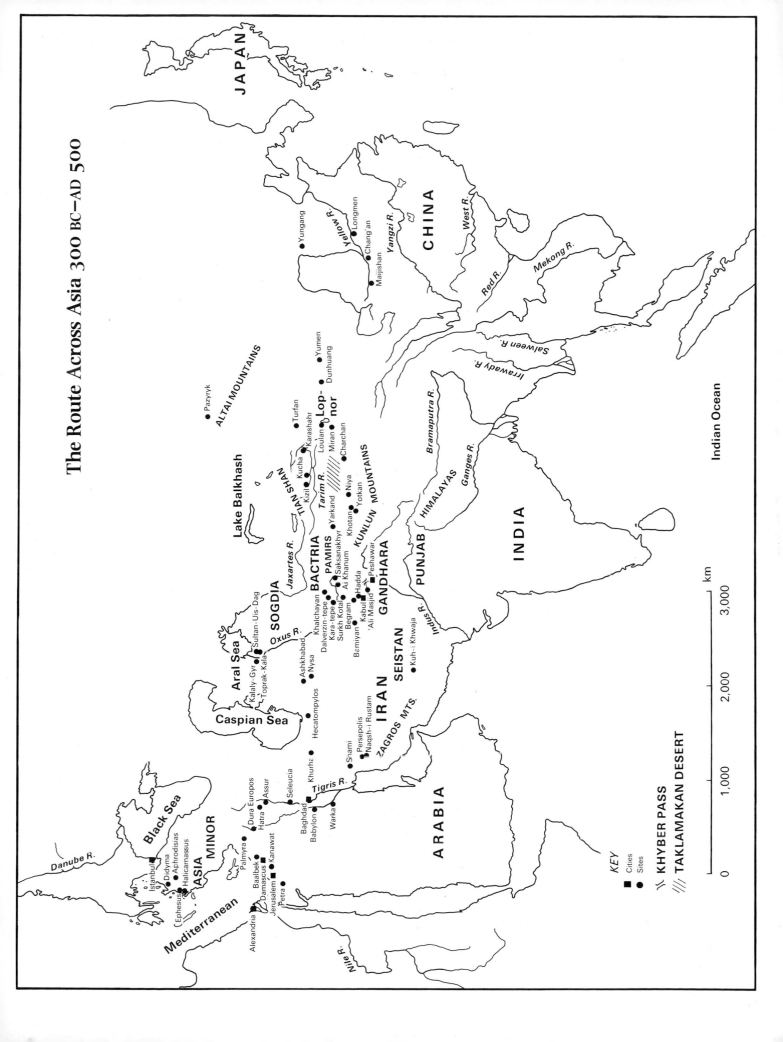

The Route Across Asia 300 BC–AD 500

JAPAN

CHINA

Yellow R.
Yungang
Longmen
Chang'an
Maijishan
Yangzi R.
West R.
Red R.
Mekong R.

Salween R.
Irrawady R.

Pazyryk
ALTAI MOUNTAINS

Yumen
Dunhuang
Turfan
Lop-nor
Karashahr
Loulan
Miran
Kucha
Kizil
Charchan
Niya
Yotkan
Khotan
TIAN SHAN
Tarim R.
Yarkand
KUNLUN MOUNTAINS

Lake Balkhash

Bramaputra R.
Ganges R.
HIMALAYAS

Jaxartes R.
BACTRIA
PAMIRS
Saksanakhyr
Ai Khanum
Peshawar
GANDHARA
PUNJAB
INDIA

SOGDIA
Sultan-Uis-Dag
Khalchayan
Dalverzin-tepe
Kara-tepe
Surkh Kotal
Hadda
Kabul
'Ali Masjid
Bemiyan
Begram

Aral Sea
Kalaly-Gyr
Toprak-Kala
Oxus R.
Ashkhabad
Nysa
IRAN
SEISTAN
Indus R.
Kuh-i Khwaja

Caspian Sea
Hecatompylos
ZAGROS MTS.
Persepolis
Naqsh-i Rustam
Shami

Dura Europos
Assur
Seleucia
Tigris R.
Hatra
Khurhe

Black Sea
Danube R.
ASIA MINOR
Palmyra
Istanbul
Didyma
Aphrodisias
Halicarnassus
Ephesus
Baghdad
Babylon
Warka

Baalbek
Damascus
Kanawat
Alexandria
Jerusalem
Petra
Mediterranean
Nile R.

ARABIA

Indian Ocean

km
3,000
2,000
1,000
0

KEY
Cities ■ Sites ●
KHYBER PASS ⟋⟋
TAKLAMAKAN DESERT ///

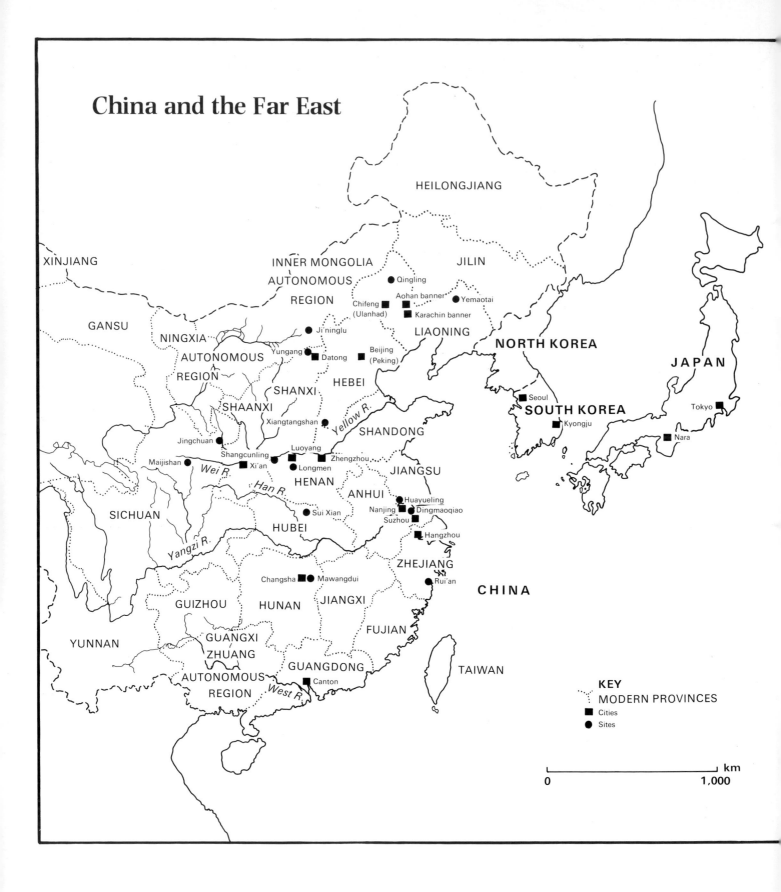

China and the Far East

XINJIANG

HEILONGJIANG

INNER MONGOLIA
AUTONOMOUS
REGION

JILIN

● Qingling

● Aohan banner

Chifeng
(Ulanhad) ■

■ Karachin banner

● Yemaotai

LIAONING

GANSU

NINGXIA
AUTONOMOUS
REGION

● Ji'ninglu

Yungang
■
■ Datong

Beijing
(Peking) ■

NORTH KOREA

JAPAN

SHANXI

HEBEI

SHAANXI

Xiangtangshan ●

Yellow R.

SHANDONG

Seoul ■

SOUTH KOREA

Tokyo ■

Jingchuan ●

Shangcunling ●
Maijishan ● ■ Xi'an

Wei R.

Luoyang
●
● Longmen

■ Zhengzhou

Kyongju ■

Nara ■

Han R.

HENAN

JIANGSU

SICHUAN

● Sui Xian

ANHUI

Huayueling ●
Nanjing ■●
Suzhou ●

● Dingmaoqiao

Yangzi R.

HUBEI

■ Hangzhou

ZHEJIANG

Changsha ■ ● Mawangdui

● Rui'an

CHINA

GUIZHOU

HUNAN

JIANGXI

YUNNAN

GUANGXI
ZHUANG
AUTONOMOUS
REGION

FUJIAN

GUANGDONG

West R.

■ Canton

TAIWAN

KEY

⋯⋯ MODERN PROVINCES

■ Cities

● Sites

km

0 1,000

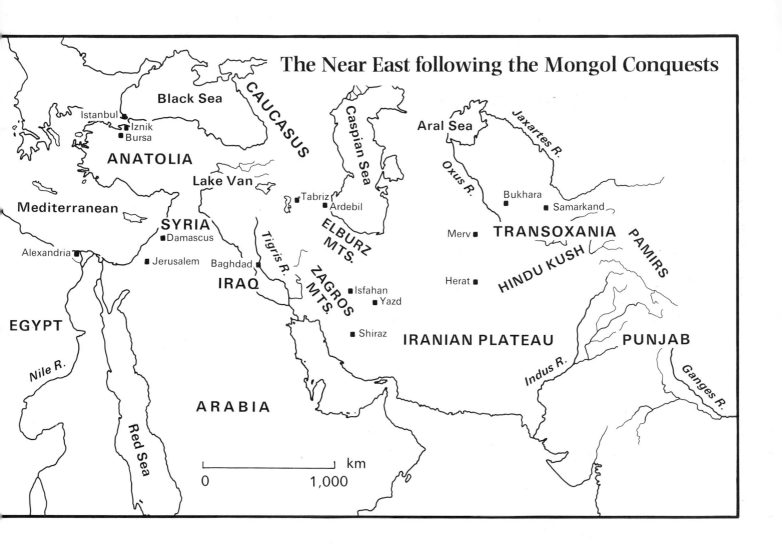

The Near East following the Mongol Conquests

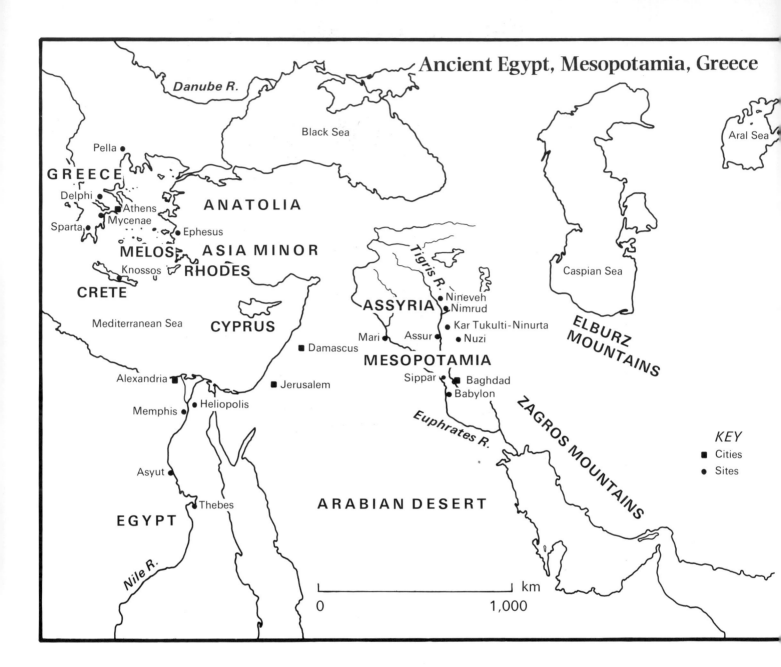

Ancient Egypt, Mesopotamia, Greece

Danube R.

Black Sea

Aral Sea

GREECE

Pella

Delphi

Athens

Mycenae

Sparta

MELOS

Ephesus

ANATOLIA

ASIA MINOR

RHODES

Knossos

CRETE

CYPRUS

Mediterranean Sea

Caspian Sea

ASSYRIA

Nineveh

Nimrud

Kar Tukulti-Ninurta

Mari

Assur

Nuzi

ELBURZ
MOUNTAINS

Damascus

MESOPOTAMIA

Alexandria

Jerusalem

Sippar

Baghdad

Babylon

Memphis

Heliopolis

Euphrates R.

Tigris R.

ZAGROS MOUNTAINS

KEY

■ Cities

● Sites

Asyut

ARABIAN DESERT

EGYPT

Thebes

Nile R.

km

0 1,000

226

Chinese dynasties

c.1700 BC	1050 BC	**Shang dynasty**
c.1050	221	**Zhou dynasty**
c.1050	771	Western Zhou
770	221	Eastern Zhou
770	475	*Spring and Autumn period*
475	221	*Warring States period*
221	206	**Qin dynasty**
206 BC	AD 220	**Han dynasty**
206 BC	AD 9	Western Han
AD 9	AD 23	Xin dynasty (Wang Mang)
25	220	Eastern Han
220	265	**The Three Kingdoms**
220	265	Wei dynasty
221	263	Shu-Han dynasty
222	280	Wu dynasty
265	420	**Jin dynasty**
265	316	Western Jin
317	420	Eastern Jin
386	589	**Southern and Northern dynasties**
420	589	Southern dynasties
420	479	*Song*
479	502	*Qi*
502	557	*Liang*
557	589	*Chen*
386	581	Northern dynasties
386	534	*Northern Wei*
534	550	*Eastern Wei*
550	577	*Northern Qi*
535	557	*Western Wei*
557	581	*Northern Zhou*
581	618	**Sui dynasty**
618	906	**Tang dynasty**
907	960	**Five dynasties**
960	1279	**Song dynasty**
960	1127	Northern Song
1127	1279	Southern Song
907	1125	**Liao dynasty**
1115	1234	**Jin dynasty**
1206	1368	**Yuan dynasty** (In south China the Song dynasty lasted until 1279)
1368	1644	**Ming dynasty**
1644	1911	**Qing dynasty**

Bibliography

Periodicals published in the People's Republic of China are cited by title as follows:

Kaogu
Kaoguxue jikan
Kaogu xuebao
Kaogu yu wenwu
Wenwu
Wenwu ziliao congkan
Zhejiang sheng wenwu kaogu kan

ANDRAE 1923. Walter Andrae, *Farbige Keramik aus Assur und ihre Vorstufen in Altassyrischen Wandmalereien*, Berlin, 1923

ANDRAE AND LENZEN 1933. Walter Andrae and Heinz Lenzen, *Die Partherstadt Assur*, Ausgrabungen der Deutschen Orient-Gesellschaft in Assur VIII, Leipzig, 1933

AKIYAMA 1968. Akiyama Terukazu *et al.*, *Arts of China, Neolithic Cultures to the T'ang Dynasty: Recent Discoveries*, Tokyo, Palo Alto, 1968

AKURGAL 1968. Ekrem Akurgal, *The Birth of Greek Art, The Mediterranean and the Near East*, trans. Wayne Dynes, London, 1968

ALLAN AND RABY 1982. James Allan and Julian Raby, 'Metalwork' in Yanni Petsopoulos (ed.), *Tulips, Arabesques and Turbans, Decorative Arts from the Ottoman Empire*, London, 1982, pp. 17–48

ALPERS 1983. Svetlana Alpers, *The Art of Describing, Dutch art in the seventeenth century*, Chicago, London, 1983

ARCHER 1971. Mildred Archer, 'Banaras and British Art' in *Chhavi*, Golden Jubilee Volume, Banaras, 1971, pp. 43–7

ADDIS 1979. J.M. Addis, *Chinese Porcelain from the Addis Collection*, London, 1979

D'ARGENCE 1981. René-Yvon Lefèbre d'Argencé, 'A New Approach to the Study of Medieval Jade Zoomorphs', *Zhongyang Yanjiuyuan Guoji Hanxue Huiyi lunwen ji, yishu shi zu*, Taibei, 1981, pp. 247–318

ATIL 1980. Esin Atil (ed.), *Turkish Art*, Washington D.C., New York, 1980

BAGLEY 1985. Robert W. Bagley, *Shang Ritual Bronzes from the Arthur M. Sackler Collections*, Cambridge, Mass., Washington D.C., 1985 (forthcoming)

BARNETT 1957. R.D. Barnett, *A Catalogue of the Nimrud Ivories with other examples of Ancient Near Eastern Ivories in the British Museum*, London, 1957

BARNETT 1982. Richard D. Barnett, *Ancient Ivories in the Middle East; Qedem 14*, Monographs of the Institute of Archaeology, the Hebrew University of Jerusalem, Jerusalem, 1982

BARRETT 1949. Douglas Barrett, *Islamic Metalwork in the British Museum*, London, 1949

BARTHOUX 1933. Jules Barthoux, *Les Fouilles de Hadda I, Stupas et Sites*, Mémoires de la Délégation Archéologique Française en Afghanistan, IV, Paris, 1933

BEIJING 1957. Su Bai, *Baisha Song mu*, Wenwu chubanshe, Beijing, 1957

BEIJING 1959a. *Shaanbei Dong Han huaxiang shike xuanji*, Wenwu chubanshe, Beijing, 1959

BEIJING 1959b. *Shancunling Guoguo mudi*, Kexue chubanshe, Beijing, 1959

BEIJING 1964. *Qian Shu Wang Jian mu fajue baogao*, Wenwu chubanshe, Beijing, 1964

BEIJING 1965. *Shaanxi Tongchuan Yaozhou yao*, Kexue chubanshe, Beijing, 1965

BEIJING 1972a. *Wenhua da geming qijian chutu wenwu, di yi ji*, Wenwu chubanshe, Beijing, 1972

BEIJING 1972b. *Xin Zhongguo chutu wenwu* ('Historical Relics Unearthed in New China'), Waiwen chubanshe, Beijing, 1972

BEIJING 1972c. *Sichou zhi lu, Han Tang zhiwu*, Wenwu chubanshe, Beijing, 1972

BEIJING 1973. *Changsha Mawangdui yi hao Han mu*, Wenwu chubanshe, 2 vols, Beijing, 1973

BEIJING 1977. *Yungang shiku*, Wenwu chubanshe, Beijing, 1977

BEIJING 1979. *Ci yuan* (dictionary in 4 vols), Shangwu yinshuguan, Beijing, 1979

BEIJING 1980a. *Yinxu Fu Hao mu*, Wenwu chubanshe, Beijing, 1980

BEIJING 1980b. *Shaanxi chutu Shang Zhou qingtongqi*, 2, Wenwu chubanshe, Beijing, 1980

BEIJING 1980c. *Longmen shiku*, Wenwu chubanshe, Beijing, 1980

BEIJING 1980d. *Sui Xian Zeng Hou Yi mu*, Wenwu chubanshe, Beijing, 1980

BEIJING 1980e. *The Flying Devis of Dunhuang*, Zhongguo luyou chubanshe, Beijing, 1980

BEIJING 1980f. *Ying xian mu ta*, Wenwu chubanshe, Beijing, 1980

BEIJING 1981a. *Yunnan qingtongqi*, Wenwu chubanshe, Beijing, 1981

BEIJING 1981b. *Liu Chao yishu*, Wenwu chubanshe, Beijing, 1981

BEIJING 1981c. *Jin Si*, Wenwu chubanshe, Beijing, 1981

BEIJING 1982a. *Tangdai tu'an ji*, Renmin meishu chubanshe, Beijing, 1982

BEIJING 1982b. *Fuzhou Nan Song Huang Sheng mu*, Wenwu chubanshe, Beijing, 1982

BEIJING 1983a. *Kai Hua Si Songdai bihua*, Wenwu chubanshe, Beijing, 1983

BEIJING 1983b. *Yan Shan Si Jindai bihua*, Wenwu chubanshe, Beijing, 1983

BEIJING 1983c. *Fouguang Si Shijia ta he Chongfu Si Liao Jin bihua*, Wenwu chubanshe, Beijing, 1983

BERLIN 1970. Staatliche Museen Preussischer Kulturbesitz, Museum für Ostasiatische Kunst, *Ausgewählte Werke Ostasiatischer Kunst*, Berlin, 1970

BERNARD 1967. Paul Bernard, 'Ai Khanum on the Oxus: A Hellenistic City in Central Asia', *Proceedings of the British Academy*, LIII, pp. 71–95

BERNARD 1982. Paul Bernard, 'An Ancient Greek City in Central Asia', *Scientific American*, 246, 1 (Jan. 1982), pp. 148–59.

VON BISSING 1940. W. von Bissing, 'Ägyptische und ägyptisierende Alabastergefässe aus der Deutschen Ausgrabungen in Assur', *Zeitschrift für Assyriologie und Vorderasiatische Archäologie*, N.S., 12, 1940, pp. 149–82

BOARDMAN 1975. John Boardman, *Athenian Red Figure Vases, the Archaic Period*, London, 1975

BODDE 1975. Derk Bodde, *Festivals in Classical China, New Year and Other Annual Observances during the Han Dynasty (206 BC–AD 220)*, Princeton, 1975

BULLING 1960. A. Gutkind Bulling, *The Decoration of Mirrors of the Han Period, A Chronology*, Artibus Asiae, Supplementum XX, Ascona, 1960

BULLING 1974. A. Gutkind Bulling, 'The Guide of the Souls Picture in the Western Han tomb in Ma-wang-tui near Ch'ang-sha', *Oriental Art*, XX, 2 (Summer 1974), pp. 158–73

BUSH 1975. Susan Bush, 'Thunder monsters, auspicious animals and floral ornament in early sixth-century China', *Ars Orientalis*, X (1975), pp. 19–33

BUTLER 1903. Howard Crosby Butler, *Architecture and other Arts, Part II of the publication of an American archaeological expedition to Syria in 1899–1900*, New York, 1903

CAMBRIDGE 1968. *The Cambridge History of Iran*, vol. 5, *The Saljuq and Mongol periods*, J.A. Boyle (ed.), Cambridge, 1968

CAMBRIDGE 1983. *The Cambridge History of Iran*, vol. 3, *The Seleucid, Parthian and Sasanian Periods*, Ehsan Yarshater (ed.), Cambridge, 1983

CAMMANN 1951. Schuyler Cammann, 'The Symbolism of the Cloud Collar Motif', *Art Bulletin*, 1951, pp. 1–9

CAMMANN 1952. Schuyler Cammann, *China's Dragon Robes*, New York, 1952

CARSWELL 1972. John Carswell, 'Six Tiles' in Richard Ettinghausen (ed.), *Islamic Art in the Metropolitan Museum of Art*, New York, 1972, pp. 99–123

CARSWELL 1982. John Carswell, 'Ceramics' in Yanni Petsopoulos (ed.), *Tulips, Arabesques and Turbans, Decorative Arts from the Ottoman Empire*, London, 1982, pp. 73–96

CARSWELL 1984. John Carswell, 'The Tiles in the Yeni Kaplica Baths at Bursa', *Apollo*, July 1984, pp. 36–43

CATLEUGH 1983. Jon Catleugh, *William De Morgan Tiles*, with essays by Elizabeth Aslin and Alan Caiger-Smith, London, 1983

CHARBONNEAUX, MARTIN, VILLARD, 1973. Jean Charbonneaux, Roland Martin, François Villard, *Hellenistic Art 330–50 BC*, trans. Peter Green, London, 1973

CH'EN 1964. Kenneth K.S. Ch'en, *Buddhism in China, a Historical Survey*, Princeton, 1964

CH'EN 1966. Ch'en Yuan, *Western and Central Asians in China under the Mongols, their Transformation into Chinese*, trans. and annot. Ch'en Hsing-hai and L. Carrington Goodrich, Monumenta Serica Monograph XV, Los Angeles, 1966

CHENG 1957. Cheng Te-k'un, 'Yin-yang Wu-hsing and Han art', *Harvard Journal of Asiatic Studies*, 20 (1957), pp. 162–86

CHENG 1969. Cheng Te-k'un, 'Jade Flowers and Floral Patterns in Chinese Decorative Art', *Journal of the Institute of Chinese Studies*, II, 2 (Sept. 1969), reprint, pp. 1–81

CHRISTIE 1910. A.H. Christie, *Traditional Methods of Pattern Designing*, Oxford, 1910, 2nd edn 1929; reprinted by Dover Publications, as *Pattern Design, An Introduction to the Study of Formal Ornament*, New York, 1969

CLEVELAND 1968. Sherman E. Lee and Wai-kam Ho, *Chinese Art under the Mongols: The Yuan Dynasty (1279–1368)*, exh. cat., Cleveland Museum of Art, Cleveland, 1968

CLEVELAND 1980. *Eight Dynasties of Chinese paintings, the Collections of the Nelson-Gallery Atkins Museum*, exh. cat., Kansas City and the Cleveland Museum of Art, Cleveland, Indiana, 1980

COLLEDGE 1967. Malcolm A.R. Colledge, *The Parthians*, London, 1967

COLLEDGE 1976. Malcolm A.R. Colledge, *The Art of Palmyra*, London, 1976

COLLEDGE 1977. Malcolm A.R. Colledge, *Parthian Art*, London, 1977

CONRADS 1970. Ulrich Conrads, *Programmes and Manifestos on 20th-century Architecture*, trans. Michael Bullock, London, 1970

COOMARASWAMY 1935. Ananda K. Coomaraswamy, *Elements of Buddhist Iconography*, Cambridge, Mass., London, Oxford, 1935

CURATOLA 1982. Giovanni Curatola, 'The Viar Dragon', *Soltâniye III, Quaderni del Seminario di Iranistica, Urâlo-Altaistica e Caucasologia dell' Università Degli Studi di Venezia*, 9, Venice, 1982

DARBY 1977. William J. Darby, Paul Ghalioungui, Louis Grivetti, *Food: the Gift of Osiris*, London, New York, San Francisco, 1977

DARKEVICH 1976. V.T. Darkevich, *Khudozhestvenny Metall Vostoka, VIII–XIII vv*, Moscow, 1976

DAVIES 1923. Nina de Garis Davies, *The Tombs of Two Officials of Tuthmosis the Fourth, Nos 75 and 90*, The Theban Tomb Series (3rd memoir), London, 1923

DAVIES 1926. Nina de Garis Davies, *The Tomb of Huy, Viceroy of Nubia in the Reign of Tutankhamun, No. 40*, with explanatory text by Alan H. Gardiner, The Theban Tomb Series (4th memoir), London, 1926

DAVIES 1936. Nina M. Davies, *Ancient Egyptian Painting*, with editorial assistance of Alan H. Gardiner, Chicago, 1936

DAWKINS 1978. Richard Dawkins, *The Selfish Gene*, Oxford, 1975, paperback edn 1978

DAWSON 1984. Aileen Dawson, *Masterpieces of Wedgwood in the British Museum*, London, 1984

DAY 1890. Lewis F. Day, *Ornamental Design*, London, 1890, comprising *Planning of Ornament, Anatomy of Pattern*, and *Application of Ornament*

DAY 1903. Lewis F. Day, *Pattern Design, A Book for Students, Treating in a Practical Way of the Anatomy, Planning and Evolution of Repeated Ornament*, London, 1903; reprinted by Dover Publications, New York, 1979

DENNY 1983. Walter B. Denny, 'Dating Ottoman works in the Saz Style', *Muqarnas*, I, New Haven, London, 1983, pp. 103–21

DIENY 1982. Jean-Pierre Diény, 'Histoire et philologie de la Chine Classique (Programme de l'année 1977–78)', *Annuaire 1978/9*, Ecole Pratique des Hautes Etudes IV, Section Sciences Historiques et Philologiques, Paris, 1982, pp. 1,045–62

DIEULAFOY 1884. Marcel Dieulafoy, *L'Art Antique de La Perse, Achéménides, Parthes, Sassanides*, Paris, 1884 *et seq.*

EBREY 1978. Patricia Buckley Ebrey, *The Aristocratic Families of Early Imperial China, A Case Study of the Po-ling Ts'ui Family*, London, New York, Sydney, 1978

EGAMI. Egami Yasushi, *Nippon aya no genryū*, Tokyo, 1983

ETTINGHAUSEN 1959. Richard Ettinghausen, 'On Some Mongol Miniatures', *Kunst des Orients*, III (1959), pp. 44–65.

EVANS 1930. Arthur Evans, *The Palace of Minos, A comparative account of the successive stages of the early Cretan civilisation as illustrated by the discoveries at Knossos*, vol. III, London, 1930

FIGGESS 1964. John Figgess, 'A Group of Decorated Lacquer Caskets of the Yuan Dynasty', *Transactions of the Oriental Ceramic Society*, 36 (1964–6), pp. 39–42

FŐRTOVÁ-ŠÁMALOVÁ 1963. P. Fŏrtová-Šámalová, *Egyptian Ornament*, text by M. Vilímková, London, 1963

FOUCART 1897. George Foucart, *Histoire de l'ordre lotiforme, étude d'archéologie égyptienne*, Paris, 1897

FOUCHER 1905. A. Foucher, *L'Art Gréco-Bouddhique du Gandhara, étude sur les origines de l'influence classique dans l'art Bouddhique de l'Inde et de l'Extrème-Orient*, vol. I, Publications de l'Ecole Française d'Extrème-Orient, vol. 5, Paris, 1905

FRANKFORT 1970. Henri Frankfort, *The Art and Architecture of the Ancient Orient*, first pub. Harmondsworth 1954, paperback edn, Harmondsworth, 1970

FRUMKIN 1970. Grégoire Frumkin, *Archaeology in Soviet Central Asia*, Leiden, Cologne, 1970

FURTWÄNGLER 1906. Adolf R. Furtwängler, Ernst R. Fiechter, Hermann Thiersch, *Aegina, das Heiligtum der Aphaia*, Munich, 1906

FUX 1969. Herbert Fux, 'Chinesiche Medaillonformen in der Islamischen Kunst' in Oktay Aslanapa, Rudolf Naumann (eds.), *Forschungen zur Kunst Asiens, In Memoriam Kurt Erdmann*, Istanbul, 1969, pp. 278–300

GHIRSHMAN 1962. Roman Ghirshman, *Iran, Parthians and Sassanians*, trans. Stuart Gilbert and James Emmons, London, 1962

GHIRSHMAN 1964. Roman Ghirshman, *The Arts of Ancient Iran from its Origins to the Time of Alexander the Great*, trans. Stuart Gilbert and James Emmons, New York, 1964

GILES 1926. H.A. Giles, *The Travels of Fa-Hsien (399–414 A.D.) or Record of the Buddhist Kingdoms*, London, 1923

GILLMAN 1983. Derek Gillman, 'A New Image in Chinese Buddhist Sculpture of the Tenth to Thirteenth Century', *Transactions of the Oriental Ceramic Society*, 47 (1982–3), pp. 33–44

GILLMAN 1984. Derek Gillman, 'Ming and Qing ivories: figure carving', in William Watson (ed.) *Chinese Ivories from the Shang to the Qing*, London, 1984

GOMBRICH 1960. E.H. Gombrich, *Art and Illusion, A Study in the Psychology of Pictorial Representation*, Oxford, 1960

GOMBRICH 1973. E.H. Gombrich, 'Illusion and Art' in R.L. Gregory and E.H. Gombrich (eds), *Illusion in Nature and Art*, London, 1973

GOMBRICH 1979a. E.H. Gombrich, *The Sense of Order, A Study in the Psychology of Decorative Art*, London, 1979

GOMBRICH 1979b. E.H. Gombrich, *Ideals and Idols, Essays on Values in History and in Art*, Oxford, 1979

GOMBRICH 1982. E.H. Gombrich, *The Image and the Eye, Further Studies in the Psychology of Pictorial Representation*, Oxford, 1982

GOMPERTZ 1978. G. St G.M. Gompertz, 'Korean Inlaid Lacquer of the Koryo Period', *Transactions of the Oriental Ceramic Society*, 43 (1978–9), pp. 1–31

GOEPPER AND WHITFIELD 1984. Roger Goepper and Roderick Whitfield, *Treasures from Korea*, exh. cat., British Museum, London, 1984

GOODWIN 1971. Godfrey Goodwin, *A History of Ottoman Architecture*, London, 1971

GOODYEAR 1891. W.H. Goodyear, *The Grammar of the Lotus, A new history of Classic ornament as a development of Sun Worship*, London, 1891

GRAY 1961. Basil Gray, *Persian Painting*, Geneva, 1961

GRAY 1969. Basil Gray, 'Some Chinoiserie Drawings and their origins' in Oktay Aslanapa and Rudolf Naumann (eds), *Forschungen zur Kunst Asiens, In Memoriam Kurt Erdmann*, Istanbul, 1969, pp. 159–71

GRAY 1973. Basil Gray, 'Chinese Influence in Persian Paintings: 14th and 15th centuries', in William Watson (ed.), *The Westward Influence of Chinese Art*, Colloquies on Art and Archaeology in Asia, 3, London, 1973, pp. 11–19

GRAY 1976. Basil Gray, 'The Export of Chinese Porcelain to the Islamic World: Some reflections on its significance for Islamic art before 1400', *Transactions of the Oriental Ceramic Society*, 41 (1975–7), pp. 231–62

GRAY 1979. Basil Gray (ed.), *The Arts of the Book in Central Asia 14th–16th centuries*, Paris, London, 1979

GRAY 1978. Basil Gray, *The World History of Rashid al-Din, a study of the Royal Asiatic Society Manuscript*, London, 1978

GREGORY 1970. Richard L. Gregory, *The Intelligent Eye*, London, 1970

GREGORY 1966. Richard L. Gregory, *Eye and Brain, the Psychology of Seeing*, London, 1966

GRÜNWEDEL 1912. Albert Grünwedel, *Altbuddhistische Kultstätten in Chinesischen-Turkistan, Bericht über archäologische Arbeiten von 1906 bis 1907 bei Kuča, Qarašahr und in der Oase Turfan*, Berlin, 1912

GRUBE 1982. Ernst J. Grube, 'Painting' in Yanni Petsopoulos (ed.), *Tulips, Arabesques and Turbans, Decorative Arts of the Ottoman Empire*, London, 1982, pp. 193–200

GRUBE 1984. Ernst J. Grube and Eleanor Sims (eds), *Between China and Iran, Paintings from four Istanbul Albums*, Colloquies on Art and Archaeology in Asia, 10, New York, London, 1984

GYLLENSVÄRD 1957. Bo Gyllensvärd, 'T'ang Gold and Silver', *Bulletin of the Museum of Far Eastern Antiquities*, 29 (1957), pp. 1–230

HACKIN 1954. J. Hackin *et al.*, *Nouvelles recherches archéologiques à Bégram (ancienne Kâpici) 1939–40*, Mémoires de la Délégation Archéologique Française en Afghanistan, XI, Paris, 1954

HALLADE 1982. Madeleine Hallade, Simone Gaulier, Liliane Courtois, *Douldour-âqour et Soubachi*, Mission Paul Pelliot IV, text, Paris, 1982

HAUGLID 1947. Roar Hauglid, 'The Greek Acanthus, problems of Origin', *Acta Archaeologica*, Copenhagen, XVIII (1947), pp. 93–116

HAYASHI 1975. Ryoichi Hayashi, *The Silk Road and the Shoso-in*, trans. Robert Ricketts, Tokyo, 1975

HELCK AND WESTENDORF 1975. Wolfgang Helck and Wolfhart Westendorf, *Lexikon der Ägyptologie*, Wiesbaden, 1975 *et seq.*

HERRMANN 1977. Georgina Herrmann, *The Iranian Revival*, Oxford, 1977

HERZFELD 1941. Ernst E. Herzfeld, *Iran in the Ancient Near East, Archaeological Studies presented in the Lowell lectures at Boston*, London, New York, 1941

HIGGINS 1967. Reynold Higgins, *Minoan and Mycenean Art*, London, 1967

HOOD 1978. Sinclair Hood, *The Arts of Prehistoric Greece*, paperback edn, Harmondsworth, 1978

HÖRMANN. Hans Hörmann, 'Die Römische Bühnenfront zu Ephesos', *Jahrbuch des Deutschen Archäologischen Instituts*, XXXVIII/IX (1923–4), pp. 275–345

HORNBOSTEL-HÜTTNER 1979. Gertraut Hornbostel-Hüttner, *Studien zur Römischen Nischenarchitektur*. Studies of the Dutch Archaeological and Historical Society, vol. IX, Leiden, 1979

HUGHES 1980. Robert Hughes, *The Shock of the New*, London, 1980

HULSEWÉ 1979. A.T.P. Hulsewé, *China in Central Asia, the early stages: 125 BC–AD 23*, an annotated translation of chs 61 and 96 of the 'History of the Former Han Dynasty', with an introduction by M.A.N. Loewe, Leiden, 1979

INGHOLT 1957. Harald Ingholt, *Gandharan Art in Pakistan*, New York, 1957

IPŞIROĞLU 1964. M.S. Ipşiroğlu, *Saray-alben, Diez'sche Klebebände aus den Berliner Sammlungen. Verzeichnis der Orientalischen Handschriften in Deutschland*, VIII, Wiesbaden, 1964

IPŞIROĞLU 1965. M.S. Ipşiroğlu, *Malerei der Mongolen*, Munich, 1965

IPŞIROĞLU 1971. M.S. Ipşiroğlu, *Das Bild im Islam, Ein Verbot und seine Folgen*, Vienna, Munich, 1971

JAMES 1979. T.G.H. James, *An Introduction to Ancient Egypt*, London, 1979

JENCKS 1979. Charles Jencks, *The Language of Post-Modern Architecture*, first pub. 1977, 4th rev. enlarged edn, London, 1984

JÉQUIER 1910. Gustave Jéquier, *L'art décoratif dans l'Antiquité, décoration égyptienne, plafonds et frises végétales du Nouvel Empire thébain (1400 à 1000 avant JC)*, Paris, n.d.

JOFFROY 1979. René Joffroy, *Vix et ses trésors*, Paris, 1979

JONES 1856. Owen Jones, *The Grammar of Ornament, Illustrated by Examples from Various Styles of Ornament*, London, 1856

JULIANO 1980. Annette Juliano, *Teng-hsien, an Important Six Dynasties Tomb*, Artibus Asiae, Supplementum XXXVIII, Ascona, 1980

KANTOR 1947. Helene J. Kantor, *The Aegean and the Orient in the Second Millennium BC*, Monographs on archaeology and Fine Arts sponsored by the Archaeological Institute of America and the College Art Association of America IV, The Archaeological Institute of America Monograph no. 1, Indiana, 1947

KARLGREN 1946. Bernhard Karlgren, 'Legends and Cults in Ancient China', *Bulletin of the Museum of Far Eastern Antiquities*, 18 (1946), pp. 199–365

KARLGREN 1952. Bernhard Karlgren, *A Catalogue of the Chinese Bronzes in the Alfred F. Pillsbury Collection*, Minneapolis, 1952

KARLGREN 1968. Bernhard Karlgren, 'Some Sacrifices in Chou China', *Bulletin of the Museum of Far Eastern Antiquities*, 40 (1968), pp. 1–31

KIM AND GOMPERTZ 1961. Chewon Kim and G. St G.M. Gompertz, *The Ceramic Art of Korea*, London, 1961

KNAUER 1983. E.R. Knauer, 'The Fifth Century A.D. Buddhist Cave Temples at Yun-kang North China, A Look at Their Western Connections', *Expedition*, 25, 4 (1983), pp. 27–47

KUBLER 1962. George Kubler, *The Shape of Time, Remarks on the History of Things*, New Haven, London, 1962

KÜHNEL 1977. Ernst Kühnel, *The Arabesque*, Graz, 1977

KUWAYAMA 1982a. George Kuwayama, 'Recently Discovered Sung Lacquer' in William Watson (ed.), *Lacquerwork in Asia and Beyond*, Colloquies on Art and Archaeology in Asia, 11, London, 1982, pp. 40–69

KUWAYAMA 1982b. George Kuwayama, *Far Eastern Lacquer*, Los Angeles County Museum of Art, Los Angeles, 1982

LANE 1939. Arthur Lane, *A Guide to the Collection of Tiles*, Victoria and Albert Museum, London, 1960

LANE 1957. Arthur Lane, *Later Islamic Pottery*, London, 1957

LAWRENCE 1957. A.W. Lawrence, *Greek Architecture*, Harmondsworth, 1957

LEEUWARDEN 1964. Gemeentelijk Museum het Princessehof Leeuwarden, *Swatow*, Leeuwarden, 1964

LENINGRAD 1978. *Les Trésors de Dalverzine-tépé*, Leningrad, 1978

LI CHI 1977. Li Chi, *Anyang*, Seattle, 1977

LI SHUTONG 1969. Li Shutong, 'Tang ren xiai mudan kao', *Dalu zazhi*, 39, nos 1–2 (1969), pp. 42–66

LION-GOLDSCHMIDT 1978. Daisy Lion-Goldschmidt, *Ming Porcelain*, trans. Katherine Watson, London, 1978

LIU XINYUAN 1983. Liu Xinyuan, 'The Unique Decorative Patterns of Yüan Blue and White, the Fouliang Porcelain Bureau and the Huaju Bureau of Jindezhen', *Trade Ceramic Studies*, 3 (1983), pp. 1–12

LOEHR 1967. Max Loehr, 'The Fate of Ornament in Chinese Art', *Archives of Asian Art*, XXI (1967–8), pp. 8–19

LOEWE 1979. Michael Loewe, *Ways to Paradise, the Chinese Quest for Immortality*, London and Sydney, 1979

VAN LOHUIZEN-DE LEEUW 1979. J.E. van Lohuizen-de Leeuw, 'New Evidence with Regard to the Origin of the Buddha Image' in Herbert Härtel (ed.), *South Asian Archaeology*, Berlin, 1979, pp. 377–400

LONDON 1976a. *The Arts of Islam*, exh. cat. Hayward Gallery, The Arts Council of Great Britain, London, 8 April–4 July 1976

LONDON 1976b. *Pompeii AD 79*, exh. cat. Royal Academy of Arts, London, 20 Nov. 1976–27 Feb. 1977

LOO 1940. C.T. Loo, *An Exhibition of Chinese Stone Sculptures*, New York, 1940

LOVELL 1975. Hin-cheung Lovell, 'Some Northern Chinese Ceramic Wares of the Sixth and Seventh Centuries', *Oriental Art*, XXI, 4 (Winter 1975), pp. 328–42

LUCIE-SMITH 1981. Edward Lucie-Smith, *The Story of Craft, The Craftsman's Role in Society*, Oxford, 1981

LYTTELTON 1974. Margaret Lyttelton, *Baroque Architecture in Classical Antiquity*, London, 1974

MACDONALD AND IMAEDA 1977. Ariane MacDonald, Yoshiro Imaeda et al., *Essais sur l'Art du Tibet*, Paris, 1977

MALLWITZ 1981. Alfred Mallwitz, 'Ein Kapitell aus Gebranntem Ton, oder zúr Genesis des Korinthischen Kapitells', in *X Bericht über die Ausgrabungen in Olympia*, Deutsches Archäologisches Institute, Berlin, 1981, pp. 318–52

MARINATOS 1960. Spyridon Marinatos, *Crete and Mycenae*, London, 1960

MARTIN 1926. F.R. Martin, *Miniatures from the Period of Timur in a M.S. of the Poems of Sultan Ahmad Jalair*, Vienna, 1926

MEDLEY 1972. Margaret Medley, *Metalwork and Chinese Ceramics*, Percival David Foundation Monographs, 2, London, 1972

MEDLEY 1973. Margaret Medley, 'Chinese Ceramics and Islamic Design' in William Watson (ed.), *The Westward Influence of the Chinese Arts from the 14th to the 18th century*, Colloquies on Art and Archaeology in Asia, 3, London, 1973, pp. 1–10

MEDLEY 1974. Margaret Medley, *Yuan Porcelain and Stoneware*, London, 1974

MEDLEY 1976. Margaret Medley, *The Chinese Potter, A Practical History of Chinese Ceramics*, Oxford, 1976

MELIKIAN-CHIRVANI 1974. A.S. Melikian-Chirvani, 'L'évocation littéraire du bouddhisme dans l'Iran musulman' in Jean Aubin (ed.), *Le Monde Iranien et l'Islam. Sociétés et cultures*, Geneva, Paris, 1974, pp. 1–72

MELIKIAN-CHIRVANI 1982. A.S. Melikian-Chirvani, *Islamic Metalwork from the Iranian World, 8th–18th centuries*, Victoria and Albert Museum Catalogue, London, 1982

MEUNIE 1942. Jacques Meunié, *Shotorak*, Mémoires de la Délégation Archéologique Française en Afghanistan, x, Paris, 1942

MICHIGAN 1967. *Sasanian silver, Late Antique and early Mediaeval Arts of Luxury from Iran*, exh. cat., University of Michigan Museum of Art, Michigan, Aug.–Sept. 1967

MINO 1980. Yutaka Mino, *Freedom of Clay and Brush through Seven Centuries in Northern China: Tzu-chou Type Wares 960–1600 AD*, exh. cat. Indianapolis Museum of Art, Indianapolis, 17 Nov. 1980–18 Jan. 1981

MIZUNO AND NAGAHIRO 1952. Mizuno Seiichi and Nagahiro Toshio, *Yun-kang, the Buddhist cave Temples of the Fifth Century AD, in North China*. Detailed Report of the Archaeological Survey carried out by the Mission of the Tôhôbunka Kenkyûsho, 1938–45, Tokyo, 1952

MÖBIUS 1929. Hans Möbius, *Die Ornamente der Griechischen Grabstelen, Klassischer und Nachklassischer Zeit*, Berlin, Wilmersdorf, 1929

MORRIS 1983. Rekha Morris, 'Some Observations on recent Soviet Excavations in Soviet Central Asia and the problem of Gandhara Art', *Journal of the American Oriental Society*, 103, 3 (July–Sept. 1983), pp. 557–67

NEW YORK 1979. *Greek Art of the Aegean Islands*, exh. cat., Metropolitan Museum of Art, New York, 1 Nov. 1979–10 Feb. 1980

NEW YORK 1980. Wen Fong (ed.), *The Great Bronze Age of China, An Exhibition from the People's Republic of China*, exh. cat., Metropolitan Museum of Art, New York, 12 April–9 July, 1980

NEW YORK 1982. *Along the Ancient Silk Routes, Central Asian Art from West Berlin State Museums*, exh. cat., Metropolitan Museum of Art, New York, 3 April–20 June 1982

OLIN 1982. Margaret Rose Olin, 'Alois Riegl and the Crisis of Representation in Art Theory 1880–90', unpub. dissertation submitted to the faculty of the Division of Humanities, University of Chicago, 1982

PALUDAN 1981. Ann Paludan, *The Imperial Ming Tombs*, New Haven, London, 1981

PALUDAN 1983. Ann Paludan, 'Some Foreigners in the Spirit Roads of the Northern Song Imperial Tombs', *Oriental Art*, XXIX, 4 (Winter 1983/4), pp. 377–88

PARROT 1960. André Parrot, *Sumer*, trans. Stuart Gilbert and James Emmons, London, 1960

PARROT 1961. André Parrot, *Nineveh and Babylon*, trans. Stuart Gilbert and James Emmons, London, 1961

PEVSNER 1960. Nikolaus Pevsner, *Pioneers of Modern Design, from William Morris to Walter Gropius*, Harmondsworth, 1960 (rev. and partly rewritten edn of the work first pub. as *Pioneers of the Modern Movement*, London, 1936)

PIRAZZOLI-T'SERSTEVENS 1982. Michèle Pirazzoli-t'Serstevens, *The Han Civilisation of China*, trans. Janet Seligman, Fribourg, Switzerland, 1982

POPE 1939. Arthur Upham Pope, Phyllis Ackerman (eds), *A Survey of Persian Art from Prehistoric Times to the Present*, vol. III text, *The Art of the Book, Textiles, Carpets, Metalwork, Minor Arts*, London, New York, 1939

POPE 1972. John A. Pope, 'Chinese Influence on Iznik Pottery: A Re-examination of an Old Problem', in Richard Ettinghausen (ed.), *Islamic Art in the Metropolitan Museum of Art*, New York, 1972, pp. 124–39

POWERS 1981. Martin J. Powers, 'An Archaic Bas-relief and the Chinese Moral Cosmos in the First Century AD', *Ars Orientalis*, XII (1981), pp. 25–36

POSTGATE 1977. Nicholas Postgate, *The First Empires*, Oxford, 1977

PYE 1968. David Pye, *The Nature and the Art of Workmanship*, Cambridge, 1968

RABY 1983. Julian Raby and Ünsal Yücel, 'Blue and White, Celadon and Whiteware: Iznik's Debt to China', *Oriental Art*, XXIX, 1 (Spring 1983), pp. 38–48

RAWSON 1982. Jessica Rawson, 'The Ornament on Chinese Silver of the Tang Dynasty (AD 618–906)', *British Museum Occasional Papers*, 40, London, 1982

RAWSON 1983. Jessica Rawson, 'Eccentric Bronzes of the Early Western Zhou', *Transactions of the Oriental Ceramic Society*, 47 (1982–3), pp. 10–31

RAWSON 1984a. Jessica Rawson, 'Song Silver and its connexions with Ceramics', *Apollo*, July 1984, pp. 18–23

RAWSON 1984b. Jessica Rawson, 'The Lotus and the Dragon, Sources of Chinese Ornament', *Orientations*, Nov. 1984, pp. 22–36

READE 1983. Julian Reade, *Assyrian Sculpture*, London, 1983

RIEGL 1893. Alois Riegl, *Stilfragen: Grundlegungen zu einer Geschichte der Ornamentik*, Berlin, 1893

ROBERTSON 1965. C.M. Robertson, 'Greek Mosaics', *Journal of Hellenic Studies*, LXXXV (1965), pp. 72–85

ROGERS 1983. J.M. Rogers, *Islamic Art and Design 1500–1700*, London, 1983

ROGERS 1984. J.M. Rogers, 'A Group of Ottoman Pottery in the Godman Collection', *Burlington Magazine* (forthcoming)

ROSENFIELD 1967. John M. Rosenfield, *The Dynastic Arts of the Kushans*, Berkeley, Los Angeles, London, 1967

ROUX 1961. Georges Roux, *L'Architecture de l'Argolide aux IVe et IIIe siècles avant J.-C.*, Bibliothèque des Ecoles Françaises d'Athènes et de Rome, fascicule 199, Paris, 1961

ROWLAND 1953. Benjamin Rowland, *The Art and Architecture of India, Buddhist, Hindu, Jain*, Harmondsworth, 1953

ROWLAND 1956. Benjamin Rowland, 'The Vine-scroll in Gandhara', *Artibus Asiae*, XIX (1956), pp. 353–60

RUDENKO 1970. Sergei I. Rudenko, *Frozen Tombs of Siberia, The Pazyryk Burials of Iron-Age Horsemen*, London, 1970

SAFAR 1974. Fuad Safar and Muhammad Ali Mustafa, *Hatra the City of the Sun God*, Baghdad, 1974

SATŌ 1981. Masahiko Satō, *Chinese Ceramics, a short history*, New York, Tokyo, 1981

SAUNDERS 1971. J.J. Saunders, *The History of the Mongol Conquests*, London, 1971

SCARCIA 1975. G. Scarcia, 'The Vihār of Qonqor-olong. Preliminary Report', *East and West*, N.S. 25, 1–2 (March–June 1975), pp. 99–104

SCHEDE 1909. Martin Schede, *Antikes Traufleistenornament, zur Kunstgeschichte des Auslandes*, vol. 67, Strasburg, 1909

SCHEFOLD 1962. Karl Schefold, *Vergessenes Pompeji: Unveröffentlichte Bilder Römischer Wanddekorationen in Geschichtlicher Folge herausgegeben*, Berne, Munich, 1962

SCHLUMBERGER 1970. Daniel Schlumberger, *L'Orient Hellénisé, l'Art Grec et ses Héritiers dans l'Asie non Méditerranéenne*, Paris, 1970

SCHULZ AND WINNEFELD 1921. Bruno Schulz and Hermann Winnefeld, *Baalbek: Ergebnisse der Ausgrabungen und Untersuchungen in den Jahren 1898 bis 1905*, Berlin, Leipzig, 1921

SEELEY 1984. N.J. Seeley and P.J. Turner, 'Metallurgical Investigations of Three early Indian Coinages: Implications for Metal Trading and Dynastic Coinages', in Bridget Allchin (ed.), *South Asian Archaeology 1981*, Cambridge, 1984

SEYRIG, AMY, WILL 1975. H. Seyrig, R. Amy, E. Will, *Le Temple de Bel à Palmyre*, album, Bibliothèque Archéologique et Historique, LXXXIII, Institut Français d'Archéologie de Beyrouth, Paris, 1975

SHANGHAI 1982. Abstracts of the papers presented to the International Conference on Ancient Chinese Pottery and Porcelain held in Shanghai, Nov. 1982

SICKMAN 1978. Lawrence Sickman, 'Chinese Classic Furniture', *Transactions of the Oriental Ceramic Society*, 42 (1977–8), pp. 1–23

SIMPSON 1982. Marianna S. Simpson, 'The Role of Baghdad in the Formation of Persian Painting', in C. Adle (ed.), *Art et Société dans le Monde Iranien*, Institut Français d'Iranologie de Téhéran, Bibliothèque Iranienne, 26, Paris, 1982

SMART 1976. Ellen S. Smart, 'Fourteenth century Chinese Porcelain from a Tughlaq Palace in Delhi', *Transactions of the Oriental Ceramic Society*, 41 (1975–6), pp. 199–230

SOPER 1958. Alexander Soper, 'Northern Liang and Northern Wei in Kansu', *Artibus Asiae*, XXI (1958), pp. 131–64

SOPER 1960. Alexander Soper, 'South Chinese Influences on Buddhist Art of the Six Dynasties period', *Bulletin of the Museum of Far Eastern Antiquities*, 32 (1960), pp. 47–112

STARR 1937. Richard F.S. Starr, *Nuzi, Report on the Excavations at Yorgan Tepe near Kirkuk, Iraq, conducted by Harvard University in conjunction with the American Schools of Oriental Research and the University Museum of Philadelphia 1927–31*, Cambridge, Mass., 1937–9

STAWISKI 1979. Boris Stawiski, *Mittelasien, Kunst der Kuschan*, Leipzig, 1979

STEADMAN 1979. Philip Steadman, *The Evolution of Designs, Biological Analogy in Architecture and the Applied Arts*, Cambridge, 1979

STEIN 1907. M. Aurel Stein, *Ancient Khotan, detailed report of archaeological explorations in Chinese Turkestan, carried out and described under the orders of H.M. Indian Government*, Oxford, 1907

STEIN 1912. M. Aurel Stein, *Ruins of Desert Cathay, Personal Narrative of Explorations in Central Asia and Westernmost China*, London, 1912

STEIN 1964. M. Aurel Stein, *On Central Asian Tracks, Brief narrative of three expeditions in Innermost Asia and Northwestern China*, reprinted from the original edn of 1933, Jeannette Mirsky (ed.), Chicago, London, 1964

STEVENSON SMITH 1965. William Stevenson Smith, *Interconnections in the Ancient Near East, A study of the relationship between the Arts of Egypt, the Aegean and Western Asia*, New Haven, London, 1965

STEVENSON SMITH 1981. William Stevenson Smith, *The Art and Architecture of Ancient Egypt*, first pub. Harmondsworth, 1958; paperback edn rev. with additions by William Kelly Simpson, Harmondsworth, 1981

STRONG 1963. D.E. Strong, 'Some Observations on Early Roman Corinthian', *Journal of Roman Studies*, LIII (1963), pp. 73–84

STUCKY 1974. Rolf A. Stucky, 'The Engraved Tridacna Shells', *Dédalo*, vol. 10, no. 19, 1974

STURT 1963. George Sturt, 'The Wheelwright's Shop' (paperback edn of original edn pub. 1923), Cambridge, 1963

SULLIVAN 1892. Louis Sullivan, 'Ornament in Architecture', *Engineering Magazine* (New York), III, 5 Aug. 1892

SULLIVAN 1947. Louis Sullivan, *Kindergarten Chats*, New York, 1947

SULLIVAN. Michael Sullivan, *Chinese Landscape Painting*, vol. II, *The Sui and T'ang Dynasties*, Berkeley, Los Angeles, London, 1980

SUMMERSON 1949. John Summerson, *Heavenly Mansions and Other Essays on Architecture*, London, 1949

SUMMERSON 1977. John Summerson, 'What is Ornament and What is not' in Stephan Kieran (ed.), *Ornament*, VIA III, University of Pennsylvania, 1977

SUMMERSON 1980. John Summerson, *The Classical Language of Architecture*, London, 1980; rev. and enlarged edn, originally pub. 1963

SUN HAIBO 1937. Sun Haibo, *Xinzheng yiqi*, Beijing, 1937

TAIBEI 1972. *Han Wei Nan Bei Chao muzhi jishi*, Taibei, 1972

TAIBEI 1981. Wu Fengbei, 'A Study of Ming Dynasty Carved Lacquer ground Motifs', *National Palace Museum Quarterly*, XV, 3, 4 (Spring and Summer 1981), pp. 45–104, 15–86

TAIT 1963. G.A.D. Tait, 'The Egyptian Relief Chalice', *Journal of Egyptian Archaeology*, 49 (1963), pp. 93–139

TAIT 1960. Hugh Tait, 'Southwark (Alias Lambeth) Delftware and the Potter, Christian Wilhelm: I', *Connoisseur*, Aug. 1960, pp. 36–40

TALBOT RICE 1976. David Talbot Rice, *The Illustrations to the 'World History' of Rashid al-Din*, Basil Gray (ed.), Edinburgh, 1976

TAMURA AND KOBAYASHI 1953. Tamura Jitsuzo and Kobayashi Yukio, *Tombs and Mural Paintings of the Ch'ing-ling, Liao Imperial Mausoleums of the Eleventh Century AD in Eastern Mongolia*, Detailed Report of the Archaeological Survey carried out in 1935 and 1939, Kyoto, 1953

THOMPSON 1976. Deborah Thompson, *Stucco from Chal Tarkhan-Eshqabad near Rayy*, Colt Archaeological Institute publications, Warminster, Wiltshire, 1976

THOMPSON 1979. Deborah Thompson, 'Parthian Stucco from Warka in the British Museum: Quantitative analysis and the bust

Notes

motif in Parthian and Sasanian stucco', *Akten des VII Internationalen Kongresses für Iranische Kunst und Archäologie*, Munich, 7–10 Sept. 1976, Berlin, 1979, pp. 294–308

TITLEY 1983. Norah M. Titley, *Persian Miniature Painting, and its influence on the art of Turkey and India, the British Library Collection*, London, 1983

TOKYO 1926. Sekino Tadashi, Tokiwa Daitei, *Shina Bukkyo Shiseki*, 3, Tokyo, 1926

TOKYO 1929. *Shōsōin Gyobutsu Zuroku*, Tokyo, 1929

TOKYO 1960. *Shōsōin Homotsu*, Tokyo, 1960

TOKYO 1966. Nishikawa Yasushi, *Seian Herin*. Tokyo, 1966

TOKYO 1972. *Chugoku Bijutsu*, 3, Nagahiro Toshio (ed.), Tokyo, 1972

TOKYO 1973. *Chuka Jimmin Kyōwakoka shutsudo bumbutsuten*, Tokyo, 1973

TOKYO 1975. Shōsōin Jimusho, *Shōsōin no Shiko*, Tokyo, 1975

TOKYO 1976a. Osaka Shiritsu Bijutsukan, *Rokucho no Bijutsu*, Tokyo, 1976

TOKYO 1976b. *Sekai Tōji Zenshu*, N.S., 14, Tokyo, 1976

TOKYO 1976c. Abbe Hiroshi, *Shōsōin no gakki*, series *Nippon Bijutsu*, 2, 117, Tokyo, 1976

TOKYO 1978a. *Zui Tō no Bijutsu*, Tokyo, 1978

TOKYO 1978b. Goto Jiro, *Shōsōin no Rekishi*, series *Nippon Bijutsu*, 1, 140, Tokyo, 1978

TOKYO 1981a. *Chugokku Sekkutsu*, *Tōnkō Makkō-kutsu*, Tokyo, 1981 *et. seq.*

TOKYO 1981b. *Sekai Tōji Zenshu*, N.S., 13, Tokyo, 1981

TOKYO 1981c. Kakimoto Koichi, *Erakuga Hekiga* (*Yongle gong bihua*) Tokyo, 1981

TOYNBEE AND WARD PERKINS 1950. J.M.C. Toynbee and J.B. Ward Perkins, 'Peopled Scrolls: a Hellenistic Motif in Imperial Art', *Papers of the British School at Rome*, XVIII, N.S., V, London, 1950, pp. 1–43

VICKERS 1983. Michael Vickers, 'Les vases peints: Image ou Mirage?', in F. Lissarrague and F. Thelamon (eds), *Image et céramique grècque, Actes du Colloque de Rouen 1982*, Rouen, 1983, pp. 29–42

VIENNOT 1964. Odette Viennot, *Les Divinités Fluviales Gangā et Yamunā aux Portes des Sanctuaires de l'Inde*, Publications du Musée Guimet, Recherches et Documents d'Art et d'Archéologie, X, Paris, 1964

WADDINGTON 1977. C.H. Waddington, *Tools For Thought*, paperback edn, London, 1977

WALKER 1981. Susan Walker and Andrew Burnett, *The Image of Augustus*, London, 1981

WARD 1971. W.A. Ward, 'Egypt and the East Mediterranean World 2200–1900 BC', *Studies in Egyptian Foreign Relations During the First Intermediate Period*, Beirut, 1971

WARD PERKINS. J.B. Ward Perkins, 'The Roman West and the Parthian East', *Proceedings of the British Academy*, LI, pp. 175–99

WATSON 1971. William Watson, *Cultural Frontiers in Ancient East Asia*, Edinburgh, 1971

WAYWELL 1978. G.B. Waywell, *The Free-standing Sculptures of the Mausoleum at Halicarnassus in the British Museum*, London, 1978

WELCH 1972. Stuart C. Welch, 'Two Drawings, a Tile, a Dish and a Pair of Scissors', in Richard Ettinghausen (ed.), *Islamic Art in the Metropolitan Museum of Art*, New York, 1972, pp. 291–8

WHITFIELD 1982. Roderick Whitfield, *The Art of Central Asia: The Stein Collection in the British Museum*, 3 vols, Tokyo, 1982 *et seq.*

WIRGIN 1970. Jan Wirgin, 'Sung Ceramic Designs', *Bulletin of the Museum of Far Eastern Antiquities*, 42 (1970), pp. 1–272

WIRGIN 1976. Jan Wirgin, 'Sung Ceramic Designs and their Relation to Painting', in Margaret Medley (ed.), *Chinese Painting and the Decorative Style*, Colloquies on Art and Archaeology in Asia, 5, London, 1976

WOOD 1978. Nigel Wood, *Oriental Glazes*, London and New York, 1978

WOOD 1753. Robert Wood, *The Ruins of Palmyra, otherwise Tedmor in the Desert*, London, 1753

XI'AN 1953. *Gudai zhuangshou huawen xuanji*, Shaanxi renmin chubanshe, Xi'an, 1953

YONEZAWA 1970. Yonezawa Yoshio, Kawakita Michiaki, *Arts of China, Paintings in Chinese Museums, New Collections*, trans. George C. Hatch, Tokyo, Palo Alto, 1970

ZWALF 1979. Wladimir Zwalf, *The Shrines of Gandhara*, London, 1979

ZIMMER 1972. Heinrich Zimmer, *Myths and Symbols in Indian Art and Civilisation*, Joseph Campbell (ed.), Bollingen Series, VI, Princeton, 1972

INTRODUCTION

1 Differences between the raw materials available for porcelain manufacture in China and Europe have only recently been established. The nature of Chinese porcelain stone was discussed at the International Conference on Ancient Pottery and Porcelain held in Shanghai in November 1982. The full proceedings have not yet been published, but summaries are given in Shanghai 1982; see also Wood 1978.

2 Chinese motifs might be replaced by floral sprays and landscape scenes of European derivation, as, for example, on ceramics made by Wedgwood (Dawson 1984, pl. 3, fig. 9); but a pictorial motif combined with a border generally reproduces the balance of designs seen on Chinese ceramics. Alternatively, Europeans following Chinese example in using white clays for tablewares might decorate them with broad and narrow lines, based upon the architectural mouldings widely used as ornament in Europe.

3 The bird on the rock motif on European wares is illustrated by Tait 1960.

4 This list is limited to the animal motifs that appear as central subjects on silver and porcelain dishes. Some other creatures appear in subordinate positions, including a horse leaping over waves. This motif seems to have started life as a *qilin* leaping over clouds, as shown on a Tang-dynasty epitaph cover for Wang Yuankui, d. 854 (*Kaogu yu wenwu* 1983.1, pp. 46–51, fig. 6). Horses leaping over waves seem to have been a new reading given to an old motif.

5 The only exceptions are some early borders, which anticipate the forms used in the Buddhist caves. Like the later scrolls, these elementary foliate patterns, widely used in late Han tomb decoration and on mirrors (Beijing 1959a, pls 10, 26, 38) must have been borrowed from the West. Both scrolls and four-petalled central motifs are especially prominent on mirrors (Bulling 1960, pls 35, 41, 44–5, 70). However, there is no evidence that such designs contributed to the decoration of the Buddhist caves with which we are concerned. A familiarity with such designs may have made craftsmen more receptive to the foliate scrolls when they were re-introduced with the decoration of the Buddhist caves.

6 Gyllensvärd 1957, pp. 129–32, assumes that Sasanian silver was the source of palmette designs on Chinese silver. As described in Chapter 1, this ornament seems to have been transmitted at an earlier date in architectural decoration, and to have been developed into a variety of forms in the embellishment of stonework. This sequence explains why the ornament on Chinese silver of the Tang dynasty differs significantly from decoration of Sasanian silver, which is often supposed to have inspired it. Several other writers have noted the use of Western motifs on Chinese silver, and have also generally suggested an Indian or Sasanian source.

7 Discussion of the sources of motifs both in China and in other parts of the world often involves the suggestion that the origins of a particular design are to be found in textiles. While textiles, used as hangings, were often designed to match architecture, it is not likely that their ornament contributed directly to the development of a range of designs for ceramics. In the absence of surviving evidence, I have preferred to concentrate on the transfer of the decorative repertory of architecture to precious metals, such as silver, and then to utensils in less precious materials, such as lacquer and ceramics.

8 In the opening pages of his seminal work *Pioneers of Modern Design*, Nikolaus Pevsner conveys impatience with the 'battle of styles' (Pevsner 1960, pp. 19–20).

9 The following passage appears in *Trotzdem* 1900–1930, Brenner Verlag, Innsbruck, 1931, quoted from Conrads 1970, pp. 19–24.

10 Originally published in 'Ornament in Architecture' in *The Engineering Magazine*, New York, vol. III, no. 5, August 1892, and republished in Sullivan 1947.

11 For a discussion of both the way we see and the way we understand what we see, note Gregory 1966, 1970.

12 The last decade has seen a general recognition that something is fundamentally wrong with some of the effects of modern architecture, as set out in the commentary on modern architecture in the series 'The Shock of the New' on BBC television (Hughes 1980), and in comments by the Prince of Wales in an address to RIBA on 30 May 1984, reported in *The Times*, 31 May 1984, p. 16. Charles Jencks has led the way in a discussion of alternative forms of architecture, known by the term 'post-Modernism'. In stressing the need for ornament Jencks is, however, primarily concerned with meanings, and gives less weight to ornament that is simply attractive to its audience because it belongs to a long-standing tradition and is therefore easily recognised (Jencks 1984).

13 The difficulty in making meaningful distinctions between architecture and ornament in Western building traditions is exemplified by the discussion in Summerson 1977.

14 Gombrich 1979a, pp. 175–80, 198–9.

15 Descriptive art, such as Dutch painting, the subject of a study by Svetlana Alpers (Alpers 1983), is imbued with a message as much as other forms of art, such as narrative painting. Thus the paintings of the northern tradition set out to record the visual world in a 'scientific' form. This approach has a message for the viewer equivalent to, if different from, that of a narrative painting. The difficulty with all messages is that they are not easily understood once the society that demanded them has disappeared.

16 An emphasis on the personal view of the artist to the exclusion of other 'messages' is a late development in the history of Western European art. A long tradition of religious and political concerns shown in earlier forms of art in the West seems to have led later artists to assume that their own art, though divorced from these religious and political purposes, should also have an instructive or propagandist role. Thus artists have put personal visions in the place of the didactic concerns of Medieval or Renaissance art. However, it has proved more difficult to give weight to attitudes of a single artist than it was to attach importance to the wider messages of earlier works of art. Further, without a philosophy or indeed an aim widely accepted by the audience, single works of art by individual artists are very difficult to read, as Gombrich has pointed out (Gombrich 1982, pp. 158–61).

17 Classical sculpture, Medieval illumination and Persian paintings have very largely been discussed without reference to their frames and borders. Yet such frames and borders are essential ingredients of their compositions and affect our reading of and response to them.

18 See Gombrich's discussion of the effect produced by a mosaic of a dog found at the entrance of a house at Pompeii (Gombrich 1982, pp. 138–41).

19 Gombrich 1979a, p. 171.

20 Gombrich 1982, pp. 105–36.

21 There are many nineteenth-century works on ornament; among these Owen Jones's, *The Grammar of Ornament*, London, 1856, is pre-eminent (see pl. 12). There has been much less interest in the subject in the twentieth century.

22 Discussed in Gombrich 1979a, pp. 180–90. I am indebted to Sir Ernst Gombrich for lending me a copy of Margaret Olin's unpublished dissertation, entitled 'Alois Riegl and the Crisis of Representation in Art Theory', Chicago, 1982.

23 Goodyear 1891.

24 The difficult topic of *Kunstwollen* is discussed by Olin 1982, pp. 239–44.

25 Semper 1863.

26 Gombrich 1979a, p. 210.

27 Gombrich 1979a, p. 210.

28 Steadman 1979, pp. 233–4; Sturt 1963, pp. 91–9.

29 Pye 1968, pp. 4–8.

30 While this restriction is a striking feature of the early Chinese flower patterns described in Chapters 1 and 2, it is not necessarily found in ornamental art at different times in other parts of the world. There seems to be a remarkable correspondence between the pace of change in palmettes and spiral motifs in Greek vases and the use of related designs as architectural decoration.

31 Gombrich 1960.

32 The need for active participation of the viewer is discussed by Gregory 1966 and 1970. It is also an important element of all Gombrich's work (Gombrich 1960, 1979a, pp. 1–2).

33 Difficulties of recognition and the processes of learning to see are discussed by Gregory 1966, pp. 188–219, on the evidence of the experiences of people who have recovered from blindness and of the development of babies; Gombrich notes the problems non-European peoples have initially in reading photographs and Western paintings (Gombrich 1960, p. 53).

34 Gombrich 1973, pp. 202–4, and 1982, p. 285; Bagley 1985, n. 47.

35 Kubler 1962, p. vii.

36 The role of hierarchies, symmetry and other geometric orders are a major topic of *The Sense of Order* (Gombrich 1979a). Further, Gombrich discusses the success of certain ornaments such as the undulating scroll in terms of perceptual advantages (pp. 191–3).

37 Some of our desire for change seems to be related to our interest in games and play (Gombrich 1979a, pp. 166–7).

38 Gombrich 1979b, pp. 60–92.

39 These flowers, known in traditional terminology as leaf-palmettes, were also reused in Europe as various semi-naturalistic plants. When found on European textiles, for example, they are termed artichokes or pineapples.

CHAPTER 1

1 The palmette is a stylised floral design. In the Appendix it is suggested that it derives from a representation of a papyrus. Alternative sources in combinations of lilies and lotuses have also been proposed.

2 The date and construction of the Temple of Apollo at Didyma are discussed by Lyttelton 1974, p. 34.

3 Colledge 1976, pp. 209–12, reviews ornament at Palmyra.

4 Toynbee and Ward-Perkins 1950 discuss the history of the inhabited scroll.

5 For discussion of the temples in the Hauran area of Syria see Butler 1903, pp. 351–61.

6 There is little evidence for the transmission of palmettes as opposed to simplified acanthus or vine leaves to China. However, many of the foliage forms used in fifth-century architectural ornament in China seem to refer, if distantly, to palmettes, and it must be presumed that the palmette was also known in China (see fig. 42 and Rawson 1982, fig. 29). A striking example of a palmette on volutes at Longmen in Henan province is

illustrated in *Wenwu* 1980.1, p. 2, fig. 3. See also Beijing 1980c, fig. 69, where a palmette surmounts a long staff.

7 Prior to the period under discussion an early phase of intercourse with the West had, in the Han dynasty, brought simple half-palmette scrolls to China (see Beijing 1959, pls 10, 26, 38, and Bulling 1960, pls 35, 41). These simple patterns seem to have fallen into abeyance, and it required a further stimulus from the West to revive their use.

8 Summerson 1949, pp. 1–28.

9 The Western caves at Yungang are illustrated in Mizuno and Nagahiro 1952, vol. XV plates; for Longmen see Beijing 1980c, fig. 70. In sixth-century caves the principal niches and figures dominated, and there was less attention to well-regulated façades.

10 Mizuno and Nagahiro 1952, vol. III, plates. Plate 29 illustrates a pagoda in cave 6; for roofs see vol. VI plates, pl. 51. Such roofs revived an earlier tradition, seen at Dunhuang, Tokyo 1981a, vol. I, pls 18, 23.

11 For coffered ceilings with lotus flowers see Mizuno and Nagahiro 1952, vol. VI plates, pl. 30, vol. IX, pl. 32; for a single lotus flower see Beijing 1980c, fig. 68.

12 Mizuno and Nagahiro 1952, vol. IX, pls 19, 24. Compare Hallade 1982, pp. 316–17.

13 Bernard 1967, 1982 and Ward Perkins 1965 present different views concerning the significance of the Hellenistic contribution in Central Asia. Decorative motifs considered in this chapter suggest that Roman and Parthian art certainly offered an important stimulus. See also Seeley 1984.

14 *Wenwu* 1972.1, pp. 83–4, describes the hoard in which the cup was found together with other vessels of Central Asian origin.

15 For a recent discussion of the Assyrian reliefs see Reade 1983.

16 Waywell 1978, p. 77.

17 Walker 1981, pp. 29–35.

18 Colledge 1976, figs 28, 30. Grave stones in Classical style from Palmyra also depict figures within buildings (Colledge 1976, pls 147, 149, 150).

19 Lyttelton 1974, pp. 40–83; Charbonneaux 1973, pl. 51.

20 Ghirshman 1962, pl. 338.

21 Colledge 1976, pp. 209–10.

22 The account that follows concentrates on the Hellenistic, Parthian and Kushan development. However, the complex ornament at Yungang suggests that, were the surviving remains more complete, we might find relevant later developments under the Sasanians (see, for example, Thompson 1976).

23 For the history of the Parthian activities and an account of their material remains see Colledge 1967, 1977, Cambridge 1983, pp. 21–97.

24 For a description of sites of Parthian date see Frumkin 1970, pp. 142–4; Colledge 1977, pp. 21–79, 80–121; Herrmann 1977, pp. 34–72.

25 Herrmann 1977, pp. 34–5; Colledge 1977, fig. 33.

26 Schlumberger 1970, pp. 118–19.

27 Safar 1974, p. 210; Leningrad 1978, figs 24, 25; Rosenfield 1967, fig. 136.

28 Cambridge 1983, pp. 181–231.

29 For a translation of ch. 96 of the *Han Shu* see Hulsewé 1979. The Guishuang are mentioned on p. 122. The expanded section in the *Hou Han Shu* is found in ch. 88 on the Western Regions.

30 Rosenfield 1967; Zwalf 1979.

31 For a summary of work in the Soviet Union see Morris 1983. In Frumkin 1970 Kara-tepe is described on pp. 110–13, Khalchayan on pp. 113–15 and Dalverzin-

tepe on p. 115. For this last site see also Leningrad 1978.

32 The case for the development of images of the Buddha before the advent of the Kushans is argued in van Lohuizen de Leeuw 1979.

33 Stawiski 1979, p. 196.

34 For animal capitals and stepped merlons in cave 12 see Mizuno and Nagahiro 1952, vol. IX, pl. 19.

35 Rowland 1953, pl. 28.

36 The trabeated arch is sometimes called a broken pediment. Under this name it is mentioned by Foucher 1905, pp. 132–45. Other Pompeian wall-paintings are illustrated by Schefold 1962, pls 136–7. Knauer 1983 has also suggested that this niche outline is owed to a misunderstanding of a perspective detail. Her examples tend to be later in date than the Kushan examples illustrated here.

37 Wall-painting at Kizil is rich in details which show appreciation of Classical perspective traditions (Grünwedel 1912; New York 1982, nos 16, 18, 26, 28 (fig. j)).

38 Stawiski 1979, pl. 148.

39 Hackin 1954.

40 Stein 1912, 1964.

41 Giles 1923. Ch'en 1964, pp. 79, 81, 88.

42 The quoted passages from the *Wei Shu* and related translations are found in Mizuno and Nagahiro 1952, vol. XVI, pls 61, 72, 71. Traditionally, 1 *zhang* is taken as 10 *chi*, with 1 *chi* measured as 10 in. 1 *jin* is equivalent to 1⅓ lb.

43 For a discussion of the Yungang caves in terms of the patronage of the royal family of the Toba Wei see Soper 1960; see also *Kaogu xuebao* 1978.1, pp. 25–38.

44 Hallade 1982, pp. 272–4.

45 Thompson 1979.

46 The source of these petal designs in a Western architectural motif was first suggested by Loehr 1967, p. 15.

47 Apart from caves 7 and 8 at Yungang, caves 9 and 10 are particularly rich in Western details (see Mizuno and Nagahiro 1952, vols VI–VII).

CHAPTER 2

1 The excavation of the tomb is reported in *Wenwu* 1972.3, pp. 20–33. For further illustrations of decorated wood from the tomb see Beijing 1972a, p. 145. The borders illustrated here interestingly resemble Western uses of half-palmette scrolls. The ornament of the coffin bed does not seem yet to have been published. In addition to a lively inhabited scroll, it is bounded by deep scrolling based on the Classical wave pattern.

2 Compare Mizuno and Nagahiro 1952, vol. VII plates, pls 24, 41, 44 (cave 10).

3 The identification of these borders as lotus borders is in part speculation. However, occasionally the flowers have been replaced, perhaps at a later date, by a diminutive lotus flower, which supports the identification.

4 As suggested in Chapter 1, decoration of flowers within a coffered ceiling seems to have been borrowed from the West. In such caves as the Lianhua dong at Longmen the grid of beams is replaced by a single lotus (Beijing 1980c, fig. 67). By the Sui period, the arrangement of the ceiling designs at Dunhuang had been set, with a single lotus surrounded by various floral patterns recessed in a square field at the centre (fig. 48a). This arrangement reflected the design of Buddhist canopies hung over the heads of Buddhist images.

5 For the cult of immortality see Loewe 1979, pp. 1–16.

6 For dragon motifs related to the Xiangtangshan stele carving see Loo 1940, pl. XXVII; other borders with cloud forms

combined with half-palmette scrolls are shown in Rawson 1982, fig. 5; *Kaogu* 1978.3, pp. 168–78, figs 2, 9, 10; Xi'an 1953, 40, 60, 61.

7 I am indebted to Margaret Medley for this suggestion. For Gupta influence on Chinese figure styles see Soper 1960.

8 As illustrated in the Appendix (fig. 192g), this type of border has clear Western prototypes. Its early transmission eastwards is difficult to document, as it does not seem to appear in Gandharan work. At a slightly later date related borders are found in Central Asia (Hallade 1982, pp. 310–11).

9 Other early sixth-century flower patterns based on palmettes are illustrated in Bush 1975 and Juliano 1980. Neither author considers, however, the ultimate Western sources of the designs, preferring to discuss the balance between north and south China in their usages.

10 Korean tiles are generally cited as evidence of the date of this new rosette form because the date of the digging of the lake Anapchi is known to be 674, and a fragment of one of the tiles recovered from the lake is dated to 680 (Goepper and Whitfield 1984, pp. 104–9). At this period Korean and Chinese ornament shared many features, including the widespread use of palmettes in architectural decoration. See also *Kaogu* 1984.1, pp. 121–36, figs 3–6, for decoration comparable with Wei designs.

11 The ornament on this tile is laid out on arcaded stems with heads of alternating types. This pattern is based on a Mediterranean design in which lotus heads and buds, on arcaded stems, were arranged in a circle, a scheme which was very popular in the Far East, as on the lacquer box inlaid with silver illustrated below (fig. 112); however, its transmission eastwards is difficult to document and it has not, therefore, been considered here in detail. Compare Beijing 1982a, pp. 21–5, 28–9, 95–6; Xi'an 1953, no. 48. In most of these designs the construction of the petals of the rosettes obscures the underlying arrangement of the motifs on arcaded stems.

12 Compare the border design of the epitaph tablet for Niu Hongman dated 672, (*Wenwu ziliao congkan* 1 (1977), pp. 199–201).

13 Both the decoration of the epitaph tablets cited and illustrated, and the evidence from the Anapchi lake in Korea, suggest that these simple peony designs were formulated in the second half, mainly in the last quarter, of the seventh century. This development coincides with the reign of Gaozong (650–84). As the cult of the peony is dated to the period of influence of his consort, Wu Zetian, this dating seems plausible on both material and literary evidence. However, the peony-like borders in cave 220 at Dunhuang pose certain problems. These designs appear to be more advanced than the borders of the late seventh century, yet they are customarily dated by inscription to 642. Tokyo 1981a, vol. 3, pls 24–7. It is probable that the relevance of the inscription to the decoration of the whole cave needs to be reassessed.

14 Compare Xi'an 1953, nos 53–7, 59, 64–5; Tokyo 1966, nos 177–250. See also discussion and illustrations in Tokyo 1978a, 257–63.

15 The British Museum is indebted to Dr David McMullan for making possible the purchase of a rubbing of the epitaph cover and tablets carved for Cui Youfu. I am also grateful to Dr McMullan for drawing my attention to references concerning the activity of the Cui family; Ebrey 1978.

16 I came to appreciate the vogue for the peony, which occurred at the end of the seventh and beginning of the eighth century, following discussions with David McMullan in

early 1983, and I owe the reference to Li Shutong's essay to his kind help (Li Shutong 1969).

17 Tamura and Kobayashi 1953, pp. 210–11.

18 *Ying zao fa shi*, ch. 33.

19 Earthenware vessels decorated in relief with figures and palmettes seem to be related to the small figural terracottas found at Kushan sites (Stawiski 1979, pls 121–3), and at Yotkan (Stein 1907, pls XLV–XLVII).

20 The appliqués on Tang burial wares are often similar to the ornament moulded on tiles at the same period. For the early history of the appliqué style and its relationship to Chinese Buddhist design see Lovell 1975. Compare ceramics from a tomb at Taiyuan in Shanxi province (*Wenwu* 1983.10, pp. 1–23).

21 Scrolling patterns on textiles are fairly rare. However, a design similar to architectural ornament is seen on an embroidered fragment of the Northern Wei period (*Wenwu* 1972.2, pp. 54–60, fig. 6). See also recently excavated lacquer fragments from Ningxia (*Wenwu* 1984.6, pp. 46–56, figs 34–8). A range of textiles from Xinjiang province is published in Beijing 1972c. Embroidery made more fluent designs possible, and some silver and ceramic ornament is certainly paralleled in embroidered textiles (see Beijing 1982b). Silver, lacquer, textiles and ceramics, painted in underglaze blue with the motifs in reserve, share the practice of using a contrasting colour for the motifs with, in the case of lacquer, silk and ceramics, a dark ground to accentuate the design. However, both running scrolls and lobed frames are found more commonly in lacquer and silver than in textiles, suggesting that it is in these materials that the prototypes for ceramic ornament should be sought.

22 For silver and gilt-bronze items in Central Asian style see *Wenwu* 1972.1, pp. 83–4, fig. 28; Beijing 1972a, pp. 149–52; *Wenwu ziliao congkan* 1 (1977), pp. 149–62, pl. 13; *Kaogu* 1978.2, pp. 117–18, fig. 2; *Wenwu* 1983.8, pp. 1–7, pl. 1.

23 Tokyo 1929, 1960; Hayashi 1975.

24 For a discussion of vessel shapes see Gyllensvärd 1957. Glass imported from the West may have inspired a number of vessel shapes (Tokyo 1960, middle section, pls 1–6). In addition to glass in the Shōsōin, examples of Western glass have been found in Korea (Goepper and Whitfield 1984, nos 82, 84); compare *Wenwu* 1973.3, pp. 2–32, col. pl. 1; *Kaoguxue jikan* 3 (1983), pp. 168–95, pl. 33:1, 3.

25 Rawson 1982, figs 1, 22.

26 *Wenwu* 1966.3, pp. 8–15, 47, fig. 11. Compare a reliquary or box dated 603 (Tokyo 1973, no. 203, and Goepper and Whitfield 1984, no. 116) for an example found in Korea.

27 Rawson 1982, pp. 4–5; *Kaogu* 1980.6, pp. 536–41, 543.

28 Lacquer in the Shōsōin is illustrated in Tokyo 1975.

29 *Wenwu* 1979.3, pp. 46–8, pls 2, 3; compare also *Wenwu* 1973.1, pp. 48–58 – a box from this find is illustrated below (fig. 116); *Wenwu* 1979.11, pp. 21–31, pl. 4:2. For a discussion of early lacquer see Kuwayama 1982a and 1982b.

30 For complete views of figs 62a and b see Mino 1980, fig. 100, and Cleveland 1968, no. 157. See Satō 1981, p. 152, quoting Feng Xianming. It has also been suggested that stonewares made at Jizhou in Jiangxi province contributed to the development of the underglaze blue decoration of porcelain at Jingdezhen. While the manufacture at Jizhou may have inspired competition from Jingdezhen, the motifs on Jizhou ware are not precisely duplicated at Jingdezhen. Wave

patterns and classic scrolls are shared by the two areas, but the Jizhou vessels are distinguished by a very specific lotus design illustrated in figure 166 in Chapter 5. This design differs from the Jingdezhen lotus, which is shown with a pointed palmette leaf, by having a round realistic leaf. For porcelain decoration this is a most unusual form of lotus motif and would surely have been passed on to Jingdezhen if the Jizhou wares had been directly copied at the great porcelain kilns.

31 Tokyo 1981b, pls 113, 116, 119, 120; *Kaogu xuebao* 1959.3, pp. 107–20; *Wenwu* 1973.5, pp. 30–40; *Zhejiang sheng wenwu kaogu kan* 1981, pp. 94–104; *Wenwu* 1983.8, pp. 25–34; *Kaoguxue jikan* 3 (1983), pp. 168–95, pl. 32:1–6.

32 *Wenwu* 1973.7, pp. 20–9, 14.

33 The relationship of Ding porcelains to metal prototypes varied over the period of their manufacture. Early Ding wares were often used as Buddhist ritual vessels and thus appear in shapes developed first for gilt-bronze vessels. Ding wares of the twelfth and thirteenth centuries, in particular, display shapes of silverware and elaborate decoration appropriate to metalwork (Rawson 1984a; Wirgin 1970, pls 61, 71–6, 84, 87, 88, 96). Feng Xianming has suggested that Yue ware was a major influence on Ding ware (*Wenwu* 1973.7, pp. 20–9). However, the resemblances between the two wares may also be a consequence of similar silver vessels providing the model for both.

34 Models in paintings have also been proposed for some of the more elaborate designs on Ding ware (Wirgin 1976). I should prefer to formulate the sequence that gave rise to such apparently painterly renderings of motifs as follows: lacquerworkers, using a repertory of shapes and designs borrowed initially from silver, found that some painterly effects were possible with a technique that involved working with a brush, and thus exploited motifs also used in decorative painting, as seen on the lacquers found at Wujin (*Wenwu* 1979.3, pp. 46–8). Probably both silverware and fine porcelains were influenced by this trend in lacquerworking.

35 Dishes with flat rims, characteristic of silverware of the Song period (Rawson 1984a; *Wenwu* 1974.4, p. 78; *Wenwu ziliao congkan* 8 (1983), pp. 116–20, pl. 8:4) and widely copied in Ding ware, are less common in southern porcelains of the Song period. However, examples with *yingqing* glaze are known (Christie's auction catalogue, 20/21 June 1984, lot 171). Many *yingqing*-glazed porcelains show stippling derived from silver decoration (Wirgin 1970, pls 13–15). For recently excavated sherds from Hutian see *Wenwu* 1980.11, pp. 39–49, fig. 10, pl. 3; Liu Xinyuan 1980, pl. 2.

36 For the phoenix-headed ewer on which this design occurs see Rawson 1982, fig. 56, and Medley 1976, fig. 70.

37 This genre of decoration is discussed in Rawson 1982. The importance of inlay work as a source for broad peony leaves is confirmed by examples of peonies inlaid in slip on Korean celadons (Goepper and Whitfield 1984, no. 156). The Koreans had a rich tradition of inlay work, which seems to have been shared at least in part with south-east China. It is thus possible that the broad leaves seen on Korean celadons were also reproduced in shell in both south China and Korea. See also the shared panel shapes discussed in Chapter 4 and Gompertz 1978, pl. 2. Realistic leaves were also used on peony designs on later Ding wares (Wirgin 1970, pl. 74, pl. 102b); compare also textiles (Beijing 1982b, figs 43–5).

38 Kuwayama 1982b, fig. 11.

39 Lacquer remains are limited, but such boxes as have survived continued the Tang

tradition (Beijing 1982b, p. 90; *Wenwu* 1982.7, pp. 54–9, pl. 5:2; note also a silver bowl with a bracketed lip in pl. 5:4).

40 Similar trends have been observed in other cultures in other parts of the world (Allan and Raby 1982, Raby 1983, in the Islamic world); for Classical Greek developments see Vickers 1983.

CHAPTER 3

1 Systematic discussion of the Animals of the Directions is surprisingly limited. The following sources have been consulted: Karlgren 1946; Cheng 1957; Karlgren 1968; Bulling 1974; Bodde 1975; Loewe 1979; Powers 1981; Diény 1982; Pirazzoli-t'Serstevens 1982.

2 Beijing 1959b, p. 27, fig. 21; Beijing 1980d, pl. 89.

3 *Han Shu*, ch. 22.

4 The mirror is in the British Museum (OA 1947.7-12.334); the translation follows Loewe 1979, p. 196.

5 *Wenwu* 1976.7, pp. 51–5.

6 Beijing 1972a, pp. 44–70; *Wenwu* 1972.1, pp. 30–42. Some animal designs appear in thread relief in Han-dynasty bronze basins (*Wenwu ziliao congkan* 7 (1983), pp. 30–3, fig. 4).

7 The Hejiacun hoard contains several silver dishes decorated only with a single animal in repoussé. Such ornament cannot have been very popular as it was rapidly replaced with animal subjects surrounded with flowers, as illustrated in figs 90, 95, 99.

8 The dragon motif has been discussed by the present author in an unpublished paper, 'Dragons on Shang and Zhou bronzes', presented to the Early China Seminar at the School of Oriental and African Studies, London, 7 February 1984; a summary is to appear in *Early China* 8. Some of the content of this paper is included in Rawson 1983. Early Shang or pre-Shang snake motifs are seen on pottery from Erlitou (*Kaogu* 1965.5, pp. 215–24, pl. 3). The beaked dragon, whose outline made little contribution to the development of the *long*, is discussed in Bagley 1985, section 1.5. However, the persistent use of beaked creatures in profile established a place for other motifs also shown in profile, including the *long*.

9 Watson 1971, pp. 107–10, describes a similar phenomenon, whereby the coiled dragons of the Chinese, in use from the Shang period, were reinterpreted by the inhabitants of the steppes as coiled tigers. Both examples of the reuse of an outline developed for dragons as shapes for tigers are interesting instances of a phenomenon described in the Introduction – new interpretations provided for existing shapes or arrangements of motifs.

10 The exchanges of Chinese and nomad subjects in the bronzework of the burials of the Zhongshan kings at Pingshan Xian in Hebei province is interesting in this context (*Kaogu xuebao* 1979.2, pp. 147–84; *Wenwu* 1979.5, pp. 43–50).

11 Compare other examples in Tamura and Kobayashi 1953, fig. 214.

12 *Wenwu* 1982.11, pp. 15–27, fig. 10.

13 Lacquers from the tomb of the Ming Prince Zhu Tan are illustrated in *Wenwu* 1980.6, pp. 70–4, pl. 6; compare a lacquer box from a tomb in Sichuan province dated 1410 (*Kaogu* 1978.5, pp. 306–13, pl. 10:1).

14 *Kaogu xuebao* 1982.1, p. 103, fig. 27.

15 Xi'an 1953, no. 30, shows an example of a jewel between two phoenixes. In later ornament the flaming pearl is particularly associated with dragons; at an early date, however, jewels could be placed with any of the principal animals.

16 Figgess 1964 describes the casket, and others of similar type, in detail. Several of these containers are inscribed with a date equivalent to 1315.

17 Medley 1976, fig. 75. It is suggested above (Chapter 2, note 32) that such painterly designs on Ding ware had been anticipated in lacquer.

18 Lion-Goldschmidt 1978, pp. 258–67; Leeuwarden 1964.

19 A deer's head with prominent antlers appears on a large *ding* excavated at Anyang (Li Chi 1977, pl. 9); a *you* in the Pillsbury Collection, Minneapolis Institute of Arts, is decorated with small crouching deer (Karlgren 1952, no. 15); jades in the shape of deer have been excavated at Shaanxi Baoji Rujiazhuang (*Wenwu* 1976.4, pp. 34–56, fig. 35).

20 Bodde 1975, pp. 327–8.

21 A further horned creature is mentioned in mirror inscriptions (Loewe 1979, p. 198).

22 Biography of Sima Xiangru, *Shi Ji*, ch. 117.

23 Beijing 1981a, p. 203.

24 Cheng 1957, p. 173.

25 D'Argencé 1981.

26 Tokyo 1960, south section, pls 52–3.

27 Michigan 1967, nos 26–31.

28 Mino 1980, p. 66; Wirgin 1970, pl. 93.

29 Parrot 1960, pls 354–6; Parrot 1961, pl. 31; Ghirshman 1964, pl. 269.

30 Safar 1974, p. 198; Waywell 1978, pl. 37.

31 New York 1980, p. 58.

32 Rowland 1953, pls 8, 9, 11.

33 Beijing 1981b, pls 7, 82–3, 88, 90.

34 Near Eastern models of seated and pacing lions seem to have given rise to two parallel poses in Chinese examples.

35 Akiyama 1968, pl. 180.

36 Medley 1976, fig. 41.

37 Viennot 1964, pls 1–9. A Gupta example from Sarnarth, now in the British Museum, is illustrated in Archer 1971, fig. 186.

38 *Makara*-like fish appear on tomb bricks found in Minhou Xian in Fujian province (*Kaogu* 1980.1, pp. 59–65, fig. 3). The cup from Datong is illustrated in Beijing 1972a, p. 149.

39 *Wenwu* 1982.11, pp. 15–27, pl. 3:3. See also *Gugong bowuyuan yuankan* 1984.2, pp. 50–8, pl. 7; Gyllensvärd 1957, figs 56a, b.

40 A certain number of vessel shapes and many decorative motifs used in *yue* ware mimic silver prototypes (see Chapter 2, note 31).

41 *Makaras* continue to appear in sculpture, as on the *pailou* at the Ming tombs (Paludan 1981, fig. 6); they are also found in jade (Ayers and Rawson 1975: no. 257 illustrates some *makara* features).

42 Rawson 1982, pp. 18–20.

43 Beijing 1965, fig. 21.

44 Wirgin 1970, pls 99, 102. As mentioned above (Chapter 2, note 34), these painterly effects may have been borrowed from lacquer decoration.

45 Medley 1974, pls 30–1, 89b.

46 The use of the prunus, both in paintings and as an ornament, is the subject of a forthcoming exhibition to be held at Yale University Art Gallery. I have benefited greatly from conversations on this subject with Dr M. Neill, one of the organisers of this exhibition. I am grateful to Dr Neill for a reference to a Yuan-dynasty porcelain dish decorated with sprays of prunus, pine and bamboo (*Kaogu* 1972.6, pl. 9:3).

47 *Wenwu* 1973.4, pp. 59–66, p. 65, fig. 16, p. 66, fig. 19.

48 Wirgin 1970, pl. 13b, 38b, 84i. For a full view of the porcelain in fig. 104 see Addis 1979, no. 10.

CHAPTER 4

1 The strange lobed petals of the lotus pedestal are inexplicable, except in the context of the horizontal petal border that owes its form to the import of a Western enrichment of a moulding (Loehr 1967, p. 15).

2 Among the earliest examples of lotus petal designs is the decoration on a chicken-headed ewer dating to the Western Jin period, 265–316 (Satō 1981, p. 45, fig. 65).

3 *Wenwu* 1972.8, pp. 39–51.

4 The similarity between the small three-petalled flowers on the Ding ware bowl and the Yuan porcelain dish is one of the clearest examples of the sharing of a common repertory of design by the potters making these quite separate wares. Exactly similar shapes became available in Iran in the Timurid period – similar forms are incorporated in the chinoiserie drawings discussed in Chapter 5; an example in the National Library, West Berlin, should be noted (Diez A Fol. 73, fol. 75, no. 2). The addition of mandarin ducks to the lotus design was also anticipated in Ding ware.

5 Silver dishes with flat rims in a lotus form are not particularly common, but prominent examples have been excavated (Akiyama 1968, pl. 170). For a discussion of the related box form see Rawson 1984a.

6 S-shaped scrolls, producing a wave effect, are seen as a border to a mosaic from Pella, illustrated in the Appendix (fig. 198). The introduction of related ornament to China coincides with the widespread use of palmette scrolls in fifth-century caves at Yungang. Borders of waves are seen along the bottom of the coffin bed from the tomb of Sima Jinlong, and in a painted representation of a small seat on a lacquered fragment, also from his tomb (Beijing 1972a, pp. 143–4).

7 Tokyo 1981a, vol. 3, pls 61, 139, 155.

8 Beijing 1964, fig. 39.

9 *Wenwu* 1975.12, pp. 26–36.

10 *Wenwu* 1983.1, pp. 45–63; *Kaogu* 1959.5, p. 227, pls 5–6; *Wenwu* 1961.11, pp. 53–60; *Kaogu* 1965.7, pp. 352–6, pls 7–8; *Wenwu* 1979.2, pp. 74–8; *Wenwu* 1979.8, pp. 1–25; *Kaogu yu wenwu* 1983.6, pp. 32–9. Related shapes were used for tile ends (*Kaogu* 1977.6, pp. 422–6, fig. 2).

11 Compare the upper openings, lined with arcs, in figure 115a, b.

12 Similar shapes are found on silver containers (*Kaogu* 1961.6, pp. 302–15).

13 There has been some discussion as to the story illustrated (Mino 1980, p. 146). Figure scenes appeared as decoration where a narrative illustration was appropriate, as on mirrors (Akiyama 1968, pl. 128), or where the use of painting made the repertory of painted illustration available, as on the *biwa* in the Shōsōin (Tokyo 1960, south section, nos 98–9). While in theory there were plenty of examples of narrative illustrations for the potters to use, such illustrations do not seem to have supplied much inspiration before the late Song or Yuan periods. The use of lobed frames or lobed cartouches, in particular, illustrates a dependence on architecture or lacquer rather than on drawn or printed illustrations in a plain horizontal format.

14 *Wenwu* 1973.1, pp. 48–58, fig. 8.

15 Beijing 1979, p. 736.

16 Sceptres were also given heads in the shape of magical fungus, *lingzhi*, for which a cloud shape had been adapted to suggest a layered fungus (see below, fig. 126).

17 Examples are seen at Dunhuang (Tokyo 1981a, vol. 4, pls 43, 47, 163). These citations all refer to guardian figures dressed in armour. Similar shapes appear on the shoulders of armoured guardian figures of the Ming and Qing periods. This use accords with Liu Xinyuan's suggestion that the porcelain motif was derived from the shape of a collar worn by an official or assistant (Liu Xinyuan 1983).

18 Paludan 1983, figs 3, 17.

19 Beijing 1981c, pl. 44; Beijing 1980f, figs 132–9.

20 Cammann 1951.

21 Liu Xinyuan 1983, pp. 2–3; Beijing 1979, p. 3,328.

22 Beijing 1972a, p. 130. The fact that the cloud collar is mentioned in connection with women is slightly curious given that this example was clearly made for a man.

23 For the whole stand see *Wenwu* 1982.11, pp. 15–27, fig. 13. Such panels were widely used in Buddhist contexts; for a discussion of Buddhist canopies see Rawson 1984b.

24 Gray 1976, p. 239, draws attention to the Korean vessel, and counters Margaret Medley's suggestion (Medley 1972, p. 13), that the bracketed outlines employed on Yuan-dynasty dishes and the lobed and pointed panels had their origins in Islamic metalwork.

25 Smart 1976, pls 77c, 79a, 84e, 85b, c.

26 Margaret Medley puts forward arguments for Islamic inspiration and prototypes for Chinese panel designs (Medley 1972, 1973). Fux 1969 argues the opposing case, tracing the use of pointed and lobed panels to the Far East.

27 Rawson 1984a illustrates silver prototypes for many porcelain vessel shapes.

28 An important contribution to the organisation of porcelain decoration was made by the manufacture of porcelain copies of bronze altar vessels, such as the dated vases in the Percival David Foundation (Medley 1976, fig. 131). In China, bronze decoration, following metallic models, was arranged in narrow tiers on flasks and other vertical containers. Concentric rings of ornament in porcelain dishes provided circular schemes that paralleled the vertical organisation of the altar vases.

29 In addition to the Cizhou pillow discussed above (fig. 117), a pillow decorated in *sancai* provides an interesting comparison with Yuan-dynasty underglaze blue decoration (*Wenwu* 1981.1, pp. 81–2, pl. 1:2). This pillow, which predates the Yuan porcelains, is decorated with one lozenge-shaped panel and four round panels, all shown against a background of classic scroll. Presumably the pillow is a substitute for an item in a more precious material, possibly lacquer. Related objects may have provided the prototypes for the panels and background of classic scrolls on the Fitzwilliam jar (fig. 114) and the dish in figure 123.

30 Raby 1983 also argues that certain details of the repertory of ornament on the 'Abraham of Kütahya' wares were derived from Islamic metalwork.

31 A *famille rose* enamelled cup and saucer are in the British Museum. OA 1973.2-28.1.

32 Full illustrations of these small patterns and their origins in the West are given in Egami 1983; late examples in lacquer are fully illustrated in Taibei 1981.

33 Xi'an 1953, no. 55.

34 *Kaogu yu wenwu* 1983.1, pp. 28–31, figs 1, 2.

35 Whitfield 1982, vol. 1, pl. 7.

36 Pope 1972 discusses the relationship between Chinese porcelains and Iznik wares.

37 Lane 1957, pl. 35a.

38 Appendix, fig. 183c; Schlumberger 1970, fig. 25, and p. 93; Colledge 1977, fig. 34.

39 Egami 1983, figs 13, 19–21.

40 *Wenwu* 1983.8, pp. 13–24, figs 18, 19, 24.

41 Schlumberger 1970, p. 94.

42 Loo 1940, pl. XXVIII; Goepper and Whitfield 1984, no. 85. Compare *Wenwu* 1972.2, pp. 54–60, fig. 6; *Wenwu* 1984.6, pp. 46–56, figs 34–8.

43 Related textiles, decorated with lozenges rather than hexagons, are seen on figures of Bodhisattvas at Dunhuang as in cave 427 (Tokyo 1981a, vol. 2, pl. 51).

44 Egami 1983, fig. 17.

45 *Wenwu* 1979.8, pp. 1–17, fig. 26.

46 Tokyo 1981a, vol. 3, pl. 131; vol. 4, pl. 143; vol. 5, pls 7, 103, 129.

47 Wirgin 1970, pl. 47:h, k, pl. 50:h; Tokyo 1981b, fig. 156.

48 For early examples of the armour design, see figures represented in banner painting from Dunhuang (Whitfield 1982, vol. 2, pls 15, 16). Interlocking lattice is seen in a Song tomb at Luoyang (*Wenwu* 1983.8, p. 24, fig. 50). The use of these patterns in Islamic metalwork is illustrated in examples discussed in connection with material in the Victoria and Albert Museum (Melikian-Chirvani 1982, fig. 57, no. 108; see also London 1976, no. 199).

CHAPTER 5

1 Cambridge 1968, pp. 303–421.

2 Saunders 1971.

3 Melikian-Chirvani 1974; Scarcia 1975; Curatola 1982.

4 Gray 1973, p. 15; 1979, pp. 121–46.

5 Foreigners in China under the Mongols are fully described in Ch'en 1966. For foreigners, including Chinese, working at Maragha and Tabriz see Titley 1983, p. 17, and Gray 1978, pp. 13–21.

6 Gray 1976, p. 237.

7 The use of lustre hints at a metalwork prototype. Some of the flower ornaments may refer to Central Asian metalwork, which incorporated some Chinese motifs among others (Darkevitch 1976, pls 8, 11, 17–18, fig. 12). The decoration of dragons and phoenixes seems to refer to Chinese models in which the motifs were executed in a light colour against a dark ground (Lane 1939, pls 1–3). Textiles are often suggested as a source (Lane 1957, p. 5), but influences from metalwork and silver are also worth considering.

8 Tamura and Kobayashi 1953; Melikian-Chirvani 1982, no. 93.

9 *Wenwu* 1983.4, pp. 40–6, col. pl. and pl. 5; *Wenwu* 1982.1, pp. 54–8, figs 6–7. The figures of Mongols depicted in these tombs can be compared with figures in temple wall-paintings, including cave 332 at Dunhuang (Tokyo 1981a, vol. 5, pls 161–2), and the wall-paintings at the Shui Shen Miao (*Wenwu* 1981.5, pp. 86–91, pl. 7:2).

10 Compare the scenes in the tombs at Baisha, Hebei province (Beijing 1957).

11 A major painting illustrating similar domestic scenes is *The Night Revels of Han Qizai* (Yonezawa 1970, pls 29–30).

12 Ettinghausen 1959; Talbot Rice 1976; Gray 1978.

13 For the whole banner see Whitfield 1982, vol. 1, no. 39. Compare Ipşiroğlu 1965, pl. 12.

14 In addition to banners, a number of narrative scrolls still survive in the same painting tradition, including a handscroll illustrating the story of the nymph of the Lo River, the Lo Shentu, now in the British Museum (1930, 10-15.02). Related paintings

are found in the Kai Hua Si (Beijing 1983a), the Yan Shan Si (Beijing 1983b), and the Fo Guang Si and Chong Fu Si (Beijing 1983c). For Central Asian styles of painting later exploited in Iran see *Kaogu* 1983.7, 618–23, pls 6–7. Figures of foreigners and demons found in the Topkapi albums (Grube 1984, figs 204–5, 275–317) seem to be based on similar figures in Chinese Buddhist paintings (Cleveland 1980, no. 46; Berlin 1970, no. 34).

15 The Diez albums are catalogued in Ipşiroğlu 1964.

16 The albums in the Topkapi Saray have been widely but unevenly published. For references to such publications and further comments see Grube 1984.

17 Upham Pope 1939, p. 2,707; Gray 1976, p. 239.

18 For the whole ewer see London 1976, no. 196.

19 For the whole bucket see Barrett 1949, no. 10.

20 Compare openings in figure 115.

21 The wall-paintings at the Yongle gong show a number of other relevant thrones (Titley 1981c, pl. 25). Compare a Tibetan banner in the British Museum (1880-309) and MacDonald and Imaeda 1977, p. 111, A26, 27. See also Upham Pope 1939, pp. 2,639–47.

22 Compare a flaming pearl illustrated on a throne in a miniature in one of the Diez albums (Gray 1979, pl. xxviii).

23 Compare tables from Jin-period tombs in China (*Wenwu* 1982.1, pp. 52–3, pl. 5:2; *Kaogu yu wenwu* 1983.6, pp. 32–9, pls 5:2, 3).

24 Gray 1961, p 73; Gray 1979, fig. 87.

25 Upham Pope 1939, pp. 2,421–6.

26 Gray 1979, fig. 95, pl. LI.

27 Soper 1958.

28 Whitfield 1982, vol. I, fig. 55.

29 In addition, decoration of animals in Chinese style is shown in miniatures as part of the furnishing of rooms, especially over doorways (Titley 1983, fig. 13).

30 *Wenwu* 1975.8, pp. 31–9, fig. 23, pl. 3.

31 More striking examples in manuscript illumination of the use of compositions larger than the margins allow are seen in the *Diwan* of Sultan Ahmad Jala'ir, *c*.1405, now in the Freer Gallery of Art, Washington (Martin 1926).

32 Gray 1961, p. 100.

33 Titley 1983, pp. 240–1.

34 Kühnel gives a sketch of the development of the arabesque (Kühnel 1977). I am grateful to E.H. Gombrich for drawing my attention to a lecture by Otto Kurz in the series 'Islamic art between East and West', held in Oxford, in which Dr Kurz commented on the combination of the Islamic arabesque with Chinese flowers.

35 Upham Pope 1939, pp. 2,414–17.

36 *Wenwu* 1979.6, pp. 22–32, fig. 6.

37 *Wenwu* 1979.8, pp. 32–6, pl. 5; other relevant textiles are illustrated in *Wenwu* 1978.4, pls 2–5; *Wenwu* 1982.2, pp. 1–21, pl. I; Beijing 1982b. In the fifteenth century Timurid flower patterns based on Chinese lotus leaf designs were copied on to Chinese ceramics (Rawson 1984b, figs 22–3).

38 Ettinghausen 1959, fig. I; Simpson 1982, fig. 51.

39 Changes in leaf forms are discussed by Denny 1983 and Michael Rogers in a forthcoming article (see note 41 below).

40 Carswell 1982 and Rogers 1983 both review the history of Iznik wares.

41 I am grateful to have had the opportunity to read before publication an article by Michael Rogers, in which he has raised the problems of dating the 'Damascus' wares. He

has proposed a date in the latter part of the mid-sixteenth century. This late date seems to be at variance with the dating of related tiles in the Yeni Kaplica Baths at Bursa (Carswell 1984).

42 A third decorative scheme on the Edirne tiles (Carswell 1972, fig. E7) is based on the ancient lotus and bud motif. This formula is also found in a related form on earlier lustreware tiles. It continued in use on Iznik tiles (Raby 1983, figs 14–15; Carswell 1982, nos 82–3; see also Carswell 1984, v–vi).

43 In addition to the composition based on the Chinese lotus pattern, some dishes in the 'Damascus' group are decorated with bunches of flowers tied by a fillet. This detail recalls a prominent fifteenth-century Chinese design, and again indicates that the underlying compositions exploited the wares were borrowed from China. The Ming design was anticipated in Ding ware (Wirgin 1970, pl. 103b).

44 For a related discussion see Welch 1972. An alternative approach is found in Denny 1983.

45 Welch 1972 assumes that the artist of the drawing must have seen Ottoman designs similar to those on the tiles of the Circumcision Kiosk. I am suggesting here that the influence must in general terms be explained the other way round. I do not, however, wish to imply that the tiles are based on this particular drawing.

46 Rogers 1983, fig. 8, no. 140, illustrates a dish with a related design. The elaborate leaves discussed here are sometimes described as *saz* leaves. To date these discussions have not differentiated between the varieties of long serrated leaves. Many of the examples on the 'Damascus' wares take up the position of the fronds on the Chinese lotus designs (fig. 152), but have been given serrated edges as if to refer to acanthus leaves. Others are more elaborate and, as discussed here, were derived from Chinese lotus leaves. A third variety seems to have been derived from split-palmettes, as suggested above. The most complex leaf forms of all three varieties are subsumed under the name *saz*. Evidence for the date of the introduction of the fully developed forms in the third quarter of the sixteenth century is taken to be provided by an album of Murad III in the Oesterreichische Nationalbibliothek, Vienna (Grube 1982, nos. 186-202-206) and by embroidered kaftans in the Topkapi Saray (Denny 1983, figs 2, 13). However, the details of these developments have yet to be fully documented.

47 Similar tiles are discussed and illustrated in Catleugh 1983, pp. 71–9, fig. 129.

48 For a full view of the jar in fig. 170 see Jenyns 1953, pl. 52a. Indifferent paintings of birds and flowering trees in Chinese style in the albums in the Topkapi Saray Library seem to be based as much upon embroideries as on paintings (Grube 1984, figs 110–20, 134–6).

49 Titley 1983, pl. 9.

50 The panel at the Rüstem Pasha mosque is illustrated in Atil 1980, fig. 161.

51 Carswell 1984, fig. vii.

52 A fascinating account of the imitation, or rather the replication, of ideas is given in Dawkins 1978, pp. 203–5. This clear recognition of the way each of us makes use of ideas and skills developed by our elders and fellows has unfortunately hitherto been little appreciated. Emphasis on originality and on a rejection of past traditions has contributed to a loss of large areas of skill and of correspondingly large areas of design. The results have been far from benign, as the modern architecture discussed in the Introduction has now painfully illustrated.

APPENDIX

1 Riegl 1893; Gombrich 1979, pp. 180–90.

2 The political relations between Egypt, the Aegean and Mesopotamia, and the resulting cultural contacts are discussed by Stevenson Smith 1965.

3 Akurgal 1968, pp. 162–222.

4 Darby 1977, pp. 620–34; Helck and Wolfhart 1975, vol. 3, pp. 1,091–6.

5 Foucart 1897 discusses some early examples used in architecture. For later decorative uses see especially Tait 1963.

6 James 1979, fig. 83.

7 The origins of the palmette seem never to have been explained satisfactorily. Riegl treats the palmette as a view of the lotus (Riegl 1893, pp. 59–60, fig. 16). However, his illustration shows the combination of a lily and palmette. The role of the lily has yet to be considered. Lilies are represented in both Aegean and Egyptian art and were one of the plant forms widely manipulated in ornament. The spreading petals of the lily do indeed suggest the two volutes that later appear on the palmette. See also Stevenson Smith 1981, fig. 402.

8 Other plant motifs that might have contributed to the formulation of the palmette are seen on Cretan Kamares ware (Higgins 1967, fig. 17).

9 Compare also Stevenson Smith 1965, fig. 50b.

10 The debate on the sources of spiral patterns is not easy to resolve. While spiral patterns seem to have been widely and enthusiastically employed in the Aegean at an early date, scholars working on Egyptian sources are concerned to emphasise the independence of the Egyptian development. The priority of the Aegean is suggested by Kantor 1947, pp. 21–7, and Hood 1978: the relatively separate development of spirals in Egypt is argued by Ward 1971. Stevenson Smith 1981 illustrates early spiral patterns in fig. 205.

11 The arrangement of patterns in the Theban tombs and the wall-paintings at Knossos are surprisingly close. In addition to the examples in fig. 181, compare the running spirals in fig. 183b with Evans 1930, p. 295, fig. 193.

12 Kantor 1947, pl. IV A, B, pl. V N, O.

13 Compare the border around the neck of the Vix *krater* (Joffroy 1979, fig. 14). Related forms were employed in Ionic capitals (Lawrence 1957, p. 33), and in modillions of the Roman period (Strong 1963, pl. VIII).

14 For the range of decoration of the Theban tombs see Jones 1856. Egyptian pls VII–XI; Jéquier 1910; Förtová-Šamalová 1960.

15 Stevenson Smith 1965, fig. 53. Stylised bouquets, perhaps made in a precious metal, seem to be represented in a number of Egyptian wall-paintings.

16 Postgate 1977, pp. 115–36; Reade 1983.

17 Various trees are discussed by Stevenson Smith 1965, p. 125. On p. 113, referring to Helene Kantor, he dates the earliest appearance of the volute tree in Egypt to the Seventeenth Dynasty. Admittedly the example they both cite is diminutive. It is worth noting that related volute trees appear on Aegean pottery (GR 1911.4-28.1) and on ivories from Lachish (Barnett 1982, pl. 21d).

18 Stevenson Smith 1965, fig. 127.

19 Reade 1983, fig. 30.

20 Rudenko 1970, pl. 174.

21 Frankfort 1970, fig. 417; Ghirshman 1964, pl. 289.

22 Stucky 1974; Akurgal 1968, pp. 155–6; Barnett 1957, pls VII: G6a, G7, IX:D9, XXI: S6, XXXII: S47a, XXXIV: S50.

23 New York 1979, nos 71–2.

24 Vase designs have been chosen here to set out the development of lotus and palmette ornament because they are widely available in collections in many parts of the world. However, a similar development can be traced in architectural ornament in both terracotta and stone. Designs in these materials follow parallel evolutions despite the different techniques involved and the very different types of area to be decorated. See for example *acroteria* from Aphaia (Fürtwangler 1906, pl. 51) and the grave steles illustrated by Möbius 1929 and Hauglid 1947. Despite the dominance of palmettes in most designs, lotus buds and flowers still appear, also shown in figs 194–6. Later forms of the same designs, embellished with very full acanthus leaves, also include lotus flowers.

25 This series of ornaments on red-figured vases could also have been generated using as a starting-point a single border of lotus and palmettes on arcaded stems, as on the Caeretan *amphora* in fig. 192b. For the date of the later borders see Boardman 1975, p. 214.

26 Riegl 1893, pp. 119–24.

27 Jones 1856, Greek, pl. xix.

28 Earlier architectural ornaments, such as the palmette ornament from the Erechtheion mentioned in note 24 above, contain similar references to the ancient lotus flowers combined with palmettes. In such earlier examples, a complete palmette is generally supported on a pair of s-shaped scrolls as in the vase ornament. Only when the acanthus sheaths were insistently used with the s-shaped stems did it become necessary to divide the palmette which a pair supported. The acanthus has been extensively studied (see Riegl 1893, pp. 248-58; Möbius 1929; Hauglid 1947; Gombrich 1979, pp. 180–90).

29 Various views on the geographical origins of elaborate acanthus patterns are expressed by Roux 1961, pp. 328–31, who refers to Schede 1909, pp. 20–1, and by Lyttelton 1974, pp. 30–1.

30 The lotus and palmette border was obviously not based on a honeysuckle plant; as we have seen, it had very ancient origins in Egyptian plant designs. The borders of lotuses and palmettes in Greek architecture are also sometimes called anthemion borders; authorities who use the term seem to imply that this is a specific name for the design. However, I am indebted to Jeffrey West for drawing my attention to the proper uses of the term to describe floral borders generally. All forms of the design are best described as borders of alternating lotuses and palmettes.

31 As mentioned in the Introduction, our need to understand what we see is one of the enduring forces behind developments in all visual arts. Thus plant ornament, however remote from real plants, is generally interpreted as representing particular plants.

32 The underlying construction of a Corinthian capital consists of a pair of volutes supporting palmettes; it was used in parallel with the decoration of *acroteria* and vase painting (Mallwitz 1981, fig. 108).

33 Hauglid 1947, pp. 112–16.

34 Gombrich 1979, p. 187.

35 Robertson 1965 considers the history of the mosaics at Pella.

Glossary

Abraham of Kütahya ware. High-fired faience, made at Iznik, and possibly Kütahya, in Turkey in the early sixteenth century, decorated with distinctive flower and scroll designs in tones of blue and white.

acroterion. Architectural ornament at the apex or outer angles of a pediment on a Classical building.

amphora (Latin). A jar with two handles, used for strong liquids, especially wine.

apsaras (Sanskrit). A heavenly being or attendant of the Buddha or Bodhisattvas.

arabesque. Foliate ornament, used in the Islamic world, typically using leaves, derived from stylised half-palmettes, which were combined with spiralling stems.

bixie (Chinese). A name originally given to the protective powers of a mythical deer; later a term for a composite creature resembling a feline, often used as a guardian figure lining tomb avenues.

calyx. Collective term for the sepals of a flower; applied by analogy to cup-shaped formations of leaves, as in acanthus ornament in Classical architecture.

cella (Latin). The main part of a Classical temple.

chaitya (Sanskrit). A shrine or meeting hall. The profile of the entrance of such halls was adopted in cave architecture in India, and was later employed for niches in Buddhist structures in India, Central Asia and the Far East.

cyma reversa (Latin). Classical architectural moulding of double curvature. The moulding could be carved with a variety of leaf and tongue enrichments.

Damascus ware. Ceramics with florid decoration made at Iznik in Turkey in the mid-sixteenth century.

Ding ware. Porcelains of a creamy white tone, made in Hebei province in north China; kilns making Ding ware have been found at Jiancicun at Quyang Xian; see also Xing ware.

epitaph tablet. Square tablets of stone placed in Chinese tombs of high officials and members of the imperial families, recording the achievements of their lives. They are generally covered by a second slab with sloping sides decorated with flower scrolls surrounding a bold central inscription.

fenghuang (Chinese). A mythical bird, generally translated into English as 'phoenix'.

guilloche. A border, originating in Mesopotamia, of interlocking s-shaped motifs making a pattern that resembles a twisted rope.

he (Chinese). A wine or water-pouring vessel on three or four legs, particularly popular in the Shang (c.1700–1050 BC) and Zhou periods (c.1050–221 BC).

hydria (Greek). Water jar with two handles for lifting and a single handle behind the neck for pouring.

iwan. Three-sided, barrel-vaulted hall, first used in Parthian architecture, but later widespread in Iran and the lands of Islam.

krater (Greek). A bowl for mixing wine and water.

lekythos (Greek). A bottle for perfumed oil, used especially at funerals.

lingzhi (Chinese). A fungus thought to be able to confer immortality on those who consumed it.

long (Chinese). A dragon.

makara (Sanskrit). An Indian aquatic mythical beast.

meiping (Chinese). A flask with shoulders wider than its footring.

mudan (Chinese). Peony.

ogee. Complex profile of double curvature. The term is often used to describe arch forms employed in the later Islamic world. The shape is anticipated in the *chaitya* arch, and related shapes were widely used in China from the fifth century.

opus reticulatum (Latin). Decorative brickwork in a lattice pattern.

pailou (Chinese). A ceremonial gateway placed at entrances to Chinese temples and tombs.

palmette. A stylised plant form, consisting of a fan of graded spines supported on two volutes, widely used in the ancient Mediterranean world and the Near East.

pediment. Originally a pediment was the gabled end of a roof on a Classical building. Usually triangular in form, pediments could also be used decoratively to crown niches and window openings.

phiale (Greek). A shallow bowl used by men for pouring libations and by gods as a drinking cup.

qiangjin (Chinese). Decoration used on Far Eastern lacquer in which gold or silver was applied to a design incised in the surface.

qilin (Chinese). A Chinese mythical deer; in later periods the creature was sometimes depicted as a composite beast with both feline and deer-like features.

qingbai (Chinese). A transparent bluish glaze used on porcelains made at Jingdezhen in southern China and at other southern porcelain kilns; *see also* **yingqing**.

ruyi (Chinese). An ancient Chinese term for a sceptre or weapon, later employed to name decorative sceptres held by figures of gods.

saz (Turkish). Extravagant long feathery leaves used in Iranian and Turkish decoration from the mid-sixteenth century.

scaenae frons (Latin). Permanent stage set built at the back of stages in Roman theatres.

si ling (Chinese). The four powerful creatures – dragon, tiger, bird and deer.

si shen (Chinese). The animals of the four directions, the Green Dragon of the West, the Red Bird of the South, the White Tiger of the West and the Black Warrior of the North (tortoise and snake).

śramanas (Sanskrit). A disciple of the Buddha.

stepped merlon. Triangular architectural ornament with stepped sides, widely used in Iran, the Near East and Central Asia.

stupa (Sanskrit). A Buddhist reliquary mound.

sutra (Sanskrit). A religious discourse; otherwise a Buddhist religious text.

Swatow ware. Low-quality porcelains, possibly made in Fujian province, south-east China, in the sixteenth and seventeenth centuries. They were widely exported.

Taiyi (Chinese). The 'Supreme Unity', a deity brought under worship during the reign of the Chinese Emperor Wudi (140–87 BC).

taotie (Chinese). A monster face shown from the front, used to decorate Shang and Zhou bronzes (c.1400–250 BC). The purposes and significance of the designs, if any, are not known.

tianlu (Chinese). A heavenly deer.

trabeated arch. An angular arch form widely used in Chinese Buddhist architecture. The shape seems to have been derived from a perspective rendering of three sides of a room.

tridachna. Shells of *Tridachna squamosa* with incised designs, found in Mesopotamia.

Tripitika (Sanskrit). The Three Baskets, a general term for the canonical collection of Buddhist scriptures.

vihara (Sanskrit). A Buddhist monastery.

Vikrama era. This era, which began in 57 BC, is thought to have been initiated by the accession to paramount power of the Indo-Saka ruler, Azes I.

Vaiśravana (Sanskrit). The Buddhist Guardian of the North.

wu xing (Chinese). The five elements – wood, metal, earth, fire and water.

Xing ware. White porcelains made at kilns in Neiqiu Xian, Hebei province; superseded by Ding porcelains.

xin yuefu. A set of satirical poems composed by the Chinese poet Bo Juyi (772–846).

yingqing. A transparent glaze with a bluish tinge used on southern porcelains made at Jingdezhen in Jiangxi province and on porcelains from other southern kilns; *see also* **qingbai**.

yin yang. Chinese term for the dual forces of female and male, dark and light, moon and sun.

Yue ware. High-fired ceramics with a green glaze made at a large number of kilns in south-east China. They were the predecessors of celadons from Longquan.

yun jian (Chinese). 'Cloud collar', a term employed for a garment in use from at least the Yuan dynasty.

zhu niao (Chinese). The Red Bird of the South.

zun (Chinese). Ancient Chinese wine vessel, in use in the late Shang and Zhou periods (1200–250 BC).

Museum and library accession numbers

237

Index